DOCUMENTING AMERICA, 1935–1943

Donated by...

The

Jost-Ore

DOCUMENTING AMERICA, 1935–1943

EDITED BY CARL FLEISCHHAUER AND BEVERLY W. BRANNAN

ESSAYS BY LAWRENCE W. LEVINE AND ALAN TRACHTENBERG

UNIVERSITY OF CALIFORNIA PRESS Berkeley · Los Angeles · London

in association with the Library of Congress

University of California Press

Berkeley and Los Angeles, California

University of California Press, Ltd., London, England

© 1988 by

The Regents of the University of California

Printed in the United States of America

9 8 7 6 5 4 3 2 1

Library of Congress Cataloging-in-Publication Data

Documenting America,

1935–1943/edited by Carl Fleischhauer and

Beverly W. Brannan; essays by Lawrence W. Levine and

Alan Trachtenberg.

p. cm.—(Approaches to American culture)

Bibliography: p.

Includes index.

ISBN 0-520-06220-5 (alk. paper).

ISBN 0-520-06221-3 (pbk.)

1. United States—History—1933–1945—Pictorial

works. 2. United States—Social conditions—

1933–1945—Pictorial works. 3. Photography,

Documentary—United States—History—20th century.

I. Fleischhauer, Carl. II. Brannan, Beverly W.,

1946– III. Levine, Lawrence W. IV. Trachtenberg,

Alan. V. Series.

E806.D616 1988

973.917—dc19 87-24598

 CIP

The authors gratefully acknowledge permission to reproduce the following images in this book:

Figure 12 (page 22): Courtesy of the Walker Evans estate.

Figures 14, 19, 20, and 21 (pages 25 and 47): Copyright 1938 by Archibald MacLeish. Copyright renewed 1966 by Archibald MacLeish. Reprinted by permission of Houghton Mifflin Company.

Figure 17 (page 36): LIFE © 1937 Time Inc. Reprinted with permission.

Figure 28 (page 67): Courtesy of Paul Appel, publisher, Mt. Vernon, N.Y. 10553.

Support for the publication of this book and the mounting of an associated exhibition was provided by the following members of the National Association of Photographic Manufacturers: Eastman Kodak Company, GTE Products Corporation, Ilford Incorporated, and Schoeller Technical Papers, Incorporated.

The publishers wish to acknowledge with gratitude the contribution provided from the Art Book Fund of the Associates of the University of California Press, which is supported by a major gift of the Ahmanson Foundation.

CONTENTS

The fifteen photographic series in *Documenting America* picture the nation as it recovered from the Great Depression and entered the Second World War. Selected from the approximately 77,000 images produced by a government photographic section, the series may be seen as vignettes of life in the United States between 1935 and 1943. Because each series represents one photographer's coverage during a single assignment, the series also portray the photographers at work.

The photographic section, directed by Roy E. Stryker, operated within the Resettlement Administration (1935–1937), the Farm Security Administration (1937–1942), and the Office of War Information (1942–1943). Images made for these agencies by Walker Evans, Dorothea Lange, Russell Lee, and their colleagues have had a major impact on the history of photography. Their photographs form the core of the Farm Security Administration–Office of War Information (FSA-OWI) Collection at the Library of Congress. This book and an associated exhibition commemorate the fiftieth anniversary of Stryker's photographic section.

The 77,000 photographs created by the section have been organized three different ways.[1] During the eight-year span of the section's working life, the mounted prints were stored in vertical file cabinets, with some images arranged by state and others by subject. This system proved unsatisfactory, however, and during the Second World War these images, along with about 30,000 images gathered from other sources, were reorganized into the two arrangements that exist at the Library of Congress today. One consists of about 2,200 groups of photographs, called lots, which more or less cover the original shooting assignments. This arrangement is on microfilm. In the other about 88,000 photographic prints have been classified by subject within six broad geographic divisions. This classified file is stored in cabinets in the Prints and

Photographs Reading Room. In this book we have used the word *file* to refer to the collection as a whole and to the different physical arrangements.

The editors, believing that a well-rounded series would offer not only interesting views of American life but a good perspective on the photographer in the field, looked specifically for groups of photographs that gave complete and coherent coverage of particular subjects. In their search they scanned the entire FSA-OWI Collection. Because this book was to examine the photographers' original assignments, the editors looked at the pictures lot by lot on microfilm.

In principle, the best way to learn how a photographer documented a subject is to study the full set of exposures he or she made. This is impossible for the FSA-OWI Collection, however, because it does not include all of the original negatives. It grew out of the working picture file that Stryker compiled while his section was active, and in assembling that file, Stryker and the photographers selected the best images and "killed" others.[2] Even without the killed images, however, each assignment is still represented by dozens of prints, many of them similar views of identical subjects. Because there are so many prints, it is impossible to include complete sets here.

As a preliminary step, we selected eighty series on the basis of image and caption. Then with the help of Lawrence W. Levine, Alan Trachtenberg, and colleagues at the library, we winnowed our selection to fifteen. Commonsense guidelines influenced the process. Although this book does not represent the FSA-OWI Collection in a statistical sense, we wanted to show the work of the key photographers. The range of photographs in the collection and the format and size of this volume nevertheless dictated that some important people be left out—notably Carl Mydans, Theodor Jung, and Arthur Siegel. The book includes series from each phase of the section's existence and suggests the variety of the collection. We attempted to achieve a balance between aesthetic considerations and interesting case histories while presenting a cross section of the nation's regions and social strata.

The subjects of the series were generally defined by the grouping and captioning of the photographs in the lots. In two instances, however, the editors rearranged material and narrowed the scope of the subject to accommodate a case history approach. The series presenting Ben Shahn's photography of cotton pickers in Arkansas was selected from Shahn's work from a 1935 trip through the Midwest and the South. Shahn never arranged the photographs from this journey by chronology or subject; the 123 Arkansas photographs are filed together, including the 47 images of cotton pickers from which we chose 14 for this book.[3] And the series presenting Dorothea Lange's photography of migrant laborers in California's Imperial Valley in February and March 1937 was chosen from a lot containing all 209 images Lange took of these workers in 1937, organized without regard to location, time of year, or crop being harvested.[4]

Each series in this book is accompanied by a brief text describing the circumstances in which the pictures were created and not-

ing the extent of the holdings in the file for the assignment. When relevant and feasible, the texts treat Stryker's and the photographer's motives and discuss the relation between government policy and the subject of the photographs. They also mention photographic technology and technique when these bear upon either the photographer's approach or the form or content of the images. Captions for the photographs in this book are based on the captions on the file prints, prepared by the staff of Stryker's section from information supplied by the photographers and rewritten during a massive reorganization of the file between 1942 and 1946, and on other written information in the collection.

Lawrence W. Levine and Alan Trachtenberg not only wrote the two insightful essays included here but also contributed to the overall direction of the work, to the introduction, and to the texts that accompany the photographic series. Three colleagues at the Library of Congress also provided valuable criticism. Stephen E. Ostrow, chief of the Prints and Photographs Division, and Alan Jabbour, director of the American Folklife Center, gave the editors the time and freedom to pursue this project and read the manuscript closely and thoughtfully. Evelyn Sinclair of the library's Publishing Office helped both to organize and edit the introduction and series texts and to manage the project.

The book and exhibition involved the cooperation of several library divisions and received the vigorous support of Dana J. Pratt, director of publishing, and William F. Miner, exhibits officer. Ray Dockstader, deputy director of the American Folklife Center, worked with Thomas J. Dufficy, executive vice-president of the National Association of Photographic Manufacturers, to raise funds for the project. Generous support has been received from the Eastman Kodak Company, GTE Products Corporation, Ilford Incorporated, and Schoeller Technical Papers, Incorporated.

Claudine Weatherford did the background research, sustaining and guiding the editors during the selection process with her wit, insight, and understanding. Her research, in turn, owes a debt to the reference staff and collections at the library, where Leroy Bellamy and Jerald C. Maddox of the Prints and Photographs Reading Room were particularly helpful. Claudine Weatherford also made extensive use of the collection of Roy E. Stryker's papers at the Photographic Archives, University of Louisville, and the editors express their appreciation to James Anderson and David Horvath for making a microfilm copy of these papers available to the library for an extended period. She also examined the Dorothea Lange collection at the Oakland Museum, where she and the editors received helpful guidance from Therese Thau Heyman, the museum's senior curator of art prints and photography.

In our research, we relied on the invaluable Richard Doud materials at the Archives of American Art, Smithsonian Institution. In the mid-1960s Doud interviewed most of the principals of the FSA-OWI photographic section and prepared a book-length manuscript on the subject. Conversations with Pete Daniel, Sally Stein, and Maren Stange, working at the Smithsonian's National Museum of American History on their book *Official Images: New Deal Photography* and an accompanying exhibition, added to our store of ideas.[5]

And we benefited from Penelope Dixon's annotated bibliography *Photographers of the Farm Security Administration.*[6]

The editors found that the boundaries of the Stryker photographic materials at the Library of Congress had been drawn differently through the years. Claudine Weatherford and Nicholas Natanson helped clarify the extent of the FSA-OWI Collection and compiled much of the information presented in the Appendix. George S. Hobart, Barbara Orbach, and Carol Johnson of the Prints and Photographs Division shared their knowledge of the collection. Annette Melville, who recently compiled a guide to the microfilm of the Written Records of the Farm Security Administration Historical Section, alerted the editors in 1983 to the approaching anniversary of Stryker's section and provided the initial impetus for this project.

The Appendix and Alan Trachtenberg's essay pay tribute to Paul Vanderbilt, who reorganized the collection between 1942 and 1946 and later became the first chief of the library's Prints and Photographs Division. Our work on this project heightened our appreciation of his contributions. We made use of the Paul Vanderbilt Papers at the Archives of American Art, and during the course of our research, Vanderbilt consented to two lengthy telephone interviews and a visit by Claudine Weatherford.

We received helpful responses to early versions of our manuscript from a number of readers, including Renata V. Shaw, assistant chief of the Prints and Photographs Division. Others offered information about particular series and photographers. Steven Plattner helped us locate Esther Bubley, and Katherine Tucker Windham, Jo Roy, and M. G. Trend told us about Gee's Bend, Alabama. Trend, an anthropologist who worked in Gee's Bend during the 1980s, provided the names of the individuals identified in the captions for "Tenant Farmers." Charles L. Todd gave information about both Gee's Bend and the FSA migratory labor camp at Visalia, California. Bonnie Fletcher of the Nebraska State Historical Society clarified details about the history of Omaha, and the filmmaker Judy Goldberg gathered information from members of the Lopez family in Trampas, New Mexico. We obtained biographical information about the late Marjory Collins from Ani Mander, her former professor at Antioch University West; Howard King, Collins's longtime friend; and Eva Moseley, curator of manuscripts at the Schlesinger Library at Radcliffe College, where Collins's papers are held. Finally, several photographers or their relatives read drafts of the manuscript sections that pertained to them and offered helpful information. We are very grateful to Esther Bubley, John Collier, Jr., Jack Delano, Jean (Mrs. Russell) Lee, Arthur and Grace Rothstein, and Marion Post Wolcott for their time and suggestions.

The editing and production of this book at the University of California Press have been ably managed by Sheila Levine, Marilyn Schwartz, and Ellen Herman. Steven Renick has provided the design, and Stephanie Fowler edited the final manuscript. The photographic prints used in the publication were made by Eva Shade of the Library of Congress Photoduplication Service, under the direction of Marita V. Stamey, head of the Photographic Section, and with the assistance of Jacqueline LeClerc, who helps maintain the negative files at the Library of Congress.

NOTES

1. This topic is discussed in detail in the Appendix.

2. For a discussion of the killed images see the Appendix.

3. In addition, the series "Cotton Pickers" includes one image from a killed negative.

4. The way Lange's Imperial Valley series was compiled suggests a disjunction between this book's definition of a series and Lange's customary photographic strategy. Lange did not often dwell on the details of life in a circumscribed area. For example, the photographs she and the economist Paul S. Taylor selected for their book *An American Exodus: A Record of Human Erosion* (New York: Reynal and Hitchcock, 1939; rev. ed., New Haven: Yale University Press, 1969; reprint, New York: Arno Press, 1975) were made in a number of different locations and assembled to illuminate the national problem of farm mechanization and rural migration. Walker Evans is another example. Although Evans (with his coauthor, James Agee) assembled a series bound by place and time in *Let Us Now Praise Famous Men* (Boston: Houghton Mifflin, 1941), most often he chose to juxtapose photographs made at different times and places. Evans's series, like Lange's, examine larger themes in American culture. For an analysis of the structure underlying the sequence of the first six photographs in Evans's book *American Photographs* (New York: Museum of Modern Art, 1938), see Alan Trachtenberg, "Walker Evans' America: A Documentary Invention," in *Observations: Essays on Documentary Photography*, ed. David Featherstone (Carmel, Cal.: Friends of Photography, 1984), 56–66.

5. Pete Daniel et al., *Official Images: New Deal Photography* (Washington, D.C.: Smithsonian Institution Press, 1987).

6. Penelope Dixon, *Photographers of the Farm Security Administration: An Annotated Bibliography, 1930–1980* (New York: Garland Publishing, 1983).

Between 1935 and 1943 a group of photographers working for the federal government documented America in pictures. The photographers were members of a photographic section headed by Roy Emerson Stryker that moved from one government agency to another and then to a third during its eight-year existence. First established in the Resettlement Administration (RA) in 1935, the section became part of the Farm Security Administration (FSA) in 1937 and was transferred to the Domestic Operations Branch of the Office of War Information (OWI) in 1942. When Congress eliminated the Domestic Operations Branch in 1943, Stryker and several of the section's photographers left the government.

This book presents fifteen case histories—photographic series accompanied by texts summarizing information about the photographers, their work in the field, and their assignments and subjects. These case histories sketch the circumstances in which the photographs were made, offer glimpses of Stryker in his role as section head, and taken together, outline the history of the section. Although not every photographer is included, the series represent the section's changing roster. For a few lean months during the winter of 1937–1938, Stryker's full-time staff consisted only of Russell Lee and Arthur Rothstein, but in better times—especially at the Office of War Information—the number grew to half a dozen or more. Some, like Lee and Rothstein, stayed with the section for five or six years whereas others, including Esther Bubley, worked for a year or less. Of the twenty or more photographers who worked with Stryker, twelve are represented here: Esther Bubley, John Collier, Jr., Marjory Collins, Jack Delano, Walker Evans, Dorothea Lange, Russell Lee, Gordon Parks, Marion Post Wolcott, Arthur Rothstein, Ben Shahn, and John Vachon.

The Resettlement Administration was created to alleviate rural poverty and assist people dislocated by such forces as farm mechanization and the Dust Bowl. The underlying problems were long-standing, however, and the Resettlement Administration and its successor, the Farm Security Administration, were by no means the government's first attempt to offer assistance. Rural poverty, which had been increasing since before the First World War, reached crisis proportions during the Depression. Government aid to farmers during the Coolidge and Hoover administrations had had little effect. With the beginning of Roosevelt's New Deal in 1933, the newly formed Federal Emergency Relief Administration, the Farm Credit Administration, and the Agricultural Adjustment Administration made loans, tried to affect the market for farm commodities, resettled farmers on better land, and offered assistance under the rubric "rehabilitation."

At first the New Deal agricultural programs focused on farm owners, offering little help to tenants. The Agricultural Adjustment Administration, for example, achieved notoriety for raising commodity prices by paying farmers to reduce production. Unfortunately, the program benefited relatively prosperous farmers and threw small farmers, sharecroppers, and tenants off the land. Altogether, the discordant collection of government programs reflected the discord among liberals, conservatives, idealists, and pragmatists within the Department of Agriculture and the administration as a whole.[1]

One of the liberals was Rexford G. Tugwell, a Columbia University economics professor who had been a member of Roosevelt's brain trust. By late 1934 Tugwell had come to feel that existing farm programs placed excessive faith in business recovery and emergency relief and that they had failed to help rural America's poorest residents. His arguments and those of some members of Congress, along with the controversy over the Agricultural Adjustment Administration, nudged Roosevelt into action. His April 1935 executive order created the Resettlement Administration as an independent agency and named Tugwell as its administrator. Tugwell's prior appointment as assistant secretary of agriculture gave the new agency a connection to the Department of Agriculture.

The Resettlement Administration borrowed or transferred programs from other agencies but also developed new programs. The agency's mission was to assist the poorest farmers. It resettled them, helped establish rural cooperative enterprises, constructed three model suburban communities called greenbelt towns, and carried out rehabilitation programs that offered grants and loans to tenants and small farmers. Although the agency sought to help people stay on the land, the overall effect of its program was simply to ease the pain caused by structural changes already under way in American society. Tugwell, like other New Deal agricultural planners, believed that many rural citizens had to move to growing urban manufacturing centers. The writer George Abbott White has summarized the planners' attitude: "[Tenants and small farmers] had to understand that it was cities where they would live and work, that return to their villages and farms was impossible because it had slowly become impractical."[2]

Conservatives found Tugwell too radical and branded several of his Resettlement Administration programs socialistic as soon as they began. They were particularly critical of the rural resettlement projects and greenbelt towns because these involved federal land-ownership and experiments with government-sponsored cooperative ventures. As an independent agency without a legislative mandate, the Resettlement Administration suffered from an uncertain status in government. In December 1936 it was transferred to the Department of Agriculture, Tugwell resigned, and Secretary of Agriculture Henry Wallace named Will Alexander as Tugwell's successor. Six months later the long-awaited Bankhead-Jones Farm Tenant Act was signed into law, to aid tenant farmers and provide a congressional mandate for some of the activities the Resettlement Administration had been overseeing. Its key elements included programs for rehabilitation, health care, and the purchase of farms by tenants. Despite the reservations of Congress about both rural resettlement projects and greenbelt towns, these were allowed to continue.

Although the Farm Tenant Act established no administrative unit to carry out its programs, Wallace changed the name of the Resettlement Administration to Farm Security Administration and instructed it to perform many of the functions of the new legislation. As it had in its first guise, the Farm Security Administration focused on underprivileged individuals. A 1941 study calculated that the average net annual income of the agency's clients rose from $375 to $538 after their acceptance by the agency.[3] The historian Sidney Baldwin argues that the Farm Security Administration's rehabilitation program "probably had only a negligible impact on the nation's agriculture, but profound consequences for the human condition of the low-income farm families who were served."[4]

Because they needed congressional support and wanted to educate the public, the agencies emphasized public relations. Under the auspices of the Resettlement Administration and Farm Security Administration's active Information Division the filmmaker Pare Lorentz produced his well-known documentaries *The Plow That Broke the Plains* (1936) and *The River* (1937). The first film attributes the Dust Bowl to poor land use, and the second tells how unwise use of the land exacerbated a massive flood on the Mississippi River system. The Information Division was also home to Roy Stryker, who had been appointed chief of the Historical Section in July 1935, shortly after the Resettlement Administration was established. The section's original mandate was to prepare finished reports by a battery of economists, sociologists, statisticians, photographers, and other specialists. In fact, it produced and maintained a file of still photographs and supplied copies of the pictures for news releases, put out a variety of internal and external publications, and prepared a wide range of exhibits.

In producing photographs for public relations, Stryker understood that pictures merely celebrating agency successes would build little support. Although the file contains many such images, many more depict the problems the agency was trying to solve; these pictures had the greatest impact on members of Congress and the public. The photographers themselves generally developed little

enthusiasm for "project" photography. "I'm afraid my pictures are pretty much the same old hash," John Vachon wrote in 1938 about his coverage of the greenbelt town of Green Hills, Ohio. "Women hanging clothes on the line, children sliding down the slide, etc."[5]

The Resettlement Administration and Farm Security Administration scrapbooks of news clippings—now at the Library of Congress—show how the news media used the photographs.[6] The pictures illustrate news and feature stories prepared both by the agencies and by independent news reporters. The clippings come from the news sections and rotogravures or feature sections of daily newspapers across the country and from periodicals ranging from *Look* to agricultural journals. The most-often-published pictures show the down-and-out, usually described in captions as victims of the Depression or the Dust Bowl. Such images were often juxtaposed with photographs of newly constructed government housing or the like—pictures that displayed the positive results of RA and FSA programs.

The historian F. Jack Hurley traces Stryker's interest in photography to his work with Rexford Tugwell at Columbia. As Tugwell's student and teaching assistant in the 1920s and as an instructor in the economics department with him during the early 1930s, Stryker was taken with his mentor's humanistic approach to economics. Hurley, basing his report on interviews with the two men, wrote that Tugwell "felt that it was important for students to have visual contact with the economic institutions they were studying. What did a bank look like? What did a cotton farm look like? How did it differ from a rice farm?"[7]

In the course of compiling the illustrations for Tugwell's 1925 book *American Economic Life,* Stryker was introduced to the work of Lewis Hine and other social documentary photographers,[8] which established for him a connection between photography and economics, history, sociology, and cultural geography. At Columbia and later at the Resettlement Administration and Farm Security Administration, Stryker came to know the works of the social scientists Caroline F. Ware, Harry J. Carman, Helen and Robert S. Lynd, Arthur F. Raper, Howard W. Odum, and J. Russell Smith.[9] Several of these writers, like Tugwell, were reform minded, and their interpretive descriptions of society, like Hine's photographs, were designed to provoke change.

The file, however, contains more than just reform-minded pictures. In assigning a photographer to cover a social problem or an agency client, Stryker outlined his requirements broadly, encouraging the photographers to shoot as many aspects of their subjects as they wished. He urged them to photograph what caught their interest, even if it had no direct connection to the agency or its mandate. In a postscript to Sherwood Anderson's *Home Town,* a portrait of small-town America illustrated with FSA photographs, Edwin Rosskam, a section photoeditor, wrote that the file contained "the most gay and the most tragic—the cow barn, the migrant's tent, the tractor in the field and the jalopy on the road, the weathered faces of men, the faces of women sagging with household drudgery . . .—they are all here, photographed in their con-

text, in relation to their environment. In rows of filing cabinets, they wait for today's planner and tomorrow's historian."[10]

Stryker's instincts about documentary photography and communication were sharpened from the start by his work with Walker Evans, Ben Shahn, and other photographers. The photographers' coverage, already wide-ranging, expanded after the agency's move to the Department of Agriculture in 1937 and the passage of authorizing legislation. Soon Stryker envisioned a pictorial record of America, particularly the small-town America he had cherished during his Colorado childhood.[11] His idea for an encyclopedic file gained focus through conversations like one he had in 1936 with the sociologist Robert Lynd. After their talk Stryker issued a shooting script that called on the photographers to record the myriad details of small-town life.[12] To achieve this more comprehensive view of society, affirming photographs had to be added to the file to balance scenes of hard times. In 1939 Stryker wrote Russell Lee that "we particularly need more things on the cheery side," asking, "where are the elm-shaded streets?"[13]

But after four or five years the coverage of Stryker's section was redirected by the coming of war. As Japanese troops moved in Asia and Germany invaded Czechoslovakia, America mobilized for defense. With the attack on Pearl Harbor, the country entered the Second World War. To counter the perception that its activities were geared to the Depression while the nation was responding to war, the Farm Security Administration began emphasizing programs that boosted domestic productivity. Meanwhile, Stryker's section turned more and more to urban and industrial subjects. "It is very important," Stryker wrote Jack Delano in 1941, "that we keep our finger in defense activities the way the whole world is moving now. . . . I am determined that we are not going to find ourselves liquidated because we got on the wrong wagon."[14]

Nevertheless, congressional criticism of the Farm Security Administration grew. The budget was cut after appropriation hearings in 1942, and after the 1943 hearings key programs were eliminated and the budget cut drastically. The agency struggled along until 1946, when it was abolished by the legislation that created the Farmers Home Administration. Stryker responded to the 1942 budget cuts by increasing the work the unit undertook for other government agencies on a reimbursement basis. Two of his clients were the government's propaganda agencies: the Office of the Coordinator of Information (COI) and its successor, the Office of War Information. Stryker, who supported the propaganda effort, did work regularly for each of them. In March 1942 he wrote Russell Lee that "the COI is doing a very important [job] of propaganda in the outside and inside of the country and their work is not going to be very much questioned by the brethren on the hill."[15]

The Office of the Coordinator of Information, established in July 1941, both oversaw and overlapped a proliferation of other departments and agencies. Its operations did not fully satisfy anyone, and personality disputes led to pressure for change. In June 1942 Roosevelt eliminated it and created the Office of War Information, one of more than a dozen agencies within the Office for

Emergency Management (OEM). But the bureaucratic battle over the form, content, and extent of government propaganda continued. Some OWI department heads and advisers—including Archibald MacLeish, who served simultaneously as the Librarian of Congress and as an OWI officer—saw the war as a battle between good and evil and as an opportunity to promote democracy around the world. Others, more pragmatic, sought the most effective ways to win the war, with slender concern for international morality. Each camp wanted to shape propaganda efforts to its goals.[16]

By September 1942 Stryker and C. B. Baldwin, who had succeeded Will Alexander as head of the Farm Security Administration in 1940, decided that the photographic section had to be separated from the farm agency. The Office of War Information was a logical choice for a new home, given the section's experience in documenting the war effort and its success in carrying out propaganda assignments. Within a few weeks Associate Director Milton Eisenhower established Stryker's unit as a division in the Bureau of Publications and Graphics, part of the OWI Domestic Operations Branch.[17] Eisenhower and Stryker were longtime friends, having worked together previously at the Department of Agriculture, where Eisenhower had served as chief of the Information Division and Stryker had been head of the Historical Section at the Farm Security Administration.[18]

When he shifted to the Office of War Information, Stryker strove to maintain the momentum of the section's work. He brought with him the five or six photographers then on his staff and the RA-FSA picture file, planning to keep adding to it.[19] In 1955 the archivist Paul Vanderbilt described Stryker's Office of War Information undertaking as "virtually a continuation, using the same techniques, of the FSA survey."[20]

Never again, however, did Stryker have the administrative freedom he had enjoyed at the Farm Security Administration. Within six months of his arrival he was named chief of the News Bureau's Division of Photography by the director, Gardner Cowles, Jr., as a part of Cowles's reorganization of the Domestic Operations Branch.[21] The News Bureau, formerly the Division of Information at the Office for Emergency Management, employed an already established group of five staff photographers and four contract photographers and had its own extensive file, including photographic series on the production of military aircraft and other war matériel and on the conversion of factories to war production.[22] The News Bureau file also contained photographs made to enlist support for home victory gardens, rationing, and recycling campaigns. Stryker incorporated these photographs into his file, but he seems to have made no major effort to influence the photographic approach of the News Bureau photographers.

Cowles's reorganization, however, failed to address the fundamental issue concerning domestic propaganda, an issue that had emerged when the Office of War Information was first created. Whereas Elmer Davis, the director of the agency, held that the government should do its best to offer full and factual information to the American public, both the Department of State and the War Department argued that news should be controlled and events like

military setbacks concealed. Anti-Roosevelt congressional representatives worried that news and feature stories prepared for domestic consumption would inevitably glorify the administration. Journalists felt that news should be disseminated by the nation's free press.[23]

At budget hearings during the spring and summer of 1943, the House of Representatives, led by Republicans and southern Democrats, voted to abolish the Domestic Operations Branch. The Senate restored some funds, but for all practical purposes the branch was eliminated.[24] For Stryker the fiscal year beginning in July 1943 was a time to wind down operations and to consolidate and protect his precious file. The Office of War Information Overseas Operations Branch, headquartered in New York City, had expressed some interest in the photographs, but Stryker feared the branch might destroy the integrity of the file. He also believed that the Associated Press, an independent news service, was conspiring with his enemies in government to "smash" the file.[25] Through friends at the White House and with the assistance of Archibald MacLeish, the Librarian of Congress, Stryker arranged for the library to take custody of the photographs.

The file was to be made available to the Office of War Information for the duration of the war, after which it would be transferred to the Library of Congress. During this period the file was extensively reorganized by the archivist Paul Vanderbilt.[26] Although the legal and physical transfers did not occur until 1944 and 1946, respectively, Stryker was satisfied that the groundwork had been laid by September 1943, and he resigned from the Office of War Information. Again accompanied by some of his photographers, he moved to the Standard Oil Company and continued his documentation survey.[27]

Through the years, the photographs produced by Stryker's section at the Resettlement Administration and the Farm Security Administration have generally been presented either as individual reports on the era or as gemlike examples of photographic art. Some of the images from the period have appeared in so many publications and exhibitions that they have become icons of the Depression years. The photographs were published frequently during the late 1930s and early 1940s and after a period of decreased interest were "rediscovered" in the 1960s and 1970s. By then the social conditions documented in the pictures had become part of history, and the books in which the photographs appeared usually identified them only by the name of the artist and a brief title.[28] These books present the photographs at a respectful distance, one image to a page, each one framed in white. Sometimes the history of the federal project that created them is recounted, with the emphasis on Stryker's role. Both the passage of time and this style of publication have isolated the photographs, obscuring the circumstances of their creation.

By examining the photographs in series selected from groups of pictures by single photographers working on single subjects, this book brings us closer to the original photographic assignments and the working photographer in the field. A documentary photographer, especially one who depicts human activity, normally makes

dozens of exposures to delineate different elements of a subject, to experiment with camera angles, or to cover the steps of a process or the stages of an event. This method must be used if the photographer plans to assemble a group of photographs for a magazine picture story or a photographic file like Stryker's, but very likely it will be used even if the photographer's goal is the creation of a single image. Only rarely does a single exposure yield the desired photograph.

The six exposures Dorothea Lange made that resulted in her famous migrant mother photograph may be treated as a series (see pp. 16–17).[29] In the essay that follows, the historian Lawrence W. Levine notes that the content of the well-known image, usually understood as portraying a "perfect victim" of the Depression, is balanced by the content of Lange's other depictions of Florence Thompson and her family, pictures in which children smile and a teenager gazes dreamily off into the distance. The series conveys something more complex—and more interesting to a historian—than the famous picture alone. In his essay, Alan Trachtenberg, a close student of the history of photography, concurs that such a reading is possible, but he observes that one might also read the photographs "as a pyramidal process culminating in a masterpiece of direction and manipulation." To look at the series, Trachtenberg says, "compels a different view of the image" and allows a story to be told but does not reduce the number of possible interpretations.

Although the migrant mother series offers insights into Lange's method of working, as well as into matters of form and meaning, it provides only a glimpse of the American scene. It fails to describe the Thompson family's day-to-day life, the details of the camp where they had stopped, or the farms around Nipomo, California. In contrast, the series in this book were selected for their broader, more diverse coverage of their subjects. John Vachon's series from Omaha, Nebraska, for example, documents the city from the stockyards to the commercial district and from flophouse row to the residences of the well-to-do.

The subjects of the series in this book include a city, an occupational group, an event, a city block, a railroad station, a family, an episode in the life of an ethnic group, and a portrait of an individual. In some cases Stryker's assignment established the subject; in others the photographers themselves made the choice. Only "Small Town in Wartime" represents a subject selected according to one of Stryker's "shooting scripts," the lists of subject suggestions that Stryker sent out intermittently to each of the photographers.

The eight-year life of Stryker's section coincided with the growth of photojournalism in magazines and books; indeed, the use of the section's photographs in several influential works contributed to this growth. Henry Luce founded *Life* magazine in 1936 and the brothers John Cowles and Gardner Cowles, Jr., established *Look* the following year. Also published at the time were Archibald MacLeish's *Land of the Free*, Arthur F. Raper's *Tenants of the Almighty*, and Richard Wright and Edwin Rosskam's *Twelve Million Black Voices*, books that reproduced a number of Resettlement Administration and Farm Security Administration photographs.[30] Of course, the form and content of photojournalistic picture stories

and "documentary" or "photo-textual documentary" books encompass far more variation than the series presented here, which are unified in place and time.[31]

In 1973 Stryker wrote that the section had been part of a movement, one feature of which was the use of photography "as a serious tool of communications." During the section's formative years "the rotogravure was dying [and] the first big picture magazines, which would take its place, were already being roughed out." He contrasted the FSA-OWI photographers and serious photojournalists with mere news photographers, who went to "dog fights" and made "noun and verb" pictures. "Our kind of photography," he said, "is the adjective and adverb. The newspicture is a single frame; ours a subject viewed in series. The newspicture is dramatic, all subject and action. Ours shows what's in back of the action. It is a broader statement—frequently a mood, an accent, but more frequently a sketch and not infrequently a story."[32]

The pictures in the FSA-OWI file demonstrate that as time went on the photographers increasingly produced coverage suitable for presentation as tightly focused picture stories. This tendency, no doubt influenced by the use of such stories in magazines like *Life,* probably reflects the changing cadre of photographers more than changes in any one photographer's approach.[33] Even in the early years a photographer like Dorothea Lange showed considerable interest in placing her photographs in magazines, as our text for the 1937 series "Migrant Workers" shows. In 1938 a political scientist writing about government public relations, citing the Resettlement Administration's effective use of photographs, noted the importance of "the narrative use of pictures in sequence."[34] But only after 1940, in the work of latecomers like Marjory Collins, Gordon Parks, and John Collier, Jr., did the picture story approach flourish.

To lay out a magazine picture story, an editor needs a variety of images to choose from. The photographer must provide a selection of scenes and camera angles, close-ups and wide shots, and vertical and horizontal compositions, many of which require arranging and posing. In 1942 Arthur Rothstein likened magazine photography to directing motion pictures. "In the development of an idea," he wrote, "each photograph is required to tell its part of the story as clearly and vividly as possible. It forces the photographer to become not only a cameraman but a scenarist, dramatist, and director as well."[35] In his 1937 "Tenant Farmers" he posed a number of photographs, including the quiltmaker, the girl in the window, the family group, and the children leaving school. Evidence that the last photograph was posed is offered by a second photograph in which the same children run toward the building but telltale shadows reveal that the sun has not moved.

Rothstein's arrangements, however, are less elaborate than the carefully scripted tableaux of Marjory Collins in "Small Town in Wartime," made in 1942, or the 1943 series "The Juan Lopez Family" by John Collier, Jr. To provide continuity, Gordon Parks's 1942 coverage for "Ella Watson, U.S. Government Charwoman" includes a photograph of Watson leaving for work as well as carefully arranged pictures of Watson on the job, at home, and in church. The

photographic unit Stryker established at the Standard Oil Company in 1943 after he left the government carried the idea of scripting even further. Stryker's unit produced photographs for magazines published for Standard Oil's employees and the general public. The art historian Ulrich Keller argues in an essay on the unit that Stryker's use of scripts and his photographers' use of posing, direction, and elaborate lighting grew out of Stryker's pedagogical instincts. "His educational zeal," Keller writes, "led him to value explicitness more than spontaneity."[36]

A magazine picture story is a collaborative enterprise, and the preceding remarks have concerned the photographer's contribution. In characterizing the photographer as scenarist, Rothstein fails to note the importance of editors and writers in shaping the final message, an idea that was brought home to Stryker by Edwin Rosskam, who edited exhibits and publications for Stryker at the Farm Security Administration and who wrote in 1939 that the "new unit" of communication was "the double-paged spread" in which word and image complemented each other.[37] When Stryker arrived at Standard Oil, he insisted on being a member of the public relations department's editorial team. The comparison between photojournalism and Stryker's approach in his FSA-OWI section and at Standard Oil should not be carried too far, however. Keller contrasts Stryker's editorial system with that of *Life* magazine, arguing that Wilson Hicks, the editor of *Life*, and his colleagues controlled their stories more closely than Stryker, and that the shooting scripts given to photographers for *Life* were far more explicit than Stryker's.[38]

Stryker's emphasis on compiling the section's picture file as a record of the era and a resource for the future separates his work from commercial photojournalism. His willingness to let the photographers follow their instincts reflected not only a general confidence in their abilities but also the certainty that the discoveries they made in the field would lead to a diverse selection of photographs for the file.

When photographers think of assignments in story terms, they are likely to cover cultural relationships and processes more fully than if they simply pursue single images.[39] For example, in one of the first photographs Gordon Parks made of Ella Watson, the charwoman, holding a broom and a mop, poses in front of an American flag. Often reproduced alone, this picture is Parks's statement about the status of black women in American society. But Parks also wanted to tell the story of Watson's life, and this impulse prompted him to document her surroundings and activities.

The photographers' descriptions of culture, of course, are subject to the influences that touch reports in every medium and from every hand. The attitudes and ideas of Stryker and the photographers affected their work. Dorothea Lange's opinions about America's economic system led her to look for victims among California's migrants, whereas Arthur Rothstein saw the tenant farmers of Gee's Bend, Alabama, as members of a simple folk community. The photographers' pictorial descriptions have also been colored by direction, posing, and arranging.

These series, then, require the same critical reading that one would give any documents, artifacts, or reports. The two essays that follow are instructive on this point, and the texts that accompany the series offer evidence that allows such a reading.

NOTES

The Roy E. Stryker Papers at the Archives of American Art, Smithsonian Institution, are cited as the Stryker Papers. The Roy E. Stryker Papers at the Photographic Archives, University of Louisville, are cited as the Stryker Collection. The Paul Vanderbilt Papers at the Archives of American Art are cited as the Vanderbilt Papers.

1. The chief sources for this portion of the introduction are Sidney Baldwin, *Poverty and Politics* (Chapel Hill: University of North Carolina Press, 1968); F. Jack Hurley, *Portrait of a Decade: Roy Stryker and the Development of Documentary Photography in the Thirties* (Baton Rouge: Louisiana State University Press, 1972); and Pete Daniel, *Breaking the Land* (Urbana: University of Illinois Press, 1985).

2. George Abbott White, "Vernacular Photography: FSA Images of Depression Leisure," *Visual Communication* 9, no. 1 (Winter 1983):54.

3. Bureau of Agricultural Economics study quoted in Baldwin, *Poverty and Politics*, 212.

4. Baldwin, *Poverty and Politics*, 212.

5. Vachon to Stryker, October 1938, Stryker Papers.

6. The clippings are part of the Written Records of the Farm Security Administration, Historical Section–Office of War Information, Overseas Picture Division, Washington Section Collection, hereafter cited as the FSA-OWI Written Records. This collection, which has been microfilmed, is in lot 12024, Prints and Photographs Division, Library of Congress.

7. Hurley, *Portrait of a Decade*, 10.

8. Rexford G. Tugwell, Thomas Munro, and Roy E. Stryker, *American Economic Life* (New York: Harcourt, Brace, 1925).

9. Correspondence with the historian Caroline F. Ware is included in the Stryker Collection at the University of Louisville, and a 1939 paper "Documentary Photographs," coauthored with Paul H. Johnstone, was included in *The Cultural Approach to History*, ed. Caroline F. Ware (New York: Columbia University Press, 1940), 324–30. The historian Harry J. Carman and the sociologist Robert S. Lynd were Columbia University faculty members with whom Stryker served and later corresponded after he joined the Resettlement Administration and Farm Security Administration. Letters from Stryker to the photographers Marion Post Wolcott, Russell Lee, and Jack Delano in 1938, 1939, and 1941 indicate that Stryker was in touch with the sociologists Howard W. Odum and Arthur F. Raper at the University of North Carolina and that he arranged for some of his photographers to work with them (see, for example, Stryker to Post Wolcott, 27 December 1938, 24 April 1939, and 1 May 1939; Post Wolcott to Stryker, 2 October 1939; Stryker to Lee, 11 April 1939; and Delano to Stryker, 9 April 1941; Stryker Collection). The economic geographer J. Russell Smith was a friend and professor of Tugwell's at the University of Pennsylvania and a Columbia University faculty member during Stryker's tenure there. Stryker required that his project photographers read Smith's textbook *North America: Its People and the Resources, Development, and Prospects of the Continent as an Agricultural, Industrial, and Commercial Area* (New York: Harcourt, Brace, 1925) before traveling to the sites of their photographic assignments (see Hurley, *Portrait of a Decade*, 58–60). In 1940 Stryker sent Post Wolcott to make some land use photographs in North Carolina at Smith's request (Smith to Stryker, 27 August 1940, Stryker Collection).

10. Sherwood Anderson, *Home Town* (New York: Alliance Book Corp., 1940), 144.

11. Biographical information and analyses of Stryker's approach to documentary photography may be found in Hurley, *Portrait of a Decade;* Nancy Wood, "Portrait of Stryker," in Roy E. Stryker and Nancy Wood, *In This Proud Land: America 1935–1943 as Seen in the FSA Photographs* (Greenwich, Conn.: New York Graphic Society, 1973), 10–19; James C. Anderson, *Roy Stryker: The Humane Propagandist* (Louisville: University of Louisville Photographic Archives, 1977); Ulrich Keller, *The Highway as Habitat: A Roy Stryker Documentation* (Santa Barbara, Cal.: University Art Museum, 1986), especially 24–52; and other works. Stryker's own articles include "Documentary Photography" in *The Complete Photographer* 21 (10 April 1942): 1364–74 (revised and reprinted in vol. 7 of *The Encyclopedia of Photography*, ed. Willard D. Morgan [New York: Greystone Press, 1971], 1179–83); "Documentary Photographs" (coauthored with Johnstone) in Ware, *The Cultural Approach to History;* "The FSA Collection of Photographs," in Stryker and Wood, *In This Proud Land*, 7–9.

12. Hurley, *Portrait of a Decade*, 96–98. The script has been reproduced in Stryker and Wood, *In This Proud Land*, 187.

13. Stryker to Lee, 29 June 1939, Stryker Papers.

14. Stryker to Delano, 8 April 1941, Stryker Collection.

15. Stryker to Lee, 18 March 1942, Stryker Collection.

16. The chief source for this portion of the introduction is Allan M. Winkler, *The Politics of Propaganda: The Office of War Information, 1942–1945* (New Haven: Yale University Press, 1978).

17. Memorandum from OWI Assistant Director George A. Barnes to Milton Eisenhower, 23 September 1942, Stryker Collection.

18. Hurley, *Portrait of a Decade*, 96.

19. In a 25 August 1986 interview with Carl Fleischhauer and Beverly Brannan, the photographer Esther Bubley identified Marjory Collins, John Collier, Jr., Jack Delano, Gordon Parks, and John Vachon as moving from the FSA to the OWI with Stryker. Arthur Siegel, who may have worked for Stryker on a contract rather than a full-time basis, is also represented in the collection by photographs made for both the FSA and OWI. For notes about this interview see *Documenting America, 1935–1943*, project records, Supplementary Archives, Prints and Photographs Division, Library of Congress.

20. Paul Vanderbilt, *Guide to the Special Collection of Prints and Photographs in the Library of Congress* (Washington, D.C.: Library of Congress, 1955), 119.

21. Winkler, *The Politics of Propaganda*, 62–63; Annette Melville, *Farm Security Administration, Historical Section: A Guide to Textual Records in the Library of Congress* (Washington, D.C.: Library of Congress, 1985), 8; U.S. Office of War Information, *Handbook of Emergency War Agencies* (Washington, D.C.: Government Printing Office, March 1943), 30.

22. The information about the size of the News Bureau's staff is from an untitled and undated manuscript in box 3, Vanderbilt Papers.

23. Winkler, *The Politics of Propaganda*, 24–37.

24. Ibid., 70.

25. Hurley, *Portrait of a Decade*, 168.

26. The Appendix provides a full account of Vanderbilt's work.

27. For information about Stryker's work at Standard Oil, consult Steven Plattner, *Roy Stryker: U.S.A., 1943–1950* (Austin: University of Texas Press, 1983); Nicholas Lemann, *Out of the Forties* (Austin: Texas Monthly Press, 1983); and Keller, *The Highway as Habitat*.

28. For example, see Edward Steichen, ed., *The Bitter Years, 1935–1941* (New York: Museum of Modern Art, 1962); Stryker and Wood, *In This Proud Land;* Hank O'Neal, *A Vision Shared: A Classic Portrait of America and Its*

People, 1935–1943 (New York: St. Martin's Press, 1976); and Anderson, *Roy Stryker: The Humane Propagandist.*

29. This photograph has a literature of its own. Lange herself wrote about it in "The Assignment I'll Never Forget: Migrant Mother," *Popular Photography* 46, no. 2 (February 1960):42–43, 126. Other treatments include Paul S. Taylor, "Migrant Mother: 1936," *American West* 7, no. 3 (May 1970): 41–47; Therese Thau Heyman, *Celebrating a Collection: The Work of Dorothea Lange* (Oakland: Oakland Museum, 1978), 60–61; Milton Meltzer, *Dorothea Lange: A Photographer's Life* (New York: Farrar, Straus and Giroux, 1978), 132–36; Therese Thau Heyman and Joyce Minick, "Dorothea Lange," *American Photograper* 2, no. 2 (February 1979):50–54; Karin Becker Ohrn, *Dorothea Lange and the Documentary Tradition* (Baton Rouge: Louisiana State University Press, 1980), 79–88; and James C. Curtis, "Dorothea Lange, Migrant Mother, and the Culture of the Great Depression," *Winterthur Portfolio* 21, no. 1 (Spring 1986):1–20.

30. Archibald MacLeish, *Land of the Free* (New York: Harcourt, Brace, 1938); Arthur F. Raper, *Tenants of the Almighty* (New York: Macmillan, 1943); and Richard Wright and Edwin Rosskam, *Twelve Million Black Voices: A Folk History of the Negro in the United States* (New York: Viking Press, 1941).

31. The books are discussed in William Stott, *Documentary Expression and Thirties America* (New York: Oxford University Press, 1973; London: Oxford University Press, 1976), 211–37; and John Rogers Puckett, *Five Photo-Textual Documentaries from the Great Depression* (Ann Arbor: UMI Research Press, 1984).

32. Roy E. Stryker, "The FSA Collection of Photographs," in Stryker and Wood, *In This Proud Land,* 7–8.

33. An alternative interpretation of the relationship between the section and communications media is offered by Maren Stange, "The FSA Project and Its Predecessors," *Views: The Journal of Photography in New England* 5, no. 2 (Winter 1983–1984):14.

34. James L. McCamy, *Government Publicity* (Chicago: University of Chicago Press, 1939), 83.

35. Arthur Rothstein, "Direction in the Picture Story," *The Complete Photographer* 21 (10 April 1942):1356 (reprinted and revised in vol. 7 of *The Encyclopedia of Photography,* ed. Willard D. Morgan [New York: Greystone Press, 1971]:2893–95).

36. Keller, *The Highway as Habitat,* 38.

37. Edwin Rosskam and Ruby A. Black, eds., *Washington: Nerve Center* (New York: Alliance Book Corp., 1939), 7.

38. Keller, *The Highway as Habitat,* 29–52.

39. Keller, *The Highway as Habitat,* 43–44. Keller compares photojournalists' use of the story approach to "participant observation," a fieldwork method used by sociologists, anthropologists, and others.

THE HISTORIAN AND THE ICON

PHOTOGRAPHY AND THE HISTORY OF THE AMERICAN PEOPLE IN THE 1930s AND 1940s

LAWRENCE W. LEVINE

> We are practical beings, each of us with limited functions and duties to per-
> form. Each is bound to feel intensely the importance of his own duties and the
> significance of the situations that call these forth. But this feeling is in each of
> us a vital secret, for sympathy with which we vainly look to others. The others
> are too much absorbed in their own vital secrets to take an interest in ours.
> Hence the stupidity and injustice of our opinions, so far as they deal with the
> significance of alien lives. Hence the falsity of our judgments, so far as they
> presume to decide in an absolute way on the value of other persons' conditions
> or ideals.
>
> *William James, "On a Certain Blindness in Human Beings"* [1]

One of the more elusive and difficult historical truths is that even in the midst of disaster life goes on and human beings find ways not merely of adapting to the forces that buffet them but often of rising above their circumstances and participating actively in the shaping of their lives. Only relatively recently have historians begun to comprehend the implications of Ralph Ellison's important questions concerning the history of Afro-Americans in the United States: "Can a people . . . live and develop for over three hundred years simply by *reacting*? Are American Negroes simply the creation of white men, or have they at least helped to create themselves out of what they found around them? Men have made a way of life in caves and upon cliffs, why cannot Negroes have made a life upon the horns of the white man's dilemma?" [2] Even amid the extreme conditions of the Holocaust's concentration camps, human beings clung to life, to each other, to those creative acts that made it possible to preserve some semblance of their culture, their dignity, their sanity.

To say these things is not to minimize the importance or the impact of such phenomena as slavery, persecution, and economic travail. It is simply to assert that human beings are not wholly molded by their immediate experiences; they are the bearers of a culture which is not static and unbending but continually in a state of process, perennially the product of interaction between the past and the present. From the rarified perspective of power and decision making, which historians tend to chronicle and analyze most frequently, it is perhaps too easy to forget that all people, not just the movers and the shakers, bring something complex and enduring to their experiences and that they retain the capacity of affecting events as well as being affected by them, of changing the present as well as being changed by it, of acting as well as being acted upon.

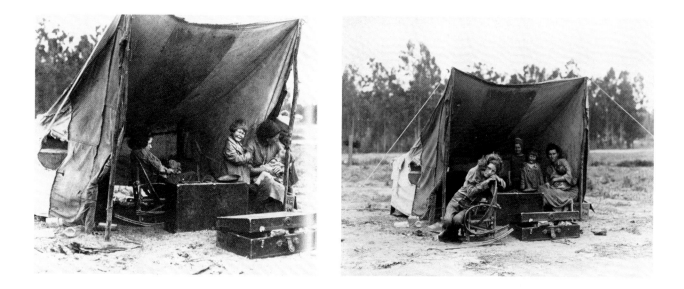

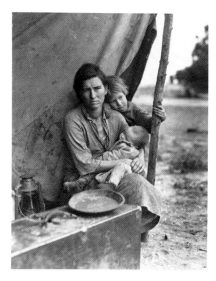

1–6. *Migrant Mother.* These six images of thirty-two-year-old Florence Thompson and her children were made by Dorothea Lange in a migrant labor camp in Nipomo, California, March 1936. Figure 1 (*top left*) is from Paul S. Taylor, "Migrant Mother: 1936," in *American West 7,* no. 3 (May 1970): 44.

The suffering of Depression America never approached the prolonged anguish of centuries of slavery or the intense horrors of the Holocaust, but that has not prevented us from searching for perfect victims during the 1930s as well as on the plantations and in the concentration camps. The images are familiar: Dorothea Lange's "Migrant Mother" (lower right), one of the most widely reproduced and familiar photographs in our history, with its gaunt, haunted—and haunting—central figure and its frightened, helpless children, immediately captured the imagination of the Depression generation and has come to represent that generation to its descendants.[3] This appears to have been the sixth and final photograph Lange took of Florence Thompson and several of her daughters on a rainy March afternoon in 1936. In an earlier photograph in the series (lower left) Lange utilized not only people but things—a battered trunk and an empty pie plate—to symbolize homelessness and poverty.[4] Many of the other widely reproduced photographs by Lange and her colleagues were similar to "Migrant Mother" in subject matter and intent. For all of the undeniable power of these images, William Stott has commented upon how little of these people we actually see: "They come to us only in images meant to break our heart. They come helpless, guiltless as children and, though helpless, yet still unvanquished by the implacable wrath of nature—flood, drought and the indifference of their society. They come, Pare Lorentz said, 'group after group of wretched human beings, starkly asking for so little, and wondering what they will get.' Never are they vicious, never depraved, never responsible for their misery. And this, of course, was intentional."[5]

Although images like these were and are among the best-known representations of the Depression, for some students of the thirties the very existence of other images, the very fact that the Resettlement Administration (RA) and Farm Security Administration (FSA) photographers did not adhere inexorably to the victimization model, is troubling. Maurice Berger, the curator of a re-

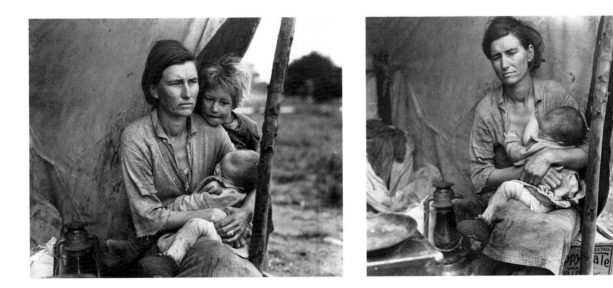

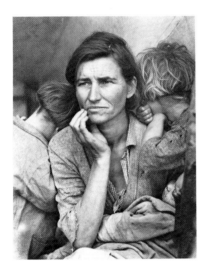

cent exhibit of RA and FSA photographs at the Hunter College Art Gallery in New York City, for example, is uncomfortable with Arthur Rothstein's photo of a farmhand in Goldendale, Washington, in 1936 or Lange's photo of the wife and children of a tobacco sharecropper in Person County, North Carolina, in July 1939 (figures 7, 8). Utilizing the technique of shooting from below, "an angle that traditionally signifies stature and esteem," Rothstein, Berger charges, created a "metaphor of stability . . . a respect for hard labor and the dignity of toil." Lange's photo "similarly ignores the devastation [of the Depression]. Not only do the robust mother and son smile, but the children appear clean, well-fed, and neatly dressed." Images like this result in "weakening the effect of the depictions of abject poverty, racial unrest, crime, disease, and despair." The photos that most commend themselves to Berger are those of the faceless and the helpless. In his "Farmer sampling wheat in Central Ohio, Summer 1938" (figure 9), Ben Shahn "shoots the filthy and ragged farmer from above (a common device in his FSA work), short-circuiting metaphors of dignity. Bent over and completely anonymous, the farmer is captured from a perspective that underlines his position on the economic ladder." John Vachon's "Sick child, Aliquippa, Pennsylvania, January 1941" (figure 10) is even more effective: "Nestled in a heap of rags, old clothing and filth, the girl is too ill to respond to the photographer's intrusion; in the midst of detritus and decay, she lies unprotected. The viewer is left gasping at the utter desperation and perilousness of her condition. 'I cannot help her,' one thinks, 'but neither can she help herself.' . . . It is through trauma that the unstaged photograph manipulates most effectively."[6]

Photographic images, like statistics, do not lie, but like statistics the truths they communicate are elusive and incomplete. The statistical chaos that prevailed in the early years of the Depression concerning such fundamental matters as the number of men and women out of work confused contemporaries and continues to

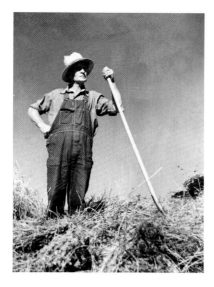

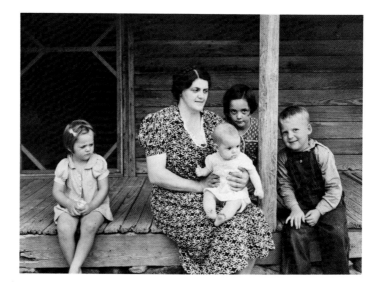

7. *Above:* Farmhand near Goldendale, Washington, July 1936. Arthur Rothstein.

8. *Right:* The wife and children of a tobacco sharecropper on their front porch, Person County, North Carolina, July 1939. Dorothea Lange.

frustrate historians. As late as 1936 Roosevelt's chief welfare adviser, Harry Hopkins, conceded that his information on unemployment was not "adequate," and whether there were eight million or eleven million jobless depended on whose figures were consulted. Rather than being used as tools for understanding the nature of the economic devastation, unemployment figures became partisan weapons, manipulated to protect or assault political leaders, to defend or alter national and local policies. President Hoover ruthlessly slashed the latest unemployment figures that reached his desk, eliminating those workers he decided were only temporarily jobless and those he deemed not seriously bent on finding work. Hoover was a classic example of how ideology can mold facts to fit expectations. In the midst of figures that told of growing unemployment, privation, and the inability of local governments and agencies to cope with the crisis, Hoover could tell a delegation that came to him in June 1930 requesting immediate expansion of federally sponsored public works, "Gentlemen, you have come sixty days too late. The depression is over." He could insist incessantly that "our people have been protected from hunger and cold" and that "nobody is actually starving." He could proclaim that "the hoboes, for example, are better fed than they have ever been." And he could maintain, even years later, that the ubiquitous apple sellers who had quickly become a feature of city street corners represented not the unemployed but rather those who had "left their jobs for the more profitable one of selling apples."[7]

To this day, estimates of the number of unemployed during the Depression's nadir in 1933 differ, ranging from thirteen to sixteen million, though statistics provided by the Bureau of Labor Statistics and the Committee on Economic Security make it clear that by March of that year at least one out of every four American workers was jobless and that only about one-quarter of those were receiving

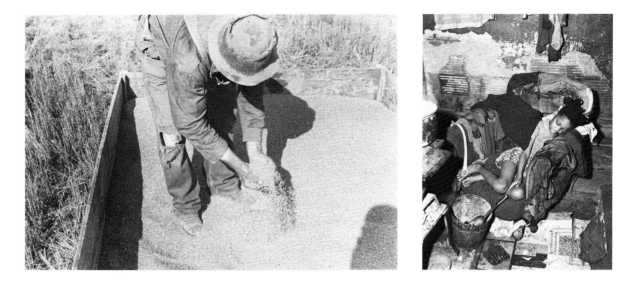

9. *Above:* Farmer sampling wheat in Central Ohio, Summer 1938. Ben Shahn.

10. *Right:* Sick child, Aliquippa, Pennsylvania, January 1941. John Vachon.

any relief, most of it grossly inadequate. But even these stark facts tell us too little. By 1933 the practice euphemistically referred to as work-sharing was widespread as employer after employer converted their workers into part-time employees. Thus while unemployment may have been the most widely dreaded condition, it was only the most extreme of the problems American workers faced. We may never know precisely how many of those who were working during the Depression had their hours—and pay—drastically reduced, but these figures indicating the number of full-time workers employed by the United States Steel Corporation are instructive:

1929: 224,980 1931: 56,619
1930: 211,055 1932: 18,938

On April 1, 1933, United States Steel employed not one full-time worker.[8]

By themselves statistics can never tell us enough; they have to be accompanied by other kinds of materials to assume their full meaning. We have focused so completely on the plight of the unemployed that we have forgotten the often desperate situation of the three out of four workers who still had employment of some sort. What did it mean to work in the midst of a severe economic crisis when losing one's job could mean disaster? How did this threat affect one's behavior and orientation? In 1939 Anna Novak spoke of her experiences in the Chicago meat-packing houses when she began to work there eight years ealier:

We used to have to buy the foremen presents, you know. On all the holidays, Christmas, Easter, Holy Week, Good Friday, you'd see the men coming to work with hip pockets bulging and take the

foremen off in corners, handing over their half pints. They sure would lay for you if you forgot their whiskey, too. Your job wasn't worth much if you didn't observe the holiday "customs." The women had to bring 'em bottles, just the same as the men. You could get along swell if you let the boss slap you on the behind and feel you up. God, I hate that stuff, you don't know! I'd rather work *any* place but in the stockyards just for that reason alone. I tried to get out a couple of times. Went to work for Container Corp. [Box factory near the yards.] Used to swing a hammer on those big wooden boxes. Look at my hands, now. [Her hands are misshapen; blunted, thickened fingers and calloused at every joint.] My husband wouldn't let me keep on there, it got to be too much for me to handle. I had to have work so I went back to the yards.[9]

It was not unusual testimony. Workers found themselves forced to accept the conditions that prevailed at their place of work. "In '34 they had me going like a clock 10 and 12 hours a day. I used to get home so tired I'd just sit down at the table and cry like a baby," Mary Siporin remembered in the closing years of the decade. "I mean there's a conditioning here by the Depression," a garbage worker told interviewers, many years later. "I'm what I call a secu-rity cat. I don't dare switch [jobs]. 'Cause I got too much whiskers on it, seniority."[10] Even this testimony gives us an incomplete pic-ture; it does not explain the thousands of workers in the rubber, automobile, and steel industries who jeopardized everything in 1936 and 1937 to strike for their right to help determine the condi-tions of their employment. For some workers, at least, the route to greater security seemed to be not through accommodation and res-ignation but through militancy and organization.

Thus while the dreary statistics of unemployment, suicide, mal-nutrition, and sickness are central to any understanding of the time, they, together with the haunting photographic images of blasted farms, faces, and hopes, leave us unprepared for other truths of life in the Great Depression. Following a lecture in which I mentioned the tens of millions of Americans who attended movies weekly in the 1930s, a student confessed that he had had no inkling that people continued to do such "normal" things. He knew that films were made during the thirties, but the images of that decade, struck so deeply into his consciousness, made it difficult for him to accept the fact that people actually could break away from their suffering long enough to attend and respond to movies. Similarly, we are not prepared to see the symbolic victims we have become familiar with do anything but appear appropriately despairing, to suffer—with admirable dignity perhaps—but to suffer nonetheless. Life, and human beings, however, are rarely that one-dimensional. The first two pictures Lange took of the Thompson family, although aesthetically less arresting than the final two, embody truths no less important. Here, in the midst of the starkest poverty, we see smil-ing children and a dreamy adolescent (see figures 1 and 2, top of p. 16).

Truths crowd out truths; realities impinge on realities; images confuse as well as enlighten, interfere as well as communicate, clash

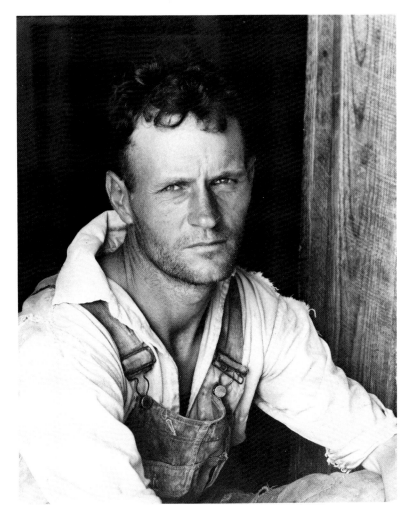

11. Floyd Burroughs (George Gudger), Hale County, Alabama, 1936. Walker Evans.

as well as complement. Neither in photographs nor in life is reality composed of a series of either/or images. In their account of three sharecropper families, *Let Us Now Praise Famous Men* (1941), James Agee and Walker Evans included many photos of the Burroughs family,* including their widely reproduced shot of an unshaven, tired, anxious Floyd Burroughs in a tattered work shirt (figure 11). They chose not to use a picture that Floyd Burroughs had requested they take of him, his arms thrown confidently around the shoulders of his smiling wife and sister-in-law, with his children posed in front, everyone looking clean and contented in their best clothing (figure 12). It was a classic family pose but not one congenial to the purposes of the book from which it was excluded. As William Stott has put it, "This George Gudger needs no one's pity"; nor did his family, which showed their ability to be "this clean without running water or sanitary facilities, this decently dressed on

* Following the mode of the period, Agee and Evans changed the names of the families they depicted in their book. Thus the Burroughs family was renamed the Gudgers, and Floyd Burroughs became George Gudger.

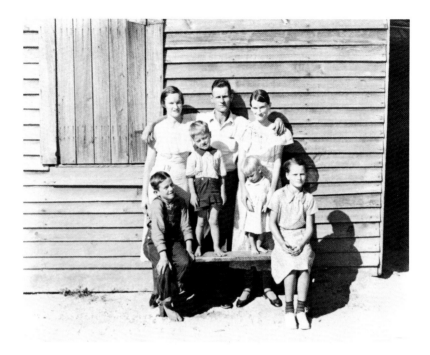

12. The Burroughs family (the Gudgers and Emma), Hale County, Alabama, 1936.

little money, this self-respecting in economic servitude, this gentle despite their hardships."[11] The fact that Burroughs, who seems to have had no objections to the other photographs that were taken, wanted himself and his family pictured in this light as well, is an important part of the reality of the thirties that we can ignore only at great cost to our understanding of the self-images and the aspirations of people like the Burroughs.[12]

That the photographs from Stryker's section are filled with these tensions and ambiguities is a clue to their essential soundness as guides for the historian. The argument that only those photographs that depict unrelieved suffering and exploitation can be trusted as accurate portrayals and have anything to say to us has at its core a concept which ultimately subverts the struggle for historical understanding: the notion that things must be one way or the other, and therefore that it is impossible to maintain any semblance of dignity or self-worth or independence in the face of poverty and exploitation. If photographs tell us that people do have this capacity, we must deny our eyes and convince ourselves that we are examining manipulated icons. If our ears tell us that even in the midst of desolation people can sing songs of transcendence and joy, we must insist that such songs are mere anodynes in the mouths of deluded singers. The urge, whether conscious or not, to deprive people without power of any determination over their destiny, of any pleasure in their lives, of any dignity in their existence, knows no single part of the political spectrum; it affects radicals and reactionaries, liberals and conservatives, alike. The only culture the poor are supposed to have is the culture of poverty: worn faces and torn clothing, dirty skin and dead eyes, ramshackle shelters and

disorganized lives. Any forms of contentment or self-respect, even cleanliness itself, have no place in this totality.

It is hardly a new position. This is what the psychologist Bruno Bettelheim had in mind when he argued that the German concentration camps infantilized their victims, whose wills became almost totally linked with those of their "significant others"—the guards/gods. It is the plantation universe sketched by the historian Stanley Elkins and populated with black slaves whose condition turned them into "Sambos" with no wills of their own and a fantasy life "limited to catfish and watermelons."[13] Here we have a closed universe whose inhabitants act according to a predetermined script. The poor and the weak, who were treated like ciphers by the more powerful during their lives, would hardly be surprised to find themselves being treated like ciphers by scholars long after their deaths. But both they and we deserve better. Historians have the same obligations to their dead subjects that anthropologists have to their living ones. They must recognize their humanity, search for their points of view, respect their complexity. The dictum that "God is in the details" has particular relevance for historians. It is precisely the details that these photographs help us to recover.

This volume is filled with truths that have been too often crowded out, realities that have been too easily blurred, images that have been too frequently lost by the simple repetition of a single dimension, by the sustained search for the ideal. The photograph is beguiling because it seems to be the quintessential objective document—reality in black and white—and thus makes a greater claim on our credulity than other types of documents. We know that newspaper reports, magazine articles, autobiographies, congressional testimony, and political speeches are all imperfect sources, deeply affected by the views and circumstances of the reporters, writers, and politicians who create them. We have even begun to learn the truth of the old saw that while figures may not lie, liars figure, and thus that even hard statistics, so solid and reliable in appearance, have to be subjected to the most rigorous of tests. But what of photographic records? While we may dismiss ideal types, we continue, sometimes in spite of ourselves, to search for ideal sources, and what could recommend themselves better than photographic records, which appear to come to us not as the figments of someone's imagination but as the objective artifacts of demonstrable reality? The truth, of course, as Halla Beloff has written, is that "like the computer, the camera is an instrument of human intelligence."[14] Consequently, the images it creates are also the products of human intelligence, like all of the other sources historians utilize, and the photograph has to be read with the same care and thoughtfulness we have learned to apply to written sources. With photographs, as with other types of historical materials, a simple change in context can drastically alter the meaning of an "objective" image. This is well demonstrated by what occurred when the figure of the plantation owner in Dorothea Lange's "Plantation owner, Clarksdale, Mississippi, June 1936" (figure 13) was used by itself two years later in Archibald MacLeish's book *The Land of the Free* (1938), accompanied by a page of MacLeish's verse (figure 14).

That MacLeish could use the white man for purposes that

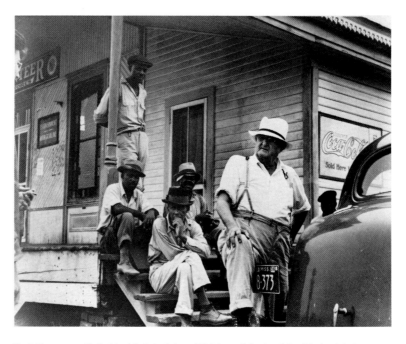

13. Plantation owner, Clarksdale, Mississippi, June 1936. Lange's husband, Paul Taylor, is just visible at the left. Dorothea Lange.

seem quite divergent from those implicit in the original photograph underlines the essential ambiguity present in Lange's picture to begin with: it captured the image of a man who exemplified the exploitative, racist, undemocratic features of southern plantation life even while he also doubtless represented many of the qualities that built the type of individualistic freedom that has characterized America throughout so much of its history. It is not that Lange and MacLeish necessarily distorted the image they were utilizing but that they had their hooks into different aspects of that image. The importance of photography as a source is precisely this: it can freeze conflicting realities, ambiguities, paradoxes, so that we can see them, examine them, recognize the larger, more complex, and often less palatable truths they direct us to.

Photographs, then, are a source that needs to be interpreted and supplemented by other evidence. They are incomplete, as historical sources always are. They have been collected and filtered through other hands, as historical sources always have been. They are filled with contradictions and paradoxes, as the most valuable historical sources frequently are. In short, they behave much like other sources historians depend on. What differs is less the uniqueness of photographic materials than our tendency to see photographs as more "real" than other sources and our relative inexperience in using them historically. We have to learn the truth of Alan Sekula's observation that "the photograph, as it stands alone, presents merely the *possibility* of meaning."[15]

As creators the photographers represented in this volume helped to mold the period in which they lived, but we must remember that they were the creatures as well as the creators of their culture and never stood wholly apart from it. They were not coolly

We told ourselves we were free because we were free.

We were free because we were that kind.

We were Americans.

All you needed for freedom was being American.
All you needed for freedom was grit in your craw

And the gall to get out on a limb and crow before sunup.

Those that hadn't it hadn't it.

"Have the elder races halted?

Do they droop and end their lessons wearied over there beyond the seas?

We take up the task eternal and the burden and the lesson —

Pioneers O Pioneers."

We told ourselves we were free because we said so.

We were free because of the Battle of Bunker Hill
And the constitution adopted at Philadelphia

14. From Archibald MacLeish, *Land of the Free.*

detached observers making disinterested portraits of a people apart; they were members of a society representing a culture to itself. They were, to a greater degree than they could have been aware, taking pictures of themselves as well as of their fellow Americans. This of course makes their work particularly valuable as a source for understanding their era but should also caution us to remember the fragility of their images and the need to supplement them.

The veteran photographer Ansel Adams complained to Roy Stryker, "What you've got are not photographers. They're a bunch of sociologists with cameras."[16] Though Adams might have said this of many groups of photographers, his insight helps us to understand both the strengths and weaknesses of these photographs as historical sources. For such influential sociologists of the period as Robert S. and Helen Merrell Lynd, Muncie, Indiana, was "Middletown" and its inhabitants nameless, ideal Middle Americans living and working in the prototypical Middle American setting. We learn to know them not as individuals but as representations. Similarly, from the photographers of the 1930s we have inherited the images of people with precious little additional information. Again, we come to know them as types: migrant farmers, sharecroppers, hoboes, unemployed men, desperate mothers, ragged children. In the captions to the photographs in this volume few names of those pictured are given because the photographers simply failed to supply them or provide other essential data concerning the people they were photographing. Dorothea Lange never inquired after the name of the woman whose image she made immortal (we know her as Florence Thompson because of researchers who later sought her out and interviewed her); never noted the names of the four

daughters pictured in the series; never sought to learn the where-abouts of Thompson's other three children or her husband; and, so far as we can tell, never wondered where Florence Thompson had been or where she hoped to go. "I did not ask her name or her history," Lange noted simply, as if this was the most reasonable possible action. Lange and most of her fellow photographers not only failed to record such elementary information as the names and backgrounds of their subjects, they rarely thought to collect such facts in the first place. They generally did not conceive of these details as necessary in accomplishing their goals. In Florence Thompson and her daughters Lange knew she had found precisely the ideal image she was searching for. When she completed her six shots, she slipped into her car and drove off. "I did not approach the tents and shelters of other stranded pea-pickers," she later noted. "It was not necessary; I knew I had recorded the essence of my assignment."[17]

The photographers were not unique. The writers employed by the Federal Writers' Project of the Works Progress Administration (WPA), who left us a monumental collection of interviews with a wide spectrum of Americans, did collect and record their subjects' names and asked them questions that frequently elicited many of the details of their subjects' lives. But they too were specifically interested in those they interviewed as types: former slaves, stockyard workers, members of the maritime union, riders of the rails, traveling salesmen, and those details that did not directly bear upon such categories were usually neither elicited nor preserved. Sylvia Diner, a WPA interviewer collecting folk songs and lore from Yugoslavian immigrants in New York City in 1938, was annoyed when her subjects insisted upon interrupting the interviews to discuss the German conquest of Czechoslovakia, a fate which they feared lay in store for their homeland as well. The singing of folk songs ended abruptly in the Sekulich home when the oldest daughter turned on the radio and the family gathered round it to hear the latest news. "The historic ballads of long ago were obliterated in the heat of current events," Diner complained. Although she praised "the analytical powers and keen concern of these supposedly simple, backward people," the details of their political views went essentially unrecorded since they deviated from her immediate conception of the group she was interviewing.[18] Similarly, the folklorists of the period collected songs, stories, jokes, anecdotes, proverbs from people whose individual names, histories, and circumstances they recorded so rarely or so incompletely that today we too often have the folklore without the folk, whose identities have become blurred by time—indeed, were *allowed* to become blurred by time—through the methods the folklorists of the period employed.

But there is a positive side to this as well; it was precisely from the photographers' attempts to picture their subjects not as individuals but as components of a larger context that at least part of the triumph of their photographs as historical documents derives. The demand for documentation, the hunger for authenticity, the urge to share in the experiences of others were widespread throughout the thirties. In this respect the FSA photographs were part of

a much larger world of documentary expression that included the movie newsreels, radio news programs, the Federal Theatre's documentary plays called "Living Newspapers," the WPA's *American Guide* series which produced geographical and cultural road maps for every state and major city as well as a host of interesting byways, the blossoming of photojournalism in *Life* and *Look* magazines, and such quasi-documentary expression as radio soap operas. William Stott has made the interesting point that while the Hoover administration was continually embarrassed by the documentary approach, the New Deal "institutionalized documentary; it made the weapon that undermined the establishment part of the establishment."[19]

The historian Irving Bernstein recently observed that "the anguish of the American people during hard times demanded a pictorial record."[20] The photographs in this volume make clear that while Bernstein has probably summed up the initial motives of many of the FSA photographers accurately, they accomplished far more than the depiction of American anguish; they created a record of American life. The photographers may have set about documenting the immediate impact of the severe economic depression, but they succeeded in creating a remarkable portrait of their countrymen's resiliency and culture. In these photographs, as in such other sources as the many oral interviews that were recorded during and after the 1930s, the more than fifteen million letters people wrote to President and Mrs. Roosevelt, and the rich folklore that was collected, we are made witness to a complex blend of despair and faith, dependency and self-sufficiency, degradation and dignity, suffering and joy.

It is difficult to take exception to a statement made by Bob Aden, who was the subject of a John Vachon photograph in 1942: "I'm sure the experience of the Depression—what we went through—established patterns and habits that all of us have carried through for the rest of our lives. For example, I could never stand to buy anything on time; I had to have the money to pay for it. The first time I bought an appliance on time, it scared me to death."[21] The effects of the Depression and the war that followed it were deep and enduring. But, as these photographs indicate, while few escaped the tumultuous events that surrounded them, they were not the mere mute products of those events; in a number of important ways, their lives often transcended their immediate experiences. What scholars are too prone to dismiss as the "trivia" of life are revealed by these sources to be often integral parts of life's essence. Ella Watson's world (see pp. 226–39) was crucially affected by the conditions of her employment; by the actions of governments, federal and local; by the racial mores and prejudices of her fellow Americans. But her world was not confined entirely by these perimeters; it included her relationships with her family, her friends, her church. It did not begin and end with the hours during which she wielded her mop in government offices; it was richer and more complex, embodying other dimensions. Whatever his original intentions, Gordon Parks's accomplishment was to afford us a glimpse of a hard life lived with a greater degree of dignity and strength, containing more variety and choice and telling us more about an entire culture, than he may have initially realized.

The process of visual documentation was by no means simple, and the photographers' own needs and perceptions often become almost indelibly intermeshed with those of their subjects. Depression Americans, living through one of the greatest crises in their history, were prone to look back upon the past, and particularly the folk past, as a symbol of a simpler, cleaner, less problem-ridden time when individuals still commanded their own destinies and shaped their own universe to a greater extent than was any longer possible. This urge to look back, which certainly was present in the nineteenth century, became particularly noticeable after the trauma of the First World War. In the 1920s popular culture was laced through with an emphasis on the self-sufficient heroes of such bygone eras as the Old West, when good and bad supposedly were distinguished with ease and human beings had the capacity to alter their environment. This urge led as well to an appreciation of the self-contained folk in what were conceived of as primitive societies and explains the surprising popularity of such documentary films as Robert Flaherty's *Nanook of the North* (1922), which depicted the hard but integrated and meaningful life of an Eskimo group, and the vogue of Black Harlem, where people were portrayed as still expressing their repressed urges and experiencing life more fully on their own terms. There was, of course, another side to this romantic urge: if the "primitive" were envied, they were also pitied and depicted as excluded from the wondrous fruits of modernity.

This ambivalent yearning to combine the innocence and clarity of the past with the sophistication and technological complexity of the present can be discerned throughout modern American culture but was particularly strong in the 1930s, when composers like Aaron Copland and George Gershwin, Hollywood directors like King Vidor and Frank Capra, and artists like Grant Wood and Thomas Hart Benton turned to the folk past and the small town in their search for the American Way.[22] This trend helps to explain why industrial strikes featured rural folk songs and singers, why Americans were so taken with films like Capra's *Mr. Deeds Goes to Town* (1936), *Mr. Smith Goes to Washington* (1939), and *Meet John Doe* (1941) which sought to probe the fate of small-town values in modern urban America, and why the photographers in Stryker's section spent far more time and energy recording agrarian and small-town America than industrial and urban America.* It is in this context that we should understand such series as "Tenant Farmers" (see pp. 146–59), in which Arthur Rothstein seems to be indulging in nostalgia for the self-sufficiency and simplicity of the Afro-American culture of Gee's Bend, Alabama, even while he reveals the bare poverty and almost total lack of modern conveniences that characterized the lives of these tenant farmers. This is not to say that in "Tenant Farmers" we are viewing Rothstein's fantasies rather than a black southern community in the 1930s, but that in order to

* Only about 25 percent of the photographs in the FSA-OWI Collection depict subjects in towns of fifty thousand or more inhabitants. Most of the urban photographs were made in 1942 and 1943 (Nicholas Natanson, *Urban Representation in the RA-FSA-OWI File, 1935–43;* unpublished report in *Documenting America, 1935–1943*, project records, Supplementary Archives, Prints and Photographs Division, Library of Congress).

understand the particular form Rothstein supplied for the substance he photographed we need to comprehend more fully the intellectual prism through which he observed that community.

It might be argued that because these photographs begin only in 1935 and stretch well into the war, it is hardly surprising that they show normal pursuits, since conditions were so much improved. It is true that in the summer of 1935 the United States economy entered its first really impressive expansion since the Depression had begun, with employment in manufacturing increasing from 7.2 million in July 1935 to 9.1 million two years later. For the entire economy there were some four million more jobs in 1937 than there had been in 1935. Despite these heartening improvements, more than seven and a half million workers remained unemployed in 1937, substantial numbers of homeless men and women continued to roam the country, and hundreds of thousands of dispossessed farmers made the trek to California in search of work and land. America had hardly reached Nirvana. Nevertheless, President Roosevelt, who was urged by such conservative advisers as Secretary of the Treasury Henry Morgenthau to declare the New Deal completed, and who was himself perennially troubled by the unbalanced budget and the federal government's increasing role in the economy, used the undeniable improvements to rationalize a cutback in federal spending, including relief. The results were, or at least should have been, predictable. In October 1937 America experienced a severe collapse reminiscent of the one eight years earlier, causing income, production, and consumption to fall and unemployment to rise to well over ten million—almost one in every five American workers—by 1938. Unemployment was to remain critically high until America's entry into World War II: almost nine and half million in 1939, over eight million in 1940, and, on the eve of Pearl Harbor, despite the stimulus that defense spending and the Lend-Lease Act (1941) had given the economy, five and a half million workers—almost one out of ten—were without jobs.[23]

World War II ended unemployment and led President Roosevelt to spend money and to centralize economic decisions to an extent he had not been willing to attempt in peacetime. But though the coming of war helped to ease the economic problems, it replaced them with the difficulties, trauma, and crises endemic to war, so that the context in which all of the photographs included here were taken remained an America beset by crisis. It was, moreover, an America not particularly confident of the future. In 1979 John Cockle, who had been photographed by John Vachon in May 1942 when Cockle was a student at the University of Nebraska, declared, "One big difference between us and people in school now is that most now have a pretty good feeling that when they get through there will be a demand for their services. That was not at all true in the late thirties, early forties. We knew we were going into the service—that was clear even before the United States was in the war. But when we got out, what then?" During the war itself 79 percent of the soldiers questioned were convinced it would be difficult for veterans to secure good jobs after the war, while 56 percent anticipated a widespread depression when the war ended and they reentered civilian society.[24]

Earlier I attempted to demonstrate that when viewed as a concise series, even so small a number of images as those Dorothea Lange took of the Thompsons supplies more dimensions and the possibility of a deeper reading than the single photo that has been most widely reproduced. This is truer still of the larger series from which we have made extensive selections that help to reveal both how the agency photographers worked and how the American people lived in the midst of America's most searing economic crisis and the early years of the war that succeeded it. Looking back on his collection from the vantage point of old age, Roy Stryker observed that "the work we did can be appreciated only when the collection is considered as a whole. The total volume, and it's a staggering volume, has a richness and distinction that simply cannot be drawn from the individual pictures themselves."[25] Though it is obviously impossible for all but a relatively few to view the collection as a whole, its significance is far better represented by the series presented here than by the single images previously available.

A number of contemporaries pointed out the difficulty of seeing the Depression with the naked eye. Caroline Bird commented that "you could feel the Depression deepen but you could not look out of the window and see it. Men who lost their jobs dropped out of sight. They were quiet, and you had to know just when and where to find them. . . . It took a knowing eye—or the eye of poverty itself—to understand or even to observe some of the action."[26] This helps to underscore the importance of the FSA-OWI photographs and the reason why the images that appear to have had the greatest contemporary impact were those that concentrated upon the Depression's ravages. For the historian there is another kind of invisibility: the difficulty of perceiving those aspects of Depression life that were not the immediate result of privation and upheaval. The series featured in this volume help to penetrate both kinds of invisibility.

Americans suffered, materially and psychically, during the years of the Great Depression to an extent which we still do not fully fathom, and continued to suffer in ways even less clear to us during the war. But they also continued, as people always must, the business of living. They ate and they laughed, they loved and they fought, they worried and they hoped, they created and reared children, they worked and they played, they dressed and shopped and ate and bathed and watched movies and ball games and each other; they filled their days, as we fill ours, with the essentials of everyday living. It is true, certainly, that they did these things in the context not just of change—which is the context of all historical action—but of rapid, visible change. During these years people learned to look to institutions, especially to the federal government, in ways that their ancestors and they themselves just a few decades earlier would never have expected. That important truth is documented in these images—especially Arthur Rothstein's portrait of a farm labor camp in California and Marjory Collins's close-up of Lititz, Pennsylvania, a year after America entered World War II—and constitutes one of the major effects of the Depression and the Second World War. As important as this truth is, as central as this devel-

opment was, we cannot begin and end our portrait of the American people by focusing all of our attention on the New Deal or FDR or the breadlines. We need, desperately, to enter the movie palace and the ballpark, the workplace and the living room, the neighborhood and the church, the stores and the streets, the farmhouse and the fields.

These photographs help us begin this process, but we will be able to learn from them only if we study them with the understanding that as familiar as the people in them might appear, they were citizens of another decade, privy to another consciousness through which they saw and understood reality. What Warren Susman has said of moving-picture images applies to still photographs as well: they "may contain disguised or unconscious assumptions and perceptions, clues to issues and concerns often fundamental to the filmmakers, but not obvious because we fail in our effort to see as they saw, feel as they felt."[27] Thus we must adopt an anthropological vision and prepare ourselves for the possibility that these people whose lives we are sharing for the moment are not necessarily earlier versions of ourselves whom we can know just by knowing ourselves. It is much safer to approach the people who inhabit these pages as different from ourselves, as people whose lives and thoughts we have to strive to understand in however flawed a manner. To attempt to capture *their* way of doing things, *their* consciousness, *their* worldview, is the stuff of history, the quest that gives historians purpose and meaning. The photographs that fill this volume help us do that, help us to comprehend a part of America we have heretofore neglected.

Any account of the period's culture must be expansive enough to include crosscurrents, ambiguities, tensions. A culture that made both *The Grapes of Wrath* and *Gone with the Wind* best-selling novels and critically acclaimed and widely attended motion pictures, was clearly not a culture monolithically fixated on either confronting or evading the central problems of the period. On the surface, John Steinbeck's *The Grapes of Wrath* and Margaret Mitchell's *Gone with the Wind* seem to be symbols of different cultural urges. The former, by graphically and sympathetically depicting the plight of Dust Bowl migrants, helped to compel Americans to confront one of the nation's salient problems, while the latter, by transporting Americans back to the Civil War era seen from a blatantly and romantically Southern perspective, ostensibly helped them forget such pressing realities. This simple dichotomy ignores the fact that, as different as they were, both of these novels—and films—sprang from the same ideological matrix and shared visions of the future. Both had at their core the conviction that the individual could surmount the difficulties of the present and that societal regeneration was possible. "We ain't gonna die out," Ma Joad declares toward the close of Steinbeck's book. "People is goin' on—changin' a little, maybe, but goin' right on." * *Gone with the Wind* ends on a more in-

* The film adaptation of the novel closes with Ma Joad asserting even more confidently, "We're the people that live. They can't wipe us out. They can't lick us. We'll go on forever, Pa, cause we're the people."

dividual but no less optimistic note with Scarlett O'Hara refusing to accept the finality of Rhett Butler's decision to leave her:

> With the spirit of her people who would not know defeat, even when it stared them in the face, she raised her chin. She could get Rhett back. She knew she could. There had never been a man she couldn't get, once she set her mind upon him.
>
> "I'll think of it tomorrow . . . I can stand it then. Tomorrow, I'll think of some way to get him back. After all, tomorrow is another day."[28]

The phenomenon of *Gone with the Wind* is particularly instructive precisely because it has so often been used as an example of the mindless "escapism" that is supposed to have beguiled the American people throughout the 1930s. As I have argued elsewhere, the notion of escapism is not particularly helpful or revealing. Even if the American people were seeking to escape their plight, the real question is why they chose this particular vehicle. Why in the midst of the nation's worst economic crisis were so many Americans so deeply attracted to a novel about the Civil War? There is no single explanation, but we would commit a serious error if we did not attempt to understand the extent to which Americans were attracted to those cultural expressions that helped them, or at least appeared to help them, comprehend their own world. The real significance of *Gone with the Wind,* then, was not escape—it probably provided no more of that than most expressive culture does—but reaffirmation. Beneath its surface the novel presented a world not really far removed from the America of the 1930s: a world which at the beginning of the novel was bursting with hope and promise, as the America of the 1920s with its promise of unprecedented and unending prosperity had been; a world governed by order and reason, as the world of the 1920s had seemed to be to so many Americans; a world which suddenly disintegrated into the chaos and unreason of civil war, as the world of the 1920s had suddenly disintegrated into the chaos and unreason of economic crisis. Through the novel's more than a thousand pages, Scarlett O'Hara emerges as the individual who refuses to give in to these irrational processes. She survives the war, the siege of Atlanta, the destruction of her society. She grows and matures, rebuilds her plantation, and, as we have just seen, closes the novel on a note of hope and ultimate triumph. With its graphic depictions of the horrors of war, *Gone with the Wind,* like *The Grapes of Wrath,* did not deny the harshness of the world it depicted. Nevertheless, again like *The Grapes of Wrath,* its central thrust was to affirm traditional American values and optimism.

In the culture of the 1930s past calamities could become didactic mechanisms for illustrating the ways in which people might triumph over adversity, rediscovering in the process those enduring values they had lost sight of in better times. *San Francisco,* the most profitable film of 1936, depicted the transformation of a hard-bitten saloonkeeper who only through the trauma of the 1906 earthquake is able to sort out his priorities and discover his true feelings for a woman he had formerly maltreated, even attaining enough humil-

ity to sink to his knees in prayer when he finally finds her unharmed by the disaster. Three years later the highly popular and critically acclaimed film *Stagecoach* pictured the individual redemptions of an outlaw, a prostitute, and an alcoholic doctor thrown together on a flight for life through Indian territory. The analogies were unmistakable: the individual, sometimes alone and sometimes in cooperation with others, could rise above disaster—be it warfare, earthquake, or depression—in pursuit of redemption, a theme that penetrated much of Depression culture.[29]

These notions of individual and societal survival and regeneration were endemic to the culture of the Great Depression, and it is hardly surprising to find them in the photographs that so quickly became an integral part of American culture. The photographs never denied the problems America faced, although like so many other genres of American culture during the period they failed to probe very deeply into their underlying causes and their relationship to other features of American life. If there is a predominant innocence in these photos, however, it is not that of evasion—since few other forms of expressive culture documented the failure of the American economy more graphically or immediately—but the innocence of faith, the belief that Americans had within themselves the qualities and traditions necessary to regenerate themselves and the American dream. Speaking of the photographer Russell Lee, Roy Stryker wrote, "When his photographs would come in, I always felt that Russell was saying, 'Now here is a fellow who is having a hard time but with a little help he's going to be all right.' And that's what gave me courage." Stryker returned to this theme again and again:

> The faces to me were the most significant part of the file. When a man is down and they have taken from him his job and his land and his home—everything he spent his life working for—he's going to have the expression of tragedy permanently on his face. But I have always believed that the American people have the ability to endure. And that is in those faces, too.

> Many of these people were sick, hungry, and miserable. The odds were against them. Yet their goodness and strength survived.

> You could look at the people and see fear and sadness and desperation. But you saw something else, too. A determination that not even the Depression could kill. The photographers saw it—documented it.[30]

These photos, then, evince Depression culture not only in their images but also in the ideology out of which those images issue. An understanding that these icons reveal not merely the external but also the internal realities, not only appearances but also beliefs, is an important key to comprehending their significance and their meaning. The ubiquitous image of the victim was originally intended to help galvanize public opinion behind the need for governmental help and reform and has served historically to explain the necessity for the massive federal intervention that took place

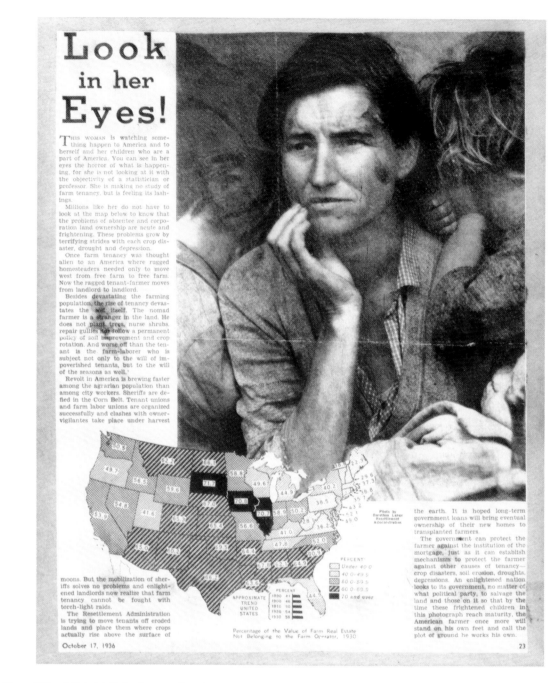

The text within the figure reads:

Look in her Eyes!

THIS WOMAN is watching something happen to America and to herself and her children who are a part of America. You can see in her eyes the horror of what is happening, for she is not looking at it with the objectivity of a statistician or professor. She is making no study of farm tenancy, but is feeling its lashings.

Millions like her do not have to look at the map below to know that the problems of absentee and corporation land ownership are acute and frightening. These problems grow by terrifying strides with each crop disaster, drought and depression.

Once farm tenancy was thought alien to an America where rugged homesteaders needed only to move west from free farm to free farm. Now the ragged tenant-farmer moves from landlord to landlord.

Besides devastating the farming population, the rise of tenancy devastates the soil itself. The nomad farmer is a stranger in the land. He does not plant trees, nurse shrubs, repair gullies nor follow a permanent policy of soil improvement and crop rotation. And worse off than the tenant is the farm-laborer who is subject not only to the will of impoverished tenants, but to the will of the seasons as well.

Revolt in America is brewing faster among the agrarian population than among city workers. Sheriffs are defied in the Corn Belt. Tenant unions and farm labor unions are organized successfully and clashes with owner-vigilantes take place under harvest moons. But the mobilization of sheriffs solves no problems and enlightened landlords now realize that farm tenancy cannot be fought with torch-light raids.

The Resettlement Administration is trying to move tenants off eroded lands and place them where crops actually rise above the surface of

Photo by Dorothea Lange Resettlement Administration

the earth. It is hoped long-term government loans will bring eventual ownership of their new homes to transplanted farmers.

The government can protect the farmer against the institution of the mortgage, just as it can establish mechanisms to protect the farmer against other causes of tenancy—crop disasters, soil erosion, droughts, depressions. An enlightened nation looks to its government, no matter of what political party, to salvage the land and those on it so that by the time these frightened children in this photograph reach maturity, the American farmer once more will stand on his own feet and call the plot of ground he works his own.

Percentage of the Value of Farm Real Estate Not Belonging to the Farm Operator, 1930

October 17, 1936

23

15. *Midweek Pictorial,* 17 October 1936, from the FSA Scrapbook, FSA-OWI Written Records.

and to justify what happened to the American polity during the thirties. Thus *Midweek Pictorial* utilized Lange's "Migrant Mother" to illustrate its indictment of the inequities inherent in farm tenancy and its demand for change, while the *Buffalo Times* employed an array of Resettlement Administration photos in the before/after format popular throughout the decade to justify federal farm programs (figures 15, 16). The documentary quality of these photos made it difficult to deny the realities of the 1930s, but the photos nevertheless furnished the opportunity of reasserting traditional beliefs. Was "Migrant Mother" a study in despair or in inner

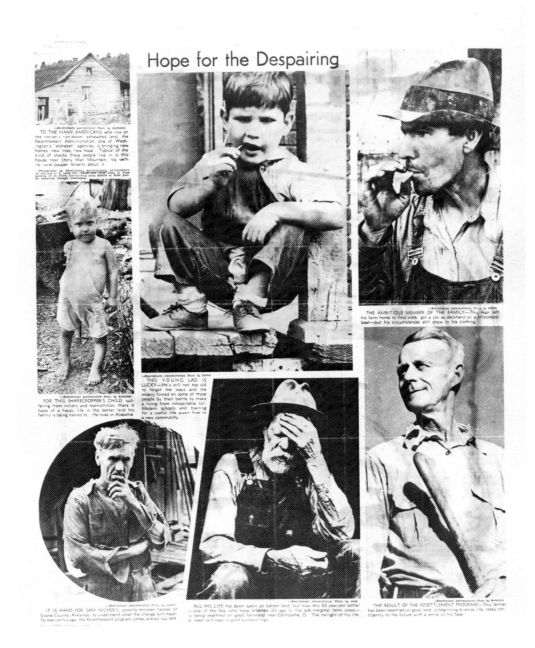

16. *Buffalo Times*, 14 February 1937, from the FSA Scrapbook.

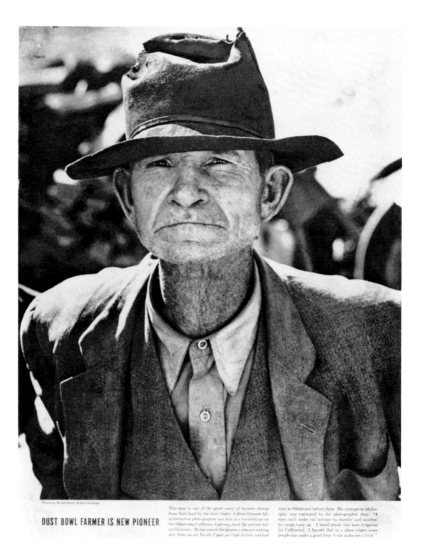

DUST BOWL FARMER IS NEW PIONEER

This man is one of the great army of farmers driven from their land by the dust blight. A Resettlement Administration photographer met him in a battered car on the Oklahoma-California highway, took his picture but not his name. He has joined the pioneers who are seeking new lives on the Pacific Coast, as their fathers trekked west to Oklahoma before them. His courageous philosophy was expressed to the photographer thus: "A man can't make out noways by standin' and watchin' his crops burn up. I heard about this here irrigation [in California]. I figured that is a place where some people can make a good livin' I can make me a livin'."

17. *Life,* 21 June 1937, from the FSA Scrapbook.

strength? Were her face and demeanor symbols of victimization or dignity? It was possible to read into these photographs what one wanted, what one needed, to see in them, and in the 1930s many wanted and needed to see both qualities. It is significant that during these years the image of the victim was never sufficient; it had to be accompanied by the symbols of dignity, inner strength, and ultimate self-reliance. Stryker identified the tension in the images his photographers captured as "dignity versus despair," and commented, "Maybe I'm a fool, but I believe that dignity wins out. When it doesn't then we as a people will become extinct."[31] Characteristically, *Life* magazine had no difficulty in perceiving in Dorothea Lange's photo of a grizzled, impoverished migrant farmer the visage of a traditional American pioneer (figure 17; see also p. 125). Though all cultures require icons, they do not require the same ones or use them for the same purposes. That the salient

qualities in the icons Depression America used to rationalize massive federal action seem to have been suffering *and* dignity, helplessness *and* self-reliance, tells us much about both the people who created them and the people for whom they were created.

It is particularly important to comprehend the extent to which the ideology represented by these symbols was a shared one. The tendency of recent critics to see Stryker as the author of the worldview that permeated the FSA-OWI file, without adequate reference to the worldviews of his photographers or their subjects, can be misleading.[32] The FSA-OWI file was, after all, reformist and optimistic, embodying a blend of individual and community orientation which was in a long-standing American tradition. Stryker certainly had his priorities, though they were no more totally consistent and successfully implemented than those of his leaders, from Rexford Guy Tugwell to Franklin Delano Roosevelt. There was confusion in Stryker's goals and actions simply because there was confusion and uncertainty in Stryker—the identical body of confusion, hesitation, and ambivalence that ran like a thread through the New Deal from 1933 to 1941. Insofar as Stryker had an ideology, it was not the product of a smoke-filled conference room teeming with politicians and capitalists; it emanated from the same matrix that had long permeated American politics and the American people and was shared by many of Stryker's colleagues and those they photographed: belief in the individual; in voluntary cooperation; in a harmony of interests; in the virtues of the agrarian/small-town way of life; in the future; in the possibilities of peaceful, progressive reform; in the superiority and primacy of the American Way. To say that politicians and businessmen often manipulated these beliefs for their own ends is not to prove that they invented them or controlled them. That the FSA-OWI photographs revealed these beliefs is hardly remarkable; so did most of the other major cultural expressions of the period—movies, radio, paintings, magazines, newspapers, music. What needs to be remarked upon is the extent to which the most widely known photographs—as well as many of the creations of the other most popular iconographic form of the period, the movie—went beyond comfortable consensus to show crisis and breakdown. What is equally important is the extent to which the photographers were able to rise beyond a simplistic rendering of their ideological concerns to create a record of those aspects of American life and culture that were generally ignored or downgraded by most cultural and artistic agencies.

Many years ago Robert Louis Stevenson described how he and his schoolmates would place a bulls-eye lantern under their coats, its presence unknown to all but one another, and walk along the links at night, "a mere pillar of darkness" to ordinary eyes, but each exulting in the knowledge that he had a hidden lantern shining at his belt. Stevenson used these recollections as a paradigm for the human condition, commenting that a good part of reality "runs underground. The observer (poor soul with his documents!) is all abroad. For to look at the man is but to court deception. . . . To one who has not the secret of the lanterns, the scene upon the links is meaningless. And hence the haunting and truly spectral unreality of realistic books."[33]

In the same sense, one might speak of "the haunting and truly spectral unreality" of many ostensibly realistic photographs. Indeed, Rexford Guy Tugwell seems to have had something like this on his mind when early in the history of the photography project he advised Stryker, "Roy, a man may have holes in his shoes, and you may see the holes when you take the picture. But maybe your sense of the human being will teach you there's a lot more to that man than the holes in his shoes, and you ought to try and get that idea across."[34] Tugwell's conception was only imperfectly realized. The difficulties were formidable: the photographers' limited vision, the subjects' ability to mask what they felt and thought, the force of ideologies, the intrusion of perceived political necessities. Arthur Rothstein, the first photographer hired by Stryker, observed, "It was our job to document the problems of the Depression so that we could justify the New Deal legislation that was designed to alleviate them."[35] Stryker's instructions to his photographers often bore this out. In January 1936, as Dorothea Lange was preparing for her first major trip for the Resettlement Administration, Stryker wrote her:

> Would you, in the next few days, take for us some good slum pictures in the San Francisco area. (Of course, no California city has slums, but I'll bet you can find them.) We need to vary the diet in some of our exhibits here by showing some western poverty instead of all south and east. . . . When you get to Los Angeles, I think it might be worthwhile to see if you can pick up some good slum pictures there also. Do not forget that we need some of the rural slum type of thing, as well as the urban.[36]

Even in the midst of this ideological and political urge to document suffering, Stryker showed that his mind never strayed too far from the practical. "As you are driving along through the agricultural areas," Stryker wrote Lange in the same letter, "would you take a few shots of various types of farm activities such as your picture showing the lettuce workers. I think Dr. Tugwell would be very appreciative of photographs of this sort to be used as illustrative material for some things which the Department of Agriculture is working on."[37] He could also issue orders to downplay adversity, as he did in his often-quoted letter to Jack Delano in the fall of 1940:

> Please watch for autumn pictures, as calls are beginning to come for them and we are short. These should be rather the symbol of Autumn . . . cornfields, pumpkins. . . . Emphasize the idea of abundance—the "horn of plenty"—and pour maple syrup over it—you know, mix well with white clouds and put on a sky-blue platter. I know your damned photographer's soul writhes, but to hell with it. Do you think I give a damn about a photographer's soul with Hitler at our doorstep? You are nothing but camera fodder to me.[38]

In the winter of 1942 Stryker asked Russell Lee and Arthur Rothstein to provide "pictures of men, women and children who appear as if they really believed in the U.S. Get people with a little spirit. Too many in our file now paint the U.S. as an old person's home and that just about everyone is too old to work and too malnourished to care much what happens." Though he quickly added, "(Don't misunderstand the above. FSA is still interested in the lower-income groups and we want to continue to photograph this group.)"[39]

That there is more continuity in these photographs than such gyrating mandates suggest, that Stryker's photographers did not veer wildly from recording victims to recording self-sufficient patriots, was the result both of the photographers' talent and integrity and Stryker's hunger for documentary detail, which provided the underpinning for the entire project and supplied a wealth of information about American culture and belief. He instructed his photographers to record the scenes of everyday life: "How do people spend their evenings," he would ask; "show this at varied income levels." He requested pictures of home life, of leisure pursuits, of people going to church, of group activities, of the woman's world, of backyards and porches, of baseball diamonds, of the way people dressed and decorated their walls, of the differences in their behavior on and off the job. He was proud of the fact that his photographers caught people in everyday situations. He boasted of the fact that "in our entire collection we have only one picture of Franklin Roosevelt, the most newsworthy man of the era. . . . You'll find no record of big people or big events in the collection. There are pictures that say Depression, but there are no pictures of sit-down strikes, no apple salesmen on street corners, not a single shot of Wall Street, and absolutely no celebrities."[40]

This final boast—"absolutely no celebrities"—highlights one of the truths of the FSA-OWI photographs: they paid more attention to regional and folk than to popular and mass culture. While these documents attest to America's complex ethnic, regional, and cultural heterogeneity, they are less successful in depicting the growing uniformity and standardization imposed by the forces of modernization. There are, to be sure, important indications of the intrusion of a national culture onto the local scene: John Vachon's photograph of a long line of cars and parking meters in Omaha, Nebraska, might have been taken in scores of American cities which could have easily supplied not only the cars and meters but also the background replete with a Woolworth's, a chain drug store, and a movie theater (see p. 95). The same point is made by Vachon's shot of an Omaha newsstand with its array of national periodicals, photojournals, and western, sport, detective, and romance pulp magazines (see p. 96). Arthur Rothstein's portrait of a young black girl in Gee's Bend, Alabama, peering from a cabin window next to which hangs a newspaper advertisement for Shredded Wheat and another featuring a white woman holding a platter of food above the caption, "Your Baker Offers You a Tempting Variety!" (see p. 151) testifies poignantly to the fate of local culture in general and local cuisines in particular. John Collier's photo of a wall in the Lopez

home decorated by religious icons, family photos, and a newspaper or magazine photo of an actress (see p. 300) illustrates impressively the increasingly complex blend of traditional, family, and mass cultures. These nationalizing tendencies are depicted even more starkly by the Office of War Information photographs of war mobilization, defense industries, and increased movement of rural populations to city factory jobs.

Nevertheless, one has to supplement these photographs with other sources to grasp fully the truth that by the 1930s all types of Americans from all areas of the country could view identical movies, listen to identical recordings in their homes or on jukeboxes, follow the same soap operas, laugh at the same comedians, be exposed to the same commercial messages, learn from the same news commentators, simultaneously attend the same presidential fireside chats, and listen as a nation to graphic on-the-spot accounts of Babe Ruth hitting his home runs or Joe Louis defending his heavyweight championship. Warren Susman has observed that while the photograph, the radio, and the moving picture were not new to the 1930s, "the sophisticated uses to which they were put created a special community of all Americans (possibly an international community) unthinkable previously. The shift to a culture of sight and sound was of profound importance; it increased our self-awareness as a culture; it helped create a unity of response and action not previously possible; it made us more susceptible than ever to those who would mold culture and thought."[41] Photography was not merely a mechanism for depicting these changes, it was simultaneously their product and their agent, their creation and their creator.

At the end of his life Stryker insisted that his goal had been to "record on film as much of America as we could in terms of people and the land. We photographed destitute migrants and average American townspeople, sharecroppers and prosperous farmers, eroded land and fertile land, human misery and human elation." It was precisely for this documentation of the varied and unspectacular aspects of America that Stryker came more and more to value his collection. "*We introduced America to Americans,*" he asserted. Doubtless this was claiming too much, though it is true that by providing a ready source of photographs for newspapers, government agencies, and national magazines, Stryker's photographic file did constitute one of the many vehicles in the thirties and forties that provided Americans with the opportunity to share experiences, images, and culture. Stryker was more accurate when he wrote in 1973, "We provided some of the important material out of which histories of the period are being written."[42] And, it should be added, will continue to be written, for one of the enduring contributions of the photographers of the FSA and OWI is to help to introduce the America of their generation to Americans of ours. They have provided us with an unusually rich historical resource, which is flawed, certainly, as all such bodies of materials are, but which affords us an unusual opportunity to explore many of the past's hidden dimensions if only we have the wisdom to use their legacy with insight and sensitivity.

NOTES

1. William James, *Selected Papers on Philosophy* (New York: E. P. Dutton, 1917), 1–2.
2. Ralph Ellison, *Shadow and Act* (New York: Random House, 1964), 303–17.
3. The newspaper and magazine clippings collected by the FSA and OWI indicate how immediate and persistent the impact of Lange's photo was. See the Written Records of the Farm Security Administration, Historical Section—Office of War Information, Overseas Picture Division, Washington Section Collection, in the Prints and Photographs Division, Library of Congress.
4. Lange left no record of the order in which she took her photos of the Thompsons. I have followed the interpretation of James C. Curtis, who has tried to establish the sequence of the shots from internal evidence ("Dorothea Lange, Migrant Mother, and the Culture of the Great Depression," *Winterthur Portfolio* 21 [Spring 1986]:1–20).
5. William Stott, *Documentary Expression and Thirties America* (New York: Oxford University Press, 1973), 58–59.
6. Maurice Berger, *FSA: The Illiterate Eye: Photographs from the Farm Security Administration*. Berger curated and wrote an essay for an exhibition held 26 November 1985–10 January 1986 at Hunter College Art Gallery, New York City.
7. Arthur Schlesinger, Jr., *The Crisis of the Old Order, 1919–1933* (Boston: Houghton Mifflin, 1957), 231, 241–42; Stott, *Documentary Expression and Thirties America*, 67–73; and Robert S. McElvaine, *The Great Depression: America, 1929–1941* (New York: Times Books, 1984), chap. 4.
8. Irving Bernstein, *A Caring Society: The New Deal, the Worker, and the Great Depression* (Boston: Houghton Mifflin, 1985), 17–18.
9. Lawrence W. Levine, "American Culture and the Great Depression," *Yale Review* 74 (Winter 1985):201.
10. Ibid.
11. James Agee and Walker Evans, *Let Us Now Praise Famous Men* (Boston: Houghton Mifflin, 1941); and Stott, *Documentary Expression and Thirties America*, 286–87.
12. Interestingly, the photographer of the Burroughs family, Walker Evans, has been criticized for the opposite tendency as well: for posing his subjects and rearranging the belongings in their homes "to show the order and beauty that he believed lay beneath the surface of their poverty. . . . Evans sought to ennoble the sharecroppers." See James C. Curtis and Sheila Grannen, "Let Us Now Appraise Famous Photographs: Walker Evans and Documentary Photography," *Winterthur Portfolio* 15, no. 1 (Spring 1980): 1–23. In his 1942 review of *Let Us Now Praise Famous Men* Lionel Trilling faulted James Agee for refusing to "see these people as anything but good" (Trilling, "Greatness with One Fault in It," *Kenyon Review* 4 [Winter 1942]:102).
13. Bruno Bettelheim, "Individual and Mass Behavior in Extreme Situations," *Journal of Abnormal Psychology* 38, no. 4 (October 1943):417–52; and Stanley Elkins, *Slavery: A Problem in American Institutional and Intellectual Life* (Chicago: University of Chicago Press, 1959), chap. 3.
14. Halla Beloff, *Camera Culture* (Oxford and New York: B. Blackwell, 1985), 18.
15. Alan Sekula, *Photography against the Grain: Essays and Photo Works, 1973–1983* (Halifax: Press of the Nova Scotia College of Art and Design, 1984), 7.
16. Roy E. Stryker and Nancy Wood, *In This Proud Land: America 1935–1943 as Seen in the FSA Photographs* (Greenwich, Conn.: New York Graphic Society, 1973), 8.
17. Dorothea Lange, "The Assignment I'll Never Forget: Migrant Mother," *Popular Photography* 46, no. 2 (February 1960):42–43, 126.

18. "Report and Notes on Experiences in Collecting Yugoslav Folk Material, December 13, 1938," Sylvia Diner folder, in Works Progress Administration, Federal Writers' Project Life Histories, Library of Congress.

19. Stott, *Documentary Expression and Thirties America*, 92. Throughout his study, and especially in part 2, Stott describes this documentary urge with great intelligence and insight.

20. Bernstein, *A Caring Society*, 257.

21. Bill Ganzel, *Dust Bowl Descent* (Lincoln: University of Nebraska Press, 1984), 124–25.

22. This summary of the culture of the twenties and thirties is derived from my articles "Progress and Nostalgia: The Self Image of the 1920s," in *The American Novel and the 1920s*, ed. Malcolm Bradbury (London: Edward Arnold, 1971); "American Culture and the Great Depression," *Yale Review* 74 (Winter 1985): 196–223; "Hollywood's Washington: Film Images of National Politics in the Great Depression," *Prospects* 10 (1986): 169–95.

23. Bernstein, *A Caring Society*, chap. 4; William E. Leuchtenburg, *Franklin D. Roosevelt and the New Deal, 1932–1940* (New York: Harper and Row, 1963), 243–45.

24. Ganzel, *Dust Bowl Descent*, 122–23; Samuel A. Stouffer et al., *The American Soldier: Combat and Its Aftermath*, Studies in Social Psychology in World War II, vol. 2 (Princeton: Princeton University Press, 1949), 598.

25. Stryker and Wood, *In This Proud Land*, 7.

26. Caroline Bird, *The Invisible Scar* (New York: D. McKay, 1966), 22–23.

27. Warren I. Susman, "History and Film: Artifact and Experience," *Film & History* 15 (May 1985): 30.

28. John Steinbeck, *The Grapes of Wrath* (New York: Viking Press, 1939; reprint, Bantam, 1946), 378; Margaret Mitchell, *Gone with the Wind* (New York: Macmillan, 1936; Pocket Books, 1968), 862.

29. This theme is further explored in my article "American Culture and the Great Depression."

30. Stryker and Wood, *In This Proud Land*, 14, 17.

31. Ibid.

32. See, for example, John Tagg, "The Currency of the Photograph," in *Thinking Photography*, ed. Victor Burgin (London: Macmillan, 1982), 126, 128. For a more interesting and subtle argument along these lines, see Sally Stein, "Marion Post Wolcott: Thoughts on Some Lesser Known FSA Photographs," in *Marion Post Wolcott: FSA Photographs* (Carmel, Cal.: Friends of Photography, 1983), 3–10.

33. Robert Louis Stevenson, *Across the Plains* (London: C. Scribner's Sons, 1892), 206–28.

34. Stryker and Wood, *In This Proud Land*, 11.

35. Arthur Rothstein, *Documentary Photography* (Boston: Focal Press, 1986), 36.

36. F. Jack Hurley, *Portrait of a Decade: Roy Stryker and the Development of Documentary Photography in the Thirties* (Baton Rouge: Louisiana State University Press, 1972), 70.

37. Ibid.

38. Stryker and Wood, *In This Proud Land*, 16.

39. Stryker to Lee and Rothstein, 19 February 1942, reprinted in ibid., 188.

40. Stryker and Wood, *In This Proud Land*, 8, 14, 15, 187, 188; Rothstein, *Documentary Photography*, appendix A, 163–68.

41. Warren I. Susman, *Culture as History: The Transformation of American Society in the Twentieth Century* (New York: Pantheon Books, 1984), 160.

42. Stryker and Wood, *In This Proud Land*, 8, 9, 14.

FROM IMAGE TO STORY

READING THE FILE

ALAN TRACHTENBERG

In 1935, early in Roy E. Stryker's career as chief of the Historical Section of the Resettlement Administration, a woman appeared in quest of a photograph made by Walker Evans in Bethlehem, Pennsylvania. Stryker recalled the episode some forty years later. The picture (figure 18) was

> one of a cemetery and a stone cross, with some streets and buildings and steel mills in the background. Months after we'd released that picture a woman came in and asked for a copy of it. We gave it to her and when I asked her what she wanted it for, she said, "I want to give it to my brother who's a steel executive. I want to write on it, '*Your* cemeteries, *your* streets, *your* buildings, *your* steel mills. But *our* souls, God damn you.'"[1]

In Stryker's mind the woman's reaction caught something essential in the project he had just undertaken to direct; it helped him define a goal. "Pictures like these were pretty heady. . . . They gave me the first evidence of what we could do."[2]

The anecdote is slight, but it catches something essential and instructive in our project as well, our own encounter, fifty years after the making of the images, with the formidable Farm Security Administration–Office of War Information (FSA-OWI) file. The file is tangible: actual file cabinets, microfilm readers, card catalogs. It is public property, open to all in the Prints and Photographs Division of the Library of Congress. We are free to visit it, open its drawers, browse among its images and captions; free to request any picture that catches our fancy or fills a need. Preserved here is an unexampled record of social observations, of visual detail awaiting absorption and interpretation. Our own needs may be less fired-up

18. Graveyard, houses, and steel mill, Bethlehem, Pennsylvania, November 1935. Walker Evans.

than those of the woman in the story and more decorous, less immediate, more critical or aesthetic or historical. But whatever we may think of her particular reading of Evans's great picture or the propriety of even wishing to deface an image by writing upon it, her fervor teaches a vivid lesson. Her wish to put words on the image makes literal a desire to possess it as her own, to put herself into the picture as its active interpreter. However rash she was, however naive in literalizing a complexly organized picture, her spontaneous participation in the image by remaking its meaning on her own ground (in this case fraught with social, political, and perhaps fratricidal motives) can be nevertheless an inaugural model and exemplum.

There is another lesson here for our own confrontation with the file and its contents. To recognize that an image is a kind of writing prepares us for the larger challenge of reading or making sense of the file as a whole—that is, of the FSA-OWI documentary project itself. The file represents that project, though not as transparently as we might think. The present FSA-OWI file did not

spring into being all at once; it has its own interesting history, linked to the evolving shape of the project itself but in the end a structure placed upon the project after it had ceased. From the beginning the project and a filing system existed in symbiosis. To assemble a great collection of pictures portraying the nation at the nadir of the Depression emerged as the overriding goal of Stryker's enterprise. "This file," wrote one of the staff members, "should be considered the thing we are building." The same writer described the goal as "a monumental document comparable to the tombs of the Egyptian Pharoahs or to the Greek Temples, but far more accurate."[3]

The architectural metaphor is not farfetched. From the birth of the medium in 1839 practitioners encountered unique problems of accumulation, storage, and organization. The problem of filing, although mainly technical, was nonetheless inseparable from questions of meaning and interpretation, of knowledge and use. The present file, built by Paul Vanderbilt beginning in 1942, is one of the most literate, self-conscious, and I think elegant solutions to a problem as old as photography itself. The solution is also complex, and I want to show that its elaborate technical procedures do not exist for their own sake; they are not "neutral" devices. They represent ideas, a distinct view of society and history and human action. The file deserves to be recognized as one of the prime cultural artifacts of the New Deal. As we shall see, it embodies the era's ideology of human history as "universal" and "progressive." The file helps us see through the eyes of that vision. It gives us both the insights and the blind spots, the strengths and limitations of a major American outlook: the liberal view of society as "natural" yet infinitely manipulable. In its cultural ambition the file reaches beyond the particular goals of the FSA and the OWI. It is a view of photography itself, particularly as a medium of cognition and social knowledge. In our approach to the photographs, then, and especially to the use of recombined separate images as stories, we need to consider the file as an intellectual construction, one that stands as a massive presence between the tens of thousands of single images it contains and the meaningful stories those images might tell.

The nexus of images and stories is in fact the main theme of the file, as it was of the FSA-OWI project. Roy Stryker believed he possessed a "master" narrative of the project, and others shared his confidence in a controlling theme. Vanderbilt clarified this master story in the nuanced modulations of his classification system. But the anecdote of the fervent woman and the Bethlehem picture introduces a provocative, skeptical note. To read an image is to write upon it, to incorporate it into a story. This is not to say that an image is a blank writing pad. There is something there to be seen, and we want to see it. We never (or rarely) read nakedly, however, but always through a veil, the screen of previous interpretations, of intervening contexts or discourses, and of our own motives, hidden and known. Even the setting of our encounter leaves its imprint, coloring our perception of the image. Reading, then, often takes deliberate rewriting; we can think of it as a contest, an effort to wrest an image from the grip of previous or contending readings. Arriving at our own vision takes a conscious act of revision. This is

true whatever the object of our attention, but it is notably true of photographs, the most written upon, under, above, and around of all visual artifacts.

In 1938 a slightly cropped version of the Bethlehem image appeared in Archibald MacLeish's *Land of the Free*—"a book of photographs," explained MacLeish, "illustrated by a poem."[4] Like each of the book's eighty-eight images (drawn mostly from the FSA-OWI file), Walker Evans's photo occupies a glossy page by itself, is bled vertically to the edges, and appears without caption or identification (a list of captions and photographers appears at the end of the book) opposite a page of text.

We wonder whether the great American dream
Was the singing of locusts out of the grass to the west and the
West is behind us now:

The west wind's away from us.[5]

The image takes its place in a sequence of words and images, the governing theme of which is proclaimed in the poem's opening words, "We don't know / We aren't sure," which evoke the dubiousness of the American dream at a time typified by images of gaunt faces, resigned bodies, gnarled hands, ragged children, abandoned farms, police violence, and barbed wire.

Just preceding the Evans picture is a photograph of a Congregationalist church and graveyard: "We tell our past by the gravestones and the apple trees."[6] Just following it is a Russell Lee picture of a worried-looking farmer and two children "on cutover land in Wisconsin": "We wonder if the liberty is done: / The dreaming is finished / We can't say / We aren't sure." The three images (figures 19, 20, 21) make up a coherent passage within the argument of the poem, a kind of stanza: the Bethlehem picture with its commanding rusticated cross (implying a Catholic cemetery and immigrants) and its compressed urban-industrial imagery serves as a descending bridge from the pleasantly familiar rural Connecticut scene (all in white, with ancient lichen-covered slabs for grave markers) to the Wisconsin scene of depleted energy and belief. In that movement—from the spire of traditional communal belief, to the cross of stern judgment, to the abandoned farmer and children and the unpainted shack behind them—lies the inscribed meaning of "Bethlehem" in this setting: the alien hell that lies between there and here, between then and now.

The following year the Bethlehem picture appeared in a quite different guise on a two-page spread as the concluding image of a group of forty-one Farm Security Administration pictures presented by Edward Steichen in *U.S. Camera 1939*. The pictures had been shown in an International Photographic Exposition held in New York City that year to mark the hundredth anniversary of the birth of photography, taking their place thereby in a celebrated history of the medium as, in Steichen's words, "the most remarkable human documents that were ever rendered in pictures."[7] Steichen

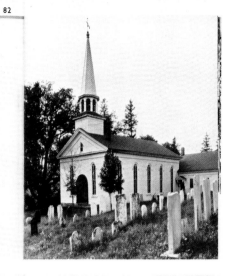

19. From Archibald MacLeish, *Land of the Free.*

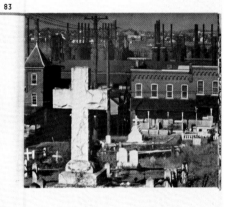

20. From Archibald MacLeish, *Land of the Free.*

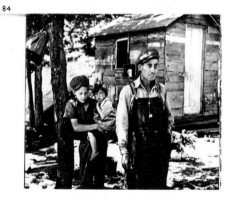

21. From Archibald MacLeish, *Land of the Free.*

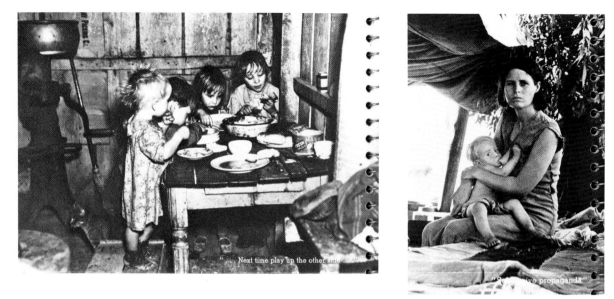

22. *Left:* From *U.S. Camera 1939*, 52.

23. *Right:* From *U.S. Camera 1939*, 58.

explained "documentary"—at the time a novel category for a salon exhibition—as pictures that "tell a story": "Have a look into the faces of the men and the women in these pages. Listen to the story they tell." As if to enhance the story, or to provoke the reader, Steichen included on the face of each image (except the first and the last) actual writing culled from the written comments of viewers of the exhibition. The comments display varying degrees of outrage, sympathy, sensitivity, and obtuseness. Their effect as captions is often ironic, at the expense of the anonymous author: "Next time play up the other side" appears on the Russell Lee picture of four children standing at their grubby Christmas dinner (figure 22); "Subversive propaganda" on Dorothea Lange's nursing migrant mother (figure 23). The irony points the reader in the right direction.

Free of any explicit commentary, the blown-up Evans picture pointedly concludes the section, the hovering angel of the group (figure 24). "For sheer story telling impact," Steichen wrote, the Bethlehem photograph, "picturing in parallel planes the cemetery, the steel plant and the home, would be hard to beat." Bled to the corners, printed (like all the pictures) in deeply saturated blacks on heavy pulp stock, and severely cropped at the top and bottom with the ominous foreground cross occupying even more of the picture plane than in the uncropped version, the presentation highlights the iconic message.

Yet another connotative use of the picture appeared in the same year. Roy Stryker and Paul H. Johnstone included it among nine images illustrating a lecture before the American Historical Association in 1939, identifying it in their text only as "Picture No. 8," which shows "housing and factory construction" and "speaks

24. From *U.S. Camera 1939*, 64–65.

volumes about the unplanned growth of an industrial city, although
the dramatic composition of the photograph makes it an example
of a type that is interpretative as well as documentary."[8] Arguing
for the value of photographic documents for historians, they ex-
plain that in depicting an aspect "of the urban milieu of which the
immigrant from a peasant culture has become a part," the picture
"has an insistence for the historian that no verbal document can
carry."[9]

MacLeish, Steichen, and Stryker: each joins the embattled sis-
ter of the steel executive in rewriting Walker Evans's picture, re-
leasing some vibrations, subduing others. This process resembles
the capture of an elusive essence in a tightly meshed net. As it takes
place, we overhear the bemused voice of the original author, Evans
himself: "People often read things into my work, but I did not con-
sciously put these things in the photographs."[10] In an unpublished
note written in 1961 for a reissue of *American Photographs*, Evans
said: "The objective picture of America in the 1930's made by Evans
was neither journalistic nor political in technique and intention. It
was reflective rather than tendentious and, in a certain way, disin-
terested."[11] Disinterest is exactly what is purged from the image by
the readings projected upon it.

Indeed, such representations of FSA pictures in the 1930s and
since have made tendentiousness seem the inner motive of the
project: the Farm Security Administration had a story to tell about
the hardship, and also the hardiness and heroism, of the times. Re-
cently Stryker's project has been severely criticized for promoting
New Deal ideology and policies: in a complex process, images that
can otherwise be seen as disinterested, objective, and reflective
were manipulated in presentation to favor the needs of the Roose-

velt administration.[12] However we judge the uses of Evans's picture, we should note that it appears in various contexts not so much as a picture by Walker Evans but as an *FSA* photograph. FSA itself has come to represent a context and to connote a particular story of the Great Depression.

Steichen mentions no photographer by name in his *U.S. Camera* introduction; he subordinates "the work of individual photographers" to "the job as a whole," each image standing for the collective project rather than an individual vision or practice. Curiously, the list of names he includes at the end of the group appears without captions or other information linking the pictures to particular investigations. Presumably the stories are internal, readable (or audible) within the pictures themselves, each self-sufficient, so long as the category FSA appears. The category projects a story or a meaning, and in the absence of captions, a meaning general, nonspecific, and perhaps self-assuring of fortitude and perseverance, those innate and invincible American values. Would particularizing captions have diverted attention, at the international exhibition as well as in the pages of *U.S. Camera,* from the images themselves, compromised their credentials for salon exhibition, cast doubt on their claim to a place within the *art* of photography? In the Steichen presentation the pictures fluctuate indecisively between two worlds: the FSA file and the galleries of fine art.

This indecision reflects the ambiguous status of photography in general, split as its functions have been between utility and aesthetics. This ambiguity in thinking about photography stands guard over any easy access to the FSA-OWI file; we encounter it as soon as we confront the file as a physical entity, in the very form and structure of the collection. Shall we seek, for example, the work of individual photographers, or the totality of pictures on certain subjects, made in certain places?

Two recent representations of the Bethlehem image dramatize this dilemma rather starkly. Both are uncropped, showing the full image as Evans himself presented it. In a 1971 Museum of Modern Art monograph on the artist, the photograph appears pristine, set alone on a page surrounded by white space, facing a page of white: the form replicates a gallery wall. Here we have the image in the context of the photographer's work, representing his vision, taking its place in his career as a picture maker. It has this place, moreover, through a process of aesthetc selection: it has survived the siftings and exclusions from the entire body of his work.[13] In 1973 the same uncropped version appears in quite another kind of book on Evans's work: a catalog of his photographs for the Farm Security Administration (a publication over which he had no control or influence). It appears in two locations: in the opening portfolio of selected images presented one to a page as pictures unto themselves and also as a small catalog image along with other such images of pictures made in Bethlehem and Pennsylvania on the same FSA trip. In the one case the image testifies to Evans's status as an artist, the maker of single fine pictures, and in the other to his practice as a journeyman photographer creating a cumulative record of social observation. Evans alone is really the context of both, but the presentation makes a difference in our reading of the same image.

25. Horse on a cold day, Woodstock, Vermont, March 1940. Marion Post Wolcott.

Is the lesson of the Bethlehem image that there are no true meanings? Are all photographs vagrant images in search of a context, of readers prepared to write meanings across their face? It is tempting to name what seems the purest, least-written-upon version of the image as the truest: the exhibition version within the *mise en scène* of Evans's 1971 book. But "art" also has a context, a discourse, within which we identify and act upon certain experiences. Recognition of this can shelter us from the difficulties associated with trying to imagine an original and essential meaning. Instead of seeking essences, the perfect meaning of single images, or an FSA "style" or "vocabulary," we should focus on the actual work of the photographers, their discoveries, their inventions, their reflections upon their activity. By entering the file and negotiating its intricate passages, we can begin to sort out its implications and impositions, its explicit intentions and those that remain hidden.

We start with an image of a horse (figure 25). The horse appears to be cold; frost gathers at its nostrils. Is it a picture of "a shivering horse" or a photograph of "cold weather"? The present version of the FSA-OWI file was built on the answers to such questions. In a remarkably lucid "Preliminary Report" (1942) on theoretical and practical aspects of the constitution of the file, Paul Vanderbilt cites this dilemma to cut to the bone of the matter. His reasoning invites close attention. He writes, "Objectively, what appears in the photograph, without any whys and wherefores, is the basis for stability in our kind of record. Yet this is far from clear." There is no escaping a "subjective element," no certainty that two people will agree to any single statement of what the photograph actually shows. Should this particular image be filed under "horse" or

under "cold weather"? Edwin Rosskam, who had helped contrive the earlier file organization that Vanderbilt's system displaced, and with whom Vanderbilt discussed the matter of the shivering horse, insisted, as Vanderbilt recounts the episode, that the horse best depicts not its own horseness but atmospheric conditions. Vanderbilt agrees: "Since cold must be shown through some objective medium, this is *in a sense* an objective judgment" (my emphasis).[14] A good case could be made for either term, subjective or objective. It is a judgment call. But the categories "horse" and "weather" still do not tell us anything particular about the picture as a picture or what it might mean under all circumstances of its viewing; they tell us only how to *identify* the picture, where in the file to look if we wish to see it again. What we see and how we understand what we see are further matters: here the subjective/objective dance begins again.

The horse is no "Bethlehem" or "Migrant Mother." But commonplace images are more typical of the FSA-OWI file and its problems of readability than is generally acknowledged. The comedy of choosing to ask What appears in the photograph? arises as a perfect emblem of the ambiguity in which most photographs reside—the same ambiguity that allows one image to serve different masters under different captions on different stages. In his many writings on the file Vanderbilt often emphasized the inescapable ambiguity of an uncaptioned, free-floating photograph and the final arbitrariness of declaring, This is cold weather, not horseness. The making of any file, he realized, is an exercise in arbitrary judgment. Yet arbitrary does not mean without reason or intent.

Among Vanderbilt's accomplishments were a number of unpublished essays and lectures explaining the principles of his system. His chief explanation of the basis of his revision of the older filing system in place when he arrived on the scene in 1942 is cognitive: the relation of photographs to knowledge. How do photographs help us know reality? We must learn to see them, he argued, not as "facts so much as conceptions."[15] In his frequent use of terms drawn from linguistics, like "denotation" and "connotation," Vanderbilt drew a fundamental analogy between photographs and language. He built into the file the theory that, like words, images can and should be endlessly recombined into new relations to generate new ideas, new cognitions, new senses of the world. Though he also designed the file for the single-image needs of picture editors and historical researchers, he described his primary goal as facilitating the use of pictures to make new and original "stories." Thus he wrote in 1959 that the task of assembling a file "is to provide for recombination and reuse. . . . Certainly the provision for location of pictures on call is not to be neglected, but more important is *the scattering of pictures in the pathways of search, where they may be found unexpected as fresh inspirations*" (my emphasis).[16]

The earliest method of organizing the burgeoning number of photographs seems to have been by state and by subject (see Appendix). But sheer accumulation of differing images began to undermine this relatively simple structure. On 1 August 1939, Stryker's section tried to provide some guidance to the growing number of users, especially newspapers and periodicals, by listing "suggestions for picture stories," such as "stories of groups of people," "crop sto-

ries," and "stories of places."[17] In a memorandum in 1941 Rosskam exhorted Stryker to introduce a clear "subject file" so that users could find what they needed with some dispatch. What stood in the way was the "haphazard system" of also filing together all pictures made on specific assignments—what later came to be known as "lots"—without cross-reference. Rosskam said even such unified groups proved to be "thoroughly unreadable" because they ignored the "intentions" of the individual pictures. Thus he titled his memo "Hieroglyphics we call our photographic file and how to decipher them."[18]

Decipher, hieroglyphic, readability: the elementary need of the file, such terms suggest, was the creation of an order like that of language, based on a clear, unequivocal code. One of Vanderbilt's first tasks was to clarify the distinction between groups of pictures that belonged together because they had resulted from a specific assignment and those whose connection with one another could be based on similarity of subject. Such similarities would provide the foundation, eventually, for the highly intricate system of classification now in place. This distinction between two radically different principles of grouping the pictures resulted in two separate physical systems: a microfilm system for the original lots and a vertical file system for the classifications. The bridge between the two is the lot number stamped on the back of each print in the classified file. To be sure, the two systems are not equal in prominence or authority. The vertical files stand in the Prints and Photographs Reading Room; they can be seen; we can open their drawers and touch the prints. Viewing the microfilm images requires special assistance at a mechanical reader. But the relation of the two systems is fundamental; it represents Vanderbilt's wish to keep intact a record of the actual order of pictures as they were produced in the field, even while he systematically dismantled that order for the sake of the larger, more intricate, and intellectually coherent order of the classification system.

No more than a system of convenience, Vanderbilt insisted, the classification categories simply clarify what is already there. The new system revises the old by rearranging it into a logically coded structure of similarities and differences. It replaces what was "linguistically" inchoate ("haphazard") with a lucid outline of nine major headings, or classes (Land, Cities and Towns, People, Homes and Living Conditions, Processing and Manufacturing, etc.), divided into six parallel regional divisions (Northeast, Southeast, etc.). The list of major headings gives no clue to the actual shape of the subject dimension of the file, with its thirteen hundred subheadings and a scheme of descending categories. A portion of "Homes and Living Conditions" illustrates a typical breakdown (the filing system is explained in the Appendix, pp. 330–33):

4 Homes and Living Conditions
- 41–43 Houses, rooms, furniture, people at home, visiting, hobbies
- 44–447 Life in tents, shacks, rooming houses, hobo jungles
- 448–46 Personal care and habits, housework, cooking, eating, sewing, sleeping
- 47–48 Porches, yards, gardens, servants

A more detailed breakdown shows an additional sixteen subheadings under "Permanent Homes" alone, including "Row Houses," "Rammed Earth Houses," "Mansions and Plantations," and "Architectural Details."[19] The placement of images within this elaborate structure depended on just such choices as that about the horse: what is the "objective" content, as best we can say, of this image?

"The theoretical basis of classification," Vanderbilt wrote in 1950, "is the actual literal subject matter of the picture itself, and not its connotation or association."[20] But how is the "literal" to be distinguished from the "associative"? There is "no way," he conceded, "of systematizing subject headings."[21] The success of the file depends entirely on the aptness of countless decisions. No wonder Vanderbilt took such pains to distinguish between "objective" (denotative) and "subjective" (connotative) meanings and to insist that the distinction was always relative and provisional, that the decision to place the horse under cold weather is only "in a sense" an objective judgment. About the actual work of assigning images to classes, he wrote in 1942: "Don't try to systematize it. Get good classifiers, trust their intuitions on what a picture is primarily concerned with, let them make such exceptions and inconsistencies as seem advisable, reverse their decisions and shift photographs when the argument is strong enough."[22] Such remarks help us see the file not as something given by the nature of the material but as something *made,* a vast cellular edifice constructed of distinct human choices. Throughout the "Preliminary Report" Vanderbilt meticulously describes that labor and reiterates his cardinal interest: to *facilitate* access to the pictures for the sake of new combinations, new associations or "subjective" meanings. He is willing to modify headings, invent new ones, shift images from place to place. Not the form of the file matters, he explains, but logical access to the pictures: "I am trying to use classification in a workable plan for the disposition of photographs, not to determine relationships or set a pattern for future use."[23] The file is "no more than a means to an end, and not an end in itself."[24]

Vanderbilt conceived the file as a facilitator, a structure of convenience. His metaphors stress the instrumental relation of means to end: the file was the dictionary to "a forceful, colorful book," "a stock room of parts" to "the assembled useful machine," a menu to the "well-balanced meal."[25] The pictorial richness of the collection lies in "the astounding juxtapositions, the sensitive and subtle details, the significant backgrounds"—connotative features the file makes no effort to reduce to number and class. The file is blind, in short, to *pictures;* it recognizes only subjects, facts, data, assuming (or pretending, in Vanderbilt's metaphors) that a detail in a photograph is indeed a transparent copy of a thing in the world, a veritable fact to be filed away, rather than an image within a larger image that may qualify, modify, contradict, or cancel its presumed status as "fact." The archival file limits itself to this pretence to ease the extraction of exactly those troublesome and complicating connotative values, thus allowing for "infinite variation in combination of photographs and in approach by users."[26] Rather than predetermine combinations that constitute a finished whole, the file traffics in component parts.

To Vanderbilt, his design was a rationalized facility for storage and retrieval, a machine apparently intending no meanings of its own, no interpretations or ideology. Strictly functional, Vanderbilt's classification system aims to neutralize conflict over the meaning of specific images by agreeing to a provisional "objective" or referential meaning *in* the file to allow convenient releasing of single images *out* of the file into contexts of the user's own devising. The file, he writes, allows access to "individual pictures of specific things" as well as to "stories" on general topics. The system accommodates "both approaches (to a specific subject regardless of connections and to a connected story made up of many subjects)."[27] Once retrieved and delivered, the image might serve any purpose. Delivery liberates the image from its categorical confinement. Mere datum in the file, in the world it becomes a picture to be read.

The process has a paradoxical result: it transfers the hieroglyphic effect from the file to the image itself, now rendered dense and opaque by its freedom, its detachment from any determinacy. By first defining the image by an "objective" determination of its subject and then releasing it into indeterminacy, the file affirms rather than subdues the ambiguity it sets out to resolve (a point to which we will return).

In the descending subheadings and sub-subheadings we catch the full thrust of the structure, the formal elegance of Vanderbilt's solution. We have only to imagine alternative systems to realize the high order of craft of this achievement, the generosity of its pragmatic efficiency. The file's clarity can only arouse respect and gratitude. Yet to imagine alternatives, no matter of what sort, impresses the truth Vanderbilt himself insisted upon: the arbitrariness of the entire vast and intricate structure. Think of a system based instead on categories like conflict, tension, paradox, contradiction. Or emotion, anger, hate, lust, affection, bafflement, wildness. Or spatial forms, ritual gestures, modes of exploitation and cooperation. The collection could have been organized into an unlimited variety of different subjects and subheadings. Vanderbilt admits as much. "There is no such thing as an ideal general sequence of subject matter." He intended an open-ended, ever-changing structure. "The order of classes is neither a very important nor very profound matter," he wrote, and while one might "claim that work, in the class sequence comes before play, it is not in the spirit of analytical criticism, but merely to facilitate storage and have a place to keep the photograph while endless discussion goes on." "The sequences of classes," he insisted, should not have "a yes-or-no, animal-vegetable-mineral type of rigidity. . . . There should be opportunity to add an infinite number of classes."[28] A breathtaking vision: the FSA-OWI file as "the nucleus of a great photo documentation of all America, the collective repository for the work of tens of thousands of photographers," a "panoramic central" file.[29]

Contingent, arbitrary, provisional, subject to change, contraction, and expansion: still, as much as Vanderbilt insists on the system's neutrality, it cannot help imposing its own meanings. Its encyclopedic intention alone inscribes a signifying order upon the variegated materials it holds, an order of descriptive classes that the "stuff" of the pictures can then be interpreted as validating,

making the file seem permanent and authoritative, a sure guide to reality. The chosen classes and headings thus also represent the FSA-OWI project in a particular way. Vanderbilt's significant and often-overlooked disclaimers aside, the classification system implies an ideal order and a unified purpose: to scan the American world with a neutral photographic lens, picking out details that construct a "panoramic" view of America.

Vanderbilt, however, seems not to have realized that his system harbored an internal contradiction: verbal classes and headings cannot be "neutral"; relations among names cannot be free of associative meanings; a structure of relations cannot avoid interpreting its materials. In short, beneath the "theoretical basis" Vanderbilt developed in his 1942 report was a set of additional assumptions that shaped the file into these particular classifications, these terms and categories and names. For example, Vanderbilt's occasional remarks about the "universality" of the total effect of the collection imply an ambition to tie the "panorama" of America to categories of existence true for all times and places. "The classification should be based on the history of man," he noted in an untitled, undated memorandum, and in a "Memorandum on the Photography of America" written in 1963, he spoke retrospectively of the collection as "a kind of timeless life panorama of great dramatic richness," something "contemplative and almost philosophical, something essentially Christian about man's concern for his fellows and the fabric and texture of our country." [30]

The Christian allusion suggests, of course, a particular source for the "universal": the Western tradition and its Bible. Furthermore, the specific categories employed in the file indicate social science as another source of universalism. Vanderbilt explained in 1950 that his use of "the geographical basis with subject divisions" drew on the model of "the cross cultural survey of the Institute of Human Relations at Yale University" along with principles of geographical classification developed by the sociologist Howard W. Odum at the University of North Carolina. The conjunction of biblical and social-science notions of universality creates a powerful impression of authority, powerful enough to make us see the natural, self-evident form of the "history of man." In a revealing passage in the 1950 draft Vanderbilt makes explicit another controlling idea, one that fuses biblical and sociological categories into a literary form:

> The best conceptual picture of the history of mankind which we have been able to devise was that of a drama in which the world is a stage, people the actors, and the struggle for existence or survival, the plot. We imagine the history of mankind as a play presented before our eyes in which we would see actors appear within a setting and identify themselves, establish relationships one with another, evolve a capacity for action, face the realities and necessities of making a living, form associations for their mutual benefit, engage in mighty conflicts between larger and larger groups, achieve through their efforts a high symbolic degree of spiritual, intellectual and technological satisfactions. The climax of our drama seeks relief and recuperation in rest and amuse-

ment and yields in the end to human weakness in the debasement of ideals for personal advantage.[31]

Two aspects of this extended and revealing analogy stand out: the file is like a book in that "dramatic events are then *made to* follow one another in a printed version of a similar drama in book form" (my emphasis); and the story of the drama is essentially evolutionary, a biblical story with God left out. A further aspect of the Christian element is the hint of a jeremiad in the final detail: "and yields in the end to human weakness in the debasement of ideals for personal advantage."

In the same essay Vanderbilt describes the file as "a functional arrangement neutral in its character founded upon evolution and actual relationships." But is "evolution" applied to social history really a "neutral" concept? Are "actual relationships" conceived as a drama or book really "objective" or scientific? In fact, the file embodies the familiar idea of history as "progress," history ordered according to climaxes and resolutions as well as the moral imperatives of a Judeo-Christian ethic. It is "progressivist," essentially optimistic about solutions to conflicts and about its own universality. In its very form, its relations of headings and subheadings, its categorical progressions, the file represents diagrammatically a grand master story, a generative cultural myth: civilization begins in a relation to "land" and proceeds to build an increasingly complex society. Deeply rooted in the national culture, this "liberal" myth remains strong, if not dominant, in many realms of American life. It views conflicts as archetypal rather than specific to social circumstances, arising from the hearts of men, from selfishness and weakness rather than from irreconcilable needs and interests of antagonistic economic groups or social classes. In short, the file tells a story of its own, and its photographs serve as much to illustrate and validate that story as the file serves to facilitate access to those images. Thus the irony of its magnificent achievement: by its very success it enacts the problem it sets out to solve. The shape of the file predetermines "objective" categorical descriptions of each image, descriptions it claims are arbitrary, provisional, disposable. But the arbitrary splitting of each image into "objective" and "subjective" aspects—stable "literal" meanings and unstable associative meanings—endows the master story with a power beyond that of a mere filing device. Such is the power of cultural myth, of ideology, that the master story seems not a story at all but a neutral "arrangement."

If the file contains an unresolved tension between "objectivity" and "subjectivity," so the project had tensions and contradictions of its own. There are many ways to describe and evaluate the FSA-OWI project: from the perspectives of New Deal politics, of "documentary" photography, of new modes of photojournalism in the mass media of the 1930s and 1940s. When viewed from the perspective of the file, however, the project presents the dilemma of representing society, of telling stories about American life, through photographs. Apart from its political motives and imperatives, its

personality conflicts, its inner chain of command, the FSA-OWI project brought into focus large questions about American social reality and how it might be formulated and communicated in pictures. The project was perhaps the greatest collective effort (though not the first) in the history of photography to mobilize resources to create a cumulative picture of a place and time: in Roy Stryker's words, "to portray America." In the process, it encountered significant problems of depiction latent in the medium but also arising from the severe crisis (social, economic, cultural) of American society in the throes of the Great Depression. A mass of memoranda and drafts of essays and lectures stored in the Stryker and Vanderbilt archives discloses a remarkable effort among the staff to clarify goals and formulate theories of photography and society. These, together with Vanderbilt's file, can help us identify hidden issues of the FSA-OWI enterprise itself.

It is enlightening to learn how indistinct was the plan Stryker brought with him to Washington in 1935, how much in the early days he took his cues from his photographers and their work. Nothing in Stryker's original charge as chief of the Historical Section—to "direct the activities of investigators, photographers, economists, sociologists and statisticians engaged in the accumulation and compilations of reports"[32]—anticipates the goal of portraying a whole society, an act of documentation for its own (or for the file's) sake. But the First Annual Report of the Resettlement Administration in 1935 notes that the goal of the Historical Section would be reached "not only in keeping a record of the administration's projects, but also in perpetuating photographically certain aspects of the American scene which may prove incalculably valuable in time to come."[33]

Whatever its sources, Stryker adopted the idea of a historical record with evangelical fervor, which explains the remarkable latitude he afforded his corps of predominantly young, middle-class photographers. Arthur Rothstein writes that "the Farm Security file would never have been created if we hadn't the freedom to photograph anything, anywhere in the United States—anything that we came across that seemed interesting, and vital."[34] John Vachon agrees:

> Through some sublime extension of logic which has never been satisfactorily explained to anyone, Stryker believed that while documenting these mundane activities [routine pictures of housing projects, farmers on federal aid, and so forth], his photographers should, along the way, photograph whatever they saw, really saw: people, towns, road signs, railroad stations, barber shops, the weather, or the objects on top of a chest of drawers in Grundy Co., Iowa.[35]

In his eight years as chief of the unit Stryker cast an ever-widening net, seeking from his photographers an expanding horizon of scenes, things, faces, places—an epic ambition resulting, as he put it, in "the great number of photographs that got into the collection which had nothing to with official business."[36]

26. Railroad station, Edwards, Mississippi, [February 1936]. Walker Evans.

Was there a single coherent idea or theory guiding Stryker in his expanded intention? The extraordinary leap beyond the routine official purposes of his office is not easily accounted for. Stryker attributed the birth of the larger project to a "personal dream" of "a pictorial encyclopedia of American agriculture."[37] We can understand "dream" in two senses, not only as an ambition but also as a wish fulfillment. American agriculture and small-town life had already changed in profound ways. Stryker wished to preserve what was already lost. "Through the pictures," he recalled to Nancy Wood in 1973, "the small town emerged as a thing possessing emotional and esthetic advantages: kinship with nature and the seasons, neighborliness, kindliness, spaciousness."[38] And in a passage of remarkable pathos:

I remember Walker Evans' picture [figure 26] of the train tracks in a small town, like Montrose [Stryker's hometown in Colorado]. The empty station platform, the station thermometer, the idle baggage carts, the quiet stores, the people talking together, and beyond them, the weather-beaten houses where they lived, all this reminded me of the town where I had grown up. I would look at pictures like that and long for a time when the world was safer and more peaceful. I'd think back to the days before radio and television when all there was to do was go down to the tracks and watch the flyer go through. That was the nostalgic way in which those town pictures hit me.[39]

The chord struck here betrays one source of Stryker's encyclopedic ambition: the dream of translating what was no longer a vital culture into an abstract and timeless "value."

The hold of this lost vision on Stryker and many other Americans cannot be exaggerated. The specific form it would take in the FSA-OWI project began to emerge in 1935, paradoxically, with the enlistment of the urbane Walker Evans. Beyond doubt Evans was the most decisive figure in the early years of the project. "I saw his pictures," recalled Stryker. "I walked at night with him and I talked to him. He told me about what the photographer was for, what a photographer should do, and he gave me his rationale for pictures. It was extremely interesting because it was opening up a whole new field of ideas."[40] Evans joined the Resettlement Administration with an already mature view of his intentions in photography. "I am exceedingly interested in the undertaking," Evans wrote about a month before his initial appointment as an "Assistant Specialist in Information," "which seems to me to have enormous possibilities, of precisely the sort that interest me."[41] As early as 1931 he had written in a *Hound & Horn* essay archly titled "The Reappearance of Photography" that "the real significance of photography was submerged soon after its discovery." Fakery, pretension, and commercial slickness had prevailed over the kinds of direct, honest records foretold by Louis Jacques Daguerre and other pioneers. In the work of Eugène Atget and of August Sander, however, the young Evans recognized "one of the futures of photography. . . . It is a photographic editing of society, a clinical process; even enough of a cultural necessity to make one wonder why other so-called advanced countries of the world have not also been examined and recorded."[42] In a 1934 letter to Ernestine Evans (also an acquaintance of Stryker's and no relation to Walker Evans), Evans sketched what may be the earliest model for Stryker's famous shooting scripts:

> People, all classes, surrounded by bunches of the new down-and-out.
> Automobiles and the automobile landscape.
> Architecture, American urban taste, commerce, small scale, large scale, the city street atmosphere, the street smell, the hateful stuff, women's clubs, fake culture, bad education, religion in decay.
> The movies.
> Evidence of what the people of the city read, eat, see for amusement, do for relaxation and not get it.[43]

In the "Outline Memorandum" he wrote for Stryker about his first trip for the unit through Pennsylvania, the Ohio Valley, and the southeastern states, Evans described his general intention as "still photography, of a general sociological nature," and his "first objective" in the Pittsburgh vicinity as "photography, documentary in style, of industrial subjects, emphasis on housing and home-life of working-class people. Graphic record of a complete, complex, pictorially rich modern industrial center."[44]

Evans provided a theory and an exemplary practice for the project in its early days, one that it could not effectively sustain. Whatever the intentions of a "pure" record, government sponsor-

ship imposed its own needs and demands. In its effort to bolster a stricken economic system without abandoning the basic forms of private ownership and capitalist enterprise, the New Deal sought to employ all the technologies of communication to foster its authority and to win support for its programs on behalf of a liberal, progressivist idea of America. Evans had proclaimed the credo of the "pure" record maker even before joining the project. "Never make photographic statements for the government or do photographic chores for gov or anyone in gov, no matter how powerful," he wrote in a draft for a memorandum before he accepted the government position. "This is pure record not propaganda. The value and, if you like, even the propaganda value for the government lies in the record itself which in the long run will prove an intelligent and farsighted thing to have done. NO POLITICS whatever."[45]

Significantly, Evans's insistence on independence had more to do with politics than with the notion of photographs as *social* knowledge. His mention of the "general sociological nature" of his pictures accorded at least in principle with Stryker's social-science outlook.[46] Indeed, rapport between photographer and social scientist would emerge as a key motif in the project, an explicit part of its developing rationale and a theme repeated often in memoranda. Stryker conceived of that rapport as a two-way street: the photographers "must be something of sociologists, economists, historians,"[47] and "the student of social structure needs to know what the photographer is prepared to reveal."[48] If the aim was "to bring the photographer together with the social scientist and historian,"[49] Stryker's means included requiring the photographers to prepare for their fieldwork through systematic, close study of local conditions: "geography, the agricultural system, the crops grown, the dominant industries, the living habits of the people."[50] This entailed two essential obligations on the part of the photographer: to prepare a "shooting script" beforehand (usually in cooperation with the Washington staff) and to accompany each print with a report and caption.

Stryker schooled his photographers in both tasks. Of key importance is the fact that the *words* of scripts and captions played a central role in shaping the preliminary file before 1942, providing the raw stuff that Vanderbilt molded into the liberal-humanist vision of the completed file. Vanderbilt's subject headings correspond roughly to the less systematic ethnographic and geopolitical categories included in Stryker's shooting scripts. After a meeting in 1936 with the sociologist Robert S. Lynd, Stryker jotted down what became the first script sent out to all his photographers:

> Home in the evening
>> Photographs showing the various ways that different income groups spend their evenings, for example:
> Informal clothes
> Listening to the radio
> Bridge
> More precise dress
> Guests.[51]

The following excerpt from a 1938 letter to Sheldon Dick before his assignment to a Pennsylvania coal town expresses more eloquently Stryker's idea of social depiction:

> The specific things I noted when I was there were that the town dropped down into a Pennsylvania mountain valley. Everywhere you look is man-made desolation, waste piles, bare hills, dirty streets. It is terribly important that you in some way try to show the town against this background of waste piles and coal tipples. In other words, it is a coal town and your pictures must tell it. It is a church dominated place. . . . The place is not prosperous, people are loafing in saloons and around the streets. You must get this feeling of unemployment. There are many unpaved streets. . . . The houses are old and rundown. The place is devoid of paint. I am sure lots of cheap liquor is consumed for no other reason than in an attempt to blot out the drabness of the place. When you are ready to shoot people try to pick up something of the feeling on the side of youth. Try to portray the hopelessness of their position . . . youth's confusions—liquor, swing, sex, and more liquor. The actual details will have to be worked out by yourself.[52]

An amalgam of social science (geography, ethnography, sociology), New Deal politics, and liberal reformism, the passage is a virtual scenario; it implies a narrative, a chapter in that master story of the "history of mankind" that Vanderbilt would inscribe as the "neutral" shape of the file. To separate the strands of social-science assumptions, political agenda, and moral attitude is impossible; all are fused indivisibly into a single vision. It is not to demean the vision or to question its sincerity or even validity as a program of representation to say that it bears the mark of cultural myth or wields the invisible power of ideology: it tells a story even before the making of the pictures.

"A 'story,'" wrote Vanderbilt, "is what any man thinks it is, in the light of his ignorance, knowledge, prejudice or imagination." It is a fabrication, something imagined, made up. The "author" of the file never wants us to forget this fundamental premise of his own construction: the role of the arbitrary at every turn. In Vanderbilt's terminology stories are "subjective," a product of "ignorance, knowledge, prejudice or imagination." Because stories might cut across all possible "objective" designations of subject, region, or photographer, better, he explained, that "story" signify "known photographer's assignments, one of the few more or less controllable factors we have."[53] Thus the lot, the basic unit of the file, consists (more or less) of pictures made on a single assignment. The system of subject classification and cross-referencing facilitates that "infinite variety" Vanderbilt imagined; the lots give us stories already constructed, from pictures made by the same photographer at a given place and time (during periods ranging from an hour or two to, more rarely, several days).

Is the master story, the universal "history of mankind," that runs through and organizes the "objective" categories also arbi-

trary, a fabrication? What role does it play in saying what kinds of stories the file makes available in its role as facilitator? The question is more easily stated than answered, more readily explored than laid to rest, but must be kept in mind.

The unity of time and place found in the microfilmed lots does not suffice as a story; we need an action, a happening in space and time, and a teller, someone responsible for the order in which the action is recounted in voice, writing, or image. In a photographic sequence of an ongoing or unfolding event, such as a baseball player rounding first base in an effort to stretch a single into a double or a presidential press conference or an assassination, the aptness of the term "story" is unmistakable: something happening, even if not particularly complex or interesting, is being reported. Pictures can infuse a dry verbal account of phases of an action with the illusion of life. Most often "story" is loosely applied to groups of photographs in the sense of "news story"—a presentation of facts regarding an event or occasion or character, but not necessarily with a distinct narrator or even a distinct plot. In many instances of static, descriptive photographs, the happening is the actual making of the photograph, which is inscribed in the image and is an essential even if hidden element in the content of any "photostory."

Like other visual forms with inscribed narratives, from carved burial urns to stained glass windows, comic strips, and movies, photographs seem to make do without an overt narrator; their fiction is that the world tells or writes about itself through images, that in photographs we see not the view of a "narrator" but the world itself—people, rocks, fences, clouds. No teller tells (or writes) these stories; they happen by themselves. Thus Steichen imitating a circus barker in *U.S. Camera:*

> "Now step up folks, and look this way!" Have a look into these faces of the men and women in these pages. Listen to the story they tell and they will leave you with a feeling of a living experience you won't forget; and the babies, and the children; weird, hungry, dirty, lovable, heart-breaking images; and then there are the fierce stories of strong, gaunt men and women in time of flood and drought. If you are the kind of rugged individualist who likes to say "Am I my brother's keeper?", don't look at these pictures—they may change your mind.[54]

Steichen's response to the Farm Security Administration photos was and is still the most common. We want to understand the source of that response: does it come from the pictures themselves or from the way in which he views them?

Steichen's way of viewing the images can be discerned in the kind of story he "hears." "Fierce stories of strong, gaunt men and women in time of flood and drought" are presumably the stories of the Depression, the monumental economic collapse and consequent social distress that constitute the major "stuff" of the FSA-OWI Collection. Steichen's response places the crises elsewhere,

somewhere we are not, yet can view, thanks to the photographs. The pictures transport us as disembodied, even voyeuristic eyes to the southern countryside and small towns, to shantytowns on the edge of California's fruit fields, to the interiors of sharecroppers' shacks and the dark doorways of the poor, to the roads trod by migrant laborers, to the dole lines with the great army of the unemployed. The photographs did not invent these unpretty scenes, but our reading of the images makes them seem *real* in this particular way. In Steichen's version the pictures are transparent communications of the story of those who suffer. The sympathy and pity and perhaps guilt we feel confirm for us that we have indeed heard a story, have had "a living experience." We ourselves, this very publication of the pictures in *U.S. Camera* assures us, are not among the afflicted; the crisis is felt only among the "lower orders," that is, the uneducated, chronically poor blacks and whites, the drifting migrant families, whom we can look "down" on in an act of self-ennoblement. The story we hear is a "pastoral," a story in which the lowly "shepherd" characters—the ignorant, dirty, and hungry but wise and just country folk—instruct us in dignity, humility, sorrow, transcendence, or whatever we clean urban people (perhaps just beginning to feel the crunch ourselves) might wish to hear from such imagined characters. We have become *their* narrators, the tellers of *their* story; that we are merely listening to a tale told by a picture is only an illusion fostered by a certain way of thinking about these pictures.

The most common way of thinking about these and any self-declared "documentary" photographs is that they are "realistic." A very loosely used term, "realism" most often means that such pictures have a strict reference to subject, time, and place and cannot legitimately be understood in any other way. Beaumont Newhall in a 1938 essay addressed the problem of how to see the images as both social science and art, as factual document and imaginative expression—the same ambiguity systematized in Vanderbilt's conception of the file. Newhall insisted that Stryker's photographers, while "never losing sight of the primary sociological purpose of their survey," nevertheless produce "photographs which deserve the consideration of all who appreciate art in its richest and fullest meaning."[55] But because of their origin as documentary, referential images, such photographs cannot be taken as pictures alone. "The photograph is not valid as a document," wrote Newhall, "until it is placed in relationship to the beholder's experience." An identifying caption naming a place and time may suffice, "but more extended captions enable the beholder to orientate himself." "A series of photographs" is even better, "the richest manner of giving photographs significance, for each picture reinforces the other."[56] Of course, true works of photographic art can stand on their own. Thus the dilemma of making "art" out of social observation remains unsolved; even as art, social documentary photographs are considered intrinsically different. Such pictures demand a "relationship to the beholder's experience" presented clearly and unambiguously.

The concept of pictorial realism provides a key to that relationship, the link between the picture and the world. As a concept realism signifies not only the appearance of actuality within a picture

but also a moral outlook. "Certainly the documentary photographer is a realist rather than an escapist by the very fact that he accepts his environment," Stryker wrote in a brief essay, "Documentary Photography," in 1939.[57] He goes on to define realism as a moral stance, "a deep respect for human beings." "The 'documentarians' differ from strictly pictorial photographers chiefly in the degree and quality of their love for life. They insist that life is so exciting that it needs no embellishment." To define a pictorial system as a function of a "love for life" may seem a confusion of genres. But few words are as tainted by promiscuous crossings of boundaries as this honorific label, realism. Stryker and Steichen both assume that the term connotes a positive, cheerful, hopeful, and uplifting view of things. "An affirmation, not a negation," as Stryker puts it, as if abstractions like goodness, dignity, and endurance rather than the particularities of time and place constituted the reality captured and classified in the FSA-OWI file as a whole. "There's honesty there, and compassion, and a natural regard for individual dignity," wrote Stryker. "These are the things that, in my opinion, give the collection its special appeal."[58] Such terms distract us from the particular to the universal; to put it strongly, they drain the image of exactly what gives it its photographic power: particularities of place and person, costume and texture, hour and minute of day or night.

Ben Shahn recalled that "we tried to present the ordinary in an extraordinary manner. . . . We just took pictures that cried out to be taken."[59] That cry belonged to the decade; a hunger for "the real thing," for the true and enduring *American* values, appeared in the arts, theater, cinema, design, fiction, popular song and dance and speech—hardly a surprising response to the often shattering breakdowns, the social and personal traumas of the period.[60] A quest for "the real" had another significance in this decade of exodus, of uprootedness and movement: it was also a quest for place, a desire for images of rooted settlements and familiar landmarks. This collective wish, if we can read retrospectively from images consumed to images desired, arose in reaction to the great changes in relation to place and to "cultural space" represented by the destruction of rural culture. If there is a great overarching theme of the FSA-OWI file, it is surely the end of rural America and its displacement by a commercial, urban culture with its marketplace relationships. Automobiles, movies, telephone poles, billboards, canned food, ready-made clothing: these familiar icons from the file bespeak a vast upheaval—Edmund Wilson called it an earthquake—a profound breach in the relation of American society to its "nature" and to the production of sustenance from the land. Throughout the file we observe the machine as the agent of change and particularly of the impoverishment of displaced, not to say annihilated, rural workers. The replacement of handmade signs by printed signs and billboards and the extrusion of handcrafts to the margin known as "folk culture" reflect deeper displacements.

Under the heading of realism the pictures are assumed to be statements already complete and self-sustaining, statements moreover of general and typical rather than particular meanings. So deeply ingrained that it seemed "natural," the theory of photo-

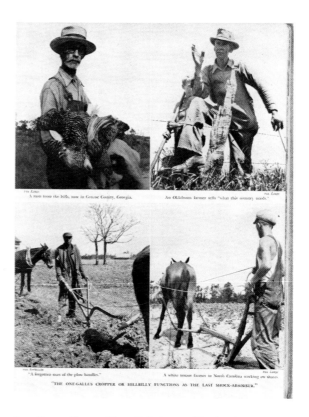

27. From Herman Clarence Nixon, *Forty Acres and Steel Mules*, 15.

graphic "realism" implied by words like "look" and "listen" hardly needed explicit statement and defense. Indeed in their sundry uses in the 1930s the Farm Security Administration pictures helped define and confirm realism as the medium's normative aesthetic standard. Through Stryker's efforts certain images appeared regularly in a variety of media—newspapers, magazines, government reports, scholarly works, exhibitions, photographic books—creating an impression of a "new FSA vocabulary in photography,"[61] a distinct mode of picture making and story telling. Whether in the press or in the newly established photographic magazines (*Life, Look, Fortune*) or in texts such as Herman Clarence Nixon's *Forty Acres and Steel Mules* (1938), the pictures are typically captioned, framed in words that focus each image on a central theme (figure 27). In the two books for which Edwin Rosskam selected and edited FSA pictures, Sherwood Anderson's *Home Town* (1940) and Richard Wright and Rosskam's *Twelve Million Black Voices* (1941), the images are embedded within a text, not as illustrations but as illuminations, pictorial correlatives, parallel visual texts (figures 28, 29). In all cases, although the images appear in groups, the burden of communication rests on the cumulative effect of *individual* images, not on interactive relations, juxtapositions, or serial progressions. The pictures are assumed to be self-explanatory, yet they are ringed and focused by words, securely held in check by a textual frame that ensures that they will be understood as "realistic."[62]

28. From Sherwood Anderson, *Home Town.*

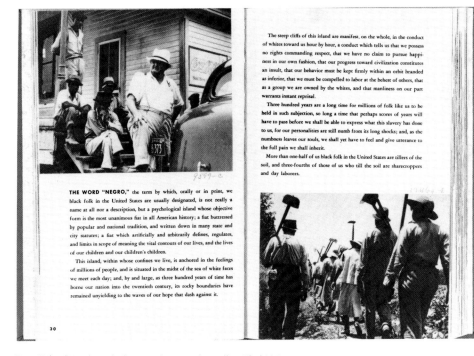

29. From Richard Wright and Edwin Rosskam, *Twelve Million Black Voices.*

Taken alone, Dorothea Lange's famous "Migrant Mother" (figure 30) is a timeless madonna. The "holy mother" theme captions the image, placing it so that we apprehend the universal in the guise of the immediate, the sacred incarnate as the humble. In the same act of recognition we note pathetic differences: a worried rather than beatific look, children clinging for protection rather than lolling in bliss. The differences produce an ironic effect: how worn and beaten, how sorrowful this holy mother, who takes upon herself the entire spiritual trauma of the times—the social destitution of the poor and outcast. If there is redemptive power here— the extraordinary fame of the image suggests so—one of its sources is the particularizing power of the camera, which makes the madonna seem a real creature of here and now, as frail against the storm as you and I. But that is as far as the "madonna" interpretation goes toward acknowledging the particularities of the image. The story proper to the actual woman and children and to the photograph itself remains outside the frame of the universal. While elevating the image to sacral heights, the abstract theme threatens to dissolve the photograph's thisness of time and place into a whatness of pious emotion. Thus "humanitarian realism" captures and binds the fleeting image to an abstraction, completes its meaning at the expense of particularity. Because we are unable or unwilling to see what is there—the blank future in the woman's squinting eyes—we confess ourselves haunted. The abstraction allays our fears and gives us "art" besides.

"Madonna of the Migrants" is one thing; the same picture set within the sequence of six exposures made by Lange on that gray afternoon near Nipomo, California, and read with Lange's own commentary in mind is quite another (see figures 1–6).[63] We can take this group as a unit in itself, several perspectives of a single scene, Lange's camera selecting and excluding details and personae as it changes position. The mother remains the central point of interest in each, but less dominating in some than in others. The group of pictures can be read also as a sequence of "trial" takes leading up to the final image, as if the setting were a studio, Lange a director seeking a certain image, a special effect—and, of course, we ourselves the narrator of the story as revealed by the sequence of images. Whether we read the group as a multiperspective account of a scene, one of whose images stands out in pictorial strength, or as a pyramidal process culminating in a masterpiece of direction and manipulation, the meaning of the madonna has been altered for us; it is no longer the Virgin in humble earthly guise but a photograph and thus capable of serving more than one meaning. The sequence compels a different view of the image, but even sequences are subject to alterability, capable of more than one reading, of telling more than one story.

There are dangers in rejecting abstract categories altogether— one is a radical nominalism that would have us attend to only the surface, to proper names, to individual life histories. This would be too unsparing, leaving us with fragments and shards. The caption "Migrant Mother" may say too much and too little about the case at hand, but the woman's proper name by itself tells us even less. We need a balance: enough categorization (such as social class) to con-

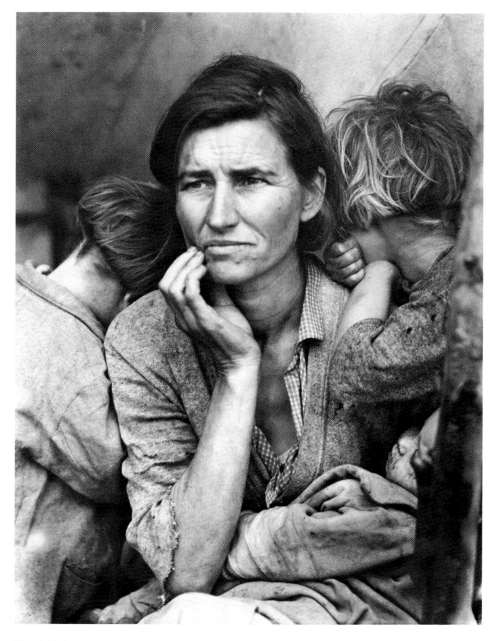

30. Migrant Mother.

nect the individual with others living the same history, yet not enough to hide the individual in a cloud of global categories. The terms "mother" and "migrant" each imply a social setting that might explicate this image in relation to others. In contrast, a different reading emerges when we see the image within a setting of other photographs made on the same occasion—in the context of a shooting sequence or assignment.[64]

The FSA-OWI photographs tell not a single "story" but a multitude of stories. Images deposited in the lots are raw material, not yet ordered, not yet inflected into distinct relationships or sequences. They await another editorial act, a more focused construction: the invention of a "story" in which each image has its say. The most telling lesson to be learned in the process of recombining and reordering images is that rather than providing objective facts of time and place, photographs place us in someone else's point of view. The series presented here, composed of the work of single photographers on specific assignments, allow us to examine and explore different perspectives. What habits and qualities of seeing account for an individual point of view? What makes one photographer's work more or less intelligent, acute, knowing, persuasive? Such differences may seem obvious in some cases—one cannot mistake a typical picture by Ben Shahn for one by Dorothea Lange—but in most cases discrimination takes careful scrutiny and judgment.

The point is simple and commonplace but still worth noting: differences in point of view, or in what is loosely called "style," produce different versions of reality. Rather than as a measure of an objective reality, indicating what exists in the world, photographs are better thought of as a means of representation. In regard to photostories, unity of place and time give us no particular assurance of the truth of time and place. Such unities are just as arbitrary as other categories. This is not to doubt "objective" reality but to say that in opening us to the world, these photographic series help us understand that what we call reality rests on certain chosen ordering principles, such as causality, chronology, similarity and difference, echo and dissonance, unfoldings and regressions. As fictions, as stories, the photoseries show us that versions of the past are indeed made up. That recognition can free us from the tyranny of any fixed version, permitting critical historical judgment.

The final danger is to see any photograph as fixed and final, either in order, meaning, or time and place. The FSA-OWI file itself seems a monumental fixity, though in the spirit of its liberalism it makes pragmatic provision for change, for construction of countless versions of the America it portrays. This fluid openness within the boundaries of its master story makes the file less a solution than an opportunity. Vanderbilt encourages us to repeat his own act of myth making, of finding or inventing lines of force and resistance, patterns of order among discrete images. The opportunity has its treacherous passages, and we need an abundance of skepticism about the order already imposed. In the end we do well to approach the file in the spirit of the impulsive woman who wished to scrawl her message across the face of Evans's Bethlehem picture. The file becomes our history only by our acting upon it, deciphering its portent in light of our own view of the times and its anguishes,

triumphs, conflicts, and resolutions. We might thereby discover a point of view, revise a received opinion. The stories presented here are exercises, in the noble sense of disciplined praxis, in making history. They point us in the right direction, toward our own innumerable everyday acts as unconscious historians. The file invites us to make such acts conscious and knowing.

NOTES

I want to thank Cynthia Ott of the Archives of American Art for her generous help; Beverly Brannan and Carl Fleischhauer for their unstinting assistance, advice, and patience; Robert Byer and Maren Stange for reading the essay and sharing their insights about the issues addressed here; and Betty Trachtenberg for the acute eye she cast upon the several versions of this essay.

1. Roy E. Stryker and Nancy Wood, *In This Proud Land: America 1935–1943 as Seen in the FSA Photographs* (Greenwich, Conn.: New York Graphic Society, 1973), 7.

2. Ibid.

3. "Standards of the Documentary File," n.d., Paul Vanderbilt Papers, Archives of American Art, Smithsonian Institution, Washington, D.C. (hereafter cited as the Vanderbilt Papers), 4.

4. Archibald MacLeish, *Land of the Free* (New York: Harcourt, Brace, 1938), 89.

5. Ibid., 83.

6. Ibid., 82.

7. T. J. Maloney, ed., *U.S. Camera 1939* (New York: William Morrow, 1938), 44.

8. Roy E. Stryker and Paul H. Johnstone, "Documentary Photographs," in *The Cultural Approach to History,* ed. Caroline F. Ware (New York: Columbia University Press, 1940), 328–29.

9. Ibid., 330.

10. Hank O'Neal, *A Vision Shared: A Classic Portrait of America and Its People, 1935–1943* (New York: St. Martin's Press, 1976), 60.

11. *Walker Evans at Work* (New York: Harper and Row, 1982), 151.

12. See William Stott, *Documentary Expression and Thirties America* (New York: Oxford University Press, 1973); Maren Stange, "'Symbols of Ideal Life': Technology, Mass Media, and the FSA Photography Project," *Prospects* 11 (1986):81–104, and *"Symbols of Ideal Life": Social Documentary Photography in America, 1890–1950* (New York: Cambridge University Press, 1988); John Tagg, "The Currency of the Photograph," in *Thinking Photography,* ed. Victor Burgin (London: Macmillan, 1982), 110–41; John D. Stoeckle and George Abbott White, *Plain Pictures of Plain Doctoring* (Cambridge: MIT Press, 1985); and Maurice Berger, *FSA: The Illiterate Eye: Photographs from the Farm Security Administration* (New York: Hunter College Art Gallery, 1985).

13. *Walker Evans* (New York: Museum of Modern Art, 1971), 143.

14. Paul Vanderbilt, "Preliminary Report on the Organization of a Master Photograph File for the Publications Section of the Office of War Information," 31 October 1942, Roy E. Stryker Papers, Archives of American Art, Smithsonian Institution, Washington, D.C. (hereafter cited as Stryker Papers), 27.

15. Paul Vanderbilt, "Computations for a Viewfinder," *Afterimage* (September 1976):12.

16. Ibid., 13.

17. [Edwin Rosskam?], "Picture Stories Available in the FSA Collection," 1 August 1939, Vanderbilt Papers.

18. Rosskam, "Memorandum to: Roy E. Stryker," 5 July 1941, Vanderbilt Papers, 1.

19. *America 1935–1946: Index to the Microfiche* (Cambridge: Chadwyck-Healey, 1981), 17.

20. Vanderbilt, "Notes on the Classification Used for the Stryker Project" (uncorrected draft), Vanderbilt Papers, 18.

21. Vanderbilt, "Preliminary Report," Stryker Papers, 13.

22. Ibid., 27.

23. Ibid., 28.

24. Ibid., 6.

25. Ibid.

26. Ibid., 5.

27. Ibid., 12.

28. Ibid., 25.

29. Ibid., 31.

30. Vanderbilt, untitled, undated memorandum, Vanderbilt Papers, n.p.; and "Memorandum on the Photography of America," 7 February 1963, Vanderbilt Papers, 2.

31. Vanderbilt, "Notes on the Classification," 13–14.

32. Stryker and Wood, *In This Proud Land,* 11.

33. Annette Melville, *Farm Security Administration, Historical Section: A Guide to Textual Records in the Library of Congress* (Washington, D.C.: Library of Congress, 1985), 11.

34. Arthur Rothstein, in Thomas H. Garver, *Just before the War* (Balboa, Cal.: Newport Harbor Art Museum, 1968), n.p.

35. John Vachon in ibid., n.p.

36. Stryker and Wood, *In This Proud Land,* 7.

37. Ibid.

38. Ibid., 15.

39. Ibid. In a review of Anderson's *Home Town* published in the 13 October 1940 issue of the New York newspaper *PM*, Evans's picture appeared over the following caption written by Ralph Steiner, editor of the newspaper's photography department: "Walker Evans likes scenes which bring back memories of the turn of the century. The empty station platform, the waiting baggage trucks, the station thermometer, the small, dead stores, the quiet knot of townspeople remind you of the town you came from or visited as a youth when the world was slower, safer, more peaceful. This is just the sort of place where the evening diversion was to go down to the tracks and watch the 'flyer' go through. Today many a small town looks about the way it did in '99. Had Evans taken more photographs he would have shown how the town has changed."

40. Garver, *Just before the War,* n.p.

41. *Walker Evans at Work,* 112.

42. Walker Evans, "The Reappearance of Photography," *Hound & Horn* 5 (October–December 1931): 124–28.

43. *Walker Evans at Work,* 98.

44. Ibid.

45. Ibid., 112.

46. F. Jack Hurley, *Portrait of a Decade: Roy Stryker and the Development of Documentary Photography in the Thirties* (Baton Rouge: Louisiana State University Press, 1972), 13–15; Stange, *"Symbols of Ideal Life": Social Documentary Photography in America, 1890–1950,* chap. 3.

47. Roy E. Stryker, "Conference on Photography, Biltmore Hotel, New York City, 9 February 1940," Vanderbilt Papers, 2.

48. [Roy E. Stryker], "The Photographer and the Focus of Attention," n.d., Vanderbilt Papers, 1.

49. Ibid., 2.

50. Stryker, "Conference on Photography" 2.

51. Stryker and Wood, *In This Proud Land,* 187.
52. Stryker to Dick, 17 October 1938, Vanderbilt Papers.
53. Vanderbilt, "Preliminary Report," Stryker Papers, 13.
54. Edward Steichen, "The F.S.A. Photographers," in *U.S. Camera 1939,* ed. T. J. Maloney (New York: William Morrow, 1938), 44.
55. Beaumont Newhall, "Documentary Approach to Photography," *Parnassus,* March 1938.
56. Ibid., 6.
57. Roy E. Stryker, "Documentary Photography," in vol. 7 of *The Encyclopedia of Photography,* ed. Willard D. Morgan (New York: Greystone Press, 1971), 1179–83.
58. Stryker and Wood, *In This Proud Land,* 7.
59. Quoted in Davis Pratt, ed., *The Photographic Eye of Ben Shahn* (Cambridge: Harvard University Press, 1975), x.
60. See especially Warren I. Susman, *Culture as History: The Transformation of American Society in the Twentieth Century* (New York: Pantheon Books, 1984), chaps. 9–11.
61. Grace M. Mayer, introductory note to *The Bitter Years, 1935–1941,* ed. Edward Steichen (New York: Museum of Modern Art, 1962), vi.
62. The notable exception to this prevailing practice was Walker Evans, *American Photographs* (New York: Museum of Modern Art, 1938). See Alan Trachtenberg, "Walker Evans' America: A Documentary Invention," in *Observations: Essays on Documentary Photography,* ed. David Featherstone (Carmel, Cal.: Friends of Photography, 1984), 55–66. While Evans's photographs accompanying James Agee's text in *Let Us Now Praise Famous Men* (Boston: Houghton Mifflin, 1941) do obey a rough unity of time and place, they are presented as a portfolio in their own right, free of any verbal text or caption.
63. Dorothea Lange, "The Assignment I'll Never Forget: Migrant Mother," *Popular Photography* 46, no. 2 (February 1960):42–43, 126.
64. See James C. Curtis, "Dorothea Lange, Migrant Mother, and the Culture of the Great Depression," *Winterthur Portfolio* 21, no. 1 (Spring 1986):1–20.

C O T T O N P I C K E R S

BEN SHAHN

Pulaski County, Arkansas, October 1935
Resettlement Administration, Lot 1657

Ben Shahn made two important contributions to the newly formed Historical Section in 1935. First, of course, were the photographs he himself added to the agency's file. The portion dating from 1935 is small—less than 2 percent of the eight-year accumulation—but about one-third of those early images are Shahn's. And second, his counsel, along with that of several colleagues at the Resettlement Administration, helped Roy Stryker clarify his mission.[1] Shahn's sophistication as a painter and printmaker and his keenly felt moral sensibility influenced the running dialogue he had with Stryker. Once, Shahn recalled in 1964, he had explained to Stryker that a certain photograph of soil erosion would not strongly affect viewers. "Look Roy," Shahn had said, "you're not going to move anybody with this eroded soil—but the effect this eroded soil has on a kid who looks starved, this is going to move people."[2]

Born in Lithuania in 1898, Ben Shahn immigrated to New York City with his family at the age of six.[3] He was apprenticed to a commercial lithographer in 1911 and earned his living in the trade until the early 1930s, when he began to receive recognition as a fine artist. In 1934, after exhibitions of his series of paintings about the Dreyfus and Sacco-Vanzetti affairs, he was commissioned to produce a mural by the Federal Emergency Relief Administration. The following year Rexford Tugwell invited Shahn to join the Resettlement Administration. He worked as an artist in the agency's Special Skills Division and was an unofficial, part-time member of Stryker's photographic section. Shahn later told his biographer Selden Rodman that his chief duty was "to explain in posters to the people who need it what is being done for them and to the others what they are paying for."[4]

For a while Shahn had shared a Manhattan studio with the photographer Walker Evans. In 1933, when Shahn's younger brother

76

paid off a wager with a Leica camera, the painter turned to Evans for instruction in its use. Shahn recalled that the first lesson was delivered as Evans dashed out the door on his way to a photographic assignment and consisted of the shouted instruction, "f9 for the bright side of the street, f4.5 for the shady side!"[5] He received more lessons from Evans in the Cape Cod community of Truro where they spent their summers, but he never attempted to master the meticulous, view-camera approach Evans favored.

Shahn's casual attitude about matters of photographic technique stemmed from his use of photographs as a basis for drawings and paintings. He tended to think of his compact 35-mm Leica as a mechanical sketch pad. Although some of his Resettlement Administration photographs were exhibited as early as 1936, Shahn continued to insist that they "weren't just photographs to me: in a real sense they were the raw materials of painting."[6] His drawings and paintings from the period include elements from his photographs, and at least two include self-portraits of Shahn holding a Leica with a right-angle viewfinder, a device that permits the photographer to face in one direction while pointing the camera in another.[7]

The photographs presented here have been drawn from the body of work Shahn produced during a two- or three-month trip through the South and the Midwest in the fall of 1935. He and his wife, the artist Bernarda Bryson, made the trek in Shahn's Model A. The Special Skills Division paid the travel costs, but Stryker encouraged Shahn to take photographs and furnished film and laboratory services. Shahn described the trip to an interviewer in 1964:

> It was suggested that I first take a trip around the country in the areas in which [the Resettlement Administration] worked—to see what it was all about. And I tell you that was a revelation to me. My experience had been all European. I had been in Europe for four years. I studied there, and my knowledge of the United States came via New York and mostly through Union Square.[8]

The file contains 123 photographs from the Arkansas portion of the trip, ranging from urban scenes in West Memphis to images of mountaineers in the Ozarks. The 15 photographs presented here have been selected from two groups made in Pulaski County: a group of 28 photographs depicting cotton pickers at work—most appear to have been made on the Alexander plantation near Scott— and a group of 19 pictures made on a Sunday in a sharecroppers' community in or near Little Rock. The photograph of the four pickers along the road at day's end was selected from the collection's killed negatives.[9] Shahn's photographs have something of the quality of sketches. The plane of focus is not always on the subject of greatest interest, shadows or objects occasionally obscure important pictorial elements, and some images have been framed in a loose or imprecise way, reflecting Shahn's view of his photographs as instrumental and his belief that content was more important than form or technique. His praise for the photographs of Henri Cartier-Bresson may be read as stating his own goals. "The thing that makes them memorable is their content," Shahn said. "To me,

[Cartier-Bresson] is supremely the artist when he is looking for his subject. The rest is mechanical. The feeling for the subject and the ability to know just when to press the shutter—that is not mechanical."[10]

The photographs show how Shahn moved through and around the scene as he made a set of exposures. At the building where the pickers congregated at the start of the day, for example, the overall coverage includes a wide-perspective establishing shot, medium shots of little groups of pickers, and a near close-up of a man sitting on the stoop. This use of motion picture terminology would be agreeable to Shahn, who once likened his photography of a country auction to the creation of a movie script. "I'd first go out and photograph all the signs on the telegraph poles," Shahn said, "and then get the people gathering, and all kinds of details of them, and then examine the things, and the auctioneer, and so forth."[11] Shahn may have used his right-angle viewfinder when he photographed this series; if so, his facing in another direction did not keep the nursing mother from fixing him with a penetrating stare.

Shahn set off with neither a specific photographic assignment nor a social-science lesson from Stryker, who typically wanted his photographers to be well informed about their subject matter and the agency's policies and activities. There would have been plenty for Stryker and Shahn to discuss concerning cotton and Arkansas. Beginning in 1933 the Agricultural Adjustment Administration had tried to counteract a badly depressed cotton market by paying planters not to grow the commodity. This federal program benefited large landowners but displaced small farmers, tenants, sharecroppers, and farm laborers, forcing many of them to take less secure and lower-paying work as wage hands. No state suffered more than Arkansas, where by the spring of 1935 conditions were so bad that the newly formed Southern Tenant Farmers Union called a strike. The entire issue focused attention on the need for rural assistance and rehabilitation, contributing in an important way to Roosevelt's establishment of the Resettlement Administration.[12]

Shahn, no doubt aware of the controversy over cotton policy even if he was unfamiliar with its details, would certainly have been conscious of the association between the crop and the blacks who had worked it since the time of slavery. Remarks he made years later suggest that although he was drawn toward general social and political issues, he was indifferent to the intricacies of agricultural policy and the Resettlement Administration's programs. In a 1944 interview Shahn described the Resettlement Administration and Farm Security Administration undertakings as "helping the underprivileged" and as having "only one purpose—a moral one."[13] The photographs of the cotton pickers can serve as a report on the effects of an economic system just as the picture of a starving child can be read as showing the end result of soil erosion. In 1957 Shahn reflected on the lessons he had learned about the diversity of individuals and the complexity of regional differences:

I had then [in the late 1930s] crossed and recrossed many sections of the country, and had come to know well so many people of all

kinds of belief and temperament, which they maintained with a transcendent indifference to their lot in life. Theories had melted before such experience. My own painting then had turned from what is called "social realism" into a sort of personal realism. . . . There were the poor who were rich in spirit, and the rich who were also sometimes rich in spirit. There was the South and its storytelling art, stories of snakes and storms and haunted houses, enchanting; and yet such talent thriving in the same human shell with hopeless prejudices, bigotry, and ignorance.[14]

Shahn's concern was for the individual—who was also the chief focus of Resettlement Administration and Farm Security Administration programs. The essential significance of these programs resided, the historian Sidney Baldwin has written, not in their effect on the agricultural marketplace but rather "in the human condition of the people served and on the lives of the rural communities in which they operated."[15] Thus the spirit of Ben Shahn's photographs perfectly fits the spirit of the agency.

NOTES

1. F. Jack Hurley, *Portrait of a Decade: Roy Stryker and the Development of Documentary Photography in the Thirties* (Baton Rouge: Louisiana State University Press, 1972), 36–54.
2. From an interview with Shahn conducted by Richard Doud, 14 April 1964, quoted in Hurley, *Portrait of a Decade*, 50.
3. Biographical information from Bernarda Bryson Shahn, *Ben Shahn* (New York: Harry N. Abrams, 1972), 345–47.
4. Selden Rodman, *Portrait of the Artist as an American* (New York: Harper and Brothers, 1951), 89.
5. Ibid., 90.
6. Ibid., 91.
7. Ibid., xv, 78.
8. From an interview with Shahn conducted by Richard Doud, 14 April 1964, quoted in John D. Morse, ed., *Ben Shahn* (New York: Praeger Publishers, 1972), 135–36.
9. Some of the killed negatives from Shahn's trip have holes punched in them, but others, like this one, do not.
10. From an interview by John D. Morse, "Henri Cartier-Bresson," in the *Magazine of Art*, May 1947, quoted in Morse, *Ben Shahn*, 134.
11. From an interview by Richard Doud, 14 April 1964, quoted in *The Photographic Eye of Ben Shahn*, ed. Davis Pratt (Cambridge: Harvard University Press, 1975), x.
12. The policy matters alluded to here are discussed in Pete Daniel, *Breaking the Land* (Urbana: University of Illinois Press, 1985); Sidney Baldwin, *Poverty and Politics* (Chapel Hill: University of North Carolina Press, 1968); and Stephen F. Strausberg, "The Effectiveness of the New Deal in Arkansas," in *The Depression in the Southwest*, ed. Donald W. Whisenhunt (Port Washington, N.Y.: Kennikat Press, 1980), 102–16.
13. From John D. Morse, "Ben Shahn: An Interview," in the *Magazine of Art*, April 1944, quoted in Morse, *Ben Shahn*, 133.
14. Ben Shahn, *The Shape of Content* (1957; reprint, New York: Vintage Books, 1969), 47–48.
15. Baldwin, *Poverty and Politics*, 263.

a

b

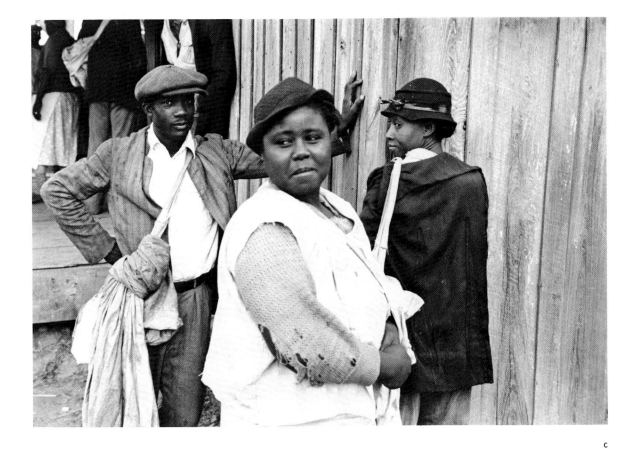

c

a. Cotton pickers on the Alexander plantation at 6:30 A.M., waiting for the workday to start.

b. Cotton picker.

c. Cotton pickers.

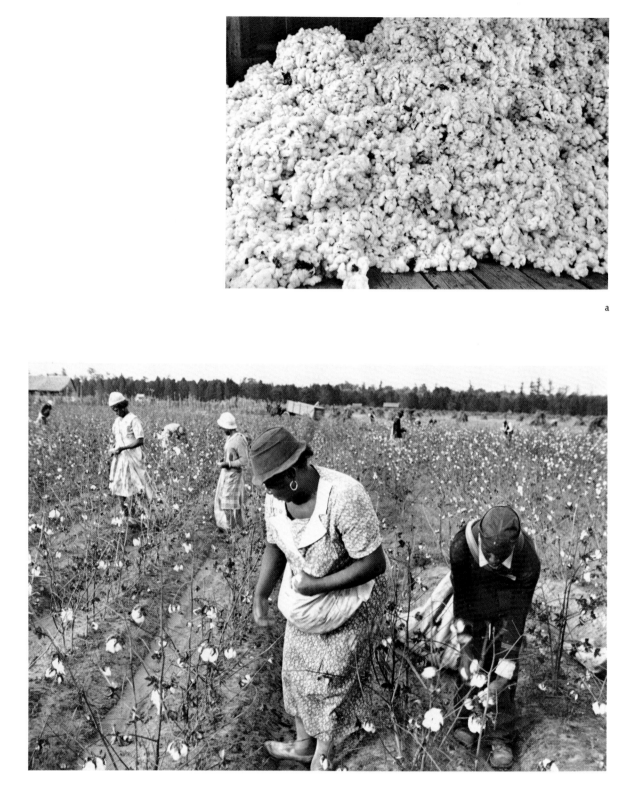

a

b

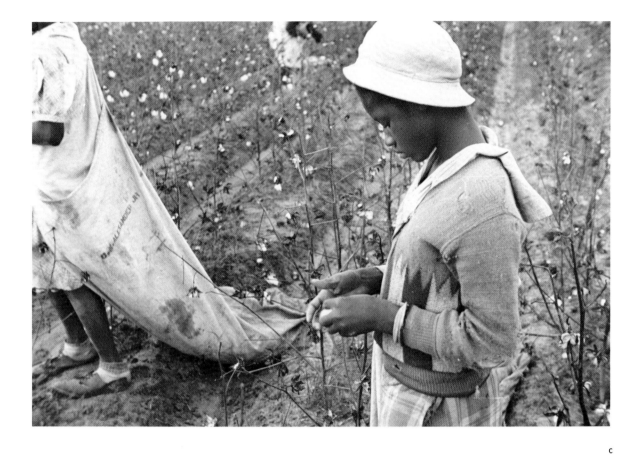

c

a. Cotton on the porch of a sharecropper's home on the Maria plantation.

b. Picking cotton on the Alexander plantation.

c. Cotton picker.

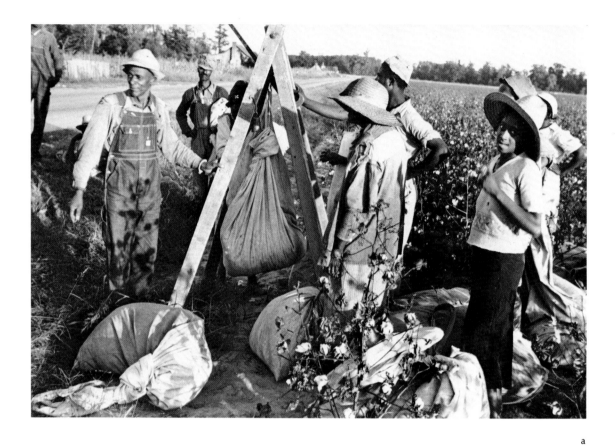

a

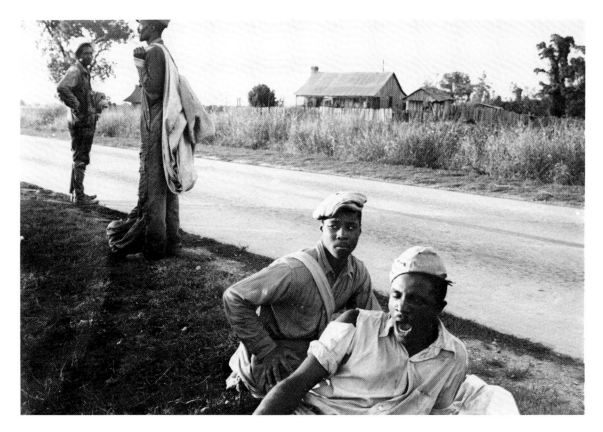

b

a. Weighing in cotton.

b. At the end of the day.

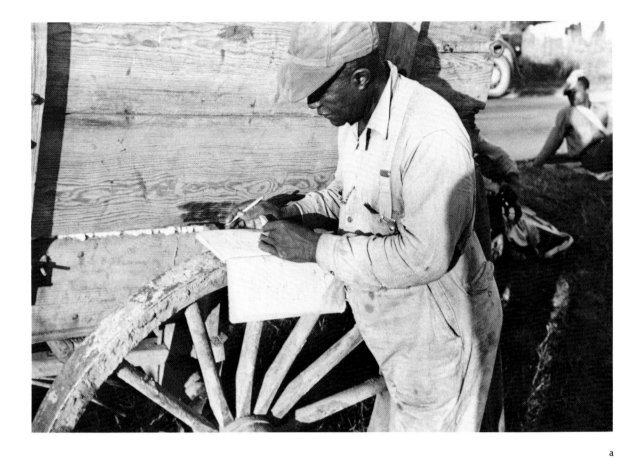

a

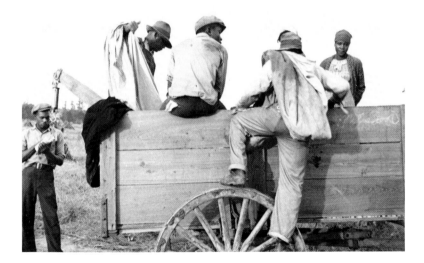

b

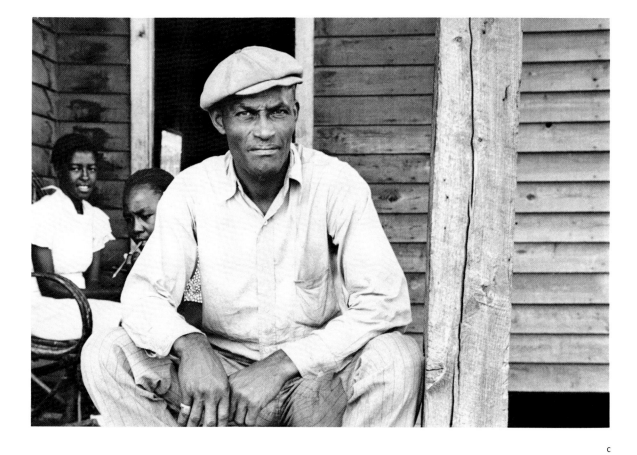

c

a. Tally at the weigh station.

b. Going home.

c. Sharecropper at home on Sunday.

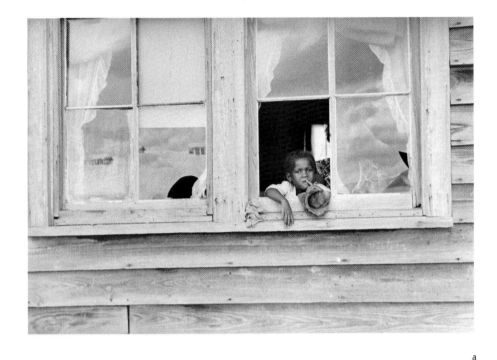

a

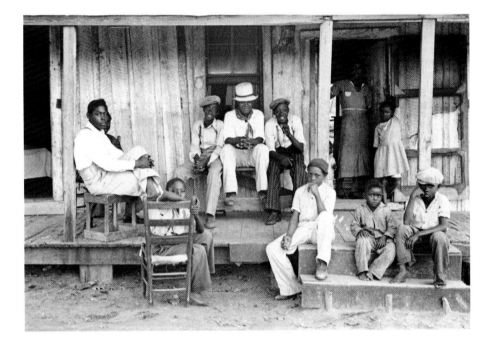

b

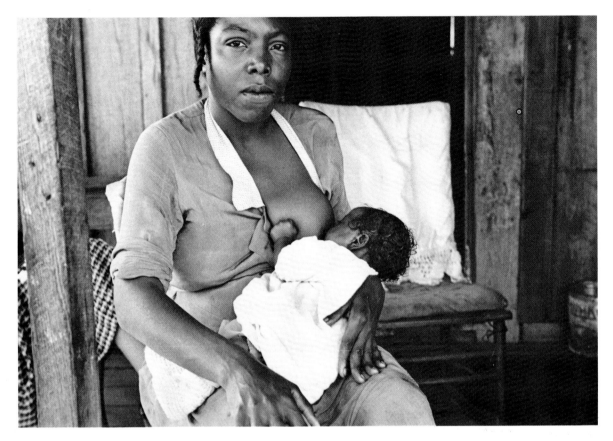

c

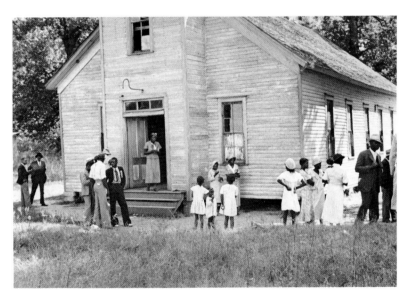

a. At home.

b. Sunday on the porch.

c. Mother and child.

d. After church.

d

O M A H A

JOHN VACHON

Omaha, Nebraska, November 1938
Farm Security Administration, Lot 412

John Vachon's first job at the Farm Security Administration carried the title "assistant messenger." He was twenty-one and had come to Washington, D.C., from his native Minnesota to attend Catholic University of America. Vachon had no intention of becoming a photographer when he took the position in 1936, but as his responsibilities increased for maintaining the FSA photographic file, his interest in photography grew. A memoir by his son quotes Roy Stryker as telling the file clerk, "When you do the filing, why don't you *look* at the pictures." [1]

By 1937 Vachon had looked enough to want to make photographs himself, and with advice from Ben Shahn he tried out a Leica in and around Washington. His weekend photographs of "everything in the Potomac River valley" were clearly the work of a beginner, but Stryker lent him equipment and encouraged him to keep at it. [2] Vachon received help as well from Walker Evans, who insisted that he master the view camera, and Arthur Rothstein, who took him along on a photographic assignment to the mountains of Virginia. In October and November 1938 Vachon traveled to Nebraska on his first extensive solo trip. He photographed agricultural programs on behalf of the FSA's regional office and pursued an extra assignment from Stryker: the city of Omaha. [3]

Stryker's instructions about what to photograph seem not to have been very detailed. Years later Vachon recalled that "my only clue was an article in a recent *Harper's* by George Leighton," a reference to a politically charged item in the magazine by the periodical's associate editor. [4] The 1938 article traced the development of the Union Pacific and other railroads—for which Omaha was an important center—and the political machinations that made their builders millionaires. It also described Omaha's stockyards, owned by Chicagoans Swift, Cudahy, and Armour; the failed attempts of

regional reformist and populist movements; a riot and the lynching of a black man; the nefarious influence of the absentee-owned Nebraska Power Company; and two infamous streetcar employees' strikes that had been put down by thugs from Benjamin Danbaum's detective service. Although Leighton ended his story with Depression hard times and the collapse of the city's businesses, his conclusion was optimistic: the New Deal's farm, soil, water, and power projects would bring hope to the parched plains.

Leighton planned to publish a book containing this article and similar social histories of four other American cities, and Stryker wanted the book to be illustrated with Farm Security Administration photographs. As Vachon was leaving Lincoln for Omaha, he wrote Stryker, "Are you going to send me a list of definite things Leighton would like from Omaha?"[5] In a 1973 interview Vachon recalled the Omaha assignment as a moment of artistic maturation:

> I spent a cold November week in Omaha and walked a hundred miles. Was it Kearney Street where unemployed men sat all day on the steps of cheap hotels? A tattoo parlor, and the city mission with its soup kitchen. Men hanging around the stockyards. One morning I photographed a grain elevator: pure sun-brushed silo columns of cement rising from behind a CB&Q freight car. The genius of Walker Evans and Charles Sheeler welded into one supreme photographic statement, I told myself. Then it occurred to me that it was I who was looking at the grain elevator. For the past year I had been sedulously aping the masters. And in Omaha I realized that I had developed my own style with the camera. I knew that I would photograph only what pleased me or astonished my eye, and only in the way I saw it.[6]

Vachon's Omaha take added 208 photographs to the file. The pictures suggest an act of exploration; looking at them, it is easy to imagine a young photographer under multiple influences—wanting to illustrate Leighton's article, responding to Stryker's standing order for general-interest photographs, and seeking his own voice as an artist. The following year Edward Steichen selected Vachon's signature photograph of the freight car and silos for a photographic annual.[7]

When Leighton's book was published in 1939, only five of Vachon's photographs were used.[8] The volume is not heavily illustrated to begin with, but it is also true that Vachon's pictures do not offer perfect illustrations for the text. Leighton's scenes were set in the past, and many of their subjects—human and architectural—were no longer available to Vachon's camera. And Leighton's article is a single-minded chronicle of moral decay and economic collapse. While some of Vachon's images express these themes, others do not. His photographs of people, for example, include both portraits of Depression victims and scenes of comfortable everyday life. Vachon's notes for the caption of one of the photographs included here underscore the straitened circumstances of two transients he photographed on lower Douglas Street. "These men are both past 60," he wrote. "Neither of them expects to ever work

again. They ride freight trains from Omaha to Kansas City to St. Louis and back again."[9] But in other photographs kindly looking housewives tend their flowers or chat with the mailman.

The photographs that represent Leighton's ruling class do not contain clear-cut indictments of the forces of capitalism. Vachon's pictures of the former homes of the robber barons tell us more about wealth's mutability than about its venality. To make the photograph of a run-down mansion suit the tone of the book, Leighton added a lengthy caption that derided former owner John A. Creighton for installing a "liquoratory" and reported that the structure had become a boardinghouse. Two of Vachon's photographs juxtapose rows of small workers' houses with a billboard and a power plant that represent the absentee-owned Nebraska Power Company. The images succeed as descriptions of vernacular architecture but fail as statements of economic cause and effect. Although Vachon photographed a streetcar motorman, nothing in the picture suggests the long and difficult strike; only the photograph of strikebreaker Danbaum's detective van contains a hint of menace.

The Omaha in Vachon's photographs is more varied and complex than the one in Leighton's text, but the photographer's broad coverage may in fact have been inspired by the attention the writer paid to the many levels of the city's society. Vachon's survey of architecture, ethnic signs, and downtown street scenes provides a cross section of the city. But Vachon's curiosity about how things look outstripped his intellectual involvement in history and sociology. His images of the ebb and flow of life on disorderly city streets anticipate the postwar generation of "street photographers," whose most famous exponent is Robert Frank.

The hallmark of this style of photography is the portrayal of people and places encountered on the street, unembellished by the beautifying contrivances used by calendar and public relations photographers. One influence on both Vachon and Frank was Walker Evans. The critic Jonathan Green's description of Evans's and Frank's choice of subject matter as what was "considered beneath notice" applies to Vachon as well: "images of the roadside, automobiles, gasoline stations, American flags in out-of-the-way places, barbershops, bums, billboards, luncheonettes, political posters, public monuments, and cemeteries."[10]

Vachon's pictures of Omaha's streets offer a personal vision of an imperfect world, and they pass the test he posed for himself when he first arrived in Nebraska. "Omaha looked swell this morning out the train window," he wrote Stryker two or three weeks before he returned to photograph the city. "Very unspectacular, and ordinary looking, but definitely camera-challenging."[11]

NOTES

1. Brian Vachon, "John Vachon: A Remembrance," in *American Photographer* 3, no. 4 (October 1979): 36.
2. Anne Hull, "John Vachon, Noted Cameraman, Departs," *Greenbelt [Maryland] Cooperator* 8, no. 8 (8 October 1943): 1–2.
3. John Vachon, "Tribute to a Man, an Era, an Art," *Harper's*, September 1973, 96–99.
4. Vachon, "Tribute to a Man," 98; and George R. Leighton, "Omaha, Nebraska," *Harper's*, July 1938, 113–14, 320–28.

5. Vachon to Stryker, [October 1938], Roy E. Stryker Papers, Photographic Archives, University of Louisville, Louisville, Ky., hereafter cited as the Stryker Collection.

6. Vachon, "Tribute to a Man," 98. The street with cheap hotels was Douglas Street, and the railroad car was from the Chicago Great Western (CGW) line.

7. T. J. Maloney, ed., *U.S. Camera 1940* (New York: Random House, 1939), 197.

8. George R. Leighton, "Omaha, Nebraska: The Glory Has Departed," in *Five Cities: The Story of Their Youth and Old Age* (New York: Harper and Brothers, 1939), 140–236; Vachon's photographs appear on 151, 198, 199, 215, and 216.

9. File caption for negative LC-USF34-8859-D.

10. Jonathan Green, *American Photography: A Critical History, 1945 to the Present* (New York: Harry N. Abrams, 1984), 82.

11. Vachon to Stryker, 12 October 1938, Stryker Collection.

a

b

c

a. "Nebraska is the white spot of the nation: no luxury tax, no bonded debt, highways all
 paid for . . ."

b. At the Armistice Day parade.

c. Cars and parking meters.

a

b

c

a. Newsstand.

b. On a streetcar.

c. Danbaum armored car.

a

a. Oak bar from a more prosperous era.

b. Flophouse on lower Douglas Street.

b

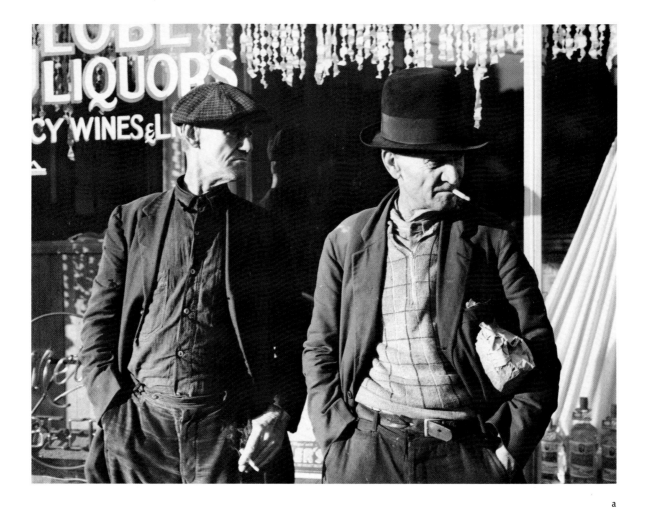

a

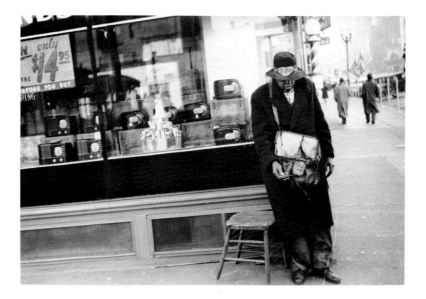

b

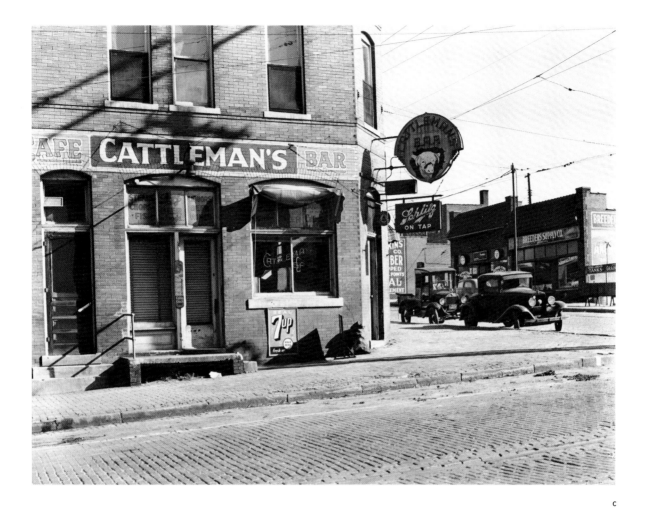

a. Unemployed men who ride the freight trains from Omaha to Kansas City and St. Louis and back.

b. Blind beggar.

c. Saloon in the stockyard district.

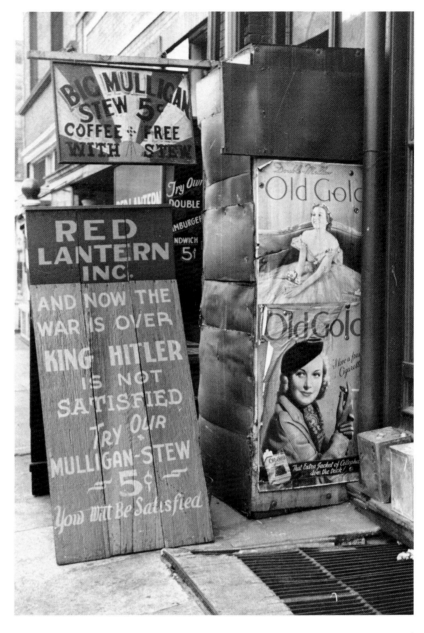

a. Restaurant sign.

b. High school student's car.

c. In the wholesale district.

b

c

a

b

c

d

a. Boxcar and grain elevators.

b. Stockyard salesman and buyers.

c. Houses near the Nebraska Power Company plant.

d. Rooming house window.

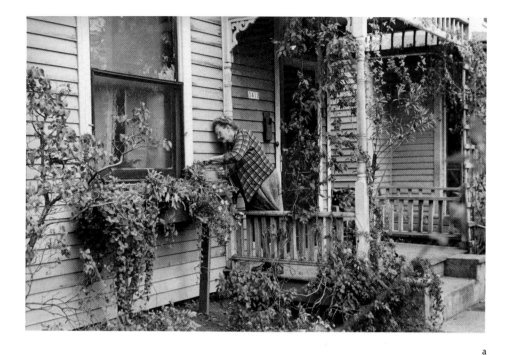

a

b

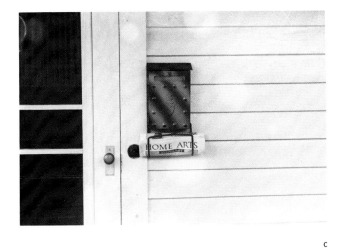

a. Tending the flowers.

b. Mail delivery.

c. Mailbox.

d. Public Works Administration housing.

c

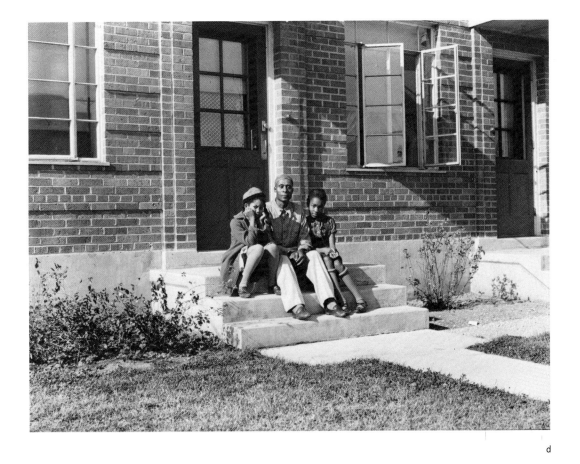

d

a

a. House and fence with graffiti.

b. Rooming house, formerly the home of the Creighton family.

c. Election campaign signs.

b

c

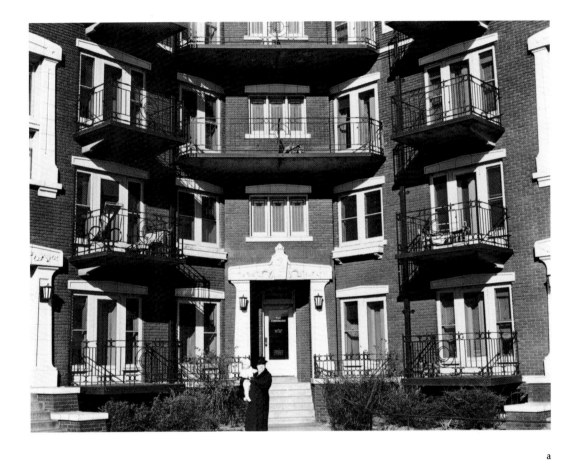

a

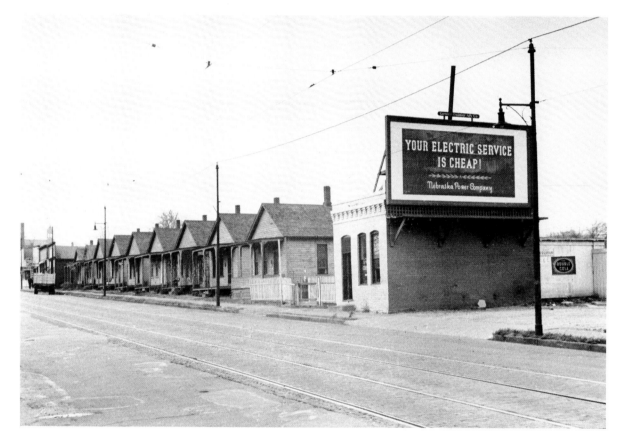

b

a. The Coronado Apartments.

b. In the Italian district.

a

a. Backyard and Roman Catholic church.

b. Omaha.

b

M I G R A N T W O R K E R S

DOROTHEA LANGE

Imperial Valley, California, February and March 1937
Resettlement Administration, Lot 345

Dorothea Lange was born in Hoboken, New Jersey, in 1895 and studied photography in New York City before the First World War. In 1919 she moved to San Francisco, where she earned her living as a portrait photographer for more than a decade. During the Depression's early years Lange's interest in social issues grew, and she began to photograph the city's dispossessed. A 1934 exhibition of these photographs introduced her to Paul Taylor, an associate professor of economics at the University of California at Berkeley, and in February 1935 the couple together documented migrant farm workers in Nipomo and the Imperial Valley for the California State Emergency Relief Administration.

Copies of the reports Lange and Taylor produced reached Roy Stryker, who offered Lange a job with the Resettlement Administration in August 1935.[1] Unlike the agency's other photographers, Lange did not move to Washington but used her Berkeley home as a base of operations.[2] She and Taylor were married that winter.

Lange returned to the Imperial Valley in early 1937 for the Resettlement Administration. The valley was in a state of crisis, and on February 16 Lange reported the situation to Stryker:

> I was forced to switch from Nipomo to the Imperial Valley because of the conditions there. They have always been notoriously bad as you know and what goes on in the Imperial is beyond belief. The Imperial Valley has a social structure all its own and partly because of its isolation in the state those in control get away with it. But this year's freeze practically wiped out the crop and what it didn't kill is delayed—in the meanwhile, because of the warm, no rain climate and possibilities for work the region is swamped with homeless moving families. The relief association offices are open day and night 24 hours. The people continue to pour in and there is no way to stop them and no work when they get there.[3]

114

As many as six thousand migrants arrived in California from the Midwest every month, driven by unemployment, drought, and the loss of farm tenancy. In *An American Exodus,* which he co-authored with Lange, Taylor wrote that the Okies and Arkies had "been scattered like the shavings from a clean-cutting plane." Many drifted to the Imperial Valley after the completion of Boulder (Hoover) Dam in 1936, which guaranteed the valley a supply of water for irrigation. But the migrants, who competed with Mexicans and other immigrants for work, were offered "not land, but jobs on the land."[4] The land was held by relatively few owners. In 1935 one-third of the farm acreage in the six hundred square miles of the Imperial Valley consisted of operations in excess of five hundred acres; seventy-four individuals and companies controlled much of the cropland.[5]

In his biography of Lange, Milton Meltzer includes a marvelous account of Lange's trip. He reports that shortages of funds had led Stryker to lay off the photographer in October 1936. After two months of anxiety for them both, Stryker was able to rehire Lange in late January 1937; the photographer and her friend Ron Partridge set out for the valley the day after Stryker approved the trip. Long, exhausting days of photography were followed by overnight stays in rickety tourist courts paid for by Lange's four-dollar-per-diem maintenance allowance. Partridge has described how Lange worked:

> She would walk through the field and talk to people, asking simple questions—what are you picking? . . . How long have you been here? When do you eat lunch? . . . I'd like to photograph you, she'd say, and by now it would be "Sure, why not," and they would pose a little, but she would sort of ignore it, walk around until they forgot us and were back at work.[6]

In the file Lange's ninety-seven Imperial Valley photographs from 1937 are integrated with more than one hundred other images of California migrants she made that year. Some of her Imperial Valley photographs document conditions: the makeshift camps on the banks of irrigation ditches, the use of irrigation water for cooking and washing, the crowds at the relief offices, and, when work was available, the stoop labor. Her photography was not limited to Okies and Arkies, for she also photographed the camps occupied by Mexican laborers, a Japanese-owned farm, and Filipinos picking lettuce.

The most poignant and moving photographs from Lange's trip convey a mood rather than describe circumstances or activities: the man hunkered at the edge of the field, the mother and child in the tent opening, and the trio of men, one of whom casts a defiant glance at the photographer. The photographs are character studies that render the textures of skin and clothing with an artist's eye and depict posture, gesture, and gaze with an ethnologist's. But their subjects are anonymous, and the pictures become genre studies: "the pea picker" or "the jobless man on relief."

Lange's photographs were intended to bolster support for the establishment of migrant camps in the area by the Resettlement

Administration. On 12 March, five days after she returned home, Lange wrote Stryker that her "negatives are loaded with ammunition." She added that the situation was "no longer a publicity campaign for migratory agricultural labor camps" but rather "a major migration of people and a rotten mess."[7]

Much of Lange's correspondence with Stryker during this period concerns the distribution of prints of these photographs. She saw an immediate need for pictures by the agencies endeavoring to help the migrants and received permission to supply prints to the head of the state emergency relief office in the Imperial Valley and to the Resettlement Administration's regional office.[8] She also wanted to supply photographs to a variety of other organizations, and between 1937 and 1940 the pictures were used in a report to the U.S. Senate, in *An American Exodus*, for a Works Progress Administration exhibit in San Francisco, and by a number of newspapers and periodicals.[9]

Both Stryker and Lange were keen to place a story about migrants in *Life* magazine, but disagreements about who would edit and submit material muddled the process. In December 1936 Stryker found himself debating with his boss whether the agency or the photographer should submit the story and whether the agency should approve the final text and layout.[10] The same issue also emerges in the correspondence between Lange and Stryker. On 16 February 1937, as she set out for the valley, Lange wrote that she had contacted *Life* about the story and that she wanted to send them "some of this new Imperial stuff to choose from, if they decide to run the series."[11] Stryker replied that "LIFE is terribly interested in a migrant lay-out, but we are holding everything up now, awaiting the new migrant stuff you can send us."[12] Ten days later Lange asked, "Do you want me to do this story for Life, or shall I send on the material with factual captions, place, date, etc.—for assemblage elsewhere?"[13]

In the end Lange herself compiled the story, informing Stryker that she would limit the pictures to ones made in California and explaining that this would make "a more pointed story" than a series of pictures from across the nation.[14] Lange submitted twenty-five pictures on the theme of human erosion, but Stryker had separately sent *Life* the set of pictures from the Senate report, instructing them not to use any photographs until the report had been published.[15]

Only one of Lange's photographs of migrants ultimately appeared in *Life*. At the end of a six-page spread on the Dust Bowl in the issue dated 21 June 1937, following an optimistic look at new farming practices designed to reduce erosion, the magazine displayed a striking full-page close-up of the man with the defiant glance, cropped from the center of the four-by-five-inch negative.[16] Lange was not credited, although the agency was. *Life* did not present the unidentified man as a victim of human erosion but called him a "new pioneer" seeking a new life in California. According to *Life*, his "courageous philosophy" led him to say, "I heerd about this here irrigation. . . . I figured that in a place where some people can make a good livin' I can make me a livin'."[17]

In a 1964 interview conducted by Richard Doud, Lange discounted the contemporary impact of the Resettlement Administra-

tion and Farm Security Administration photographs, forgetting for a moment that her own pictures had influenced public opinion and government policy. *Life*'s use of her Imperial Valley photograph may have contributed to her bleak assessment that "during the years [the section] was being formed, it was not a [public relations] success." Recalling Stryker's encounters with major magazines, she asked, "Did Roy ever tell you of the many, many trips he made to New York, with pictures under his arm, trying to peddle them to periodicals and to publications, and didn't make it? . . . That's a little bit humiliating, and embarrassing to him."[18]

The picture magazines were reluctant to use the Resettlement Administration and Farm Security Administration photographs, Lange speculated, because of the media's emphasis on current events. The photographs "got mixed up with news," Lange told Doud, adding, "This was a state and a condition we were describing, and had no appeal." She concluded, however, that the judgment of history has established the importance of the photographs. "But time of course is a very great editor, and a great publicist," Lange said. "Time has given those things the value."[19]

NOTES

1. Copies of the reports are in lots 897 and 898, Prints and Photographs Division, Library of Congress.
2. Much of the information in this text is from Karin Becker Ohrn, *Dorothea Lange and the Documentary Tradition* (Baton Rouge: Louisiana State University Press, 1980), 38–49; Milton Meltzer, *Dorothea Lange: A Photographer's Life* (New York: Farrar, Straus and Giroux, 1978), 126–29; and an interview with Dorothea Lange by Richard Doud, 22 May 1964, Archives of American Art, Smithsonian Institution.
3. Lange to Stryker, 16 February 1937, Stryker Collection.
4. Paul S. Taylor and Dorothea Lange, *An American Exodus: A Record of Human Erosion* (New York: Reynal and Hitchcock, 1939; rev. ed., New Haven: Yale University Press, 1969; reprint, New York: Arno Press, 1975), 145, 148.
5. Federal Writers' Project, *California: A Guide to the Golden State* (New York: Hastings House, 1939), 639–40.
6. Meltzer, *Dorothea Lange: A Photographer's Life*, 163–70.
7. Lange to Stryker, 12 March 1937, Stryker Collection.
8. Ibid.
9. Meltzer, *Dorothea Lange: A Photographer's Life*, 166–69. Clippings from serials may be found in the Supplementary Reference files and agency scrapbooks, FSA-OWI Written Records (see Introduction, n. 6). Not all of the clippings offer full bibliographic citations. Lange's 1937 Imperial Valley pictures were used in the following newspapers, journals, and magazines: *St. Louis Post Dispatch Sunday Magazine*, 17 April 1938, 4; *Current History*, April 1939, 33; *Social Work*, April 1939; *St. Louis Post Dispatch Sunday Magazine*, 28 January 1940; *Country Gentleman*, February 1940, 9; and *Democratic Digest*, June–July 1940, 46.
10. Stryker to Lange, 2 December 1936, Stryker Collection.
11. Lange to Stryker, 16 February 1937, Stryker Collection.
12. Stryker to Lange, 9 March 1937, Stryker Collection.
13. Lange to Stryker, 19 March 1937, Stryker Collection.
14. Lange to Stryker, 23 March 1937, Stryker Collection.
15. Meltzer, *Dorothea Lange: A Photographer's Life*, 164–65.
16. The photograph as it appeared in *Life* is reproduced on page 36 of this book.
17. "The U.S. Dust Bowl," *Life*, 21 June 1937, 60–65.
18. Interview with Lange by Doud.
19. Ibid.

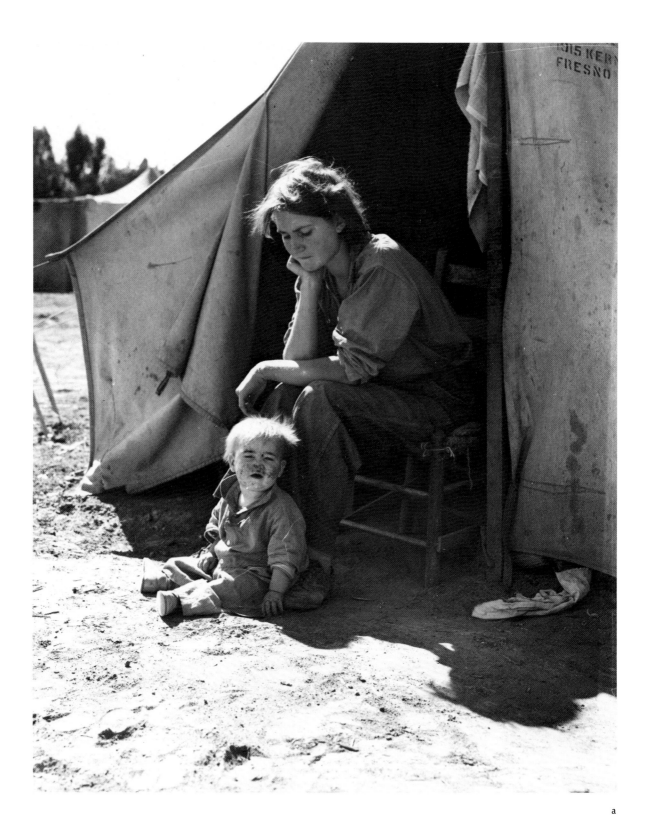

a

b

a. Eighteen-year-old mother from Oklahoma, now a California migrant.

b. Refugee camp near Holtville.

a

b

a. Migratory workers from Oklahoma washing in a hot spring in the desert.

b. The water supply in a squatter camp near Calipatria is an open settling basin fed by an irrigation ditch.

c. A drought refugee living in a camp on the bank of an irrigation ditch.

d. A crew of thirty-five Filipinos cut and load lettuce.

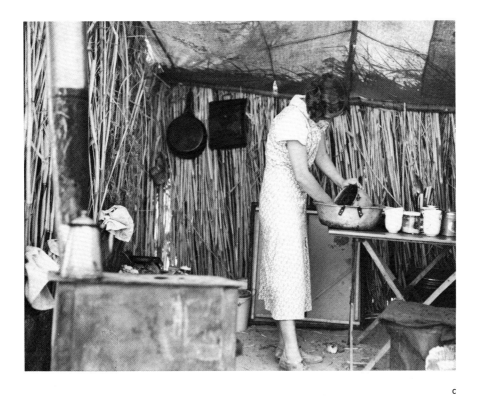

c

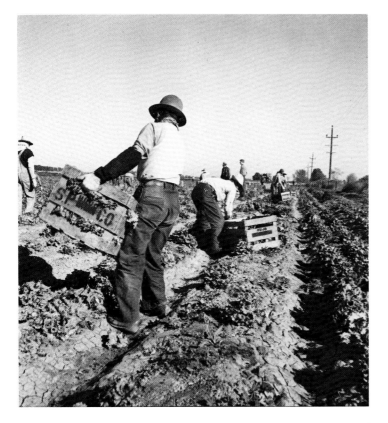

d

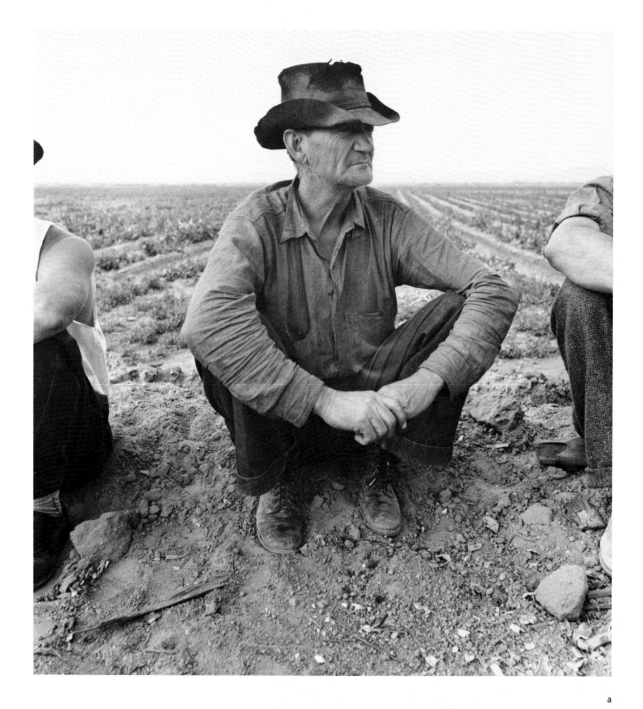

a

a. A migrant agricultural worker in Holtville.

b. Ditch bank housing for Mexican field workers.

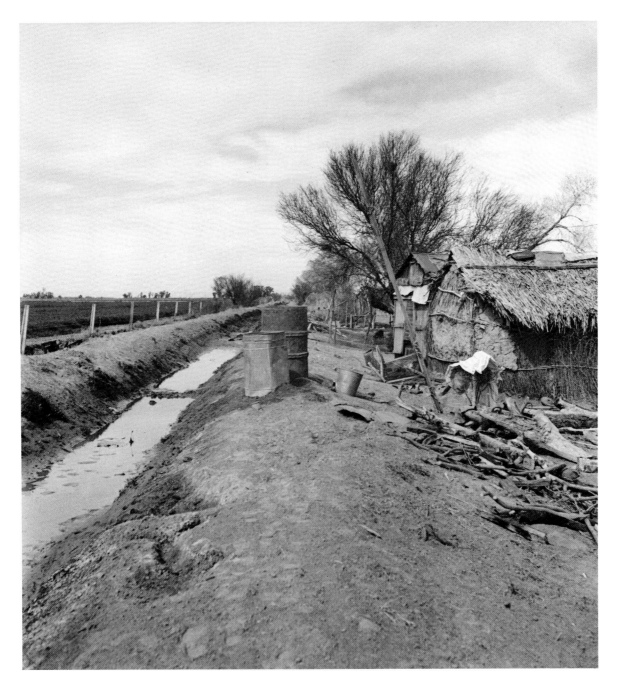

b

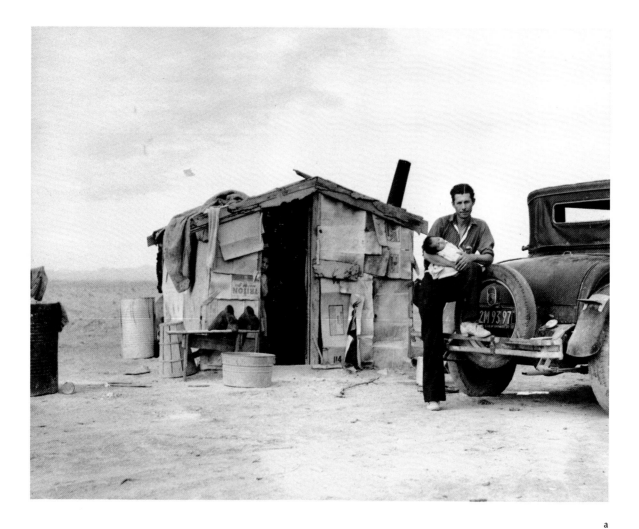

a

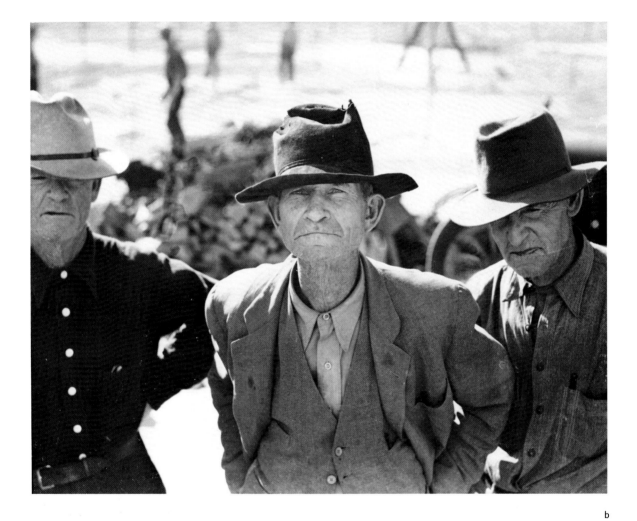

b

a. Migratory Mexican field worker's home on the edge of a frozen pea field.

b. Former tenant farmers on relief.

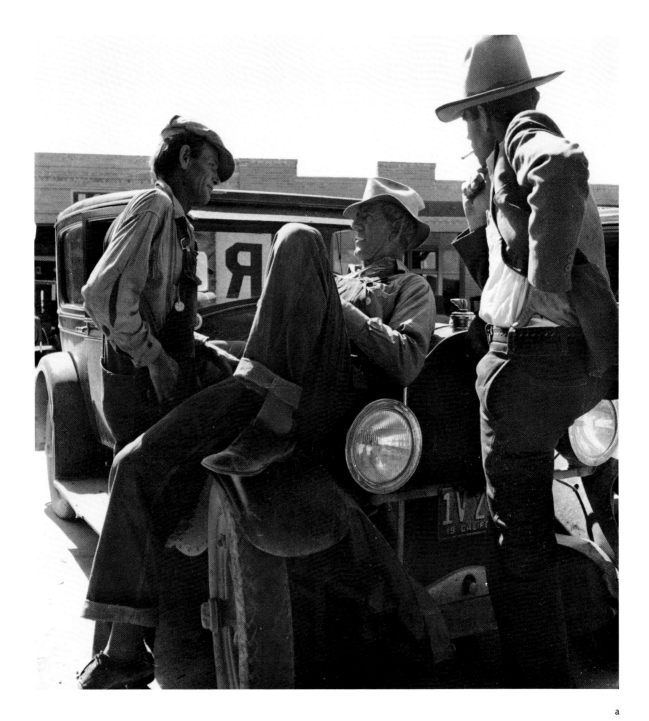

a

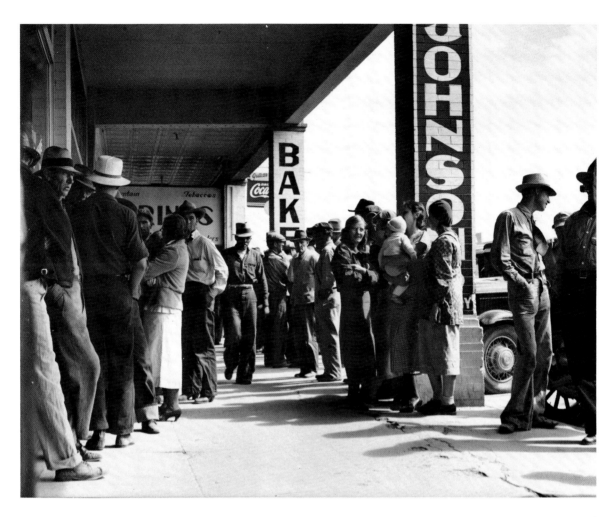

b

a. Drought refugees waiting for relief checks in Calipatria.

b. Waiting for relief checks in Calipatria.

N E W Y O R K C I T Y B L O C K

WALKER EVANS

New York, New York, 23 August 1938
Farm Security Administration, Lot 962

Walker Evans already had a reputation, if not a steady income, as a photographer when Roy Stryker hired him at the Resettlement Administration in October 1935. Evans had taken up photography in 1928, at the age of twenty-five. He lived, in his own words, "very shabbily" in New York City, where he began to experiment with the medium by photographing city street life and vernacular architecture and by making portraits of his artist and intellectual friends.[1] During the late 1920s and early 1930s his paid projects included illustrating a book that exposed the evils of Cuba's Machado regime and photographing African sculpture for the Museum of Modern Art.[2]

Evans came to the Resettlement Administration after doing some part-time work at the Department of the Interior, and his ideas about the systematic documentation of American culture influenced Stryker during the early period of the Historical Section. In notes written in 1934 and 1935 concerning the creation of photographs by the federal government, Evans called for images that would be a "pure record not propaganda," and he composed a list of subjects that resembled Stryker's later shooting scripts.[3] During the eighteen months or so that he worked at the agency, he photographed in West Virginia, Pennsylvania, Louisiana, Mississippi, Georgia, South Carolina, Alabama, Arkansas, and Tennessee, but his best-known work during the period was a series of photographs of Alabama sharecroppers produced for *Fortune* magazine during a leave of absence. The periodical published neither the photographs nor the text that James Agee wrote to counterpoint them, but both finally appeared in the 1941 book *Let Us Now Praise Famous Men.*[4] The many influential photographs Evans made during this period were described by the critic John Szarkowski in 1973 as

128

"poetic uses of bare-faced facts, facts presented with such fastidious reserve that the quality of the picture seemed identical to that of the subject."[5]

Stryker admired Evans's photographs, but the two men did not always get along well. In part this reflected differences in personality, but it also reflected the conflict between Evans's ideal of creating a pure record and Stryker's concern with producing photographs useful to the agency and promoting political or social change. The two parted company during 1937, and Evans returned to New York City, where he worked on his exhibit and book *American Photographs*, continued to prepare his contribution to *Let Us Now Praise Famous Men*, and began to make a series of photographs in the city's subways.[6]

In spite of his high level of creative activity, Evans seems to have needed money. Letters he and Stryker exchanged during April, May, and June 1938 refer to Evans's failure to obtain a Guggenheim Fellowship and allude to a possible short-term assignment for the Farm Security Administration.[7] These photographs taken in New York City probably represent the outcome of the matter, although nothing in the agency's files explains why this subject was selected, if Evans was paid, or whether he and Stryker were satisfied with the pictures.

Captions for the file prints state that the photographs were made during the summer of 1938 on Manhattan's East Sixty-first Street. Internal evidence supplies more details: the four issues of the *Daily Mirror* in one photograph carry the date Tuesday, 23 August; the position of the sun's shadows on the building facades shows that the film had been exposed within an hour or two that morning; and an examination of street signs and house numbers indicates that Evans stayed more or less in the single block between First and Second avenues. The brevity of the visit, the lack of a written assignment, and the choice of a site not far from Evans's East Ninety-second Street apartment imply that he, rather than Stryker, chose the subject.

These pictures of the neighborhood's residents, streets, signs, and buildings display Evans's interest in ordinary people and his fondness for vernacular expression. From the twenties through the fifties Evans made candid photographs of people on the street, pictures akin to these images of residents on urban stoops and sidewalks. Referring in 1971 to some of his 1928 and 1929 photographs, Evans said, "I found I wanted to get a type in the street, a 'snapshot' of a fellow on the waterfront, or a stenographer at lunch. That was a good vein. I still mine that vein."[8] Vernacular expression appears in the photographs in the form of advertisements and architecture. The pictures of notices, signs, and billboards in this series convey a sense of the passage of time: thirty-cent lunches and five-cents-per-pound peaches are things of the past, and we have long forgotten the political candidate named Jeremiah T. Mahoney. And the erosion Evans captured in the photograph of Mahoney's poster reminds us how ephemeral human endeavor is.

Patterns of masonry, windows, fire escapes, and shadows transform the photographs of apartment house facades into geometric

abstractions. In the 1930s Evans often rendered buildings—for example, the rural churches he photographed in the South—as two-dimensional studies in form and texture, but he typically portrayed the entire facade. These photographs of tenement fronts recall his experiments of the 1920s, in which foreshortening, sharp-angled compositions, the use of strong shadows, and the exclusion of the roof and sidewalk heightened the degree of abstraction. The entire take also contains photographs that look up and down the block; in these, whole buildings are seen in their architectural context, and the block itself is presented as the setting for human activity.

Analysis of the negatives suggests that the photographer shot four rolls of film; the take is represented by fifty negatives in the FSA-OWI Collection in the Library of Congress. The file contains several strips of negatives from two of the rolls but only fragments from the other two. Evans probably made a selection from the entire take and then sent the chosen negative strips to Washington, D.C.[9]

Our twenty-picture selection presents what we believe to have been Evans's shooting sequence. Images of building facades and people on the stoops recur throughout the series, indicating Evans's interest in these two subjects and showing how he made multiple exposures in a quest for the most satisfactory photograph possible.[10] Evans must have made two or three passes up and down the block, photographing alternately the apartment houses on the sunny side and the people in the shade. Note that the first and last images depict the same building, and the movement of the sun has shifted the shadows cast by the balconies. At the west end of the block Evans photographed the elevated railway tracks and street sign; at the east end of the block he made a number of views of the intersection of East Sixty-first Street and First Avenue, including the perspective shot of the entire block on page 140.

Census records, real estate guides, and fire insurance maps draw a profile of the neighborhood in the 1930s. Situated at the southern end of the city's Yorkville District, the block was predominantly Italian, although many Irish and Poles lived on nearby East Side streets. The population grew during the decade, with most families living in rented three- and four-room apartments or in "rooming and lodging" houses built before 1900. Most buildings provided shared toilets and tubs, and nearly all residents had electricity or gas for cooking and lighting. Rents ranged from ten to fifty dollars per month. Residents either rode public transportation (a tramway ran parallel to East Sixty-first Street, and the EL traveled along Second Avenue) or walked; few owned automobiles. A Roman Catholic church on East Sixty-first—identified as Our Lady of Perpetual Help on a 1934 map—adjoined a parochial school facing East Sixty-second Street. Many small businesses served the neighborhood, and a few larger concerns like warehouses and a laundry served a citywide clientele.[11]

Evans probably knew little about social and economic conditions on the block. In any case, he was inclined to argue that photographers did not need such knowledge. The act of photographing, he told Leslie Katz, is "all done instinctively, as far as I can see, not consciously." This is consistent with Evans's diffidence at the ap-

plication of the label "documentary" to his photographs. "The term should be *documentary style*," he told Katz. "You see, a document has use, whereas art is really useless. Therefore art is never a document, although it can adopt that style."[12]

NOTES

1. Lincoln Caplan, ed., "Walker Evans on Himself," *New Republic*, 13 November 1976, 23. Other biographic information in this text has been drawn from the following sources: John Szarkowski, Introduction to *Walker Evans* (New York: Museum of Modern Art, 1971); Hurley, *Portrait of a Decade; Walker Evans: Photographs for the Farm Security Administration, 1935–1938* (New York: Da Capo Press, 1973); and *Walker Evans at Work* (New York: Harper and Row, 1982). The last work contains selected original documents and an essay by Jerry L. Thompson.

2. Carleton Beals, *The Crime of Cuba* (Philadelphia: J. B. Lippincott, 1933), 31 photographs by Evans; Paul Radin and James Johnson Sweeney, *African Folktales and Sculpture* (New York: Pantheon Books, 1952), 113 photographs by Evans.

3. *Walker Evans at Work*, 107, 112.

4. James Agee and Walker Evans, *Let Us Now Praise Famous Men* (Boston: Houghton Mifflin, 1941).

5. John Szarkowski, *Looking at Photographs* (New York: Museum of Modern Art, 1973), 116.

6. Walker Evans: American Photographs (one-man photographic exhibition), Museum of Modern Art, New York, 28 September–18 November 1938; Walker Evans, *American Photographs* (New York: Museum of Modern Art, 1938); Agee and Evans, *Let Us Now Praise Famous Men;* Walker Evans, *Many Are Called* (Boston: Houghton Mifflin, 1966). The subway series is published in the last work.

7. Stryker to Evans, 20 April, 20 May, and 3 June 1938; Evans to Stryker, 21 April, 26 May, and 15 June 1938; Stryker Collection.

8. Katz, Leslie, "Interview with Walker Evans," *Art in America*, March/April 1971, 85.

9. This series was exposed on 35-mm film. Unlike other film sizes used by the section's photographers, 35-mm negatives are too small to be cut into individual frames for storage, so the agency stored them in strips of five. The determination of Evans's probable shooting sequence depended on the availability of these strips and on edge numbers added to the film by the manufacturer (not the numbers assigned by the agency to identify negatives in the file). The position of the manufacturer's edge numbers may vary from roll to roll, and the numbers themselves indicate the sequence of exposures within each roll. The edge numbers for this group of negatives reach a high value of 44, implying that Evans may have "bulk-loaded" the film. The negatives include about a half-dozen images that seem to have been neither published nor printed for the file. The unprinted negatives are represented here by the picture of the two men passing on the sidewalk and the close-up of the political poster.

10. Evans's method is discussed in Jerry L. Thompson, "Walker Evans: Some Notes on His Way of Working," in *Walker Evans at Work*, 9–17.

11. Fred H. Allen, *New York City, Westchester, and Nassau Counties in Relation to Real Estate Investments, 1942* (New York: Bowery Savings Bank et al., 1942); *Real Property Inventory City of New York: Borough of Manhattan* (New York: New York Housing Authority, 1934); *Real Estate Directory of the Borough of Manhattan* (New York: Real Estate Directory Company, 1938); *Manhattan Land Book* (New York: G. W. Bromley, 1934); New York (map from vol. 6 of the series *New York, 1903–1919* [Pelham, N.Y.: Sanborn Map Co., 1907]).

12. Katz, "Interview with Walker Evans," 85, 87.

a

b

a. Apartment building, 311 East Sixty-first Street.

b. In front of 310 East Sixty-first Street.

c. Moving possessions, 317 East Sixty-first Street.

a

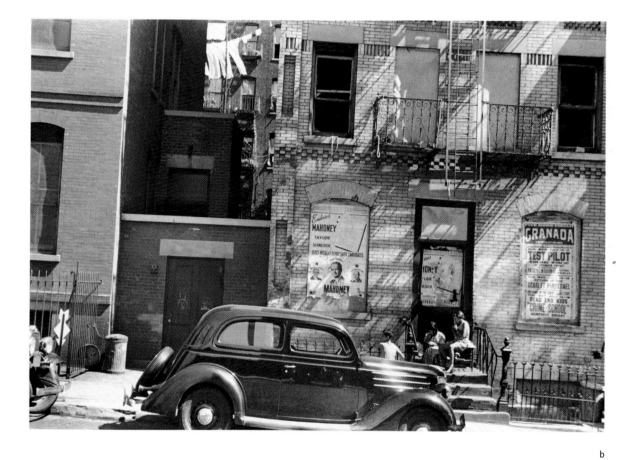

b

a. Apartment buildings, 315 and 317 East Sixty-first Street.

b. 345 East Sixty-first Street.

a

a. Political poster, 345 East Sixty-first Street.

b. Children on East Sixty-first Street, probably between First and Second avenues.

c. Tenants on East Sixty-first Street, probably between First and Second avenues.

d. Apartments for rent, 326 East Sixty-first Street.

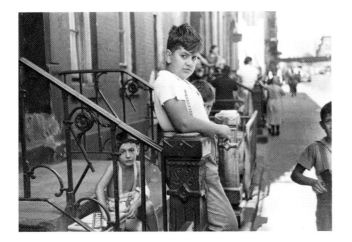

b

c

d

a

b

a. Newspapers for sale at a grocery, 324 East Sixty-first Street.

b. Tenant on East Sixty-first Street, probably between First and Second avenues.

c. Second Avenue and East Sixty-first Street.

c

a

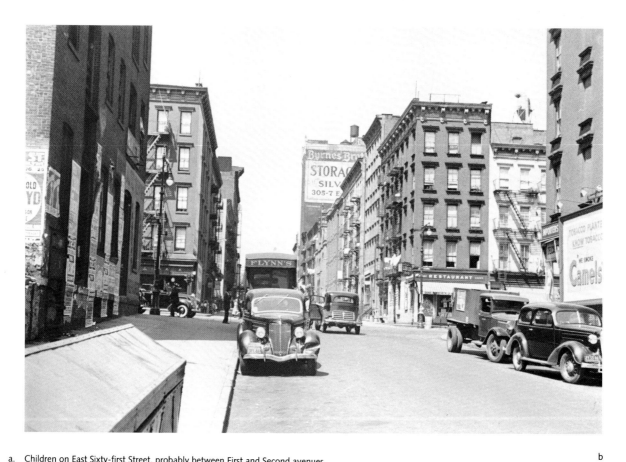

a. Children on East Sixty-first Street, probably between First and Second avenues.

b

b. First Avenue and East Sixty-first Street.

c. Laundry, near the intersection of First Avenue and East Sixty-first Street.

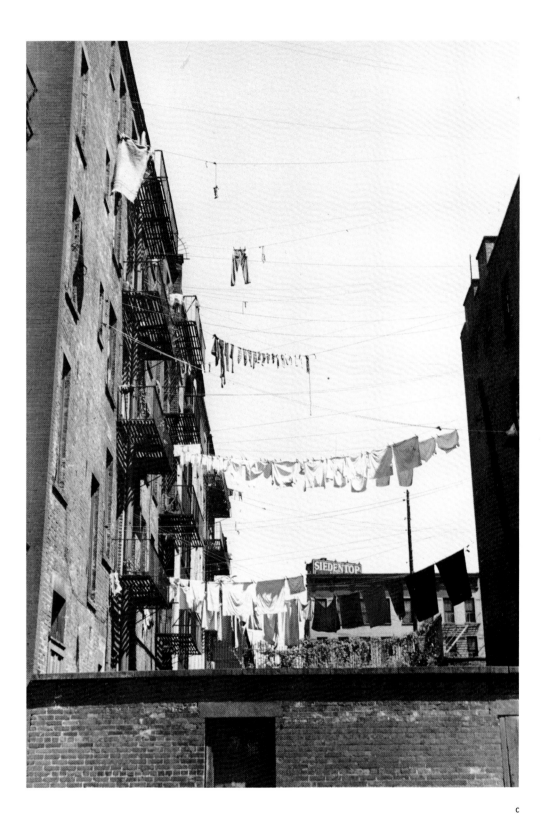

c

a

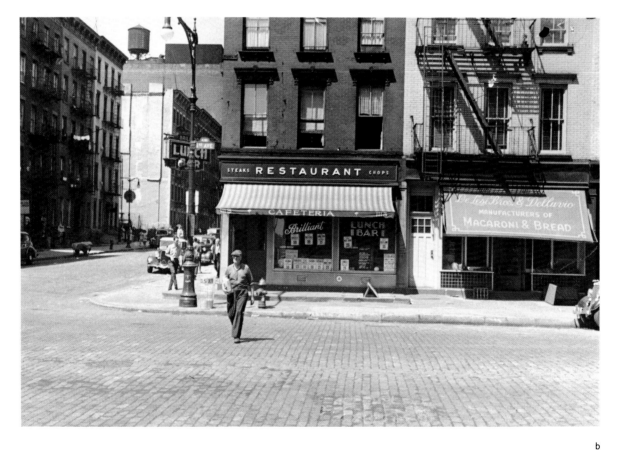

b

a. 401 East Sixty-first Street.

b. Restaurant and bakery, 1113 and 1115 First Avenue.

c. Children on East Sixty-first Street, probably between First and Second avenues.

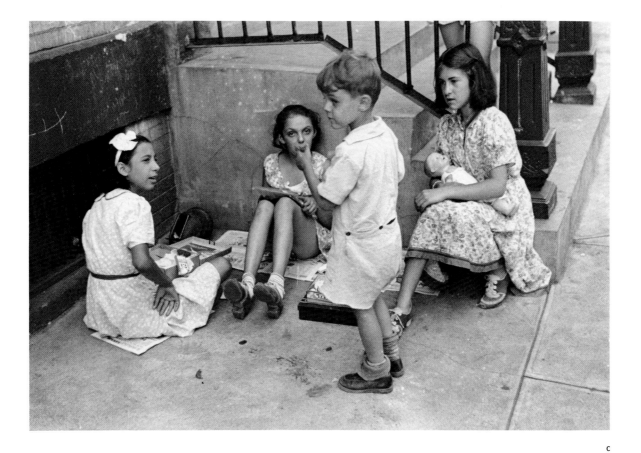

c

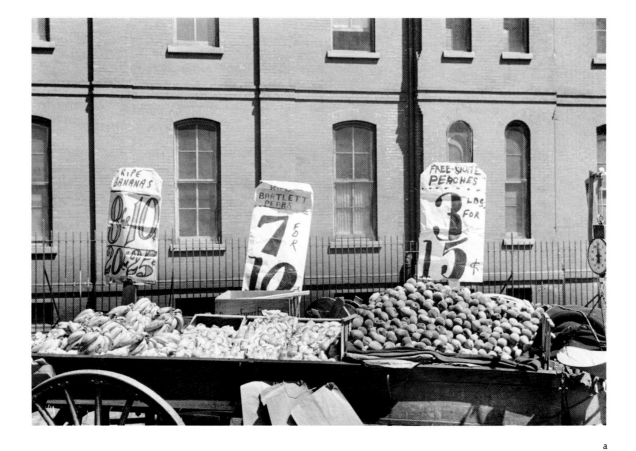

a

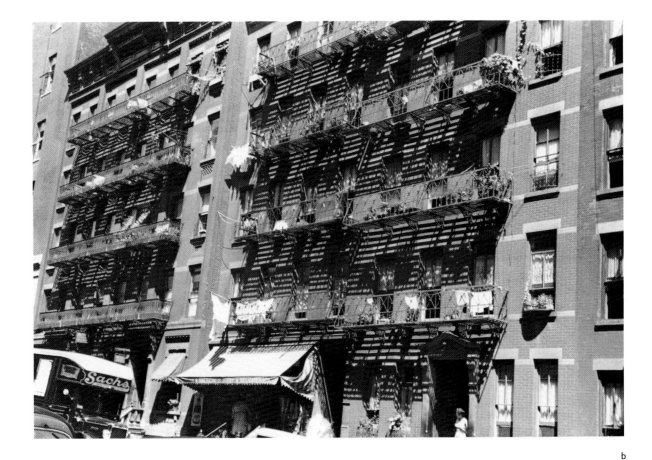

b

a. Fruit vendor's wagon in front of the rectory, 323 East Sixty-first Street.

b. Apartments and stores, 309 and 311 East Sixty-first Street.

T E N A N T F A R M E R S

ARTHUR ROTHSTEIN

Gee's Bend, Alabama, February and April 1937
Resettlement Administration, Lot 1616

In February 1937 Arthur Rothstein was in north-central Alabama photographing Birmingham's steel industry and some nearby resettlement housing projects when he received new instructions from Roy Stryker. "The other day, while getting out a set of pictures for the Administrator to take to Congress," Stryker wrote on 5 February, "I realized how lean our file is on good southern tenancy pictures. [We must] find families that are fairly representative of the conditions in the tenancy areas, then take quite a series of pictures on each of these families, showing the house, the people, the children, the farm, the buildings and fences, etc."[1]

Rothstein, born in New York City in 1915, had been Stryker's student at Columbia University in the early 1930s. In 1935, as a college senior, he prepared a set of copy photographs for a picture source book on American agriculture that Stryker was assembling. The book was never completed, but before the year was out Stryker had hired Rothstein at the Resettlement Administration.

The photographs made during Rothstein's five-year stint with the photographic section form a catalog of the agency's initiatives. His first assignment was to document the lives of some Virginia farmers who were being evicted to make way for the Shenandoah National Park and about to be relocated by the Resettlement Administration. Subsequent trips took him to the Dust Bowl and to cattle ranches in Montana. The immediate incentive for his February 1937 assignment came from the attention generated by farm tenant legislation sponsored in the Senate by John H. Bankhead, a moderate Democrat from Alabama with a strong interest in agriculture. Enacted in July, the Bankhead-Jones Farm Tenant Act gave the agency its new lease on life as the Farm Security Administration.

On 18 February Stryker wrote Rothstein that the journalist Beverly Smith had told him about a tenant community at Gee's Bend, Alabama, "the most primitive set-up he has ever heard of. Their houses are of mud and stakes which they hew themselves."

Smith was preparing an article on tenancy for the July issue of *American Magazine*, but Stryker sensed bigger possibilities, telling Rothstein, "We could do a swell story; one that LIFE will grab."[2] Stryker planned to visit Alabama and asked Rothstein to wait for him, but he was never able to make the trip, and Rothstein went to Gee's Bend alone.

The residents of Gee's Bend symbolized two different things to the Resettlement Administration. Reports about the community prepared by the agency describe the residents as isolated and primitive, people whose speech, habits, and material culture partook of an African origin and an older way of life. In contrast, the agency's agenda for rehabilitation implied a view of the residents as the victims of slavery and the farm tenant system on a former plantation. The two perceptions may be seen as related: if these tenants—despite their primitive culture—could benefit from training and financial assistance, their success would demonstrate the efficacy of the programs.

Lying at the edge of the Black Belt in Wilcox County, about thirty miles southwest of Selma, Gee's Bend is a block of land enclosed on three sides by a massive turn in the Alabama River. The Resettlement Administration reports emphasize its isolation, describing the unreliable ferry that approached from the east and the poor muddy road that entered from the west. Founded by the Gee family early in the 1800s, the plantation was sold to Mark Pettway in 1845. Many of the black tenants Rothstein photographed were named Pettway. The white Pettways had sold the plantation in the early years of this century, and the seven hundred or so blacks had since rented or sharecropped the land from its successive owners.

The reports also stress the group's unique customs and language, sometimes in patronizing terms. "Truly these are primitive people," a 1937 report states, "living together in this tribal like settlement far away from civilization in their habits and manner of living."[3] Quoting from an article by Renwick C. Kennedy, a Presbyterian minister from nearby Camden, the report emphasizes the distinctive culture of the residents of Gee's Bend, reporting that other blacks in the region called them Africans.[4]

The community had received public assistance from the Red Cross in 1932 and federal and state aid in 1933 and 1934. Beginning in 1935 the Resettlement Administration made agricultural loans and offered farm and home management advice. In 1937 the average rural rehabilitation loan to Gee's Bend families was $353.41, and the agency reports speak of possible cooperative undertakings—a building campaign for houses, barns, a schoolhouse, and a sawmill. Residents were also encouraged to replace oxen with more efficient mules. One report concludes with the hope that "a few years will change this primitive settlement to a modern rural community."[5]

Rothstein's photographs, made as these activities were getting under way, may be read as the "before" in a before-and-after pair. The fifty-one photographs selected for the file mostly illustrate the "primitive" aspects of the place, concentrating on a gourd water dipper, meat curing in trees, hand-hewn fence palings, and unglazed cabin windows. The pictures of relatively new, or at least "less primitive," items are limited to the Pettway family's former home, the steel plow pulled by a mule, and the frame church that

also served as a school. The killed negatives include one view of a new house under construction.

Unlike the subjects of many Resettlement Administration and Farm Security Administration photographs, the people of Gee's Bend are not portrayed as victims. The photographs do not show the backbreaking work of cultivation and harvest but only offer a glimpse of spring plowing. In their homes the residents do not merely inhabit substandard housing but are engaged in a variety of domestic activities. The dwellings at Gee's Bend must have been as uncomfortable as the frame shacks thrown up for farm workers everywhere, but Rothstein's photographs emphasize the log cabins' picturesque qualities. This affirming image of life in Gee's Bend is reinforced by Rothstein's deliberate, balanced compositions, which lend dignity to the people being pictured.

There does not seem to have been a *Life* magazine story about Gee's Bend, but a long article ran in the *New York Times Magazine* of 27 August 1937. It is illustrated by eleven of Rothstein's pictures, with a text that draws heavily upon a Resettlement Administration report dated in May. The story extols the agency's regional director as intelligent and sympathetic and describes the Gee's Bend project in glowing terms. The reporter, John Temple Graves II, perceived the project as retaining agrarian—and African—values. "No one can visit Gee's Bend without an appreciation of racial virtues preserved there," he wrote, "which tend to disappear in more civilized quarters where the ambition of the Negro is to become only a carbon copy of the white man."[6]

The agency's programs at Gee's Bend continued after Rothstein's visit. During 1937 the agency purchased the old Pettway plantation and two adjacent farms, divided the land, and rented it to the tenants. The following year a nurse began working in the community, and construction began for a school, store, blacksmith shop, and cooperative cotton gin. By 1939 enough visible change had occurred there for Stryker to send Marion Post Wolcott to photograph the signs of progress—to get the "after" pictures.[7] During the forties, many families at Gee's Bend bought their farms from the government for an average of $1,400 each. This was about $2,600 less per farm than the total cost to the government for developing the eighty-eight units, a subsidy that seems to have been fairly typical for Farm Security Administration projects of this type.[8]

Gee's Bend has continued to fascinate outsiders. In 1941 the New York University speech professor and folklore collector Robert Sonkin recorded music, recitations, discussion, and a Fourth of July program at Gee's Bend.[9] A 1962 biography of Will Alexander—Rexford Tugwell's successor as head of the Farm Security Administration—concludes with a paean of praise woven around the story of the community's successful development.[10] Gee's Bend became an important part of the mid-1960s Freedom Quilting Bee, an offshoot of the civil rights movement designed to boost family income and foster community development by selling handcrafts to outsiders.[11] Calvin Trillin devoted a 1969 *New Yorker* piece to the opening of the community's new sewing center, paid for with quilting bee revenues.[12] The University of Alabama's 1982 tour guide *Seeing Historic Alabama* cited the Farm Security Administration project and the quilting bee at Gee's Bend.[13] In 1983 an exhibit in Bir-

mingham sponsored by the Alabama Humanities Foundation included several of Rothstein's photographs of Gee's Bend, and an oral history project at the Birmingham public library sent new researchers and a photographer to document a new generation of residents.[14] Nevertheless, the residents themselves have expressed some doubt that the attention they have received has improved their lot in life. In 1985 the local historian Katherine Tucker Windham reported: "They say, 'Ain't nothing ever happened.'"[15]

NOTES

1. Stryker to Rothstein, 5 February 1937, Stryker Collection.

2. Beverly Smith, "Molasses and Sowbelly," *American Magazine* 124, no. 1 (July 1937):156–57, 164–67; Stryker to Rothstein, 18 February 1937, Stryker Collection.

3. Resettlement Administration report, 21 May 1937; Written Records of the Farm Security Administration, Historical Section–Office of War Information, Overseas Picture Division, Washington Section Collection, Library of Congress, hereafter cited as FSA-OWI Written Records. The supplementary reference files in this collection contain variants of this report with later dates; similar overviews may be found in the Charles L. Todd/Migratory Labor Collection, Archive of Folk Culture, Library of Congress.

4. Renwick C. Kennedy, "Life at Gee's Bend," *Christian Century,* 1 September 1937, 1072–75.

5. Resettlement Administration report dated 21 May 1937, 8; see also a Farm Security Administration report dated 16 September 1939, revised 17 January 1941; FSA-OWI Written Records.

6. John Temple Graves II, "The Big World at Last Reaches Gee's Bend," *New York Times Magazine,* 22 August 1937, 12–15.

7. Farm Security Administration report, 16 September 1939, revised 17 January 1941, FSA-OWI Written Records; Post Wolcott's photographs are stored in lot 1617.

8. Paul K. Conkin, *Tomorrow a New World: The New Deal Community Program* (Ithaca, N.Y.: Cornell University Press, 1959), 230. A thorough overview of the Gee's Bend project, including an economic analysis of its outcome that calculates a one dollar benefit for each two dollars spent, may be found in M. G. Trend and W. L. Lett, "Government Capital and Minority Enterprise: An Evaluation of a Depression-Era Social Program," *American Anthropologist* 88, no. 3 (September 1986), 595–609.

9. The recordings and additional documentation are part of the Robert Sonkin/Gee's Bend, Alabama, and the Todd/Migratory Labor collections, Archive of Folk Culture, Library of Congress.

10. Wilma Dykeman and James Stokely, *Seeds of Southern Change: The Life of Will Alexander* (Chicago: University of Chicago Press, 1962), 311–15.

11. Janet Strain McDonald, "Quilting Women," in *Black Belt to Hill Country: Alabama Quilts from the Robert and Helen Cargo Collection* (Birmingham: Birmingham Museum of Art, 1982), 21–26.

12. Calvin Trillin, "The Black Womens of Wilcox County Is About to Do Something," *New Yorker,* 22 March 1969, 102–8.

13. Virginia Van der Veer Hamilton, *Seeing Historic Alabama: Fifteen Guided Tours* (University: University of Alabama Press, 1982), 143.

14. The exhibit, titled Five Cent Cotton, was organized by Jo Roy; its accompanying booklet is *Five Cent Cotton: Images of the Depression in Alabama* (Birmingham: Birmingham Public Library, 1982). The materials collected during the course of the oral history project are in the Birmingham Public Library.

15. Telephone conversation with Katherine Tucker Windham by Claudine Weatherford, 19 July 1985, *Documenting America, 1935–1943,* project records, Supplementary Archives, Prints and Photographs Division, Library of Congress, hereafter cited as *Documenting America* Project Records.

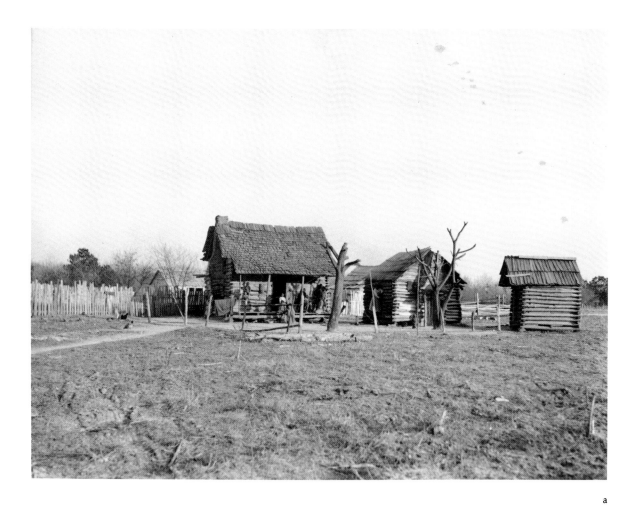

a

a. Cabins and outbuildings on the former Pettway plantation.

b. Artelia Bendolph.

c. Cabin.

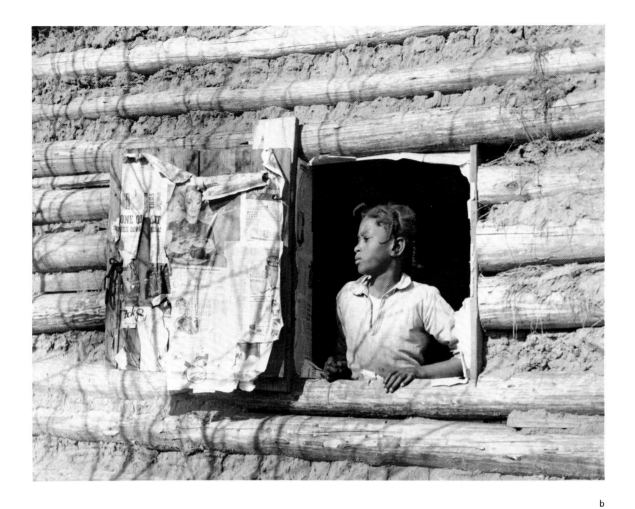

b

c

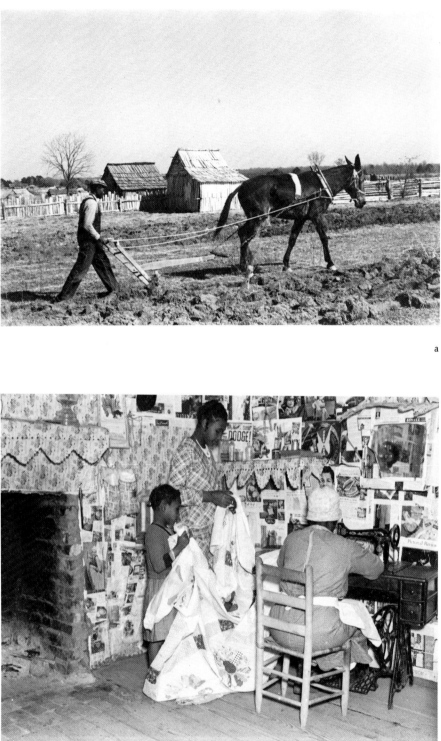

a

b

c

a. Houston or Erick Kennedy plowing.

b. Jennie Pettway and another girl with
 the quilter Jorena Pettway.

c. The former home of the Pettways.

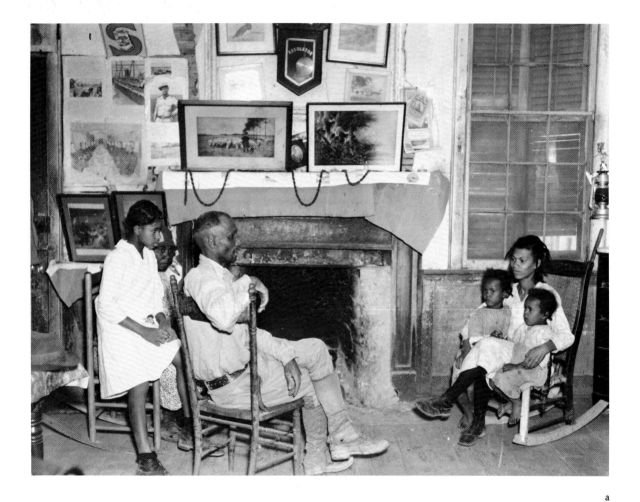

a

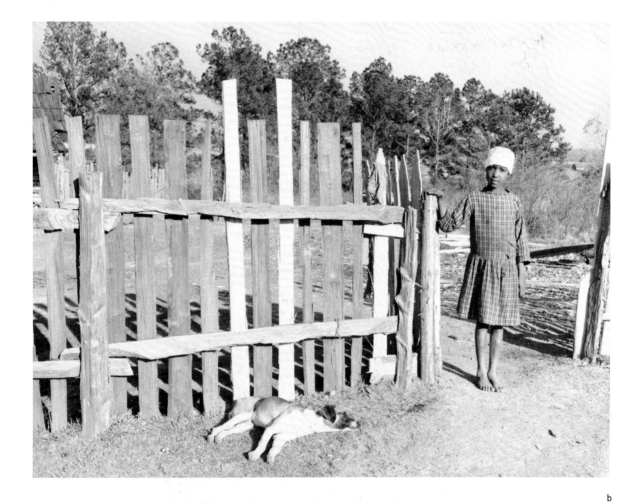

b

a. Interior of the old Pettway home, occupied by the foreman John Miller and his family.
 Melvine Miller is at the extreme left, and Cherokee Parker Pettway
 is the adult seated at the right.

b. On the Pettway plantation. Probably Adell Pettway.

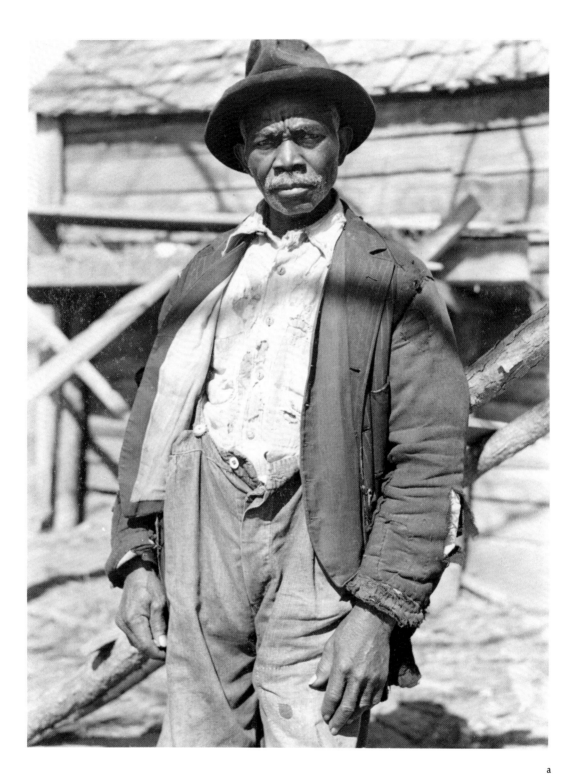

a

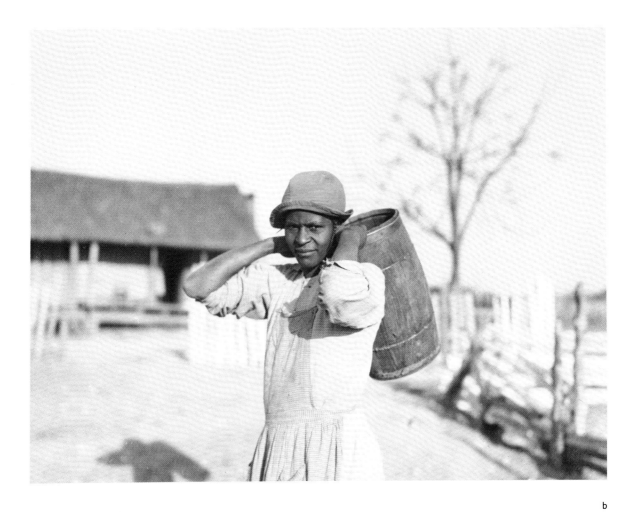

b

a. Willie S. Pettway.

b. Annie Pettway Bendolph.

c. Bucket and gourd.

c

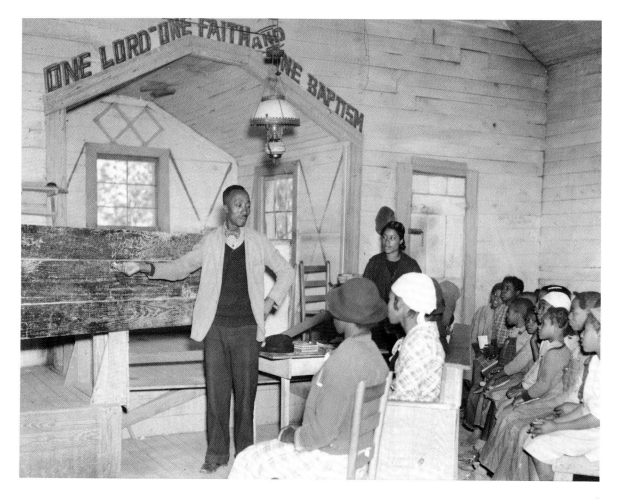

a

a. Mr. Hale from Snow Hill conducting school in the
 Pleasant Grove Baptist Church building.

b. At the end of the school day.

c. Curing meat.

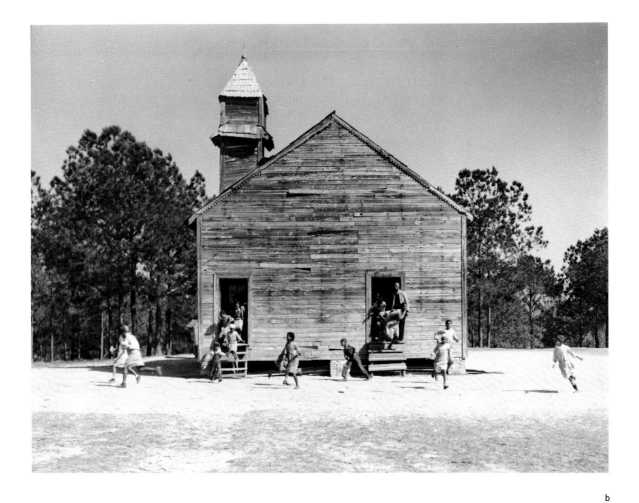

b

c

S A L V A T I O N A R M Y

DOROTHEA LANGE

San Francisco, California, April 1939
Farm Security Administration, Lot 380

Dorothea Lange is best known for her pictures of migrants, tenant farmers, and other rural folk, but she also made photographs in the city. Her 1933 photographs of the White Angel breadline, a San Francisco food charity, are an early sign of this interest, and the following year she photographed strikes and labor rallies in San Francisco. When Lange went to work for the Resettlement Administration in August 1935, she continued to devote a portion of her energies to urban subjects. In 1936, for example, she photographed a group of New York City residents selected for resettlement in the new community of Roosevelt, New Jersey, and Bonus Army sympathizers on Manhattan's Lower East Side.[1]

Lange's concern for the urban disadvantaged continued after she left Roy Stryker's section in 1940. In 1952, on the eve of an exhibition of her work at the Museum of Modern Art and after a period of inactivity, Lange's son reported that the photographer's current plans included a project to photograph "The Walking Wounded," defined as "photographs of the spiritually maimed, who, traveling the streets of every city, most people give less attention than they give a man with a carbuncle on his neck."[2] The 1939 photographs of San Francisco's Salvation Army and the people it served presage that project as well as recall Lange's earlier work.

Lange herself probably selected the Salvation Army as a subject. Stryker did not issue a shooting script requesting such photographs until the following year, a directive that Lange's pictures may have inspired.[3] None of his letters from early 1939 mentions the Salvation Army, but he did request more pictures of migrant farm workers. Between February and April, Lange made several trips to California's agricultural valleys and occasionally crossed the bay from her Berkeley home to make photographs in San Francisco. In January or February (the date is uncertain) she photographed a

rally to protest a congressional cut in relief appropriations, and in April she produced this series and made a few photographs of the city's architecture and of the new San Francisco-Oakland Bay Bridge.[4]

On Palm Sunday weekend Lange documented the first of two regular morning services at Salvation Army headquarters and then accompanied the group to an open-air meeting where they sought to attract newcomers.[5] The full take numbers thirty-five photographs, of which fifteen are reproduced here. Lange photographed the various elements of the indoor service, culminating with a picture of the adjutant and a penitent kneeling in prayer. The interior views are all lit by flash. In most rooms the existing illumination comes from above, but the beam of light from Lange's camera-mounted flashgun strikes the subjects horizontally. The angle and the harshness of the flash give the pictures a staged quality. Lange herself disliked flash and generally avoided it.[6] The exterior views were exposed in daylight and are more naturalistic. These photographs show Army missionaries marching from the pawnshops and hotels of Minna Street to an alley barricaded for a road construction project, where the group conducts an outdoor meeting.

In most of her Depression-era photographs Lange's attitude is clearly expressed. Her sympathies lie with the migrant workers, the tenant farmers who have lost their jobs as a result of farm mechanization, and the victims of the Dust Bowl. In this series, however, Lange's attitude toward her subject is unclear. For the most part the Salvation Army's officers and soldiers are portrayed as honest, dedicated people. But Lange's favorite picture—the only one included in published collections of her work—is the photograph of the old soldier and the little girl holding American flags. Its strength resides in its ambiguous mixture of the symbols of patriotism, evangelism, and age. The photographs of bystanders are also ambiguous. In nearly every case Lange's captions assert that the bystanders ignored the Army's ministrations. The Army commanded only "slight attention" from the occupants of a hotel lobby, and young men "loiter" to watch "and then pass on."[7] Did Lange mean to indicate that the organization was ineffective or to demonstrate that American citizens were indifferent to those who assisted the walking wounded?

Lange never wrote down her impressions of the Salvation Army. Her attitude may have been positive since the Army, like the Farm Security Administration, held that the poor were not to blame for their poverty, and that rehabilitation could make them productive citizens. But Lange's feelings toward Salvation Army and FSA programs were more likely to have been mixed; her photographs of Farm Security Administration projects share some of the ambiguity of these pictures of the Salvation Army. When Stryker assigned Arthur Rothstein to photograph the FSA migrant labor camp in Visalia, California, it was to fill the gaps Lange had left in her earlier coverage.[8] The Salvation Army's evangelism may have put Lange off, just as it did her fellow Californian John Steinbeck. In his novel *The Grapes of Wrath*, a character says of the Army, "They made us crawl for our dinner. They took our dignity. They— I hate 'em."[9] Contrasting Lange's photographs of human suffering

with her depictions of charitable institutions suggests that while she was clear about the societal problems that engaged her sympathies and interests, she was far less certain about the programs designed to solve them.

NOTES

1. Lots 1312–14, 1291–92, Farm Security Administration–Office of War Information Collection, Prints and Photographs Division, Library of Congress.
2. Daniel Dixon, "Dorothea Lange," *Modern Photography*, December 1952, 140. Lange seems not to have carried out the "Walking Wounded" project, at least not as a focused undertaking.
3. Stryker, "Suggestions for Photographers: F.S.A. 1940," Roy E. Stryker Papers, Archives of American Art, Smithsonian Institution (hereafter cited as Stryker Papers).
4. Lots 378–79 contain a variety of photographs made in San Francisco during the years 1935–1939.
5. The information about these photographs has been drawn from the FSA-OWI Collection's separate caption file for negatives 16043–20268, A–E Series, box 9, FSA-OWI Written Records.
6. Ohrn, *Dorothea Lange*, 72.
7. File captions for negatives LC-USF34-19262-C and LC-USF34-19271-E.
8. "FSA Migratory Labor Camp," pages 188–205 of this book.
9. John Steinbeck, *The Grapes of Wrath* (New York: Viking Press, 1939), 432.

a

b

a. Waiting for the service to begin.

b. Opening the service with a collection.

a

b

a. Salvation Army "lassies" at the service.

b. Altar call.

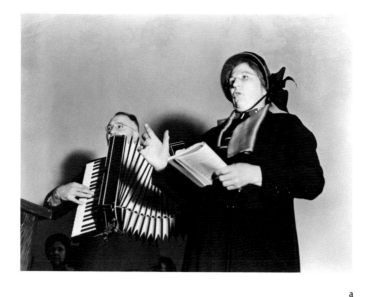

a

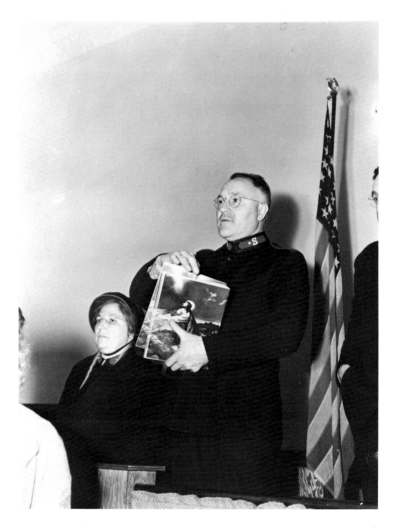

b

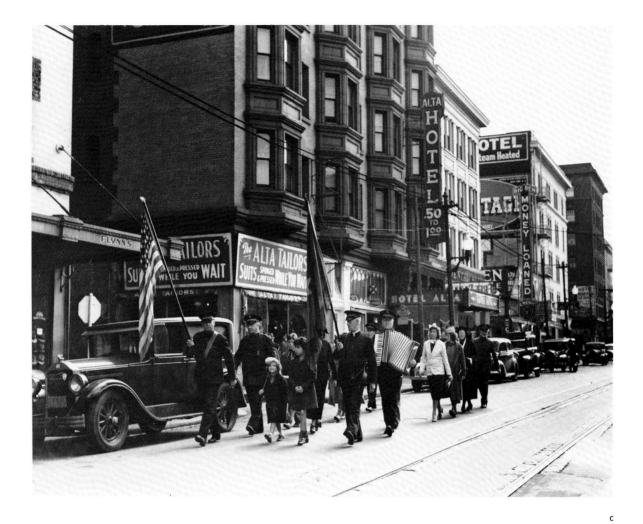

c

a. Adjutant Nock and his wife.

b. Selling the Easter edition of the *War Cry.*

c. Marching through downtown San Francisco.

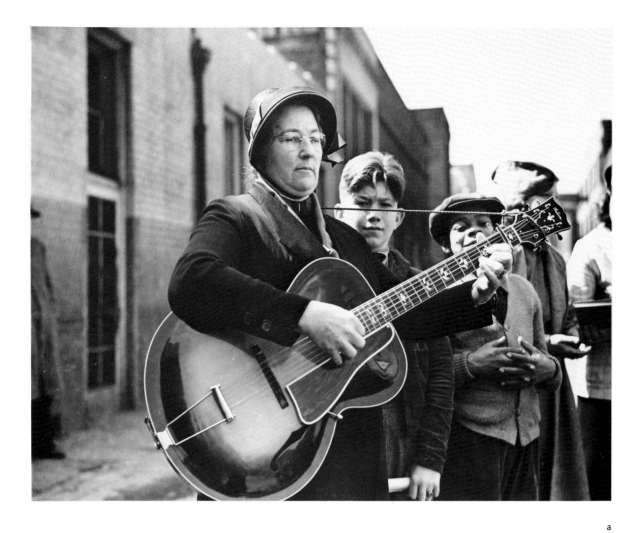

a

a. At the open-air meeting.

b. A soldier with twelve years' Salvation Army service
 preaches at the open-air meeting.

c. Bystanders watching the open-air meeting.

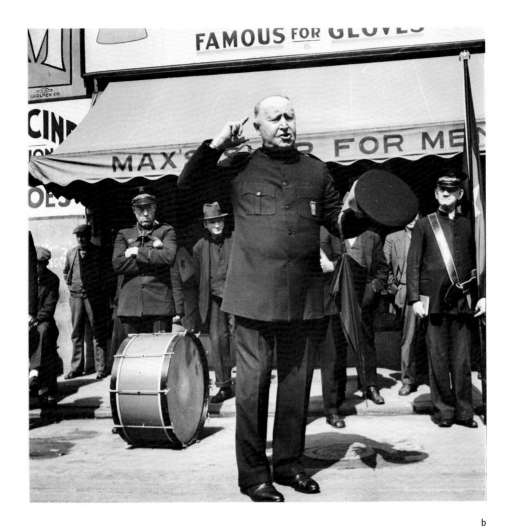

b

c

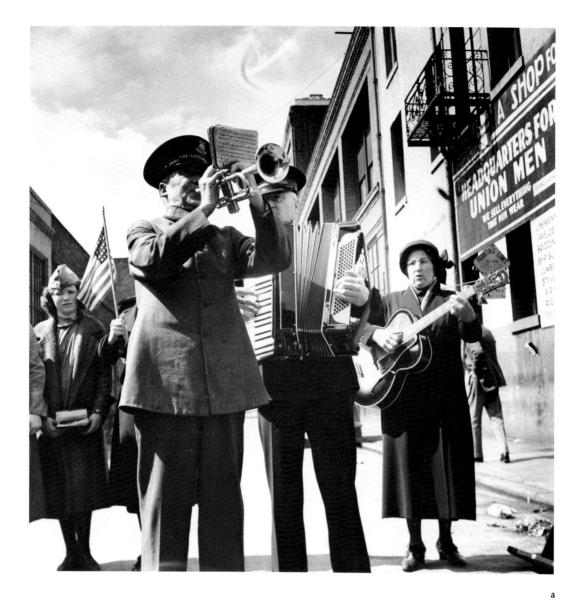

a

a. At the open-air meeting.

b. Return from the open-air meeting, as seen through a hotel lobby.

c. Passersby at the open-air meeting.

b

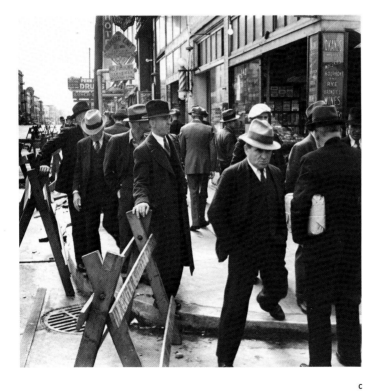

c

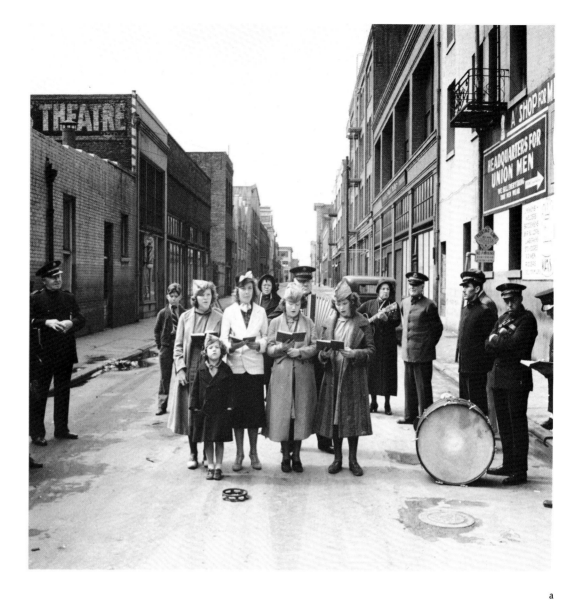

a. Girls' Sunday school class at the open-air meeting.

b. At the open-air meeting.

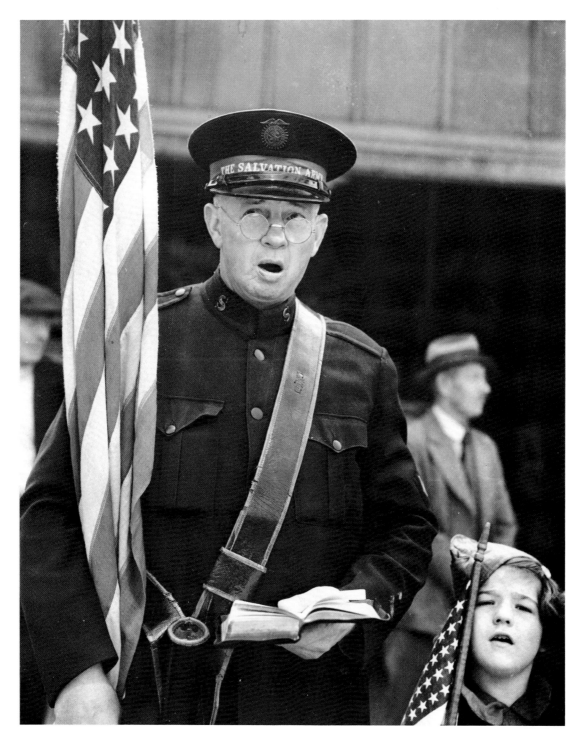

b

B E A C H R E S O R T

MARION POST WOLCOTT

Miami, Florida, January, February, and April 1939
Farm Security Administration, Lot 1602

Marion Post—who married Lee Wolcott in 1941—was twenty-eight years old when she was hired by the Farm Security Administration in 1938. In the early 1930s the New Jersey native spent nearly three years in France, Germany, and Italy and in Austria, where she acquired her first camera. When she returned to the United States, she taught school for a year before deciding to teach herself photography. In the mid-1930s she moved to New York City and improved her skills with the help of Ralph Steiner and her sister, the photographer Helen Post.

Post Wolcott attributed her keen interest in social issues to her mother, who had been a social worker for a while with Margaret Sanger, a leader in the birth-control movement. When she taught in a Massachusetts mill town in about 1934, Post Wolcott had been struck by the gap between rich and poor.[1] In 1935 she took still photographs for the film *People of the Cumberland,* an activist statement about disadvantaged southern mountaineers.[2] The photohistorian Sally Stein argues that Post Wolcott was one of the few Farm Security Administration photographers whose work explicitly describes the relationships between classes, citing as an example the photograph of the waiter serving the man at the beachside table included here.[3]

By 1938 Post Wolcott was an experienced photographer, having worked as a free-lancer in New York City and gone on to become a staffer for the *Philadelphia Evening Bulletin.*[4] But her work as a Farm Security Administration photographer presented new challenges. Her correspondence with Roy Stryker is packed with anecdotes and descriptions of her travels, to which Stryker, adopting an avuncular tone, responded with suggestions on every aspect of her work except the matter of photographic style. As was true for all the Farm Security Administration photographers, Post Wolcott's

routine official correspondence went to the office, and the meatier letters were sent to and from Stryker's home.[5]

Post Wolcott's letters from the Deep South address some aspects of the human relationships that documentary photographers must cope with in their work. She was assigned to the Farm Security Administration's Southeast Region in late 1938 to document migrant labor in orchards and on large farms and conditions on tenant farms. In a letter to Stryker about her attempts to photograph conditions near Charleston, South Carolina, she analyzed her difficulties in gaining acceptance and trust, ascribing her reception to her gender, the way she dressed, and the fact that she carried photographic equipment:

> Most of the people who would talk at all, said more or less the same thing—that they didn't like for no strangers to come botherin' around because they mostly played "dirty tricks" on them or brought "bad luck." They never would say specifically what or how, but several said [they] got things "tookin' from them"—but what? they haven't got anything! . . . Some said they didn't understand why I was riding around in that kind of country & roads all alone. A couple thought I was a gypsy—(maybe others did too) because my hair was so "long & heavy" & I had a bandanna-scarf on my head & bright colored dress & coat. All of which I remedied immediately, but it didn't seem to help. All the things in the car seemed to awe them too.[6]

Stryker replied that "colorful bandanas and brightly colored dresses, etc. aren't part of our photographer's equipment. The closer you keep to what the great back-country recognizes as the normal dress for women, the better you are going to succeed as a photographer."[7]

When Post Wolcott arrived in Florida in January, she found that cold temperatures had caused a big "freeze out" that destroyed a large portion of the crops that the migrant workers had come to pick. It would be several more weeks, she wrote Stryker, before crops would be coming in again; could she stay in Florida until the harvest began? She would photograph the idle (and unpaid) migrants waiting and in the process get better acquainted with the people. "It takes time, Roy," she wrote, "but you'll see that it's worth it. Talking, & listening to people, going back again to persuade them, or returning when the one (sometimes either the mother or father, not both) who objects to pictures will surely not be at home, or returning when the light is right."[8]

A longer stay would also permit the photography of other strata of society, pictures that could be juxtaposed with pictures of the rural poor. During her travels near Charleston, Post Wolcott had wanted to photograph "those famous gardens and estates near there—a wonderful contrast," and Stryker wrote the photographer to say she should wait out the start of the harvest in Florida by shooting "some of the tourist towns, which will show up how the 'lazy rich' waste their time; keep your camera on the middle class, also."[9]

In Miami, Post Wolcott photographed Miami Beach's expensive homes and the beach itself, the Hialeah racetrack, and a hand-

ful of urban scenes. The file contains seventy-seven prints from the assignment, dated January, February, and April. In 1984 Post Wolcott recalled how she had made the pictures: "I stayed in Miami overnight and had to drive twenty-five miles to where the migrants lived. I would go back to Miami to the wealth and the tourists, the winter population there. I thought: 'Wow, this is great. Why not use this material in exhibits and as contrast material?'"[10] Most of the photographs describe aspects of the lives of tourists and the wealthy residents of Miami Beach, including the telling picture of the employment office that supplied domestic labor and hotel and restaurant workers. A few pictures—like the one of the whimsical Gulf Hotel—reflect visual curiosity more than social analysis.

In Miami, Post Wolcott generally confronted people in relatively crowded public places, except for the couple photographed in the bar of a private home. Most of the photographs were made at a distance of at least ten or twelve feet, contain very little eye contact, and display little camera consciousness. Evidently Post Wolcott did not feel the need for intimate pictures badly enough to interact more directly with her subjects or to tackle the problem of gaining access to private homes and family life.

Post Wolcott experienced comparable problems of access in her photography of South Carolina's poor farm workers and Florida's well-to-do. Her letters enumerate her difficulties in establishing rapport with the poor, and the lack of intimacy in her Miami photographs shows that the middle and upper classes kept the photographer at a distance. She alluded to the matter and stated her preferences in exaggerated fashion in a letter she wrote to Stryker from Kentucky in 1940:

> [T]hese more prosperous farmers, & middle "clawses"—they will have none of it [being photographed], unless they look right, well dressed, powdered, & unless they know who you are & what it's for. They're all agin the government, the agricultural program & much of F.S.A. It's hard to get away with just "taking pictures" any more. Every one is so hysterically war & fifth column minded. So suspicious!
>
> In fact, I've decided in general that it's a helluva lot easier to stick to photographing migrants, sharecroppers, tenants, "niggers," clients—& the rest of those extremely poverty stricken people, who are depressed, despondent, beaten, given-up. Most of them don't object too strenuously or too long to a photographer or picture. They believe it may help them, or they may get something out of it—a little money, or better houses, or a gov. loan.[11]

Post Wolcott's photographs show that even in the Depression some citizens had wealth enough for mansions and leisure. But the people in the pictures are not caricatures of plutocrats. "There was just a little bit of, not cynicism, a little bit of the critic's viewpoint in that series of pictures and, yet, warmth," Stryker commented in the mid-1960s, with the Depression far behind him. The pictures por-

tray, he said, "another part of life in America that's a lot different than the migrants and the people that were hard up, but it's still America."[12]

NOTES

1. Marion Post Wolcott, Keynote Address, presented at the Women in Photography Conference, Syracuse, N.Y., 10–12 October 1986; Paul Raedeke, "Introduction + Interview," *Photo-Metro,* February 1986, 14.

2. Telephone conversation with Beverly Brannan, 15 May 1986, *Documenting America,* Project Records. The film is described in Russell Campbell, *Cinema Strikes Back: Radical Filmmaking in the U.S. 1930–1942* (Ann Arbor: UMI Research Press, 1982).

3. Sally Stein, "Marion Post Wolcott: Thoughts on Some Lesser Known FSA Photographs," in *Marion Post Wolcott: FSA Photographs* (Carmel, Cal.: Friends of Photography, 1983), 3–10.

4. *Marion Post Wolcott: FSA Photographs,* 44.

5. The official correspondence is now part of the FSA-OWI Written Records at the Library of Congress; the other letters may be found in the Stryker Collection at the University of Louisville.

6. Post Wolcott to Stryker, 12 January 1939, Stryker Collection.

7. Stryker to Post Wolcott, 13 January 1939, Stryker Collection.

8. Post Wolcott to Stryker, [January 1939], Stryker Collection.

9. Post Wolcott to Stryker, [12 January 1939]; Stryker to Post Wolcott, 13 January 1939; Stryker Collection.

10. Raedeke, "Introduction + Interview," 14.

11. Post Wolcott to Stryker, 28–29 July 1940; Stryker Collection.

12. From an interview with Stryker in Thomas H. Garver, *Just before the War* (Balboa, Cal.: Newport Harbor Art Museum, 1968), n.p.

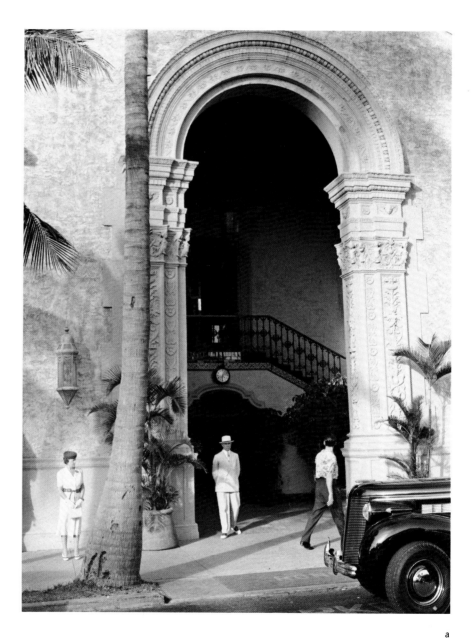

a

b

a. Hotel entrance.

b. Waterfront home.

a

a. Bar in a private home.

b. Private home.

c. Hotel and service station.

b

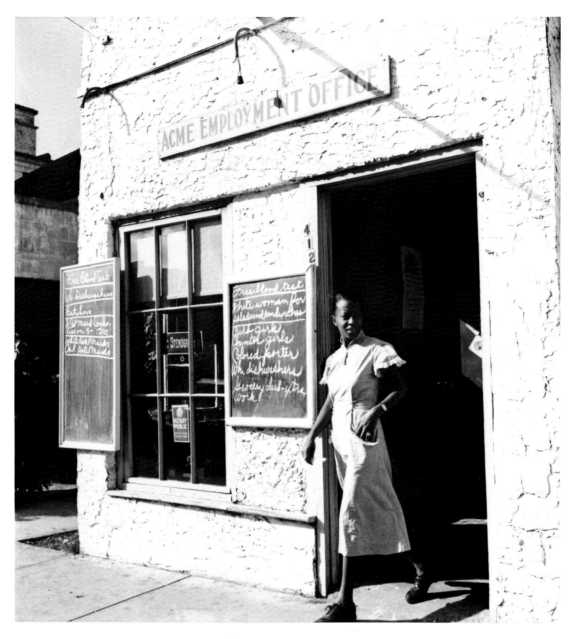

a

a. Employment agency.

b. Before the race, Hialeah Park.

c. At the track, Hialeah Park.

b

c

a

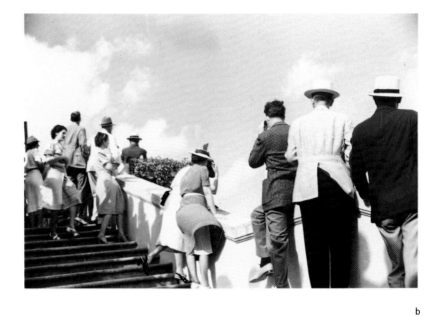

b

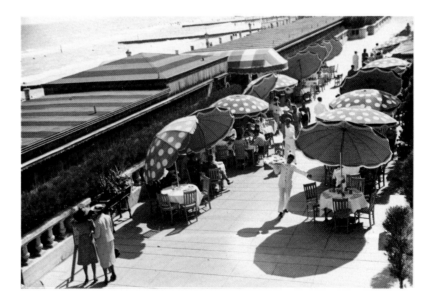

c

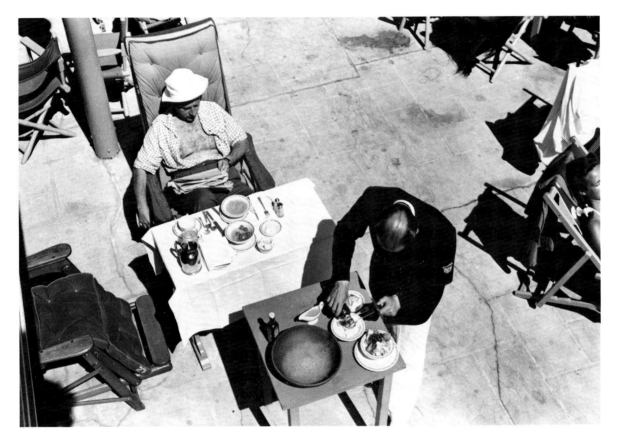

d

a. Racetrack, Hialeah Park.

b. At the track, Hialeah Park.

c. Along the beach.

d. A meal on the sidewalk at the beach.

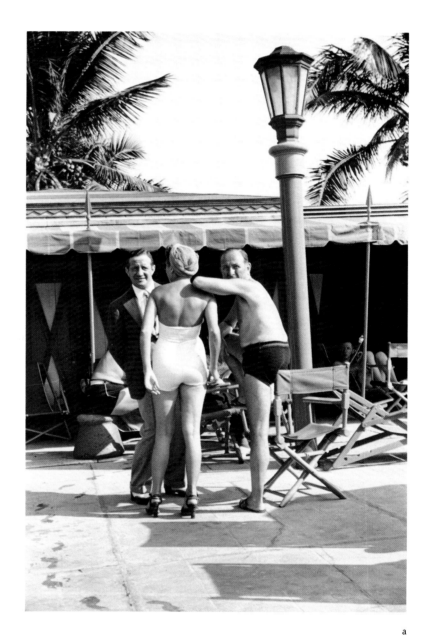

a

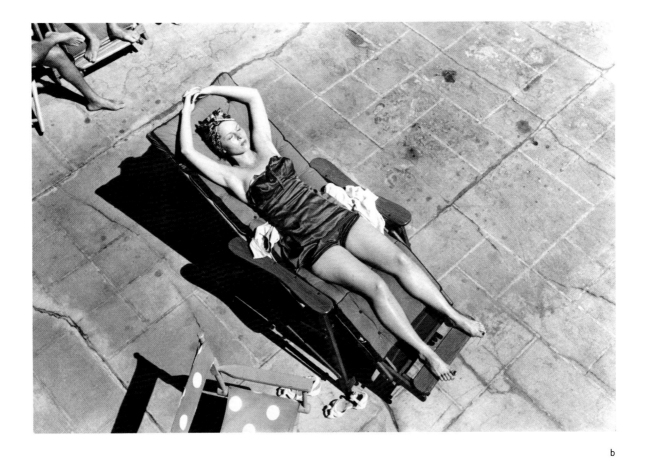

b

a. At the beach.

b. At the beach.

F S A M I G R A T O R Y L A B O R C A M P

ARTHUR ROTHSTEIN

Visalia, California, March 1940
Farm Security Administration, Lot 358

Arthur Rothstein was put off by his experiences in California in early 1940. "The weather has been terrible. It has rained every day," he wrote Roy Stryker in April, quickly turning to a more troublesome issue. "I like it the least of the western states. My impression is that everything is commercialized, the police & city officials are corrupt grafters, there is little of that gracious western hospitality & most of the people are of that reactionary, super-patriotic, fascist-minded type. Practically every newspaper features a daily red-baiting article with 2 inch headlines that condemn [Democratic] Gov. [Culbert L.] Olson, the NLRB [National Labor Relations Board], or Pres. Roosevelt."[1]

Stryker did not need to be told about California's politics. In fact, right-wing complaints about the migratory labor camps operated by the Farm Security Administration led him to send Rothstein to the state in the first place. California growers led the opposition, and their criticism was given voice in Washington by their lobbyists and congressional supporters. To counter the criticism, the agency needed to cast the camps in a good light. "I still want you to get to California and to get us a series of detailed pictures on the camps," Stryker had written early in March, "so we will quit being harassed so much by people around Washington for this particular type of photo."[2]

A program to construct camps for the Okies and Arkies who streamed into California was begun and abandoned by the state government in 1935 but quickly taken over by the Resettlement Administration.[3] In 1937 the program was passed on to the Farm Security Administration. By the end of the decade the agency was operating a dozen camps in California and several more in other parts of the West.[4] The Farm Security Administration continued the program during the war, when instead of coping with an excess

of workers, the problem had become one of "mobilizing" sufficient labor. In 1942 the Farm Security Administration had ninety-five camps with housing for seventy-five thousand people and also oversaw the importation of Mexican workers.[5]

Camps like Visalia were intended to be complete communities, not merely sites with temporary housing and sanitary facilities. This reflected the relatively permanent status of the migrants, the nearly year-round character of California's agriculture, and the sponsor's attitudes. The designations for the camps imply both their permanence and the Farm Security Administration's perception of their role. In 1940, according to the camp's newspaper, this facility was called the Visalia Migratory Labor Camp, but by 1942 the name had changed to the Tulare Farm Workers' Community.[6] In the 1942 "Victory Edition" of the community newspaper, the camp manager, Marshall E. Huffaker, said the community was part of a program "to conserve our national resources by preventing human erosion caused by poverty, sickness, insecurity and the loss of real home life and community responsibility."[7]

Huffaker went on to describe the administration of the camp: "From the very beginning, our Farm Workers' Communities have been organized and governed in the true American way—through self government." The camp featured an elected council to enact legislation, an elected community court to adjudicate violations of community laws, and committees to oversee other activities. But the camp was still a government operation, and the community manager "vetoes any Council legislation which violates laws of Federal, State and County, or regulations of the Farm Security Administration."[8]

California's growers and a significant portion of the state's business establishment viewed with suspicion any activity on behalf of migrant workers, including the creation of migrant camps. The growers would benefit from an oversupply of homeless, dependent workers. There had been strikes in California since the start of the Depression, and the growers feared unionization and continued labor unrest. They were accused of rigging pay scales and of inhibiting efforts to aid the migrants. During March 1940, the same month Rothstein visited Visalia, the New York Times carried a story about California's Associated Farmers organization.[9] The article quotes the organization's leaders as expressing pride in being "red baiters" and working against "subversive organizations." In John Steinbeck's 1939 novel The Grapes of Wrath the migrant Joad family had found succor—and had had their political consciousness raised—in a government farm labor camp.[10] Within a few months of the novel's publication Steinbeck's life was threatened.[11]

The camps were unpopular for other reasons, too. Businesspeople in the Imperial Valley complained about unfair competition from a cooperative store.[12] Charles L. Todd, a staff member at the Visalia camp, reported citizen unhappiness over the cost to local government of providing schools, health care, and the like to migrant families.[13] But above all, Todd said, the chorus of complaints held that a paternalistic government was sponsoring communism.

Stryker wanted photographs that showed polite, nonthreatening behavior, instructing Rothstein to "remember your emphasis

here is to see how people conduct themselves in and around the camp." Passing along advice from the Farm Security Administration's regional director, Stryker wrote, "With the fight as bitter as it is in California, Fred [Soule] feels that we now need to emphasize the positive side, and that mothers and children are our best bet. Get nurses treating children, mothers coming in for post-natal instruction—anything that will demonstrate child welfare work."[14]

Rothstein's methodical coverage of the Visalia camp added nearly two hundred images to the file, offering enough affirming photographs of the camp's facilities to gladden the heart of any publicist. He photographed the individual dwellings and gardens, the communal laundry and ironing room, and a wide range of organized recreational activities. The most striking pictorial aspect is the assemblage of close-up portraits, a device Rothstein also used in other series in the FSA-OWI Collection, which include his portraits of a Wisconsin farm family and the members of the Merchant Seamen's union at a New York City hiring hall.[15]

After complimenting the Visalia camp as "the best managed of all I have visited," Rothstein reported that he had captured the images Stryker had requested. "I received the flashbulbs just in time," he wrote on 1 April 1940. "I have been shooting so many pictures of babies & children in nurseries that the supply ran low sooner than I expected."[16] But neither Rothstein's photographs of mothers and children nor the other elements of the agency's publicity effort succeeded in quieting congressional dissatisfaction with the entire farm labor program. The controversy reached its climax in 1943, when the program was wrested from the Farm Security Administration and transferred to the newly created War Food Administration.

NOTES

1. Rothstein to Stryker, 1 April 1940, Stryker Collection.
2. Stryker to Rothstein, 2 March 1940, Stryker Collection.
3. Wayne D. Rasmussen, *A History of the Emergency Farm Labor Supply Program, 1943–47*, Agriculture Monograph no. 13 (Washington, D.C.: U.S. Department of Agriculture, Bureau of Agricultural Economics, 1951), 10–11.
4. Charles L. Todd, "The 'Okies' Search for a Lost Frontier," *New York Times Magazine*, 27 August 1939, 10.
5. Baldwin, *Poverty and Politics*, 222.
6. *The Hub* 1, no. 35 (26 July 1940); *The Hub* 3, no. 20 (14 June 1942). Several issues of *The Hub* are part of the Todd / Migratory Labor Collection.
7. *The Hub* 3, no. 20 (14 June 1942):2.
8. Ibid.
9. *New York Times*, 9 March 1940, from a scrapbook, Todd / Migratory Labor Collection.
10. Steinbeck, *The Grapes of Wrath*, 389–93.
11. *Los Angeles Times*, 9 July 1939, from a scrapbook, Todd / Migratory Labor Collection.
12. Scrapbook, unidentified clipping, Todd / Migratory Labor Collection.
13. Charles L. Todd, "Trampling Out the Vintage," *Common Cause* 8, no. 7 (July 1939):7–8, 30.
14. Stryker to Rothstein, 5 and 19 March 1940, Stryker Collection.
15. See lots 254 and 133.
16. Rothstein to Stryker, 1 April 1940, Stryker Collection.

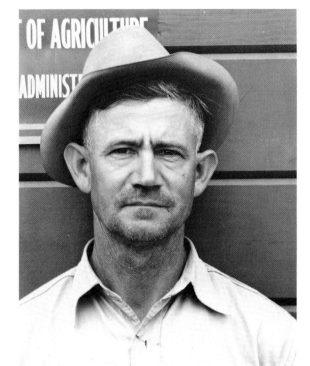

a

b

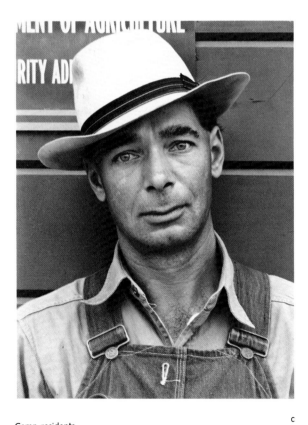

c

Camp residents.

d

a

b

c

d

e

f

g

Camp residents.

h

a. Steel cabins house individual families.

b. Vegetable garden in camp.

c. Embroidering a dish towel in a camp residence.

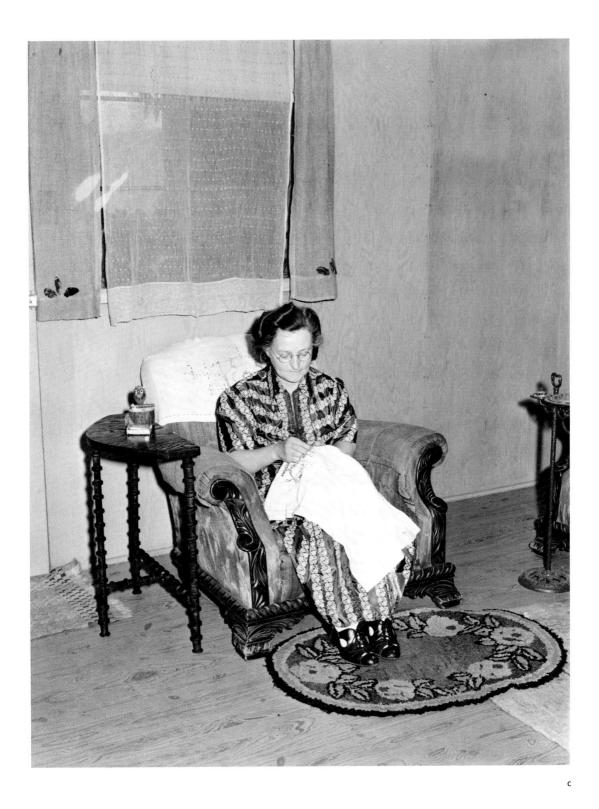

c

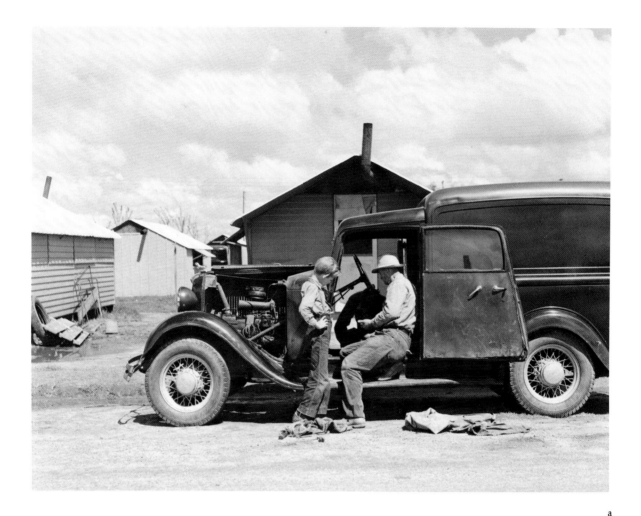

a

a. Fixing a truck.

b. Cooperative store meeting.

c. Mimeographing the camp newspaper.

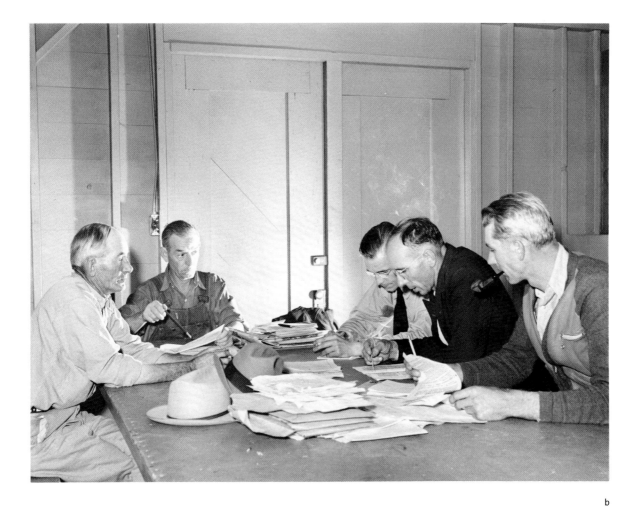

b

c

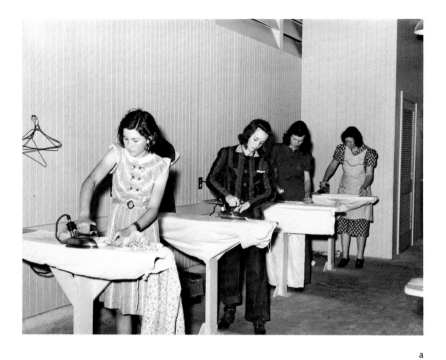

a

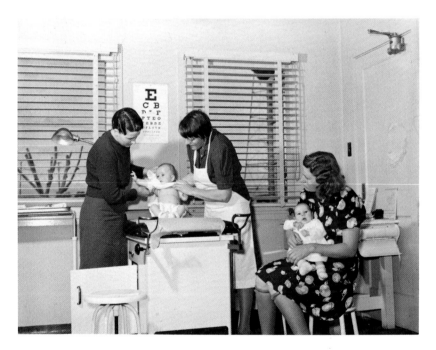

b

198 A R T H U R R O T H S T E I N

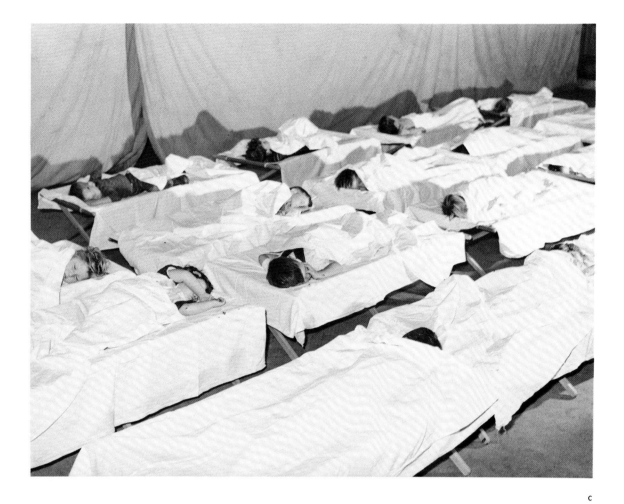

c

a. Ironing clothes in the utility building.

b. Well-baby clinic.

c. Rest period in the nursery.

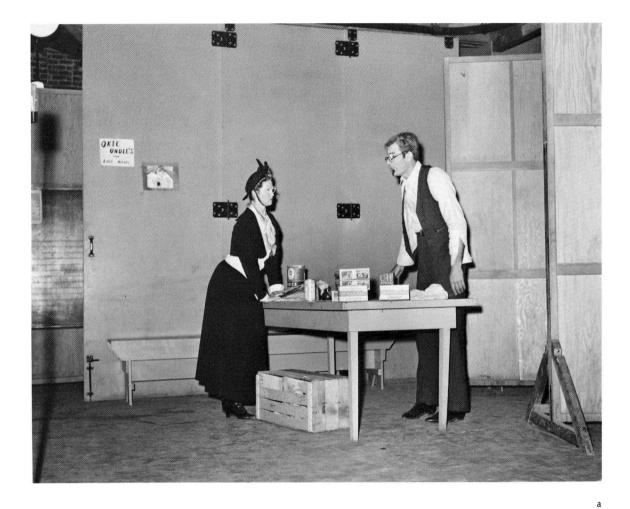

a

a. Troupe from the Arvin migratory labor camp performing
 a play for the residents of the Visalia camp.

b. Watching the play in the recreation hall.

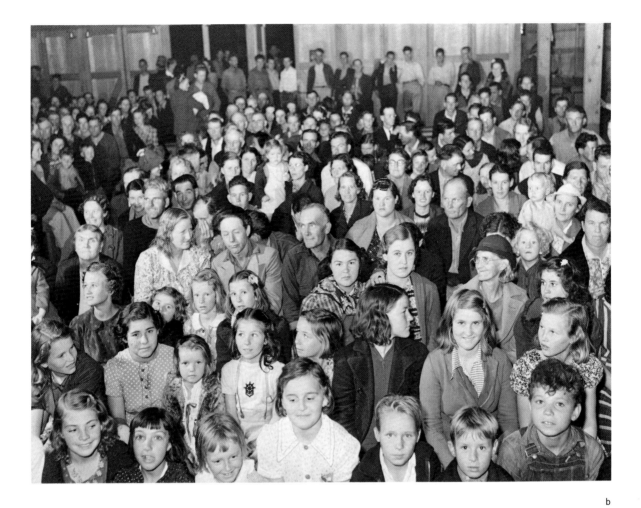

b

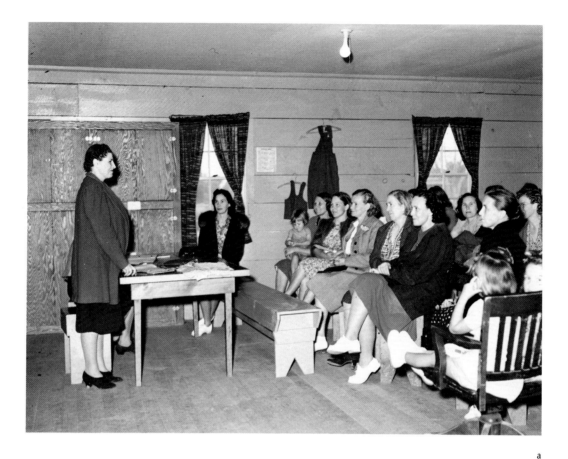

a

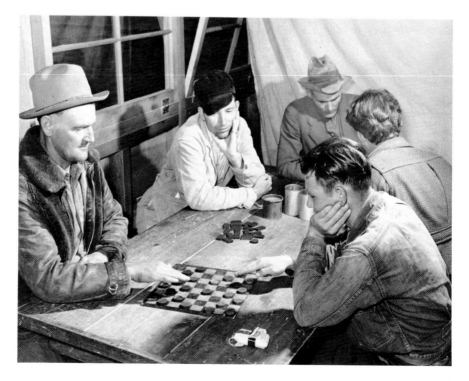

b

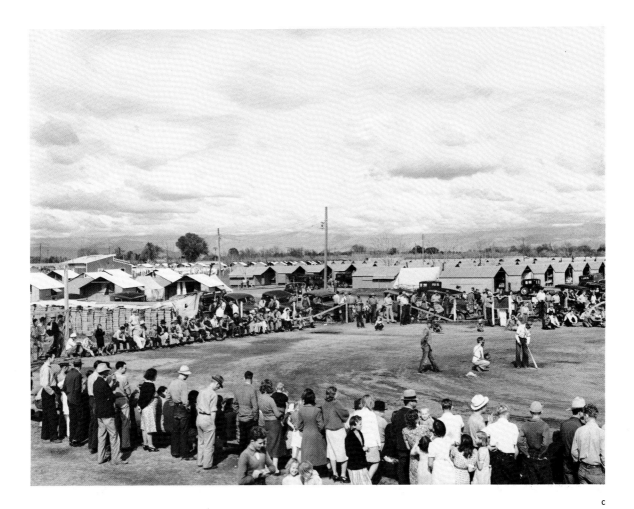

c

a. Womens' club.

b. In the recreation hall.

c. Baseball game.

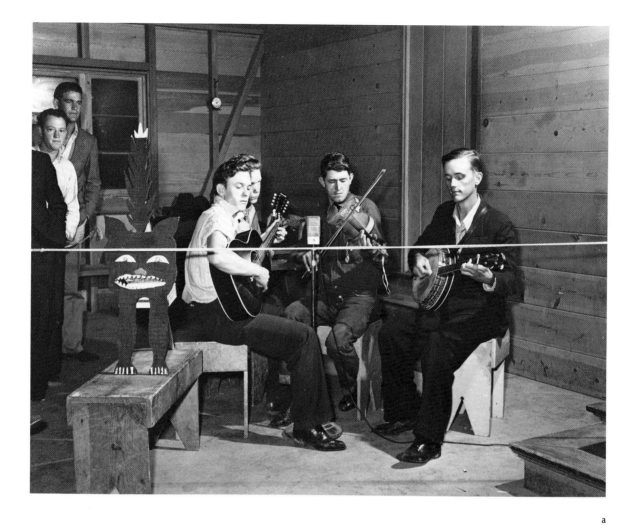

a

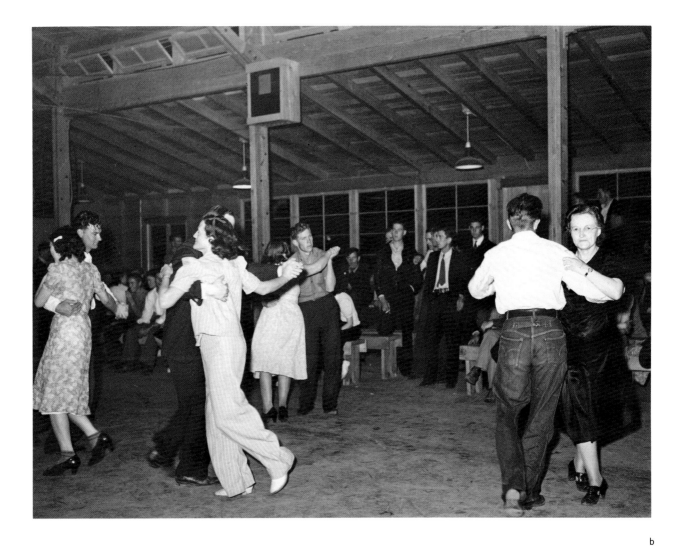

b

a. At a Saturday night dance; a string band with its kitty for contributions.

b. Saturday night dance.

I N D E P E N D E N C E D A Y

RUSSELL LEE

Vale, Oregon, 4 July 1941
Farm Security Administration, Lot 322

Russell Lee was in arid eastern Oregon to photograph the Vale and Owhyee irrigation projects in the spring of 1941. The Bureau of Reclamation, part of the Department of the Interior, had begun constructing the system's dams and canals during the 1920s, and the Farm Security Administration resettled farmers on the reclaimed land during the late 1930s. Lee had photographed several farm families by May, when another assignment took him to Caldwell, Idaho, about forty miles to the east. He returned in July to photograph Vale's Independence Day celebration.

Lee, who was born in Illinois in 1903, had studied chemical engineering before his interest in art led him to take up photography. In his biography of the photographer, F. Jack Hurley notes Lee's affection for the picture series and his willingness to document a phenomenon in exhaustive detail, speculating that this may reflect his training in science.[1] Roy Stryker, who hired Lee at the Resettlement Administration in 1936, described him years later as "a taxonomist with a camera."[2]

Lee and many of the other photographers in the section shared with Stryker an idealized vision of agrarian life in America. The powerful images of the rural poor they contributed to the file portray the ideal denied. Other photographs, however, depict its realization, and the most successful among these are the scenes of small-town life. Pictures of a courthouse square, Main Street, or a small-town livestock auction suggest the face-to-face interaction and mores of rural America even more effectively than do scenes of life on a farm. Two of Lee's most famous series are his extended portraits of the small towns of San Augustine, Texas (1939), and Pie Town, New Mexico (1940).[3]

Lee treats Vale's Independence Day celebration as an aspect of small-town life, portraying the day's activities not as miscellaneous and unconnected phenomena but as parts of a homogeneous event. The celebration is shaped by two "official" activities: the parade down Vale's main street in the morning and games and contests in the park in the afternoon. The photographs show the preparation of floats and costumes before the parade and the picnic lunches in the park between the parade and the afternoon's games. Lee creates a backdrop for these activities with his scenes of people in town for the holiday and of the action on the midway. Altogether, 133 photographs were added to the file from this event.

The normal rhythm of the day is broken by a midday grass fire that volunteer firemen extinguish. No one would prescribe such a mishap as a part of a celebratory event, and a public relations photographer hired by the sponsor would probably have been asked not to shoot it. Lee's inclusion of the fire indicates that his intent was descriptive, in contrast to the prescriptive approach of, say, Arthur Rothstein when he documented the FSA migrant camp at Visalia, California. Rothstein's assignment obliged him to show the camp as it was intended to be.[4]

Lee's descriptive approach and his unified interpretation of a complex event may have earned him the appellation "taxonomist," but his photographs are neither cold nor impersonal. The relationships between the men at the cafe, the children waiting for the parade to begin, and the motorcycle racers gathered around one of their machines are communicated by posture, gesture, proximity, and glance. Such evidence makes Lee's photographs of romantic love and family affection especially poignant, animating the photographs of the meal next to the auto, the nap after lunch, the motorcyclist and the young women, the father with his daughters on the merry-go-round, and the middle-aged couple who clasp hands during their midway ride.

Vale and the rest of the nation would undergo extreme change during the coming year. The pictures give no sense of America's defense mobilization effort and no hint that the attack on Pearl Harbor was but five months away. One of Lee's captions—which may have been written months later—calls attention to the prominence of patriotic themes in the parade. But all Independence Day parades are patriotic, and this hint is as ambiguous as the "America First" sign on one youth's costume. Does the slogan assert pride or express isolationism?

In his 1941 Fourth of July address President Roosevelt exhorted Americans not to imagine that they could defend themselves against the "new practices of tyranny" abroad without making a commitment to aid other nations, even to the extent of pledging, "if it be necessary, our very lives." Lee informs us that the baseball game was interrupted for the broadcast of this address, but he does not report the citizens' reaction to Roosevelt's ringing words: "I tell the American people solemnly that the United States will never survive as a happy and fertile oasis of liberty surrounded by a cruel desert of dictatorship."[5]

NOTES

1. F. Jack Hurley, *Russell Lee, Photographer* (Dobbs Ferry, N.Y.: Morgan and Morgan, 1978), 9–22.
2. From an interview by Richard Doud, 13 June 1963, quoted in Hurley, *Russell Lee, Photographer,* 14.
3. Selections from the San Augustine series have been published in Mark Adams and Russell Lee, "Our Town in East Texas," *Travel,* March 1940, 5–12; Sherwood Anderson, *Home Town* (New York: Alliance Book Corp., 1940), 23–29; and Hurley, *Russell Lee, Photographer,* 58–61. Selections from the Pie Town series have been published in Hurley, *Russell Lee, Photographer,* 82–85; Russell Lee, "Pie Town," *Creative Camera* 193/194 (July–August 1980): 246–53; and Hurley, "Pie Town, N.M., 1940," *American Photographer* 10, no. 3 (March 1983): 76–85. An exploration of a less-well-known Lee series from Northern New Mexico may be seen in William Wroth, ed., *Russell Lee's FSA Photographs of Chamisal and Peñasco, New Mexico* (Santa Fe: Ancient City Press, 1985).
4. "FSA Migratory Labor Camp," pages 188–205 of this book.
5. Samuel I. Rosenman, *The Public Papers and Addresses of Franklin D. Roosevelt* (New York: Harper and Brothers, 1950), 254–55. The speech may be heard on a captured German disk recording in the Motion Picture, Broadcasting, and Recorded Sound Division of the Library of Congress; LWO 6944 g. III r. 2, selection A3.

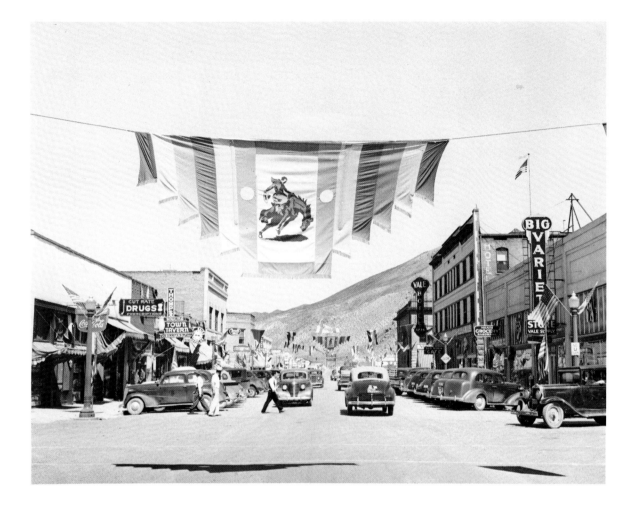

Looking east on Vale's main street.

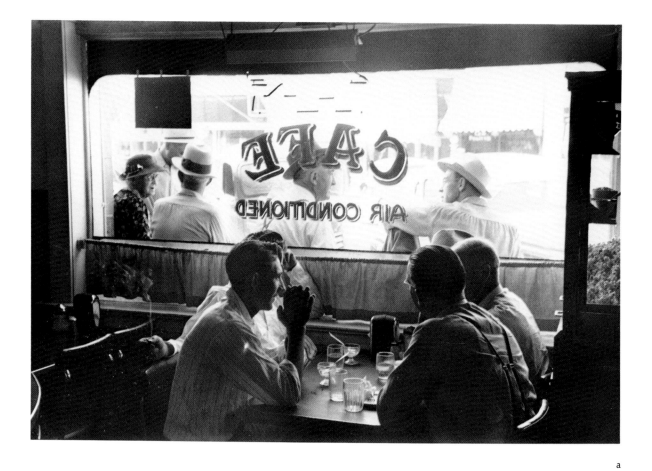

a

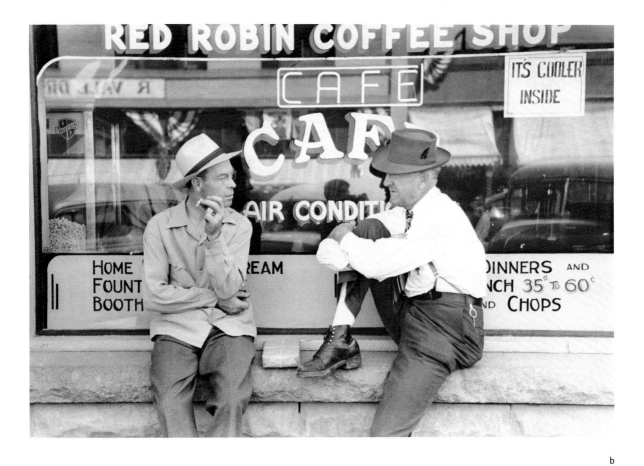

b

a. Cold drinks inside the Red Robin cafe.

b. Outside the Red Robin cafe.

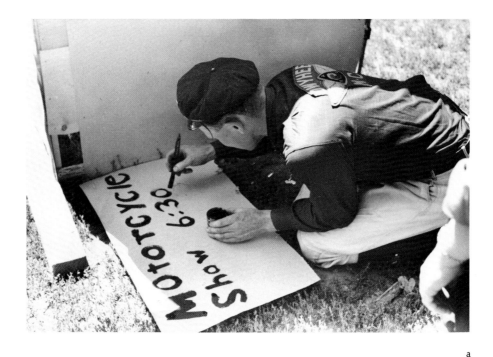

a

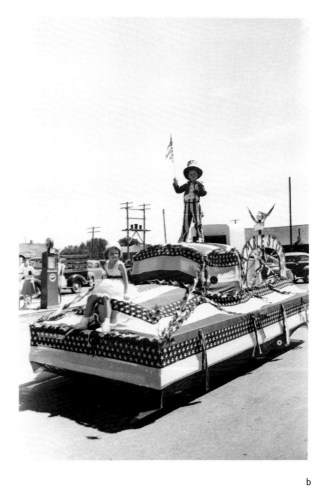

b

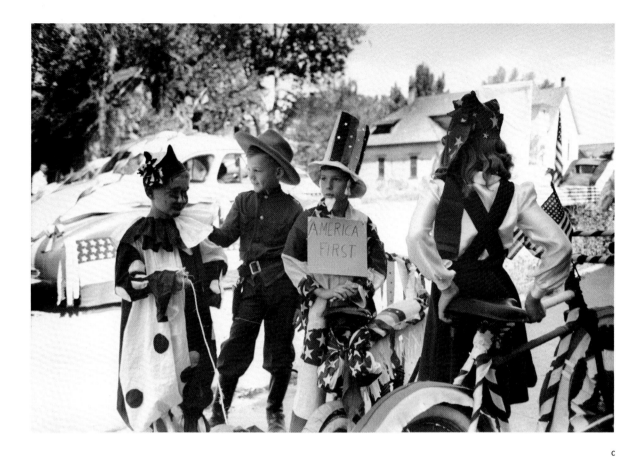

c

a. Preparing for the show.

b. Parade float.

c. Waiting for the parade to begin.

a

a. Watching the parade.

b. Motorcycle with stunt bars.

c. Lighting a firecracker.

a

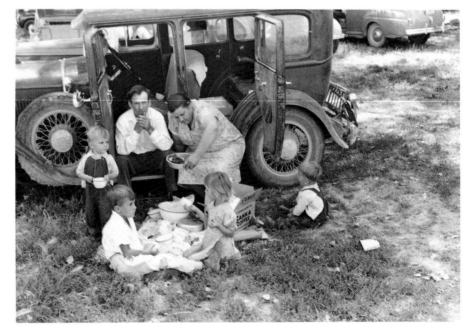

b

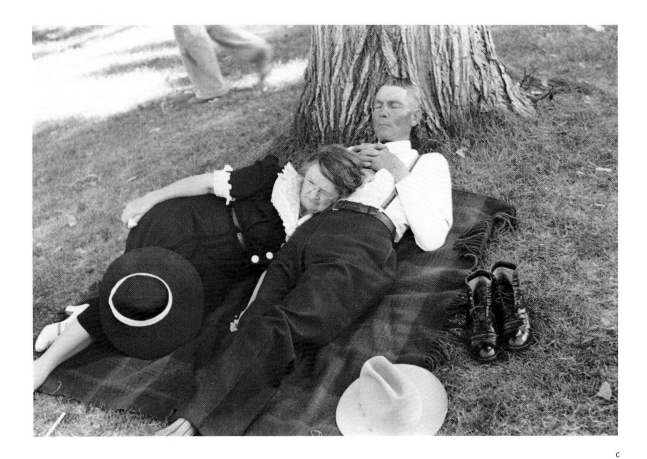

c

a. Fighting a grass fire.

b. Family picnic.

c. After lunch.

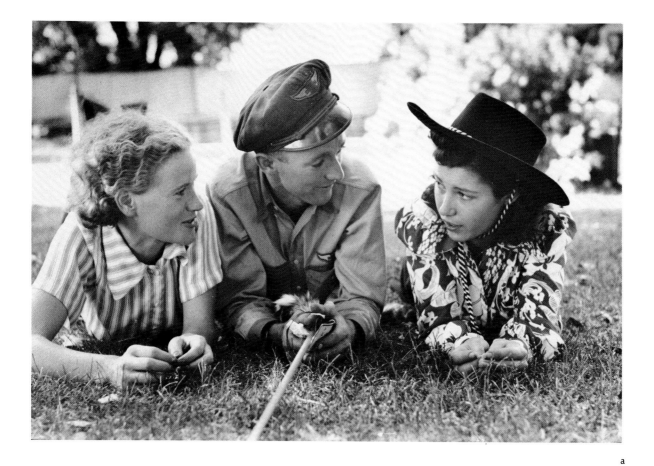

a

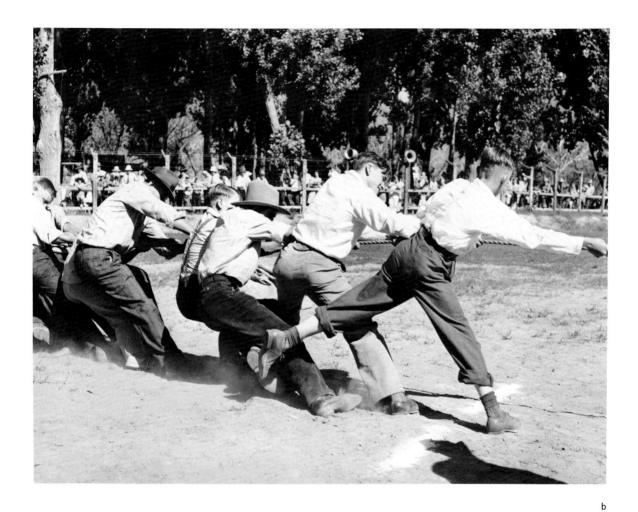

b

a. Motorcyclist and friends.

b. Tug-of-war.

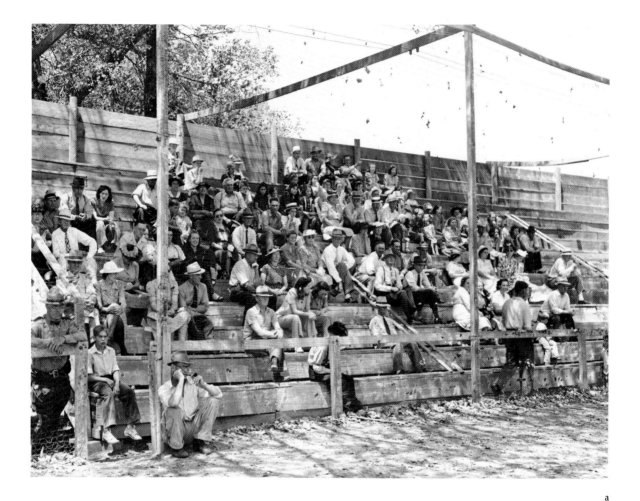

a

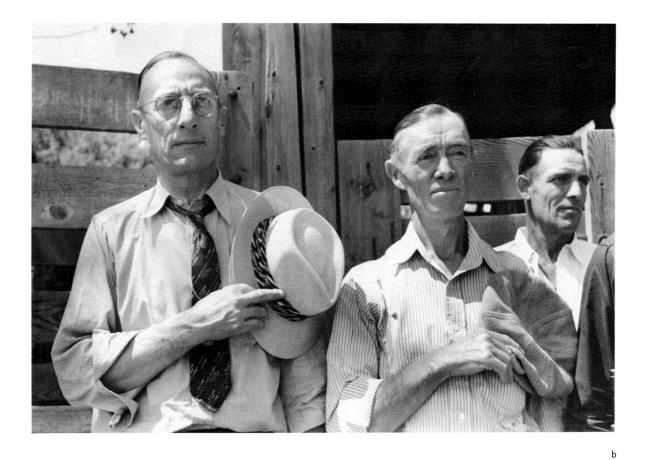

b

a. At the baseball game.

b. The pledge of allegiance at the ball field.

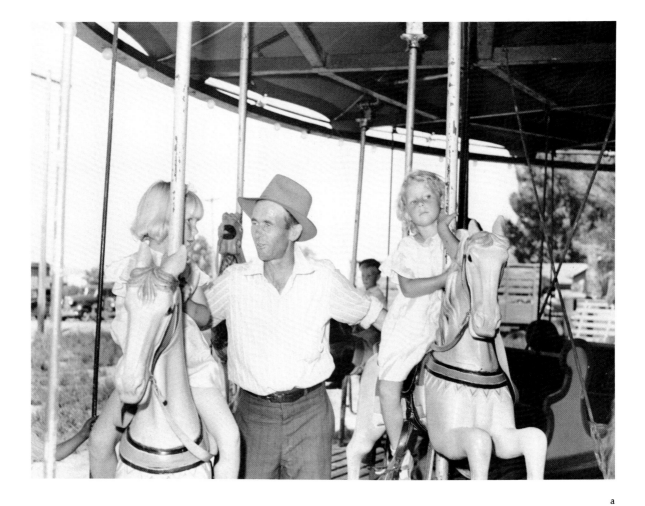

a

a. Father and daughters on the midway merry-go-round.

b. On the midway.

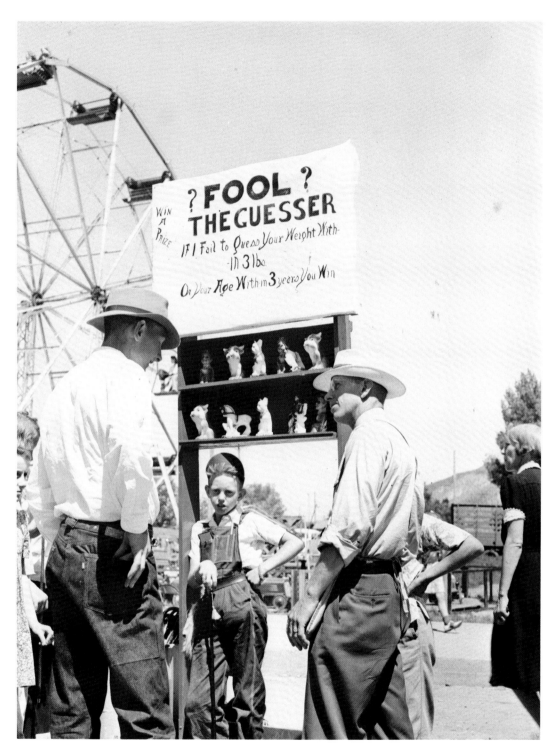

The text on the sign in the image reads:

WIN A PRIZE

? FOOL ?
THE GUESSER

If I Fail to Guess Your Weight Within 3 lbs

Or Your Age Within 3 years You Win

b

a

b

a. On the midway.

b. Decorations on the main street.

ELLA WATSON, U.S. GOVERNMENT CHARWOMAN

GORDON PARKS

Washington, D.C., July and August 1942
Farm Security Administration, Lot 156

Gordon Parks was born in Kansas in 1912 and spent his youth in Minnesota. During the Depression a variety of jobs, including stints as a musician and as a waiter on passenger trains, took him to various parts of the northern United States. He took up photography during his travels and by 1940 had made his first serious attempts to earn a living from the art as a self-taught fashion photographer in Minneapolis and Chicago. Though he had experienced racial discrimination outside the South, it was in the southern city of Washington, D.C., that Parks "found out what prejudice was really like." In 1942 an opportunity to work for the Farm Security Administration brought the photographer to the nation's capital; Parks later recalled that "discrimination and bigotry were worse there than any place I had yet seen."[1]

Parks came to Washington on a fellowship from the Julius Rosenwald Fund, a foundation dedicated to research on the South, which had a special program to encourage work of all kinds by promising blacks. In the irreverent words of the friend who told him about the program, "It's a fund set up for exceptionally able spooks and white crackers."[2] As a Rosenwald fellow, Parks joined the august company of Ralph Bunche, Zora Neale Hurston, James Baldwin, and many others.[3]

Parks, who had admired the Farm Security Administration photographs for some time, planned to spend his fellowship year as an apprentice photographer in Roy Stryker's section and had received encouragement from the FSA photographer Jack Delano when he was applying for the fellowship.[4] But when he arrived in Washington, he recalled in 1983, Stryker resisted, expressing worries about the reaction of others—in the agency as well as in the city—to a black photographer. "When I went there," Parks said, "Roy didn't want to take me into the FSA, but the Rosenwald people

were a part of that whole Rooseveltian thing. They insisted: 'Roy, you've got to do it.'" As Parks remembered it, Will Alexander—the vice president of the Rosenwald Fund and the former head of the Farm Security Administration and thus Stryker's old boss—gave the final nudge.[5]

Parks's autobiography and interviews emphasize the importance of the education Stryker gave him.[6] After asking Parks to leave his cameras in the office, Stryker sent the newly arrived photographer around Washington, instructing him to visit stores, restaurants, and theaters. When Parks was refused service, he became furious and returned to the office ready to "show the rest of the world what your great city of Washington, D.C., is really like," proposing to photograph scenes of injustice and portraits of bigots. In response, Stryker sent Parks to the file to study the work of Lange, Shahn, Evans, Delano, Rothstein, and others. Parks studied their photographs of gutted fields, dispossessed migrants, and the gaunt faces of people caught in the Depression. Although some might lay these tragedies to God, Parks wrote, "the research accompanying these stark photographs accused man himself—especially the lords of the land." As the effectiveness of photographing victims instead of perpetrators and the importance of the words that accompany photographs sank in, Parks concluded, "I began to get the point."[7]

One evening a few weeks later when he was alone in the office with Stryker, Parks said he was still seeking a way to expose intolerance with a camera. Stryker pointed out a charwoman at work in the building. "Go have a talk with her," he said. "See what she has to say about life and things." Parks complied, and he later recalled his first conversation with Ella Watson:

> She began to spill out her life's story. It was a pitiful one. She had struggled alone after her mother had died and her father had been killed by a lynch mob. She had gone through high school, married and become pregnant. Her husband was accidentally shot to death two days before their daughter was born. By the time the daughter was eighteen, she had given birth to two illegitimate children, dying two weeks after the second child's birth. What's more, the first child had been stricken with paralysis a year before its mother died.[8]

The information about Watson in the official files is considerably more understated than Parks's recollection. The captions and catalog card for the lot inform us that Watson's household included her adopted daughter and grandchildren and that her annual salary was $1,080. But these materials do not explain that the children were left with neighbors while Watson worked, nor do they highlight a detail Parks found telling. A woman—presumably white— who had a higher position occupied one of the offices Watson cleaned. But both women had started work at the same time, with the same accomplishments and education.[9]

Parks made his first photographs of Watson, two of which are included here, in an office with a large American flag on the wall. Both pictures are carefully posed, and the multiple shadows cast by

the office furniture indicate that Parks used an elaborate three-flash setup. The close-up version is one of his most famous photographs, serving as the frontispiece in Parks's word-and-picture poem *Moments without Proper Names,* a book dedicated to Stryker and containing a memorial poem for the Farm Security Administration photographer John Vachon.[10] Parks's autobiography describes Stryker's immediate reactions to the picture:

> My first photograph of [Watson] was unsubtle. I overdid it and posed her, Grant Wood style, before the American flag, a broom in one hand, a mop in the other, staring straight into the camera. Stryker took one look at it the next day and fell speechless.
> "Well, how do you like it?" I asked eagerly.
> He just smiled and shook his head. "Well?" I insisted.
> "Keep working with her. Let's see what happens," he finally replied. I followed her for nearly a month—into her home, her church, and wherever she went. "You're learning," Stryker admitted when I laid the photographs out before him late one evening. "You're showing you can involve yourself in other people. This woman has done you a great service. I hope you understand this." I did understand.[11]

The later pictures in the series were less polemical than this initial image. "That was my first lesson in how to approach a subject," Parks said later, "that you didn't have to go in with all horns blasting away."[12] This selection, drawn from the ninety images selected for the file, includes the view from Watson's window near Washington's Logan Circle, omits pictures of her neighborhood grocery and Chinese laundry, and emphasizes the activities at Saint Martin's Spiritual Church, which was the subject of more photographs than any other aspect of Watson's life. In the photograph of Watson being anointed at the altar, a double exposure adds to the background the ghostly figures of another parishioner and Reverend Gassaway. Although the double exposure may have been an accident, the photograph's suggestion of the spirituality of the service is effective.

Several of the photographs attest to Parks's concern for arrangement and lighting, including some in which reflections in mirrors play a significant role. Two of these are presented here. One serves as a portrait of an extended family: Watson and her grandchildren sit in the kitchen, her adopted daughter is seen reflected in the bureau mirror, and between them a man and a woman look out from a photograph in a picture frame. Parks does not identify the couple, but they are probably Watson and her husband or perhaps her parents. In another mirror photograph the reflected image of two grandchildren stands behind Watson's home shrine, implying her equal affection for family and religion. Parks made extensive use of flash, not only in these photographs but also in pictures like the one of Watson sweeping the office floor, illuminated by a flashgun under a desk.

In 1983, when Parks reflected on the lessons he had learned from photographing this series, his thoughts returned to the matter of intolerance. He told an interviewer that he could not simply photograph the person who had discriminated against him "and say, 'This is a bigot,' because bigots have a way of looking just like everybody else. What the camera had to do was expose the evils of racism, the evils of poverty, the discrimination and the bigotry, by showing the people who suffered most under it."[13] In the same interview he underscored the reasoning behind the title of his 1965 autobiography, *A Choice of Weapons:* "I have always felt as though I needed a weapon against evil."[14] Parks's weapon is the camera.

NOTES

1. Martin H. Bush, "A Conversation with Gordon Parks," in Martin H. Bush, *The Photographs of Gordon Parks* (Wichita: Wichita State University, 1983), 36.
2. Gordon Parks, *A Choice of Weapons* (New York: Harper and Row, 1966), 208.
3. Dykeman and Stokely, *Seeds of Southern Change*, 183–85, 268–69.
4. Hurley, *Portrait of a Decade*, 158.
5. Bush, "A Conversation with Gordon Parks," 56.
6. Parks, *A Choice of Weapons*, 220–51; interview with Gordon Parks by Richard Doud, 28 April 1964, Archives of American Art, Smithsonian Institution; Bush, "A Conversation with Gordon Parks," 36–38, 56–58.
7. Parks, *A Choice of Weapons*, 226–28.
8. Ibid., 230–31.
9. Ibid.
10. Gordon Parks, *Moments without Proper Names* (New York: Viking Press, 1975).
11. Parks, *A Choice of Weapons*, 231.
12. Interview with Gordon Parks by Richard Doud, 28 April 1964, quoted in Hurley, *Portrait of a Decade*, 158.
13. Bush, "Conversation with Gordon Parks," 38.
14. Ibid., 42.

a

a. Ella Watson, right, and her adopted daughter.

b. View from Ella Watson's window.

c. Ella Watson's adopted daughter.

b

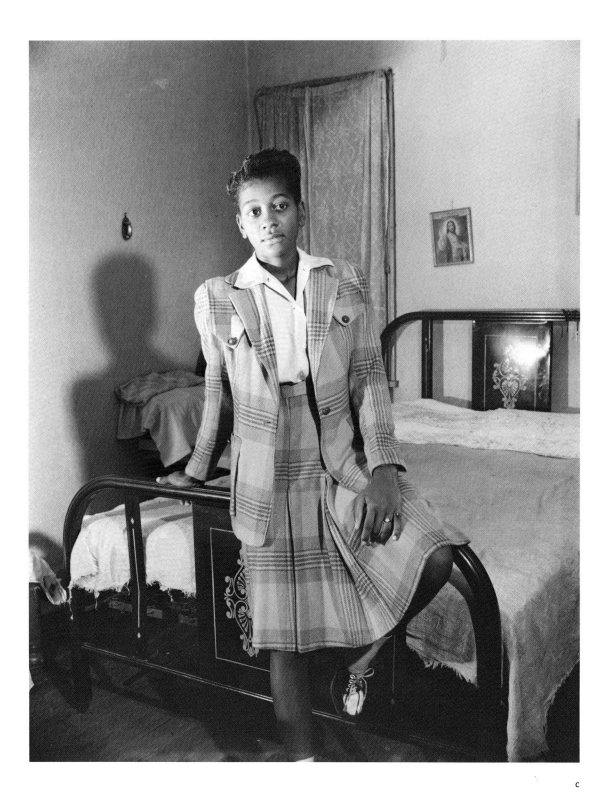

c

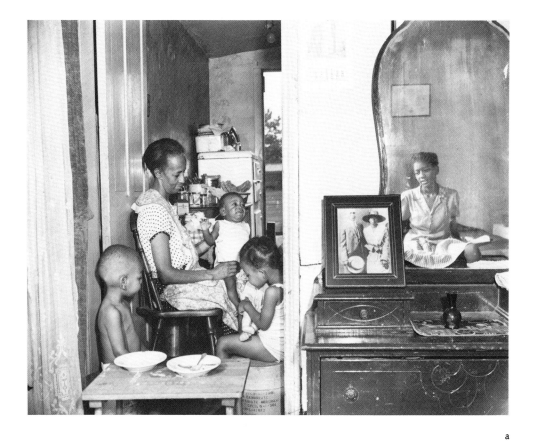

a

a. Ella Watson with three grandchildren and adopted daughter.

b. Leaving for work at 4:30 P.M.

c. Cleaning a government office at night.

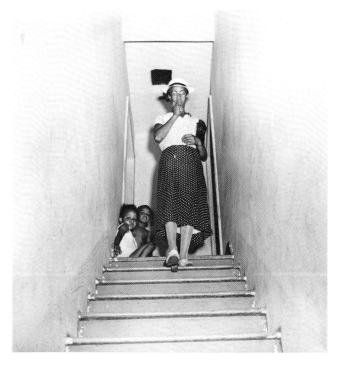

b

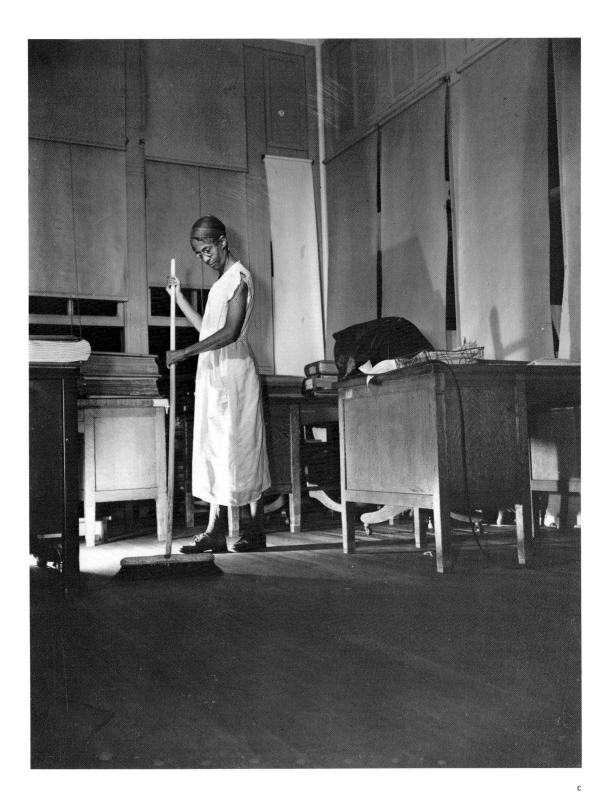

c

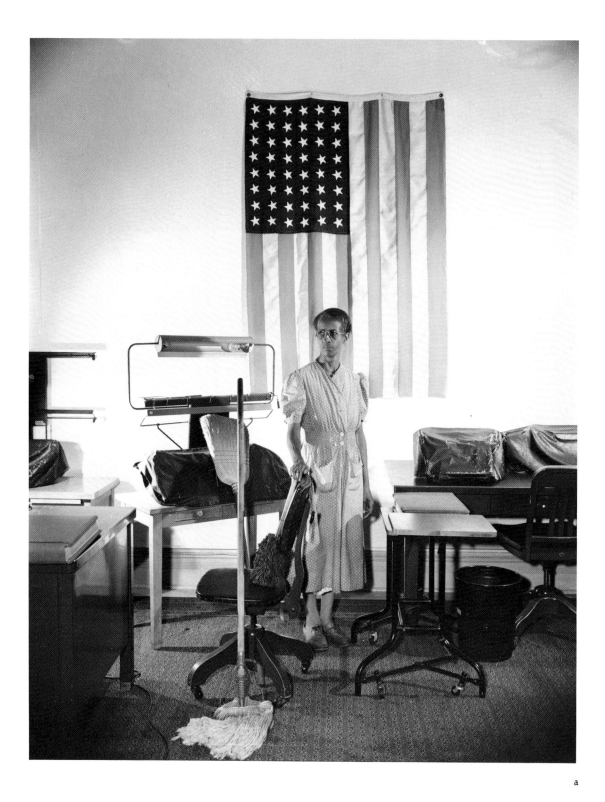

a

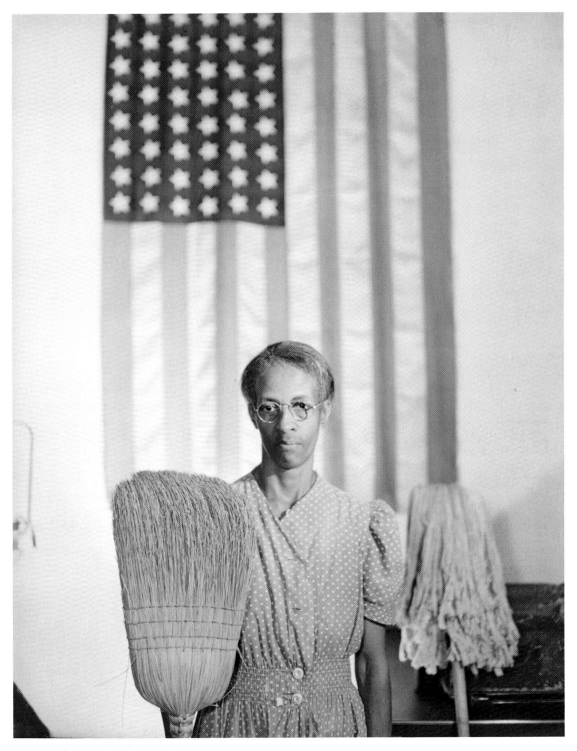

b

a and b. Ella Watson.

a

a. The Reverend Vondell Gassaway preaching the Sunday sermon at Saint
Martin's Spiritual Church.

b. Ella Watson waiting to participate in Saint Martin's annual flower bowl ceremony.

c. Reverend Gassaway stands in a bowl of sacred water banked with the roses that
he blesses and gives to celebrants.

b

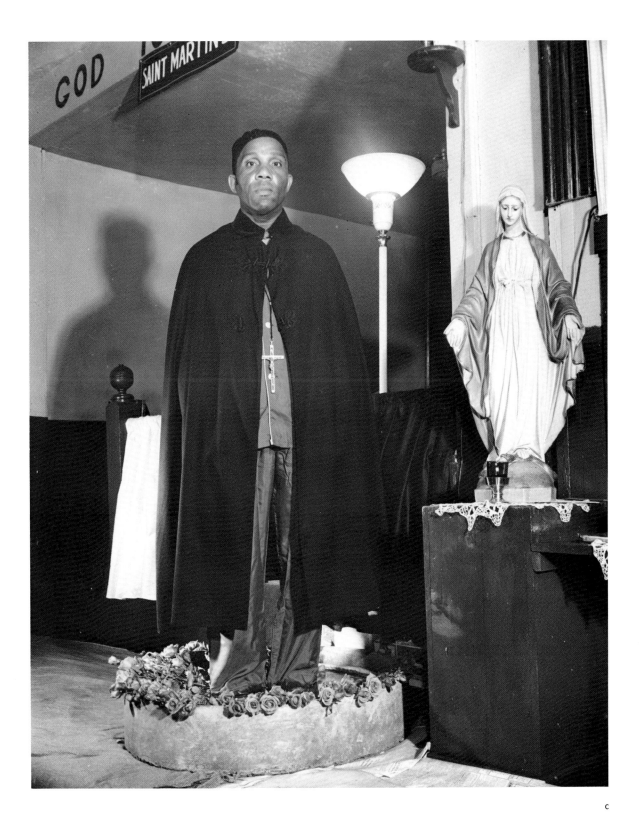

c

ELLA WATSON, U.S. GOVERNMENT CHARWOMAN 237

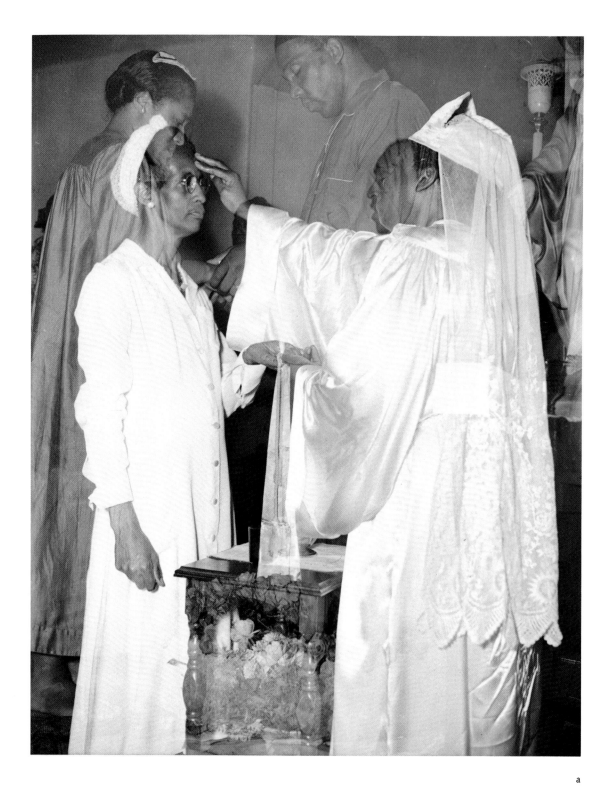

a

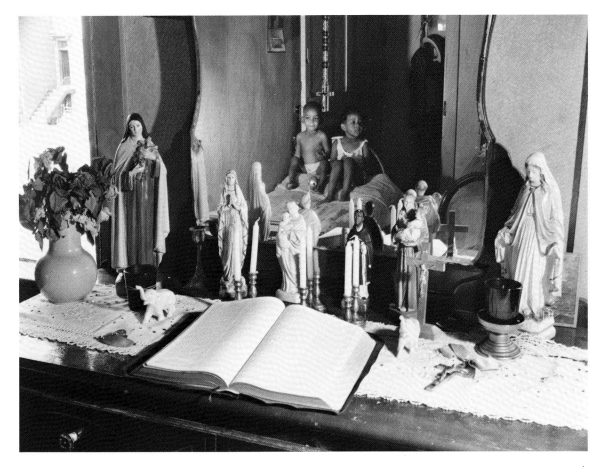

b

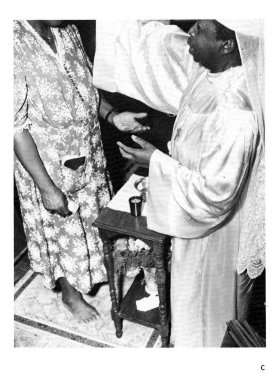

a. Ella Watson receiving a blessing and anointment from Reverend Smith; a second exposure depicts another celebrant receiving a rose from Reverend Gassaway.

b. Home altar on Ella Watson's dresser top.

c. A flower bowl ceremony participant, with contribution in hand, receiving a blessing and anointment from the Reverend Clara Smith.

c

J A P A N E S E R E L O C A T I O N

RUSSELL LEE

California, April and May 1942
Farm Security Administration, Lot 293

During the spring of 1942, Russell Lee was in California making photographs to extol the growth of guayule farming. This native American plant is a source of rubber, and as the Asian rubber supply was closed off, the government and private industry tried to increase its cultivation. Lee was aware of the public relations aspects of this assignment; the preceding December he had written Roy Stryker about the American Rubber Company's experiments with guayule, adding, "I expect they welcome any attention from the government because they need money to continue operations."[1]

Not all of the Farm Security Administration's wartime agricultural stories emphasized industry and productivity. The same caption sheets in the FSA file that identify Lee's negatives from the guayule fields near Monterey also contain the captions for his pictures of Japanese-Americans in San Benito County and the nearby town of Salinas as they prepared for their forced transfer to what were euphemistically named "relocation camps."[2] Following the attack on Pearl Harbor in December 1941, the West Coast experienced a wave of fear and anti-Oriental hysteria. A number of politicians and military commanders pushed hard for the removal from California, Oregon, and Washington of the 110,000 residents of Japanese ancestry, about two-thirds of whom were U.S. citizens. The nearly 40,000 classified as "enemy aliens" were immigrants who had been denied citizenship because of their national origin.

In February 1942 President Roosevelt signed Executive Order 9066 authorizing the secretary of war to prescribe military areas "with respect to which the right of any person to enter, remain in, or leave shall be subject to whatever restrictions the Secretary of War or the appropriate Military Commander may impose in his discretion." Through the spring and early summer the Japanese were moved first to "reception centers" and then to the relocation camps in the barren interior of the West. Historians argue that the Japa-

nese on the West Coast posed no threat and point out that no collective actions were taken against the Japanese in Hawaii—a larger group than on the mainland—or against German- or Italian-Americans.[3]

The Farm Security Administration had two connections to the effort. Its primary task was to recruit farmers to operate the six thousand farms vacated by the Japanese in the middle of the growing season. It is ironic that an agency devoted to improving the self-sufficiency of small farmers should have been forced to participate in the eviction of such a productive group. In the words of the historian Sidney Baldwin, the agency undertook the assignment "with considerable reluctance."[4] But the Farm Security Administration performed the task with dispatch, resettling new operators within two months at a cost of about $3.5 million. In the course of this work the agency did its best to protect the interests of the evicted Japanese and earned the sobriquet "Jap-Lover." The second, relatively minor, task involved arranging for a few hundred Japanese to work as paid migrant laborers on farms in remote sections of eastern Oregon, eastern Washington, and Idaho. In 1942 volunteer workers were sought at the reception and relocation centers and transported to Farm Security Administration migrant camps for the season.[5]

Why was Lee sent to photograph the relocation effort? The Farm Security Administration may have requested the photographs as part of its ongoing documentation of agency activities; in any case, no letters from Stryker regarding the assignment seem to have survived. Lee did not limit his photography to the aspects of the evacuation in which the agency was involved. His photographs show not only Japanese farmers in rural California and, in a separate series not included in this book, Japanese sugar beet workers based at an FSA migrant labor camp at Nyssa, Oregon, but also Little Tokyo (the Japanese enclave in urban Los Angeles) and the reception center that had been hastily constructed at the Santa Anita racetrack east of the city. All 263 of the photographs that were added to the file were made in April and May 1942.

Some of the photographs speak of the direct confrontation between authority and innocence: citizens wearing identification tags waiting with their belongings, uniformed men inspecting luggage and guarding people waiting in line to register, and the Santa Anita track covered by rows of barrackslike housing. Other pictures show citizens reading the evacuation orders or preparing to dispose of their property. The photograph of a street in Little Tokyo—the opening shot in this series—is unimpressive in visual terms but derives its impact from our knowledge of what happens next.

A few of the photographs are ironic. The last meal before the Japanese are evacuated from San Benito County consists of all-American hot dogs and apple pie, and the file also contains another photograph of this scene in which an American flag is prominently displayed behind the serving table. In this case, the irony is provided by Japanese evacuees, who devised a menu for their last meal in freedom to communicate that they were American citizens. In the photograph of the boy with his comic books and chocolate bar, it is the photographer who has supplied the irony. The picture says clearly, "This is the enemy we have sent to camp!"

NOTES

1. Lee to Stryker, 19 December 1941, Stryker Collection.
2. Captions for negatives 71563–74071, box 11, FSA-OWI Written Records.
3. Eugene V. Rostow, "The Japanese American Cases—A Disaster," in *The Shaping of Twentieth Century America: Interpretive Essays*, ed. Richard M. Abrams and Lawrence W. Levine (Boston: Little, Brown, 1971); Dorothy Swaine Thomas and Richard S. Nishimoto, *The Spoilage* (Berkeley: University of California Press, 1946); Dorothy Swaine Thomas, *The Salvage* (Berkeley: University of California Press, 1952); Edward H. Spicer et al., *Impounded People: Japanese-Americans in the Relocation Centers* (Tucson: University of Arizona Press, 1969); and Maisie Conrat and Richard Conrat, *Executive Order 9066: The Internment of 110,000 Japanese Americans* (Cambridge: MIT Press, 1972).
4. Baldwin, *Poverty and Politics*, 227–28.
5. The only report about the program that we have seen is dated 1942; it may have continued in following years. Supplementary Reference file 292, box 19, FSA-OWI Written Records.

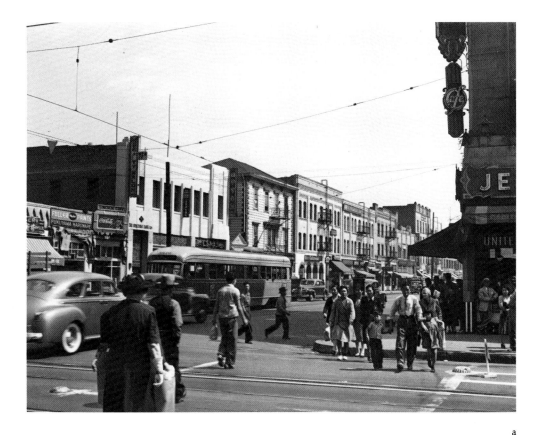

a

a. Little Tokyo, Los Angeles.

b. Reading evacuation orders on a bulletin
board at Maryknoll Mission.

b

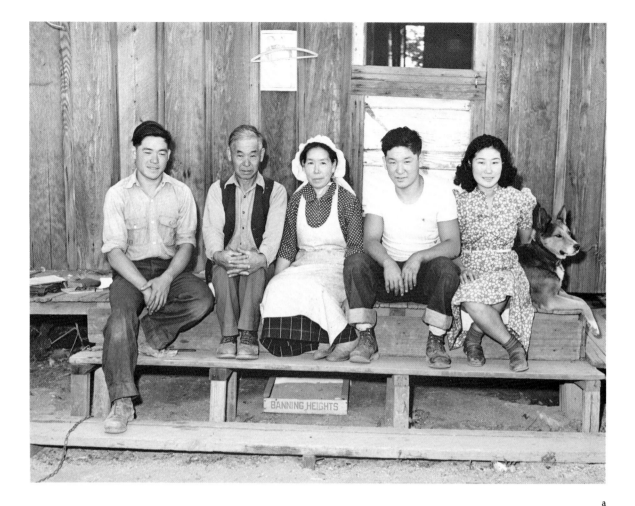

a

a. Farm family, Los Angeles County. The man at the left
 is also pictured in the following two photographs.

b. A farmer packing his tools before he is relocated,
 Los Angeles County.

c. A farmer about to be relocated shows his equipment
 to a prospective buyer, Los Angeles County.

b

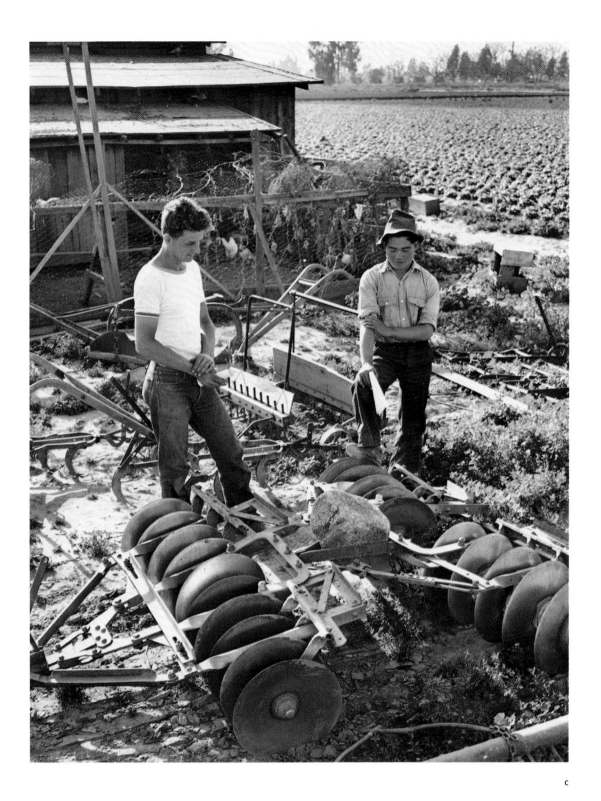

c

a

b

c

a. A farmer awaiting final evacuation orders, San Benito County, California.

b. Shop in Little Tokyo, Los Angeles.

c. Cleaning the cemetery before evacuation, San Benito County.

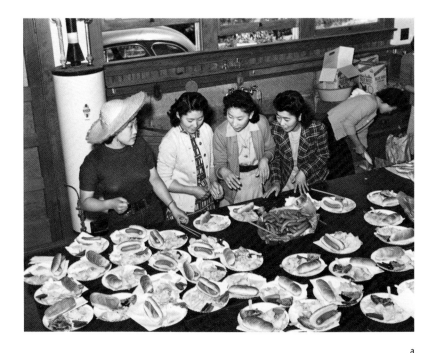

a

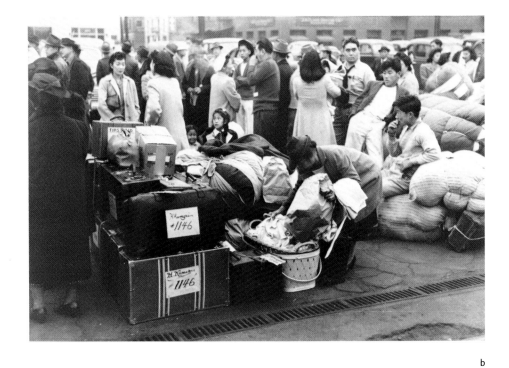

b

a. Picnic lunch for members of the Japanese-American citizens' league just before
 their evacuation, San Benito County.

b. Waiting for the train to Owens Valley, Los Angeles.

c. Child tagged for evacuation, Salinas.

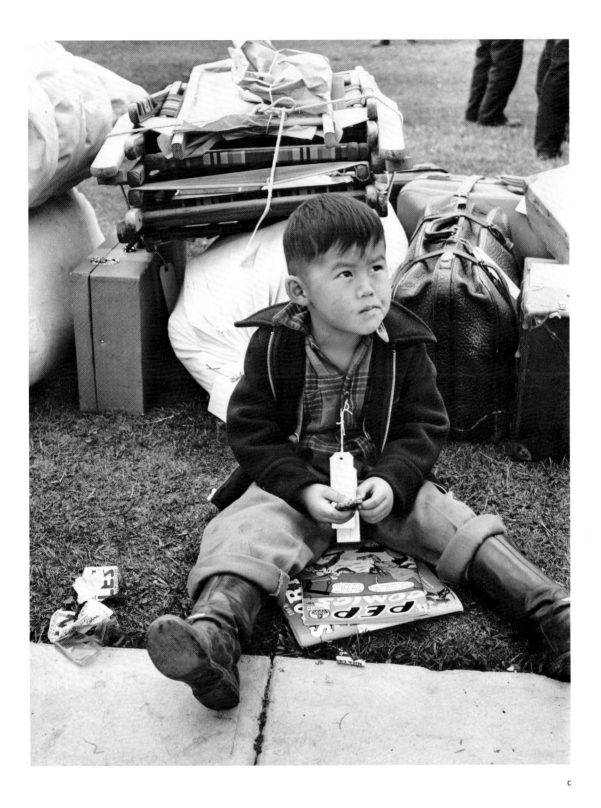

c

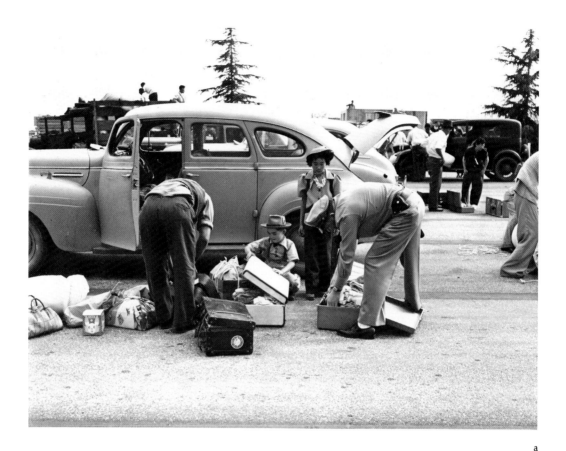

a

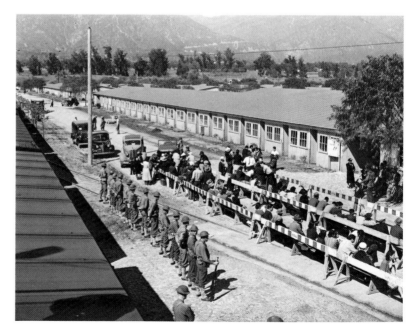

b

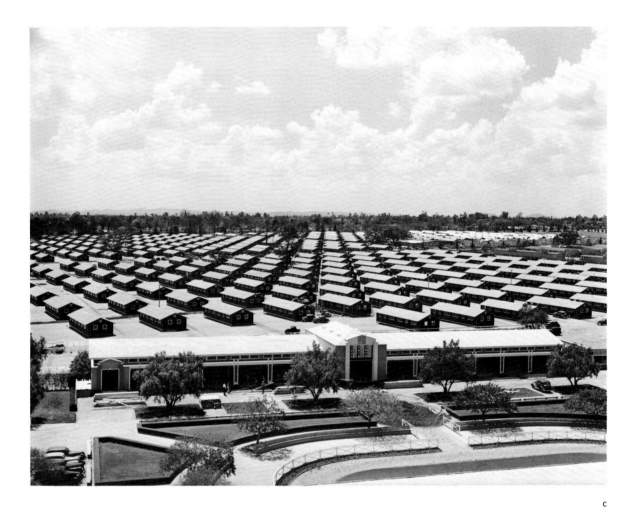

c

a. Examining the baggage of evacuees at the Santa Anita reception center.

b. Waiting to register at the Santa Anita reception center.

c. Housing at the Santa Anita reception center.

S M A L L T O W N I N W A R T I M E

MARJORY COLLINS

Lititz, Pennsylvania, November 1942
Office of War Information, Lots 258–261

Although Marjory Collins has given us one of the few photographic self-portraits made by an FSA-OWI photographer, the collection contains hardly any documents that pertain to her work or life during the time she worked for Stryker. Born in 1912, she grew up in Scarsdale, New York, and studied photography with Ralph Steiner in the 1930s.[1] After a stint as a photographer in New York City, she came to Washington, D.C., where Roy Stryker hired her at the Farm Security Administration in 1941 or 1942. The archivist Paul Vanderbilt recalled in 1986 that Collins did not have a close working relationship with her boss.[2]

Stryker's section had begun covering defense topics as early as 1940, and many of Collins's assignments document aspects of war mobilization. As the war neared and especially after Pearl Harbor, Stryker struggled to keep his section at the Farm Security Administration and to find a new role for it. A shooting script that he sent out in February 1942 was consistent with this new direction and might well have guided Collins's photography of Lititz, Pennsylvania, later that year. The script called for pictures of rubber tires and scrap metal for recycling, automobiles in used-car lots, and signs that suggested the effects of the war. The script also outlined coverage of the small town during the conflict: civil defense activities, selective service registration, home gardens, and "meetings of all kinds." People should "appear as if they really believed in the U.S."[3]

Despite his efforts to stay at the Farm Security Administration, Stryker's section was moved to the Office of War Information in October 1942. As these photographs of Lititz demonstrate, the move did not transform the section's documentation effort. The Lititz series manifests the same optimistic and uplifting spirit as the small-town stories Stryker's photographers produced before the

252

threat of war began to dominate the nation's consciousness.[4] The focus on defense mobilization is also present, although not carried to the extreme of a story idea that John Collier, Jr., submitted to Stryker in May 1942, which seems not to have been executed. "Girl in small southern town at age of seventeen writes competition essay on government housing," Collier wrote, spinning out a tale in which the girl wins the prize, raises her status by taking a business course, and meets an eligible bachelor with good prospects. "Man gets defense job, cannot get married because of no place to live, gets allotted to housing project, marriage huge success, wife gets job as secretary at powder plant and they have lived happily ever after."[5]

The Lititz series does not include a love story as fully developed as Collier's but does portray a young wife who works in an ammunition plant and lives with her parents while her husband is away in the service. Taken together, Collins's 272 photographs show a town hard at work. The connection between the war and the activities in the pictures is often established by the captions, longer and more complete than most in the FSA-OWI file.

Located about ten miles north of Lancaster in Pennsylvania Dutch country, Lititz was founded as a Moravian settlement in the mid-eighteenth century and, as Collins's pictures show, remained the home of a Moravian church and Mennonite citizens. The town is not entirely German, however; the photographs introduce us also to people named Almoney, Haines, and Dougherty. These pictures and the accompanying texts in the file show none of the prejudice against Americans of German ancestry so common during the First World War.

The American Press Association, a trade group serving the nation's weekly papers, helped distribute Collins's Lititz photographs and ran a twenty-five-picture version of the story in the June 1943 issue of its own journal.[6] In deference to its membership, the story emphasized the role of the local newspaper: three photographs of William N. Young, the publisher of the *Lititz Record-Express*, are captioned, "Ye editor, to whom everyone turns for news and guidance . . ." The matter of ethnicity is barely mentioned, appearing most explicitly in the caption of the picture of a refugee who had been a German soldier during the last war and who now makes bullets for the Allies. "The people of Lititz," we are told, "treat him as a good American."[7]

The Office of War Information's domestic propaganda frequently stressed the importance of converting existing factories to the production of war matériel, and this series shows how Lititz's Animal Trap Company turned to manufacturing bullets. And we are shown how wartime shortages have left the peanut vendor without peanuts and how the departure of young men for the service has left wives and mothers alone and the barber with far fewer customers. Collins's report on Lititz is a catalog of the community's occupations, activities, and individuals, including the butcher, the pretzel baker, and the munitions maker—as well as draft board members, housewives, the borough council, and schoolchildren. It is polite and positive—we never meet the town drunkard—but it takes in a swath of the social spectrum as broad as that addressed by the interviews of a sociologist or ethnographer.

NOTES

1. Biographical information is from a description of a collection of Marjory Collins's papers at Schlesinger Library, Radcliffe College, and from T. J. Maloney, ed., *U.S. Camera 1942* (New York: Duell, Sloane, and Pearce, 1941), 128.

2. Interview with Paul Vanderbilt by Nicholas Natanson, 28 August 1986, *Documenting America* Project Records.

3. The script is reproduced in Stryker and Wood, *In This Proud Land,* 188.

4. Two well-known examples are Russell Lee's stories about Pie Town, New Mexico, and San Augustine, Texas; see page 208, note 3, of this book. Stryker's small-town initiative is discussed in Hurley, *Portrait of a Decade,* 98–102.

5. Collier to Stryker, 31 May 1942, Stryker Papers.

6. Roy E. Stryker, "Gossip Sheet," 16 April 1943, Stryker Collection; and "A Small Town Goes to War . . . ," *American Press* 61, no. 8 (June 1943):6–16.

7. "A Small Town Goes to War . . . ," 16.

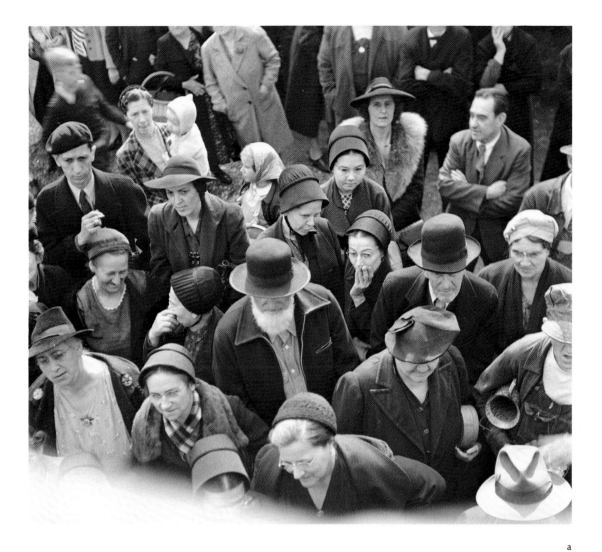

a. Bidders at an auction.

b. Self-portrait at an auction.

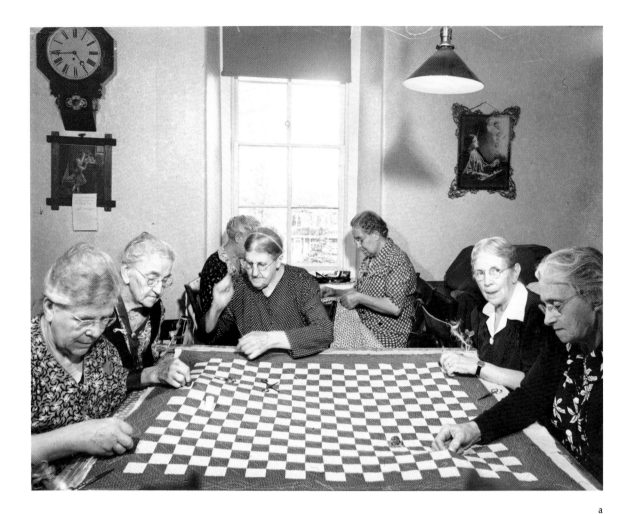

a

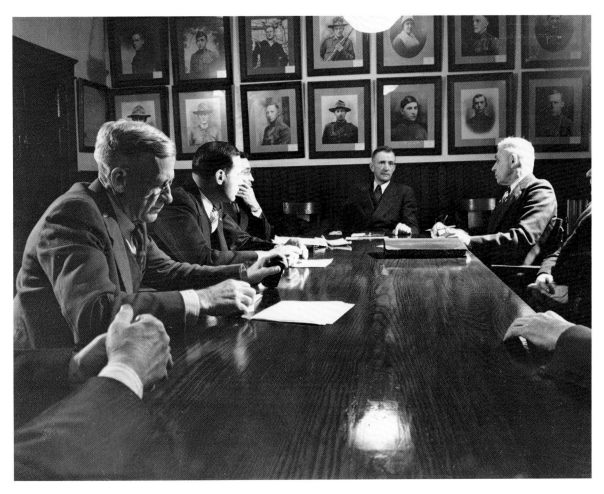

b

a. The Moravian church sewing circle. The circle's income is donated to the church.

b. The Lititz borough council meeting in a room decorated with pictures of local
people who had served in earlier wars.

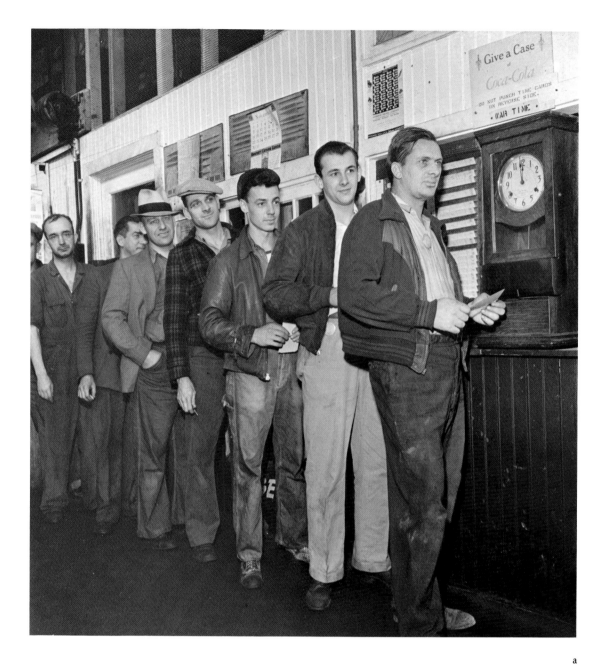

a

a. Punching out for lunch at the Animal Trap Company. This firm was converted
 to the production of ammunition during the war.

b. Father and son Lewis and Bob Haines packing pretzels at their Lititz Springs Pretzel Company.

c. Bill's Peanut Stand and Lutz's Central Market. According to the file caption, the
 shortage of peanuts reflected the heavy use of peanut oil by industry.

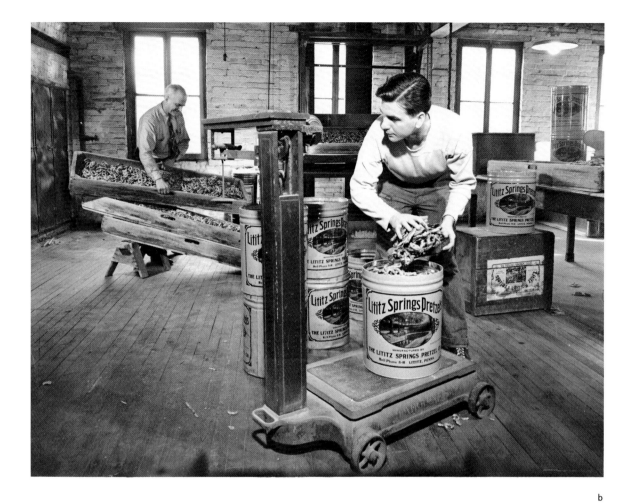

b

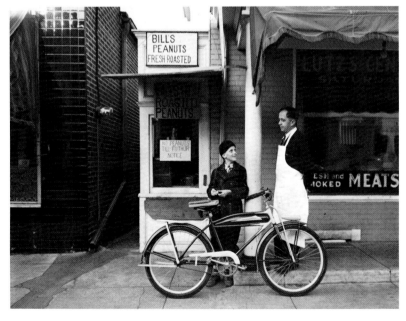

c

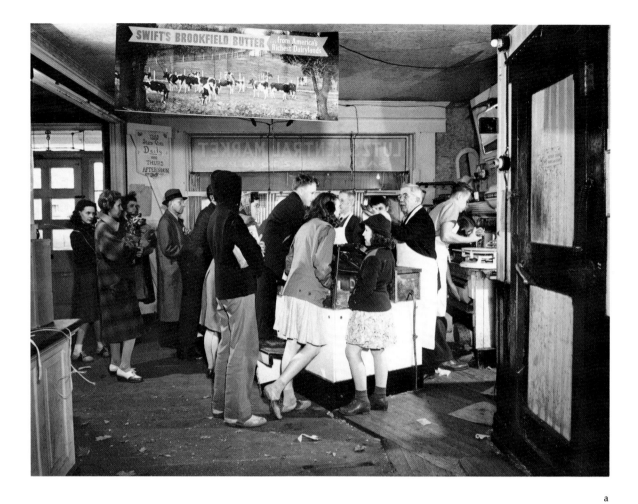

a

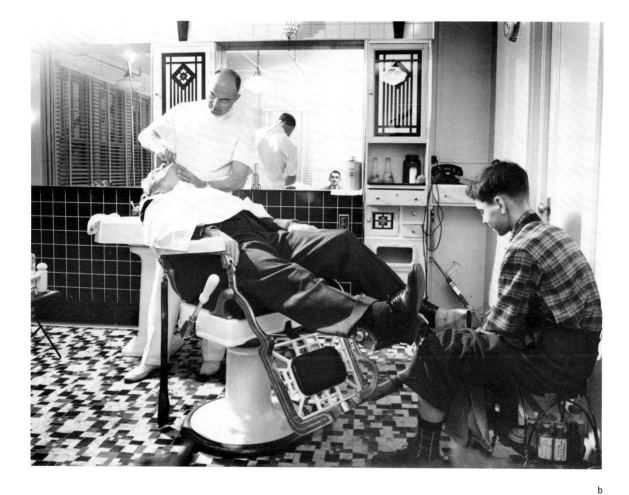

a. Benjamin Lutz, second from the right, presiding at his butcher shop at 4:30 P.M., when the shifts changed in Lititz's factories.

b. Mr. Pennepacker, one of Lititz's seven barbers. The file caption states that Pennepacker "has sixty less haircuts since the boys left town."

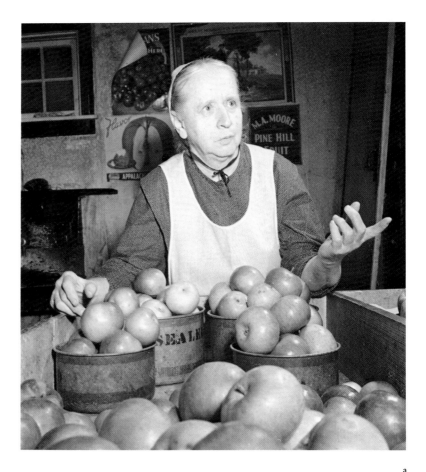

a

a. Mennonite apple seller at the farmers' market.

b. Recalled tires at the train station ready for shipment to Harrisburg. Private automobile owners were limited to five tires per vehicle.

c. Defense industry worker Irwin R. Steffy, who commutes to Lancaster every day, having his car serviced at the Pierson Motor Company.

b

c

a

a. Mrs. Morris Kreider, the wife of the hardware store owner, and Dr. Posey. The file caption states that Posey is buying "one of the last aluminum roasters," a reference to the wartime aluminum shortage.

b. Twenty-three-year-old Mrs. Julian Bachman, right, and two other gauge inspectors at the Animal Trap Company.

c. Mrs. Julian Bachman checking the size of a bullet before the cartridge is assembled.

b

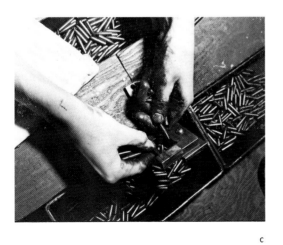

c

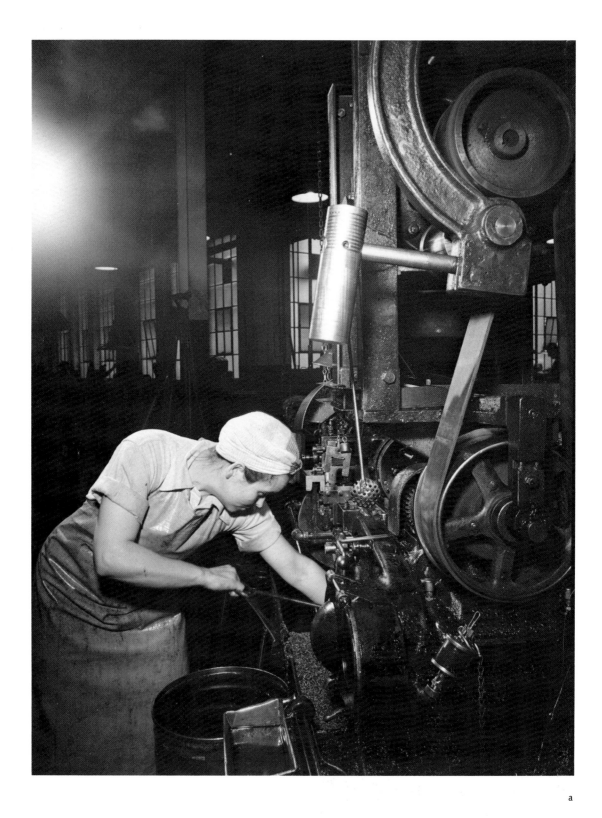

a

b

a. Emma Dougherty cleaning out her end-grinding machine. In her draft for this picture's caption Collins wrote that Dougherty "does a man's job . . . and gets [the] same pay as a man."

b. Signs, labels, and newsletters printed by the *Lititz Record-Express.* The file caption says that the newspaper has taken on these printing jobs because "national advertising has practically disappeared since the war started."

c. Hardware store owner Morris Kreider, who operates a machine shop that makes small parts for nearby defense plants.

c

b

a. Junior choir performance in the Moravian Sunday school.

b. Elizabeth Almoney, who has three sons and three brothers in the service.

a

b

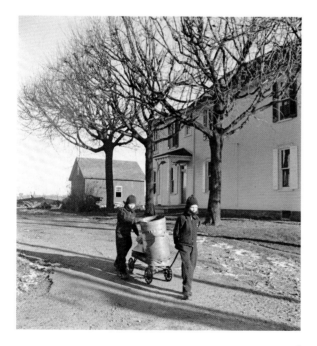

c

a. Waterworks superintendent Walter Miller dictates water bills to borough secretary and real estate broker Elam Habecker.

b. Postmaster Robert Pautz, who has three sons and one son-in-law in the service and a daughter in the U.S. War Department, chatting with two friends in the Post Office.

c. Youngsters bringing scrap metal from their barn to the curb for collection.

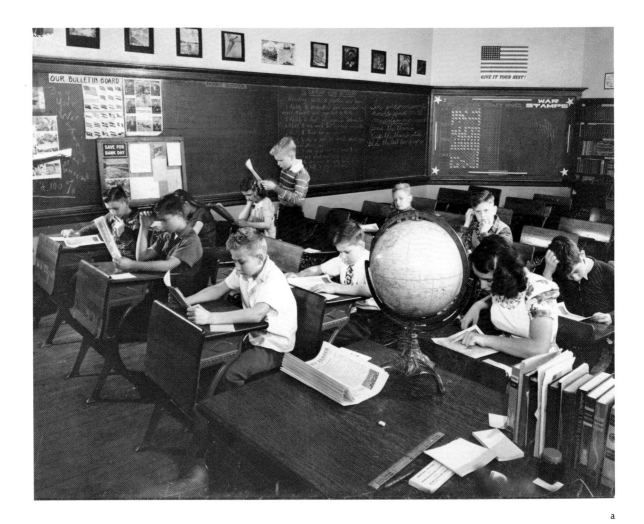

a

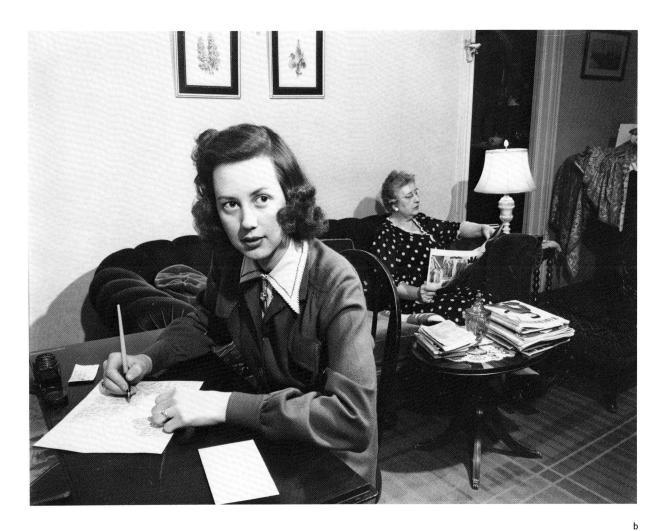

b

a. The sixth grade current events class. The file caption states that the class is "studying the route
 to [the Arctic Russian port of] Murmansk, its dangers, and the reasons for using it."

b. Mrs. Julian Bachman, living at home, writes to her husband in an Army Air Corps officer candi-
 date school in Kentucky. The couple has been married for one year.

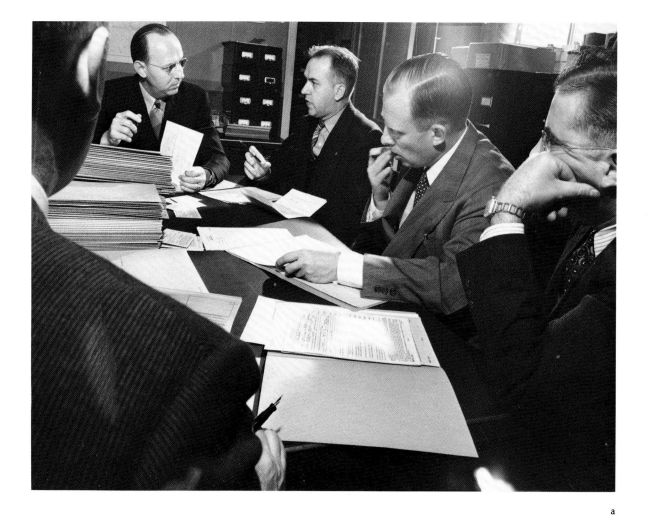

a. Draft board Number 5 in Ephrata, which selects Lititz's men for service. Left to right: Lititz banker A. L. Douple, Ephrata insurance and real estate man W. E. Buchholder, board clerk Harold Shirker, hat manufacturer George C. Ballman, and attorney John L. Bowman.

b. Paul Ritz, worker in a chocolate candy factory, serves as a volunteer airplane spotter at a hilltop post for two hours every week. Ritz is a veteran and has a son in the navy. The spotters were recruited by the American Legion.

c. Between Lititz and Manheim.

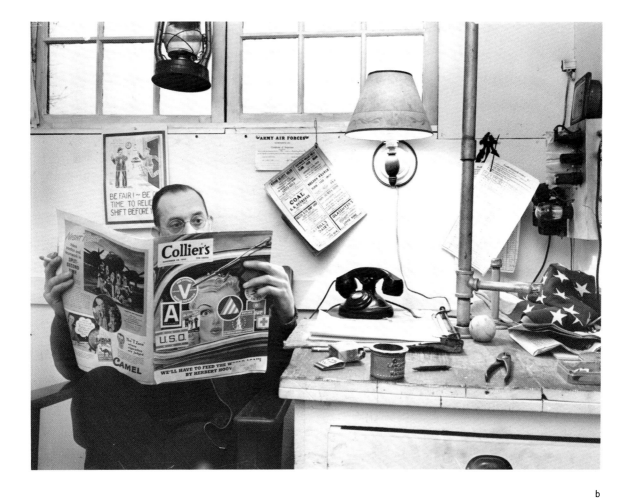

b

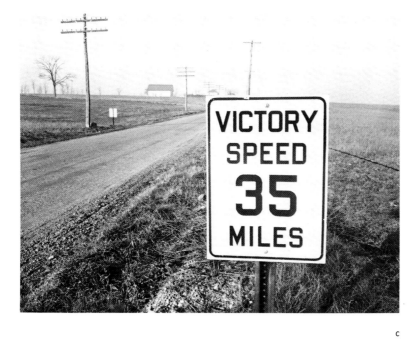

c

U N I O N S T A T I O N

JACK DELANO

Chicago, Illinois, January and February 1943
Office of War Information, Lot 223

Jack Delano produced an exhaustive view of American railroads during the winter of 1942–1943. Much of the work was carried out in Chicago, where he was based, supplemented by travel throughout the Midwest and the Southwest. Although it includes these photographs of a railway passenger station, most of the coverage emphasizes the movement of freight. Delano documented work in railyards, at coaling and watering stations, in operations departments, and on trains, always focusing attention on the people involved in the work. A representative sample of 272 of the photographs may be seen in James E. Valle's 1977 book *The Iron Horse at War.*[1]

Delano, educated at the Pennsylvania Academy of Fine Arts, was twenty-six when he was hired at the Farm Security Administration in 1940. In that same year Roy Stryker issued two shooting scripts for the photography of railroading, although in 1986 Delano could not recall having seen copies. One of the scripts reflected Stryker's interest in social history and suggested photographing the railroad in the villages and small towns where trains had been "the tie to the outside world" but were slowly losing their influence to "the bus, pleasure car, and the truck." The other script suggested that the photographers cover a large urban railway station and included a list of important features to capture: buying tickets, meeting friends, the newsstand, bulletin boards, washrooms, officials on the platform, and so on.[2]

Delano did not receive the assignment until after the war had begun, when the rationale for the story became the need to publicize the war effort. In July 1942, while still at the Farm Security Administration, Stryker wrote Delano, "We have this big transportation story which is just begging to be told."[3] In October 1942, after the section had moved to the Office of War Information, work

276

on the big story got under way, and photographers were sent to photograph not only the railroads but interstate trucking, passenger buses, and the construction of liberty ships.

The nation's railroads, which had performed disappointingly during the First World War, tried to increase their productivity in the second. The curtailment of automobile use and the need to transport servicemen contributed to a significant increase in rail travel during the war. The number of passenger miles traveled in 1943 was nearly ninety-four billion, up from the 1933 Depression low of less than seventeen billion.[4] Chicago was an important hub for forty-one different lines, with freight transfer handled by eight "belt," or switching, lines. The city had a number of passenger terminals, including Union Station, which served the Pennsylvania, Burlington, Alton, and Chicago, Milwaukee, St. Paul, and Pacific lines.

At the Office of War Information one of Stryker's regular chores was arranging for security passes to permit access to war-related industries. A three-page story outline accompanied his request to the War Department for permission to photograph Chicago's freight-handling facilities, yards, belt lines, and—presumably—Union Station. Stryker also sought the assistance of the Association of American Railroads, a trade group. The arrangements worked well. "I never had more easy access to anything," Delano recalled in 1986, adding that he carried credentials from "just about everybody under the sun."[5] The military reviewed and cleared the photographs after the fact. The file includes a lengthy exchange of letters between Stryker and various branches of the War Department requesting permission to release the railroad photographs for publication. Stryker accompanied his requests with contact sheets, prints, and captions.

This selection includes only about one-quarter of Delano's thorough and systematic coverage of Union Station, omitting photographs of such subjects as the post office, a single-cell jail for prisoners in transit, the USO lounge, a one-room hospital, and employee locker rooms. Delano used a small Rolleiflex camera to make the existing-light pictures in the station concourse and a large Speed Graphic press camera when the illumination was brighter.[6] Both cameras were fitted with flashguns, and Delano made extensive use of flash. When he set up flashguns at a distance from the camera, as for the picture taken in the interlocking tower, his wife Irene was drafted as camera assistant. In a recent interview Delano explained that Irene's contribution was not limited to rigging flashguns. She also conducted interviews and established the rapport necessary for effective documentary photography by engaging people in the get-acquainted small talk that often precedes the start of actual picture making.[7]

The series fulfills the assignment of showing the railroad during the war. Many of the passengers are men in uniform, and the grand concourse is decorated with an array of military aircraft models and a pair of exhortative murals. The mural containing the slogan For Them, Bombs—visible in our photograph—faces a similar mural emblazoned For Us, Bonds. Wartime security measures may account for an omission from the series: there are no

pictures of the station's classical facade. Without naming the building, a military censor forbade Stryker to use "the photograph of a railroad terminal."[8]

The series also offers social description like that requested in Stryker's 1940 shooting scripts. Delano's photographs portray life within a small world, a point of intersection for passengers, employees, and trains. There are a few close-up portraits in which an individual is identified and characterized—like the picture of the polyglot gateman Charles Sawyer—but Delano's real subject is the institution, and most individuals are shown in their institutional roles as porters, telegraphers, ticket agents, or passengers. By showing people as workers or travelers, the photographs portray them in only one dimension, but by showing an array of people, Delano presents a fully rounded picture of the institution.

NOTES

1. James E. Valle, *The Iron Horse at War* (Berkeley: Howell-North Books, 1977).

2. Both shooting scripts are in the Stryker Collection. The copy of the first script in this collection carries the penciled notation "probably 1940." This script, which includes an introductory paragraph that begins "the railroad has been a part of the everyday affairs of a large proportion of the villages and towns in the United States," is reproduced in Garver, *Just before the War,* n.p. The second script is titled "Suggestions for Photographs: LARGE URBAN RAILROAD STATION" and is dated 1940.

3. Stryker to Delano, 27 July 1942, Jack Delano Papers, Archives of American Art, Smithsonian Institution.

4. Joseph R. Rose, *American Wartime Transportation* (New York: Thomas Y. Crowell, 1953), 33–37.

5. Interview with Jack Delano by Carl Fleischhauer and Beverly Brannan, 30 April 1986, *Documenting America* Project Records.

6. The 2¼-inch Rolleiflex negatives carry the suffix E, and the 3¼-by-4¼-inch Speed Graphic negatives carry the suffix D.

7. Interview with Delano by Fleischhauer and Brannan.

8. Maj. Gorton V. Carruth to Stryker, 20 February 1943, Clearances, 1942–1943, box 1, FSA-OWI Written Records.

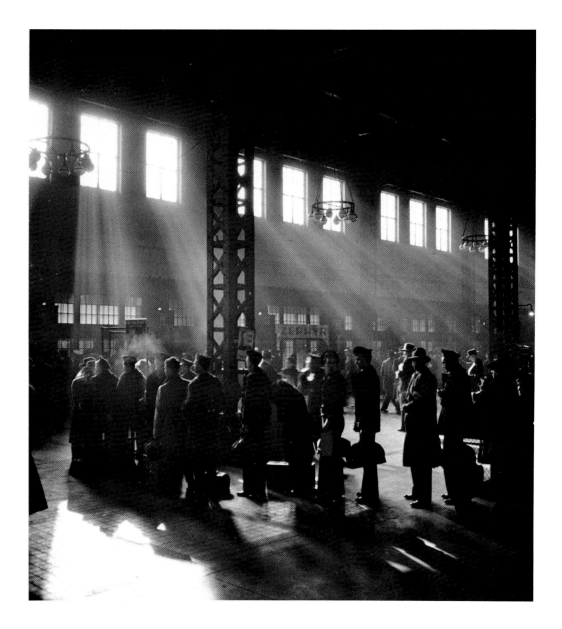

Lining up for train reservations in the concourse.

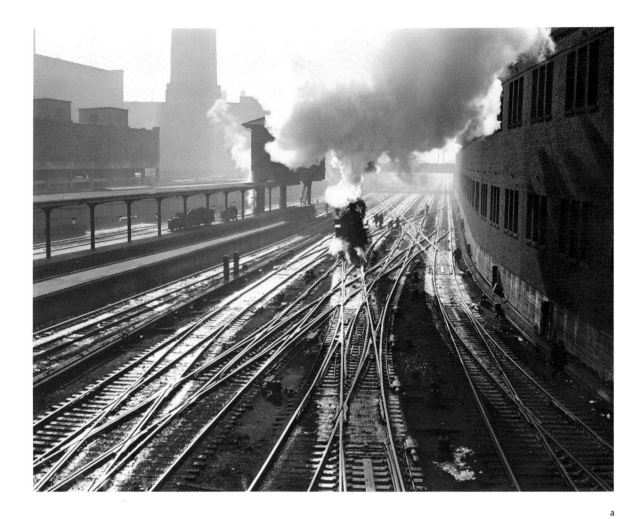

a. Tracks leading into the station. Signals and train routings are controlled from the interlocking tower obscured by the steam at the left.

b. Passengers arriving on a Chicago, Burlington, and Quincy Railroad Zephyr.

c. Engineer and trainman on the platform.

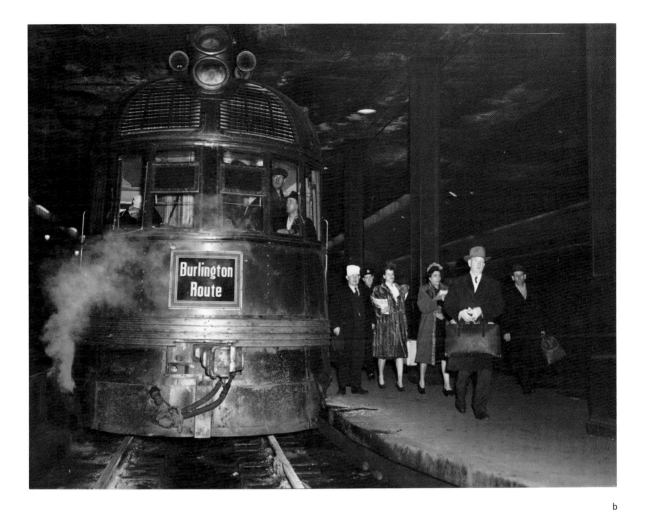

b

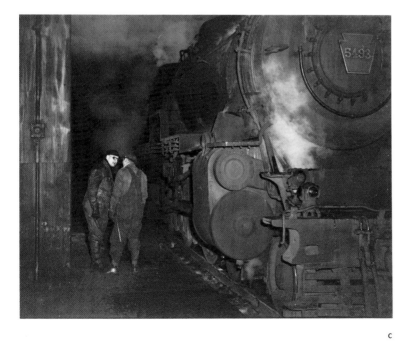

c

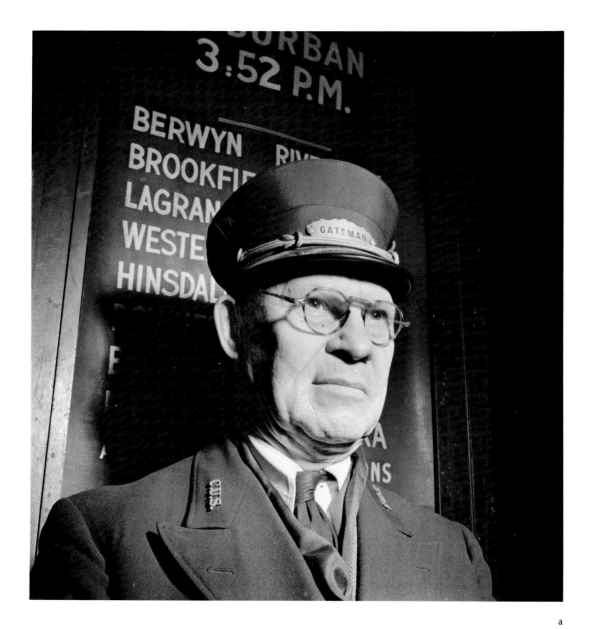

a

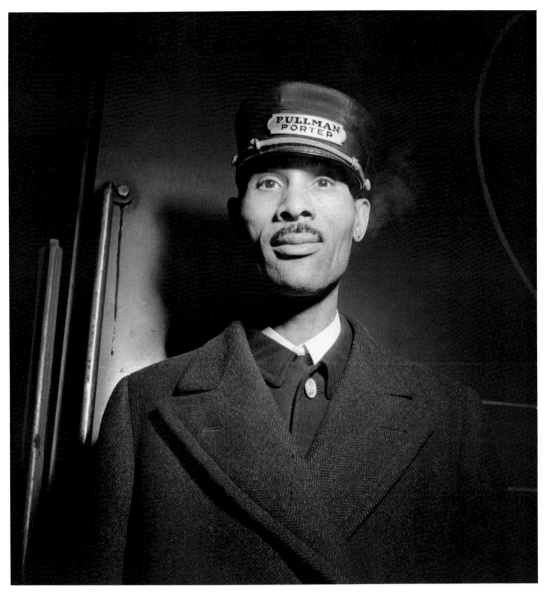

b

a. Gateman Charles Sawyer, who serves as an interpreter for speakers of
 Yiddish, Polish, German, Russian, Slovak, and Spanish.

b. Pullman porter.

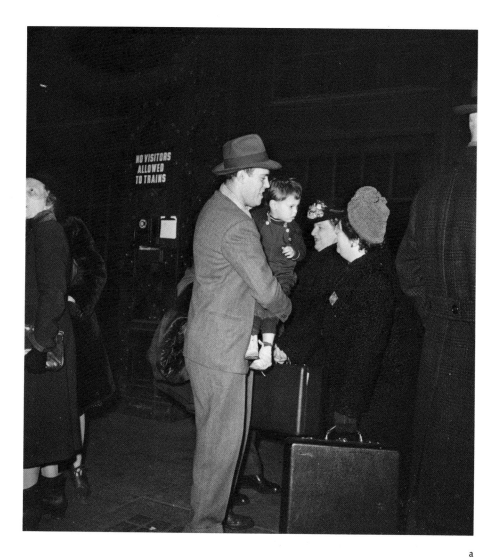

a

b

c

a. Greeting relatives.

b. Office directory.

c. In the interlocking tower, where inbound and outbound traffic is controlled.

d. Unloading a mail car.

d

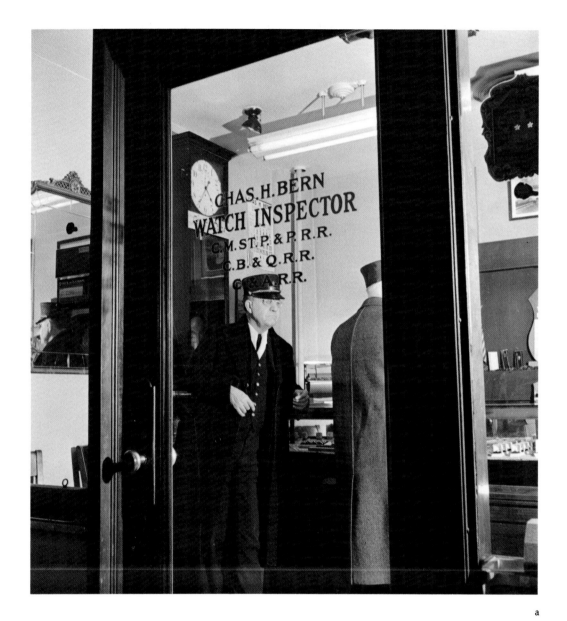

a

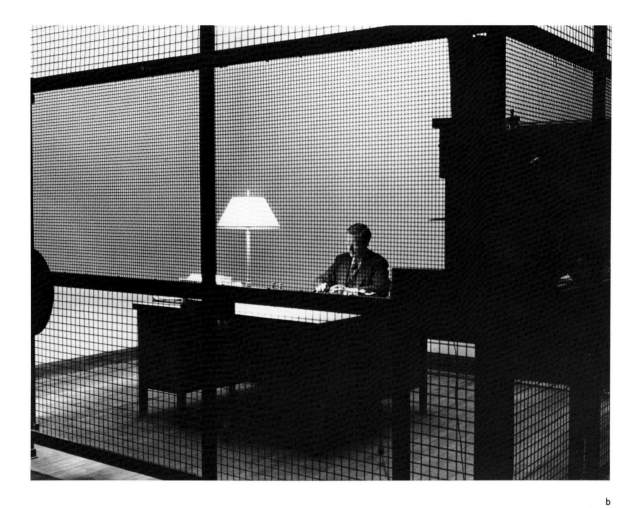

b

a. The watch inspector's office, where trainmen's watches receive periodic inspection.

b. Ticket sales cashier's office.

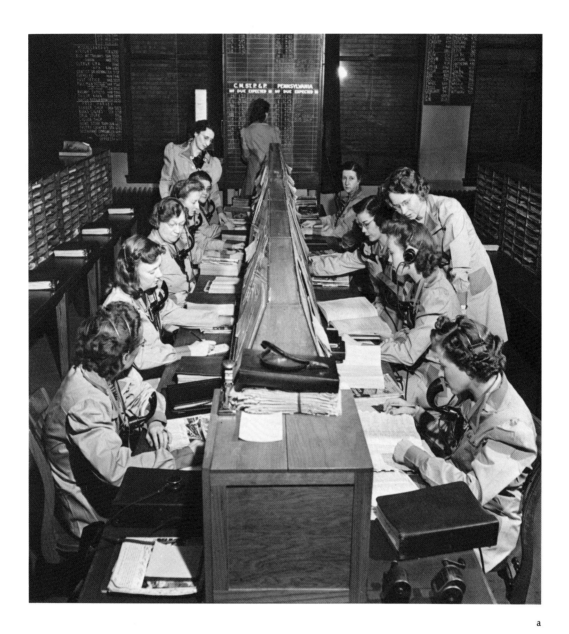

a

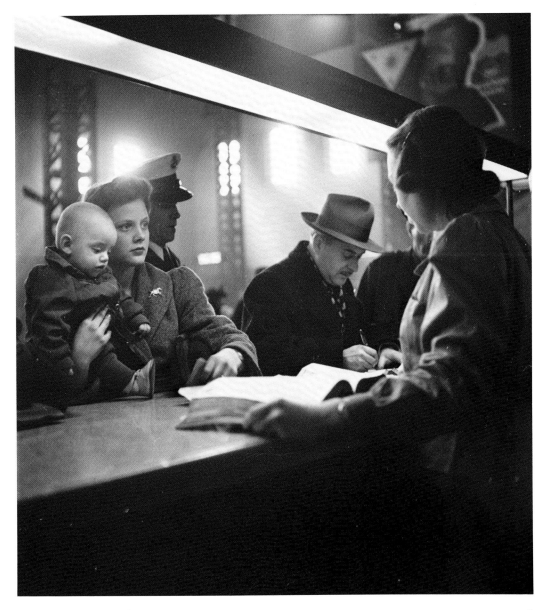

b

a. Timetable information room.

b. At the concourse information desk.

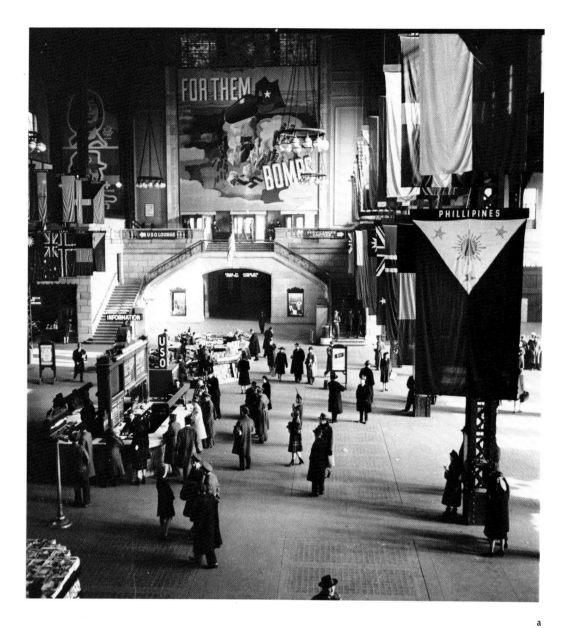

a

a. Train concourse.

b. Model military aircraft hanging from the ceiling of the train concourse.

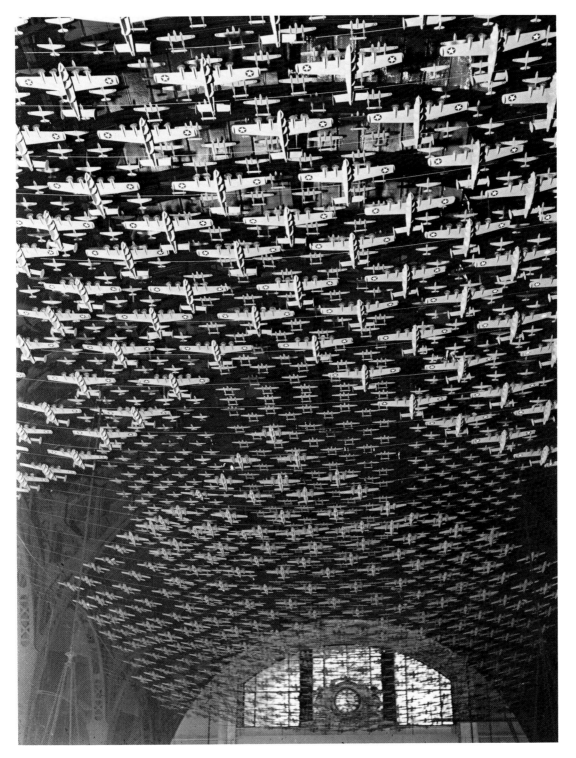

b

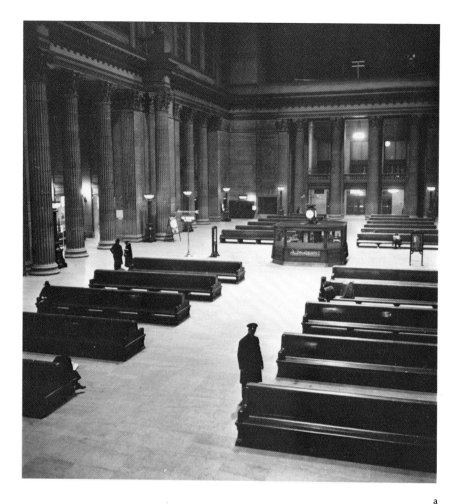

a

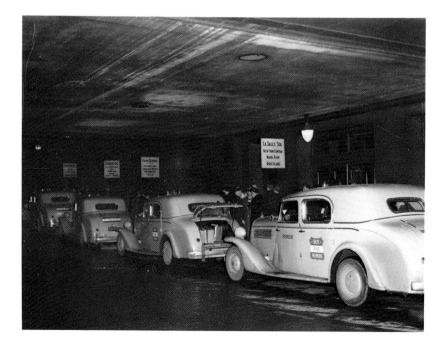

b

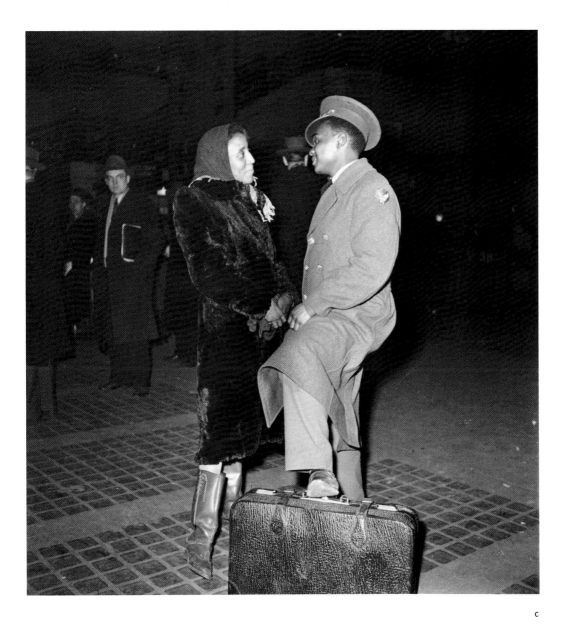

c

a. Main waiting room at 1 A.M.

b. Parmelee transfer cabs carry connecting passengers to other Chicago stations.

c. In the concourse.

T H E J U A N L O P E Z F A M I L Y

JOHN COLLIER, JR.

Trampas, New Mexico, January 1943
Office of War Information, Lots 870 and 872

John Collier, Jr., met the Lopez family in January 1943 while traveling with Father Walter Cassidy, the Roman Catholic parish priest who served Trampas, New Mexico, and several nearby communities. Collier's coverage of the Lopez family began as an element in his story of Cassidy and his activities—the file includes a photograph of Cassidy visiting the Lopez home as well as the image included here of the priest officiating at a mass in Trampas—but the family itself soon became a subject in its own right. On January 13 the photographer wrote Roy Stryker that he planned to spend two days with the Lopezes and went on to extol the picturesque aspects of the town. Trampas, Collier said, is "the center of this mountain region and full of oldness—straggeling [sic] plaza—adobe houses melting back into the earth—all surrounding a church of massive walls built during the colonization."[1]

Collier's parents had a home in Taos, New Mexico, where John, Jr., had spent much of his youth, and his three-month stay in Northern New Mexico early in 1943 seems to have been more his idea than Stryker's. Stryker's letters challenge and complain, while Collier's letters defend. In one exchange Stryker reproaches Collier for petitioning the Taos Pueblo tribal council for permission to photograph the Indian community, and Collier tries to justify his action.[2] Stryker's reproachful letter is lost, and the underlying cause of his anger is not clear, but he may have feared that Collier's action could be construed as an Office of War Information encroachment upon the preserve of the Bureau of Indian Affairs, a matter made more delicate by the fact that Collier's father was the head of the bureau.

Although Stryker asked Collier to refrain from using his contacts with the Indians, he did endorse the idea of photographing the region's Hispanics, who were the descendants of Spanish colo-

nial settlers. Collier saw his coverage of the Lopez family and Father Cassidy as chapters in an extensive documentation of life in Northern New Mexico. He photographed a clinic overseen by the church and supported by the Farm Security Administration as well as many other subjects. But he doubted the depth of home office support—perhaps fearing he had spent too many weeks in one place—and one of his letters defends his work to Stryker: "I do not wonder that you are a bit confused over the thread of my story— not until it is all together will it draw its point." The story he envisioned concerned the people and the land, the effects of modernity, and the roles of the church and the state. The "Trampas family series," Collier wrote, was intended to show the "conglomeration" of influences on the residents of the region.[3]

Collier went on to remind Stryker that the clinic was a project of the Farm Security Administration program and that the pictures of Father Cassidy could be used in the Office of War Information's current propaganda efforts. The first justification, offered three months after Stryker's section had shifted from the Farm Security Administration to the Office of War Information, probably did not carry much weight, but Collier's argument that the story about the priest and his Hispanic flock "seems very needed material for an overseas release" hit the mark.[4] While still based within the Farm Security Administration, Stryker's photographers had produced stories about "nationalities"—usually ethnic groups with European origins—for the Office of the Coordinator of Information, the predecessor of the Office of War Information. These and similar assignments continued at the new agency, and some of Collier's pictures of Northern New Mexico were distributed as part of the Office of War Information's "Portrait of America" series during 1943–1944.[5]

Juan Antonio Lopez is identified in the photographer's notes as the mayor of the town, but nearly all of the 106 photographs added to the file show him in the context of his family, and none elaborate on his civic role. Collier's captions connect the family with a conglomeration of influences: the firewood is collected from land managed by the U.S. Forest Service, the children do homework for an English-language school, and—in a pair of photographs not included here—Lopez is shown assisting at the church. The family's eldest son, Delfido, was in the military, but Collier could not find a way to convey that information in his photographs.[6] "I will not be able to draw much of a story," Collier had written Stryker about the war. "The people are parenialy [sic] poor—and a war just means boys away from home."[7]

The pictures of Lopez and his son gathering firewood and the congregation at worship seem candid. The subjects of these photographs were either sufficiently occupied to overcome the distracting presence of the photographer or the postures and movements these activities required masked visible signs of camera consciousness. Other photographs look posed: the family waiting for the meal to begin, the children doing their homework and sleeping in their beds, and the parents studying the mail-order catalog. The photographer's presence during these activities must have distracted the participants, especially since flashbulbs were used.

Flashguns and bulbs were important facts of life for the FSA-OWI photographers. The film of that era was far less sensitive to light than films now, most camera lenses had smaller maximum apertures than those currently in use, and today's relatively compact electronic flash units had not yet been developed. Collier's supply of number 5 bulbs can be seen stacked on a shelf in the photograph of the boys washing up for dinner, and his flashgun clamped to a picture frame is visible in the picture of the grandfather, Juan Romero, telling stories in front of the hearth. The scene of Maclovia Lopez spinning was illuminated by a "bare bulb"—the reflector had been removed from the flashgun—concealed in the fireplace.[8]

On February 13 Stryker sent Collier a list of unsatisfactory photographs illuminated by flash. One group of about a dozen depicted scenes that contained a lighted kerosene lamp, including the dinner table picture shown here. "The flash has made it look like a brilliant electrical illumination," Stryker wrote. "The burning lamp [looks] a little out of place." He added that the flash-illuminated scenes of children asleep seemed unnaturally bright and complained that the group at the fireplace looked stiff. "This is a problem we are all having," Stryker continued, referring to the work of Collier's colleagues. "I wish you would give some thought to it and work out some method of control that will come near what the eye sees."[9]

Collier's book *Visual Anthropology: Photography as a Research Method*, first published in 1967, emphasizes that photography is valuable in many phases of anthropological research but strikes an ambivalent note in assessing its role in the close analysis of human interaction. The 1986 edition, co-written with Malcolm Collier, contends that patterns in human use of space and nonverbal communication require "systematic and repeated recording" in still photographs, adding that "only film or video can record the realism of time and motion or the psychological reality of varieties of interpersonal relations."[10] The book does not discuss the effect of posing and directing on the photographic representation of human activities, but a reader is led to conclude that posed pictures—like the ones showing interactions between members of the Lopez family—fail to provide reliable evidence of certain aspects of behavior.

Visual Anthropology stresses the value of photographs in preparing an inventory of a family's or a community's material culture, as exemplified by Collier's photographs of the interior of the Lopez home. Collier's coverage of the house, its decor, and the family's display of pictures is one of the most striking features of this assignment. The interior views included here only suggest how thoroughly Collier documented the family's extensive collection of religious icons, popular prints, and family photographs. In 1985 Collier said that Stryker had always encouraged the photography of "popular media" to help "tell the story of the town," but he related his own impulse to photograph the decor of the Lopez home to his subsequent work in visual anthropology.[11]

Stryker often sent photographers to unfamiliar parts of the country so they would observe life with fresh eyes. But Collier was sometimes uncomfortable on such travels. In the East, where most

of his work had taken him, he felt like "a foreigner in a foreign land."[12] He expressed his love for Northern New Mexico in a letter he wrote to Stryker the day before he went to Trampas. "This is my home Roy," Collier insisted, "I can't stay in the east indefinitly [sic]—though— I appreciate that the experience so far has been very revolutionary."[13] An affection for the region may account for the idyllic element in this series, but Collier offered a different explanation for the contrast between his photographs and "the eye-stoppers about poverty" associated with his predecessors in Stryker's section. The Dust Bowl was over when he started, Collier said in 1985, and "human vitality" was his concern. "I was photographing human success stories."[14]

NOTES

1. Collier to Stryker, 13 January 1943, Stryker Papers.
2. Collier to Stryker, 26 January 1943; Stryker to Collier, 2 February 1943; Collier to Stryker, 11 February 1943; Stryker Collection.
3. Collier to Stryker, 11 February 1943, Stryker Papers.
4. Ibid.
5. "Portrait of America," no. 38, is devoted to Father Cassidy. Copies of the photographs and text for this story may be found in the Supplementary Reference files, box 22, lots 863–76, FSA-OWI Written Records.
6. Information about the family was provided to the editors by Judy Goldberg in October and December 1986, *Documenting America* Project Records.
7. Collier to Stryker, 13 January 1943, Stryker Papers.
8. Interview with John Collier, Jr., by Carl Fleischhauer, 6 December 1985, *Documenting America* Project Records.
9. Stryker to Collier, 13 February 1943, Stryker Papers.
10. John Collier, Jr., *Visual Anthropology: Photography as a Research Method* (New York: Holt, Rinehart and Winston, 1967); rev. ed., John Collier, Jr., and Malcolm Collier (Albuquerque: University of New Mexico Press, 1986), 96, 144.
11. Interview with Collier by Fleischhauer.
12. Interview with Collier by Fleischhauer.
13. Collier to Stryker, 13 January 1943, Stryker Papers.
14. Interview with Collier by Fleischhauer.

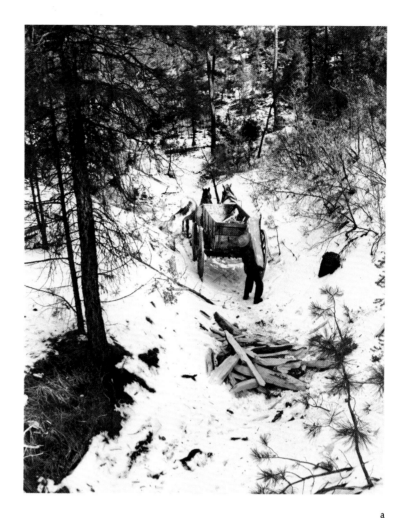

a

b

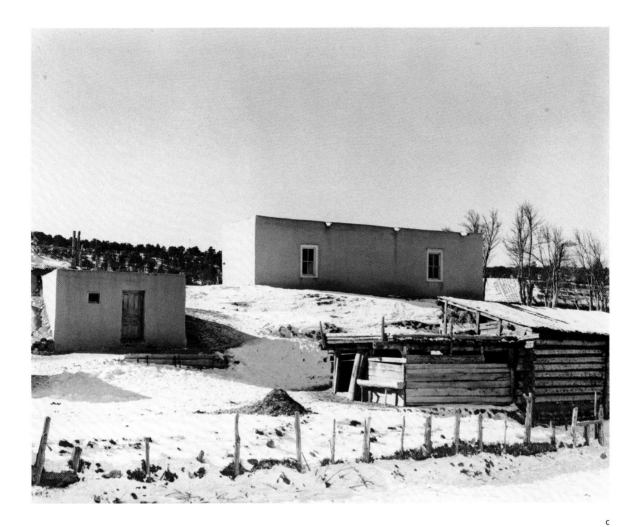

c

a. Loading firewood in the Santa Fe National Forest.

b. Juan Lopez going to the mountains for wood.

c. The Lopez house and corrals.

a

a. Religious images and family snapshots.

b. Almanac, magazine photograph, and calendar.

c. View through three rooms in the Lopez home; in the foreground drying meat hangs from the rafter.

b

c

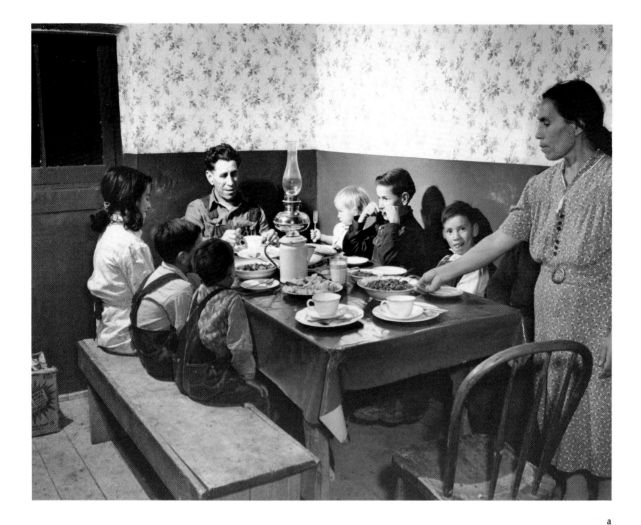

a

a. Serving dinner.

b. Washing up.

c. Maclovia Lopez.

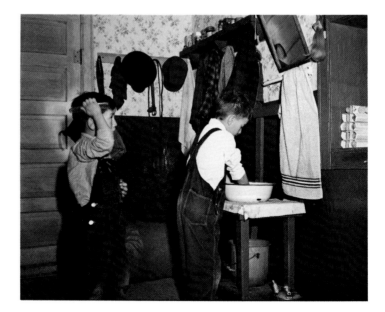

b

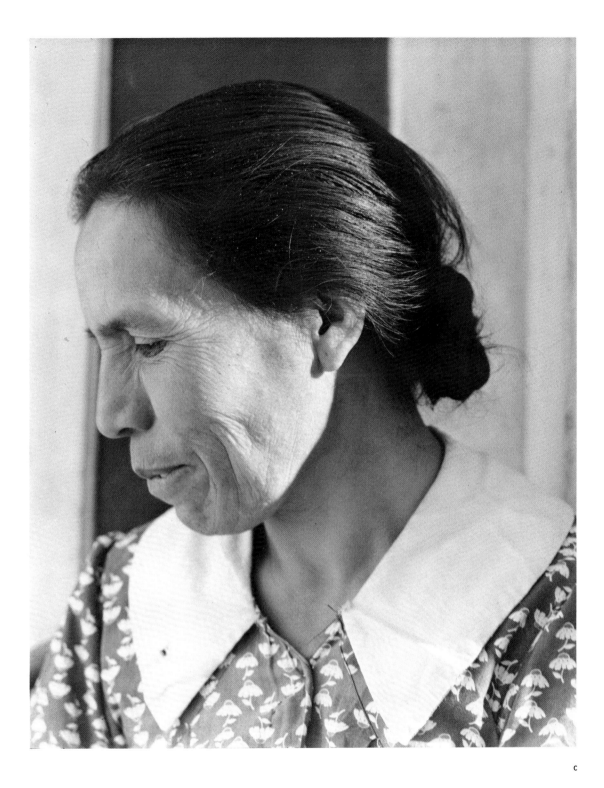

c

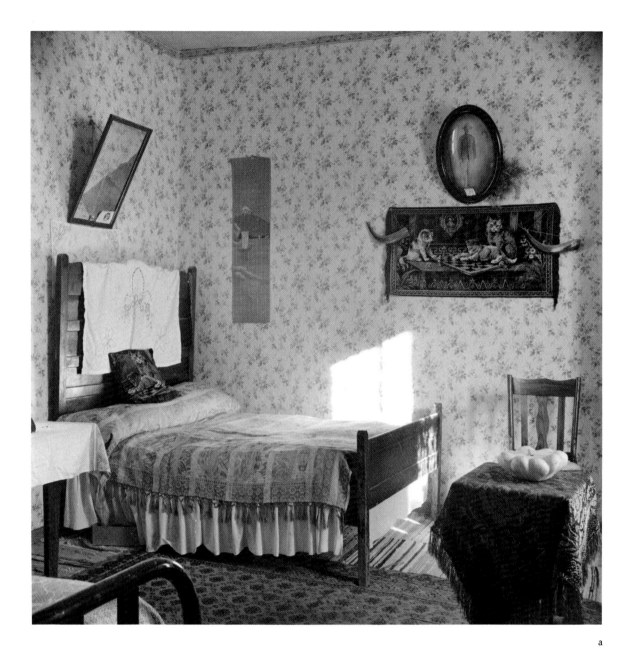

a

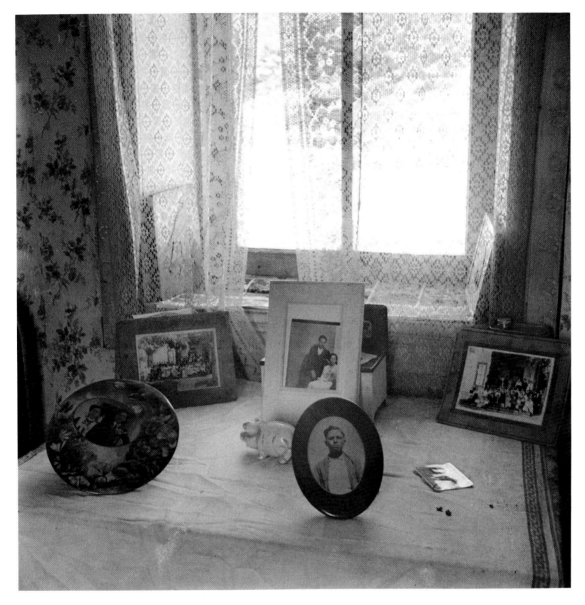

b

a. Bedroom.

b. Photographs of family and friends.

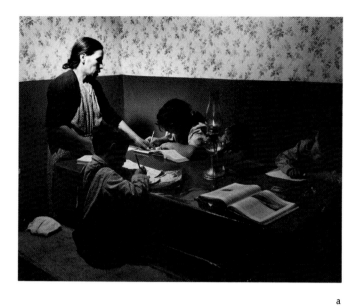

a

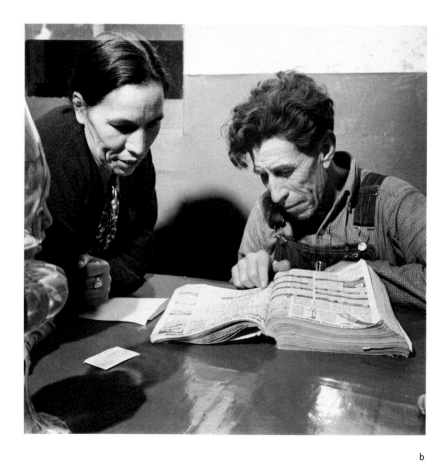

b

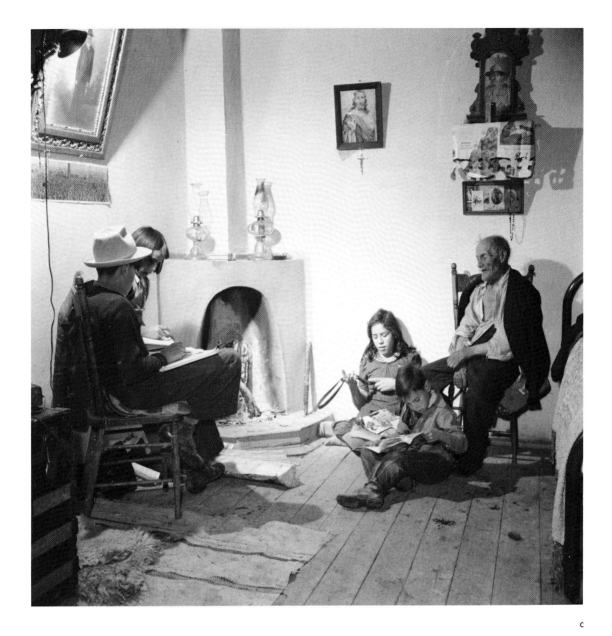

c

a. Maclovia Lopez helping her children with their homework.

b. Considering the purchase of a sixty-dollar harness in a mail-order catalog.

c. In grandfather Juan Romero's room. The file caption reports that Romero is recounting "tales of the old days when Trampas was a thriving sheep town."

a

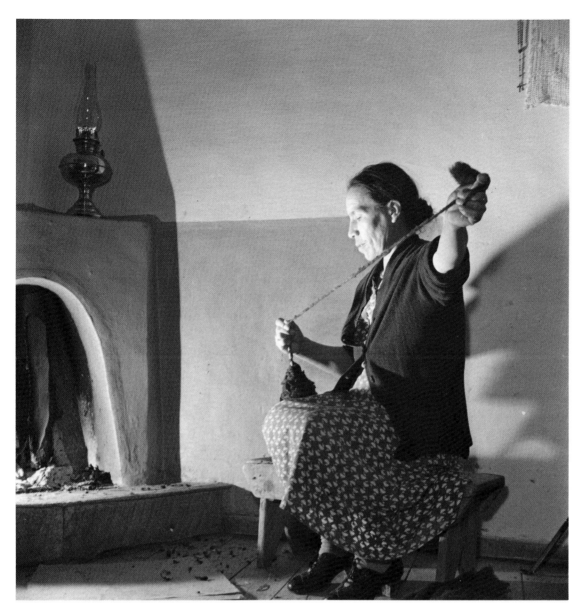

b

a. The youngest child asleep.

b. Maclovia Lopez spinning wool. The wool from the family's ten sheep is woven
 into blankets in the nearby weaving center of Cordova.

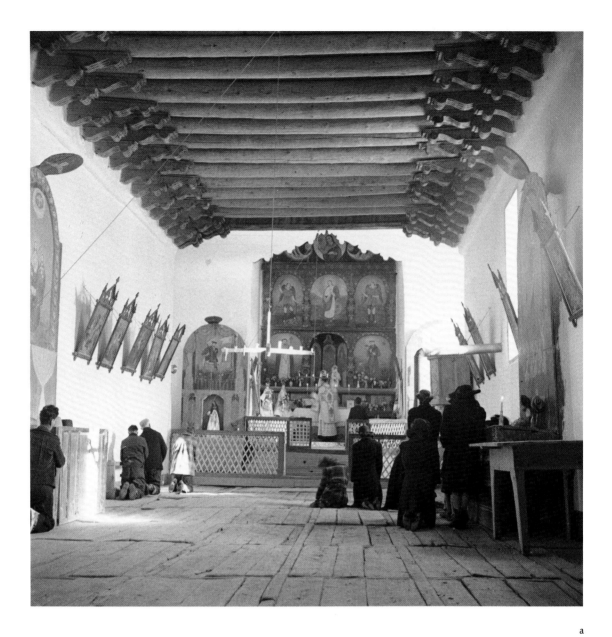

a

a. Father Walter Cassidy celebrates mass at the Trampas church.

b. Juan Lopez.

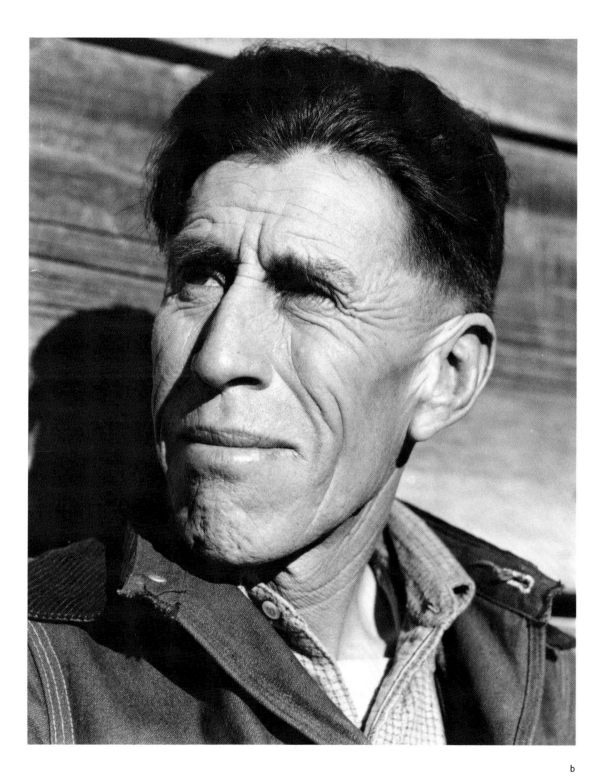

b

CROSS — COUNTRY BUS TRIP

ESTHER BUBLEY

Washington, D.C., to Memphis and return, September 1943
Office of War Information, Lots 882–85

Esther Bubley was a twenty-two-year-old art school graduate when she came to Washington from Minnesota seeking work as a photographer. She started in Roy Stryker's Office of War Information section in 1943 as a laboratory technician, spending her weekends making photographs around Washington in hopes that Stryker would give her assignments. He soon did, but the range of her work was limited by her lack of a driver's license. No license was required to ride the bus, however, and when Stryker decided to cover this aspect of wartime transportation, the assignment was ideal for Bubley.[1]

In a letter seeking the Greyhound bus company's permission to proceed, Stryker explained that his office needed "pictures covering the special transportation facilities available for the transportation of soldiers."[2] Since the photographs would show people from all walks of life, the letter's patriotic emphasis on soldiers must have been designed to ensure that permission would be granted. On the trip Bubley carried a "to whom it may concern" letter describing the need for "factual photographs of the American people and American industries for use in . . . preparing reports of the progress of the War to the people of America and the United Nations."[3] The letter also reassured readers that the film would be censored before release, probably a note Stryker added in response to the national mood rather than to law.

Bubley's photographs from the assignment, 445 of which were added to the file, form a wonderful visual diary of the September trip, full of the texture of the road, the feel of the crowded vehicles, and the monotony of the stops along the way. The buses were crowded and the roads empty, of course, because of wartime fuel and tire rationing. Bubley traveled from Washington to Pittsburgh, where she photographed the bus company's maintenance facilities;

then to Columbus and Cincinnati, where she photographed the driver Bernard Cochran; and finally through the Midwest and the South, via Indianapolis, Chicago, Louisville, Memphis, Chattanooga, Knoxville, and back to Washington.

Bubley's lively notes rival her pictures as a report on the trip, describing her encounters and characterizing her fellow passengers and the Greyhound employees.[4] A typical passage tells of her initial departure:

> The bus driver, stepping out of the dispatcher's office, contemplated the mob for a minute, then started elbowing his way to the bus. Achieving it, he opened the door and faced the crowd. "Step back, please, folks," he said. A girl in hornrimmed, harlequin glasses moved a step forward. The bus driver eyed her and said in rather a plaintive tone, "Now look, I gotta have some room to load this bus." Nobody moved. "Listen," said the driver, "I don't want to wipe the dirt off this bus with my shirt this morning." Still the ranks held firm. The girl with glasses glared alternately at the bus driver and an elderly woman, who was trying to inch in front of her. "O.K.," said the driver, "O.K. No one gets on this here bus unless I punch their ticket, and I'm starting at the back of this mob where I got room to breathe." He walked to some latecomers on the outskirts and started checking tickets. There was a mad scramble to reverse positions. Lingering at the edge of the crowd, I became one of the first to get on, and plumped down on a front seat.

After the crowded bus got under way, Bubley asked the driver about the standees in the aisle. The driver responded, "Aw, it's nothing," and said that he had carried sixty-eight on a thirty-seven-passenger vehicle the day before.

Two of Bubley's fellow passengers were a middle-aged woman and her daughter going sightseeing in Gettysburg. "I don't want her to miss anything," the woman told Bubley, who reported that the daughter proved to be more interested in a soldier than in the scenery. Other passengers included war workers traveling home to visit their families. A salesman explained that rationing had forced him to abandon his private automobile and ride the bus to make his accustomed rounds. After an evening of roller skating at one town, a group of boys rode home to the next town, fifteen minutes away. Many women were traveling to meet their soldier boyfriends and husbands.

Soldiers also had to travel. One driver told Bubley about trying to keep a drunken serviceman from boarding his bus. But a concerned passenger led a chorus of protest, and the driver was forced to admit the man. "I can tell by looking at them whether it's safe to take a drunk," the driver told Bubley. "Well, we hadn't gone more than ten miles when he [the soldier] started up the aisle. I stopped quick and opened the door, but it was too late. Did that bus smell? The old lady who had started things in the first place commenced to holler, 'Driver, can't you do something?'"

The bus drivers interested Bubley, who reported stories depicting them as ladies' men. "They might tell you that they go in for

athletic sports," one driver told her, "but don't believe it. Wolfing around, that's what they do—chasing women." But Bubley's notes devote more space to stressing Greyhound's emphasis on safety and the company's system of rewards for safe driving. She described punishments for infractions like smoking or eating while driving and told of the drivers' impatience with the nation's wartime speed limit of thirty-five miles per hour.

Senior drivers with good safety records received regular schedules. Bernard "Red" Cochran—portrayed by Bubley in pictures and words—had won several company awards for his fourteen years of accident-free driving. He was also rewarded with a regular route between his home town of Cincinnati and Louisville, a 216-mile round-trip that allowed him to spend nights with his family. He worked six days straight followed by two days off.

At home Mrs. Cochran was the family chauffeur; Red described himself as "allergic" to driving anything smaller than a bus. She and the children usually picked up Red at the terminal after work. Mrs. Cochran considered their family unusual, telling Bubley that most bus drivers tended to have a succession of wives instead of settling down and attributing the success of their marriage to the fact that she was always ready to go out in the evening to parties.

Bubley also offers a glimpse of the life of the "extra man" Clem Carlson, who was on call twenty-four hours a day to drive the second or, if necessary, third "sections" of a regular trip. A section is the additional bus put into service when an unexpectedly large number of passengers report for a scheduled route. Without a regular schedule, the extra men usually lived in company dormitories or rooming houses. Carlson shared a rented hotel room in Columbus with another extra man, but on his days off he tended a farm that he owned, which his parents maintained.

Bubley's bus trip series resulted from one of the last photographic assignments Stryker made before he left the government. He resigned from the Office of War Information in October 1943 and formed a new photographic unit at the Standard Oil Company. Jean Lee, Russell Lee's wife, served as caretaker of the section at the Office of War Information for a few more months, and Bubley recalled that she submitted the final version of her bus trip series to Lee.[5] Stryker invited Bubley to join him at Standard Oil, where she photographed another series on cross-country bus travel in 1947.[6]

NOTES

1. Interview with Esther Bubley by Beverly Brannan, 6 March 1986, *Documenting America* Project Records.
2. Stryker to Mr. McDonald, Washington, D.C., Greyhound Bus Terminal, 3 April 1943, FSA-OWI Written Records.
3. Clearance letter dated 8 April 1943, FSA-OWI Written Records.
4. Supplementary Reference files for lots 882–85, FSA-OWI Written Records.
5. Interview with Jean Lee by Carl Fleischhauer and Beverly Brannan, 30 April 1986, *Documenting America* Project Records; interview with Esther Bubley by Beverly Brannan, 6 March 1986, *Documenting America* Project Records.
6. Bubley's Standard Oil bus series has been published in Ulrich Keller, *The Highway as Habitat: A Roy Stryker Documentation* (Santa Barbara, Cal.: University Art Museum, 1986), 81–95.

The highway between Gettysburg and Pittsburgh photographed through the windshield of a bus.

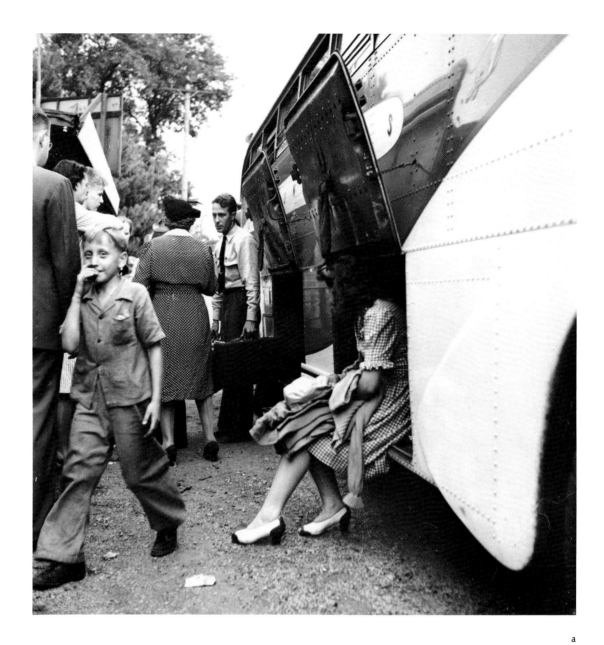

a

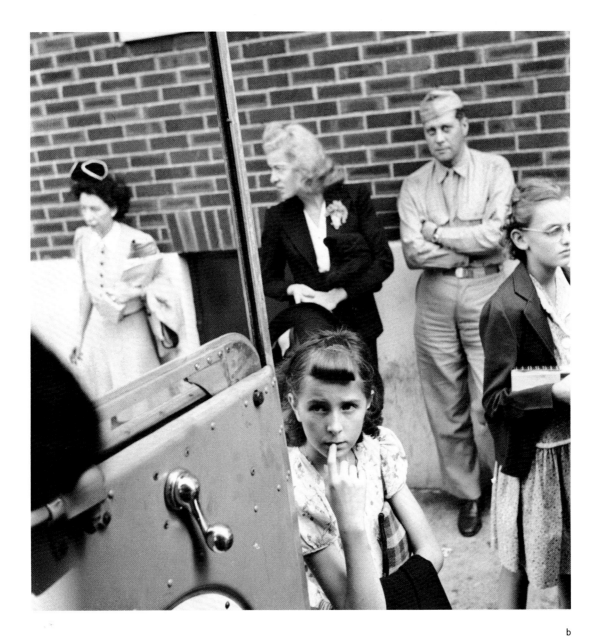

b

a. A driver removing the baggage from a bus that broke down en route to Pittsburgh.

b. Passengers in a small Pennsylvania town waiting to board a Greyhound bus.

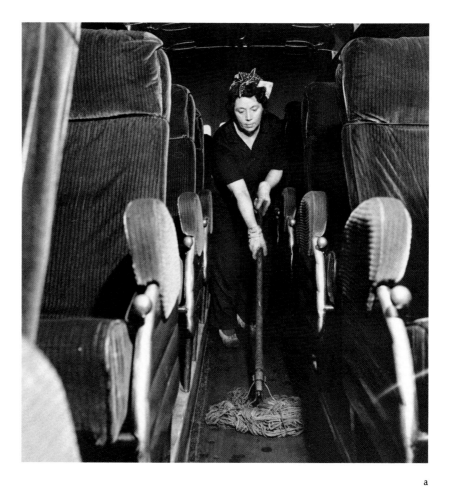

a

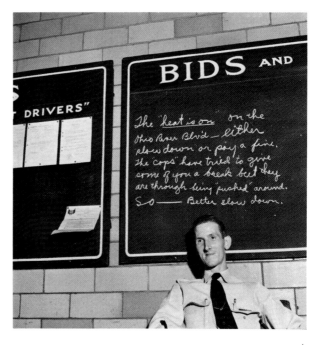

b

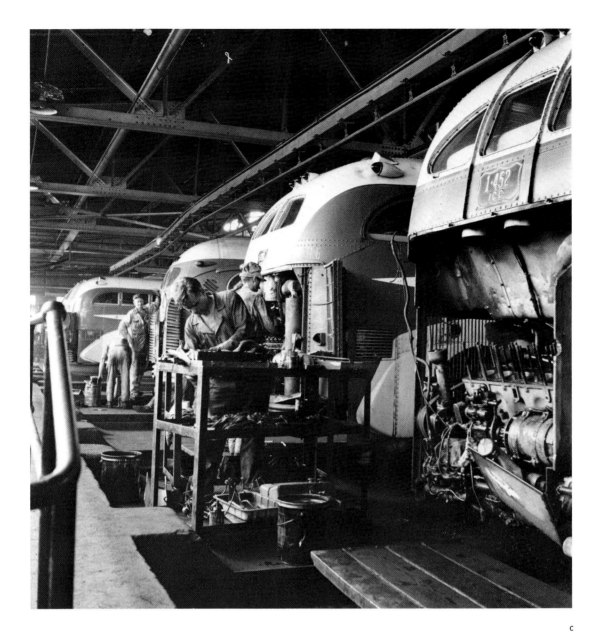

c

a. Mopping the floor of a bus in the Pittsburgh Greyhound garage.

b. The drivers' room at the Pittsburgh Greyhound garage.

c. The Pittsburgh Greyhound garage.

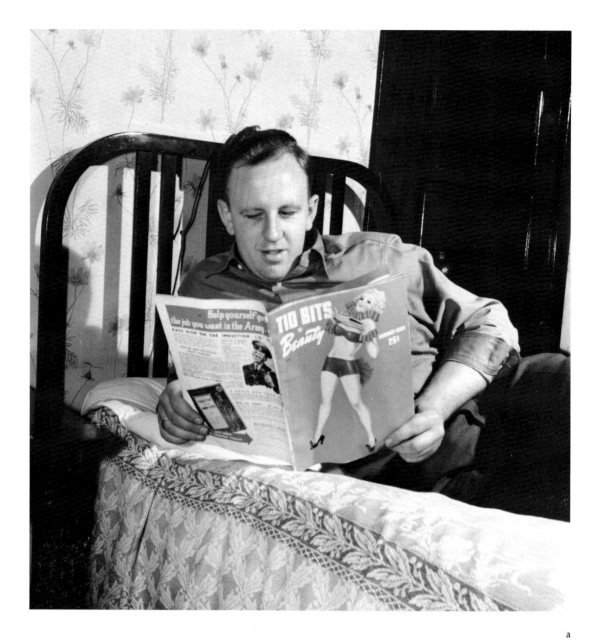

a

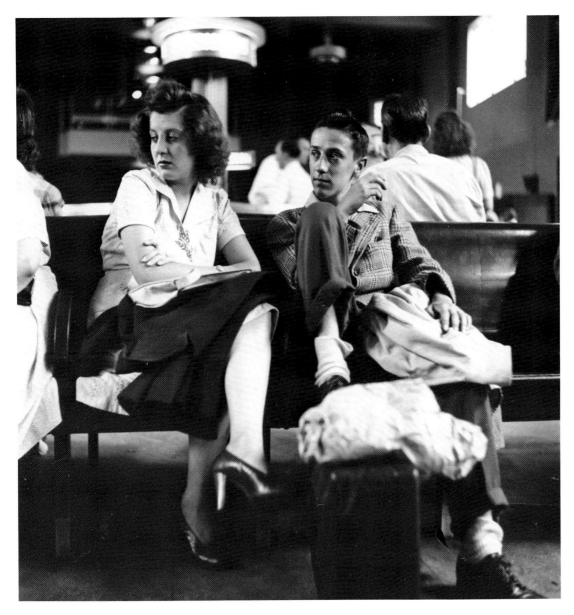

b

a. Greyhound driver Clem Carlson in a hotel room.

b. The Pittsburgh Greyhound bus station waiting room.

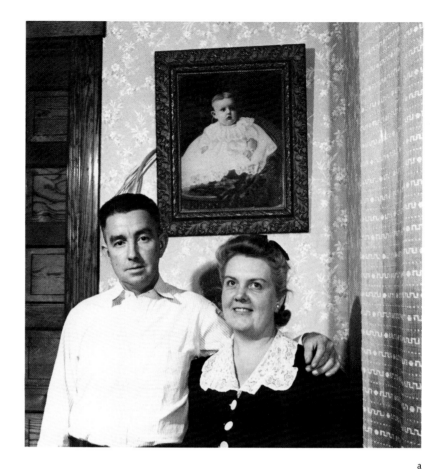

a

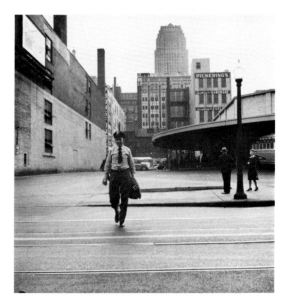

b

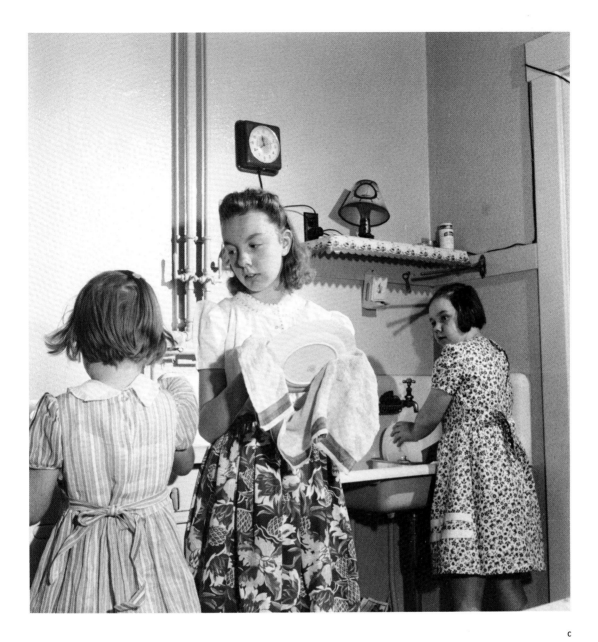

c

a. Mr. and Mrs. Bernard Cochran at home in Cincinnati.

b. Greyhound driver Bernard Cochran at the end of his run in Cincinnati.

c. The Cochran children doing dishes after Sunday dinner.

a

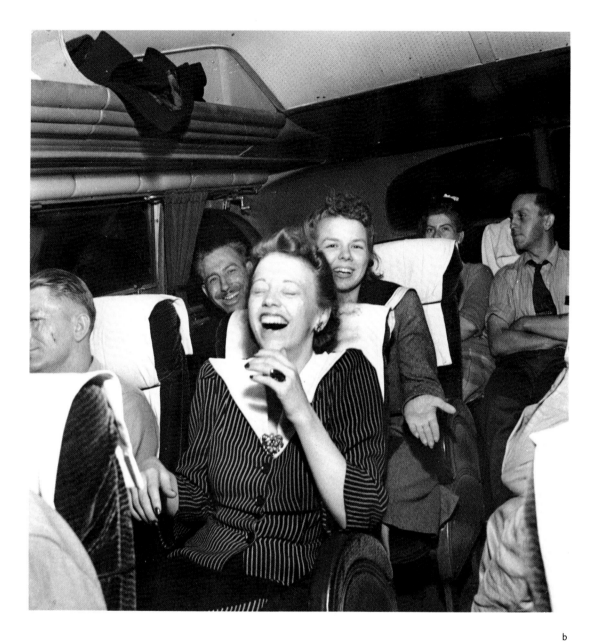

b

a. Inside restaurant across from the Columbus Greyhound bus terminal.

b. Passengers exchanging moron jokes between Pittsburgh and St. Louis.

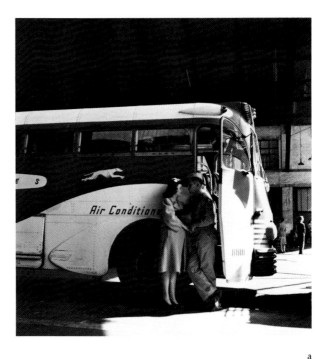

a

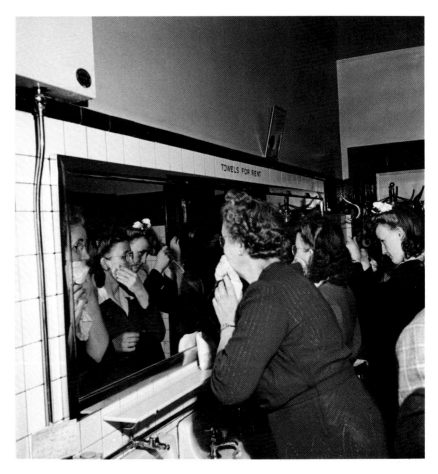

b

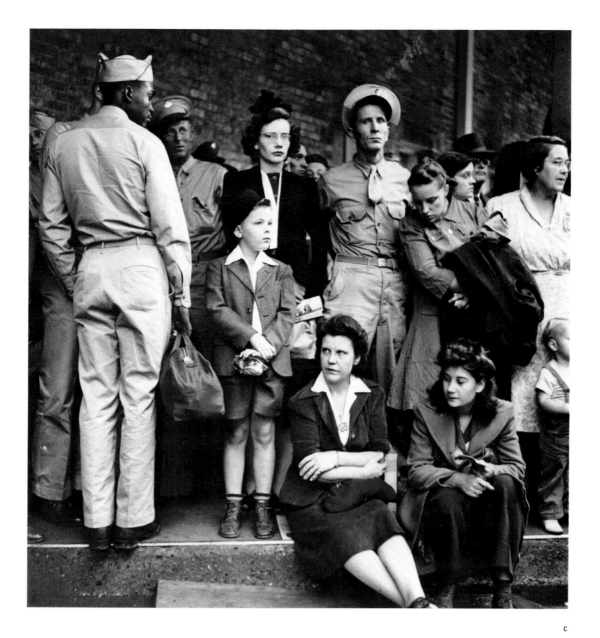

c

a. At the Indianapolis terminal.

b. In the ladies' room at the Chicago Greyhound bus terminal.

c. Waiting for a bus at the Memphis terminal.

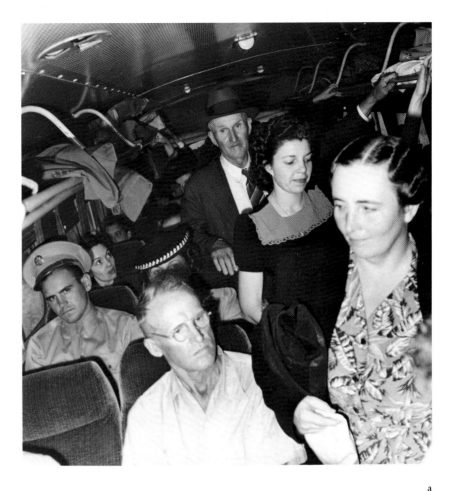

a

b

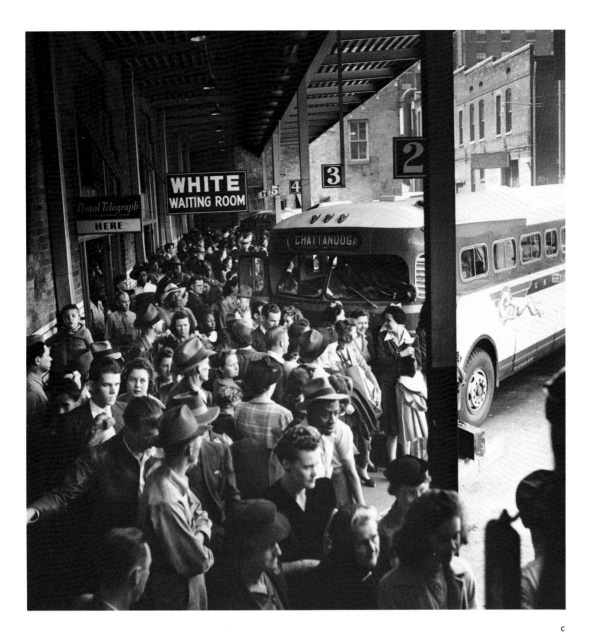

c

a. Between Knoxville and Bristol, Tennessee.

b. Unloading baggage in Chattanooga.

c. At the Memphis Greyhound terminal.

APPENDIX:

THE FSA—OWI COLLECTION

For most readers and researchers the FSA-OWI classified file of 88,000 photographic prints in the Prints and Photographs Reading Room of the Library of Congress represents Roy Stryker and the photographic section he directed at the Resettlement Administration (1935–1937), the Farm Security Administration (1937–1942), and the Office of War Information (1942–1943).[1] Approximately 77,000 of the prints in the file were produced by the section; about 11,000 photographs were gathered from other sources. In the classified file the pictures are arranged by subject in six broad regional divisions.

Another arrangement, less well known, coexists with the FSA-OWI classified file. It comprises about 2,200 "lots"—groups of photographs that received separate cataloging, with each lot more or less representing an original shooting assignment. Of the 2,200 lots, approximately 1,600 (77,000 photographs) contain the images produced by Stryker's section, and 200 (11,000 photographs) contain images gathered from other sources. The photographs from these 1,800 lots also appear in the classified file. With another set of 400 lots (19,000 photographs gathered from other sources), what is called the FSA-OWI Collection contains approximately 107,000 prints.

Descriptions of the Farm Security Administration and Office of War Information photographs have been published over the years, but none contains a complete overview of the FSA-OWI classified file or of the corollary series of lots.[2] The published descriptions emphasize the body of work created by the photographers who worked for Stryker but fail to note that he and the archivist Paul Vanderbilt gathered numerous photographs from organizations other than the three agencies listed above, reflecting their dream of a comprehensive visual encyclopedia.[3] In addition to the pictures produced by Stryker's section, both the series of lots and the classi-

fied file contain images made by the News Bureau at the Office for Emergency Management (OEM) (the News Bureau later moved to the Office of War Information), by the military services, and by industrial firms as well as a few nineteenth- and early twentieth-century images.

VANDERBILT'S
REORGANIZATION

The working file of pictures that Stryker assembled between 1935 and 1943 at the Resettlement Administration, the Farm Security Administration, and the Office of War Information was not organized systematically. Stryker saw the file as both a record of the era and an important historical resource, and in 1942 he hired Paul Vanderbilt to improve access to it.[4] Vanderbilt, who received a degree in art history and museum curatorship from Harvard in 1927, had worked as a librarian at the Philadelphia Museum of Art from 1929 to 1941 and directed a union catalog project for 150 Philadelphia libraries from 1935 to 1938. He was introduced to Stryker by the photohistorian Beaumont Newhall in 1938 or 1939 and renewed the friendship in 1941, when he was in Washington to help the U.S. Navy improve its methods for archiving photographs.[5]

Vanderbilt's reorganization began as an adjunct to Stryker's ongoing documentation effort, but within a year the section's circumstances changed, and Stryker decided to leave the government. Before he resigned, he saw to it that the Office of War Information would underwrite the cost of Vanderbilt's project and arranged for the transfer of the photographs to the Library of Congress after the war. In 1946 Vanderbilt accompanied the collection to the library, where he soon became the chief of the institution's new Prints and Photographs Division.

The organization of the file that Vanderbilt confronted on his arrival at the Office of War Information is suggested by photographs of the old file cabinets and by file categories stamped on some of the old photo mounts.[6] Most of the photographs seem to have been filed by state, and within each state by assignment or by subject. All of Russell Lee's photographs of Pie Town, New Mexico, were filed together, for example, and some of the old headings stamped on photographs from Oregon and Rhode Island read "ORE—CITIES, TOWNS, ROADSIDE" and "RI—FARMING." The old file also included photographs in more general categories without regard to geography, such as "BUSINESS, FINANCE" and "MANUFACTURING, FOOD PRODUCTS, BUTTER." In addition, hundreds of photographs awaited filing. A 1941 memorandum from the photographer and photoeditor Edwin Rosskam attests to the difficulty of finding photographs under this arrangement.

> Dear lord, please put yourself into the position of an unfortunate customer who finds that drought exists in Oklahoma, New Mexico, and among other things Texas. In each case he is given a heading. He has to hunt considerably under that heading because there are always a lot of other pictures in there besides and perhaps he doesn't like the ones he finds. But when he comes to Texas he has to go through thirteen drawers to even find his heading.[7]

Vanderbilt's reorganization consisted of three main steps. First, he assembled the contents of Stryker's file (77,000 prints) and the additional gathered photographs (30,000 prints) into lots. Vanderbilt defined a lot as "a set of prints which it is desired to keep together in some order not provided for by the [subject] classification[s], usually because it is a 'story' conceived and photographed as an interpretive unit."[8] For example, lot 1616 was made up of fifty-one photographs taken by Arthur Rothstein in Gee's Bend, Alabama, in 1937. The lots Vanderbilt established ranged in size from about thirty to more than two hundred prints. By the end of the project he had formed about 2,200 lots by incorporating preexisting groups of photographs as he found them or by reassmbling groups of photographs that had been dispersed within Stryker's former filing system.

Second, he microfilmed 1,800 of the lots (88,000 prints—the 77,000 produced by Stryker's section and 11,000 of the prints gathered from other sources) and stored the remaining 400 lots (19,000 prints) in storage boxes. He used microfilm to preserve the arrangement of the lots because he had only one print of each image.

Third, taking the 88,000 prints that had been microfilmed as lots, he established a new "classified file," in which the individual prints were sorted and rearranged by subject classes within large geographical divisions rather than in groups that represented shooting assignments or stories. The major classes in the file are

14	The Land—the background of civilization
2	Cities and Towns—as background
3	People as Such—without emphasis on their activity
4	Homes and Living Conditions
5–52	Transportation
53–65	Work—agriculture, commerce, manufacturing
66–69	Organized Society—for security, justice, regulation, and assistance
7	War
8–83	Medicine and Health
84–85	Religion
86–88	Intellectual and Creative Activity
89–94	Social and Personal Activity
96	Alphabetical Section[9]

The system of individual subclasses, like the major classes listed above, does not take the perfect form of an outline. Each subclass contains photographs, and the naming and numbering (which vary for each of the six geographical divisions) reflect Vanderbilt's pragmatic flexibility. For example, eight sequential subclasses within class 5 (Transportation) for the Southwest are

505	Horses, animal traction
5052	Riding horses
51	Automobiles
511	Garages
5114	Service stations

5116	Road repairs, maintenance
5133	Cars belonging to migrants
514	Trucks

Note that subclass 511 may be understood as a further refinement of 51, but in other cases digits are added simply to permit the insertion of a group of pictures within a set of related subclasses—subclass 5114 could as well have been assigned the number 512, for example. Alan Trachtenberg discusses Vanderbilt's pragmatic philosophy of classification in pages 52–62 of his essay.

Today the classified file, the microfilms of the lots, and the stored lots are available in the Prints and Photographs Reading Room at the Library of Congress. Microform versions of both the classified file and the lots may be found in a number of other institutions.[10]

AN OVERVIEW OF THE
MATERIALS BROUGHT
TO THE LIBRARY

The most comprehensive overview of the whole FSA-OWI Collection is found in Vanderbilt's 1955 *Guide to the Special Collections of Prints and Photographs in the Library of Congress.*[11] Six of the collections described in this guide contain virtually all the materials Vanderbilt brought to the library in 1946.

1. *Farm Security Administration Collection*
 The photographs in this collection resulted from the work of Stryker's Historical Section at the Resettlement Administration and the Farm Security Administration between 1935 and 1942.

2. *Office of War Information Collection (Overseas Operations Branch, Washington Office photograph files)*
 The photographs in this collection were produced by the photographic section headed by Stryker at the Office of War Information's Domestic Operations Branch from October 1942 until the end of 1943, when the branch was eliminated. Vanderbilt described the materials as being from the Overseas Operations Branch because this division of the Office of War Information held the photographs after the Domestic Operations Branch had been eliminated.

3. *Office for Emergency Management–Office of War Information Collection (News Bureau photographs)*
 The photographs in this group were produced by a photographic unit first established by the National Defense Advisory Commission. In 1941 it became part of the Information Division of the Office for Emergency Management, and after the Office of War Information was formed in 1942, it was transferred to that agency.[12] From about March until about September 1943, Stryker supervised the half-dozen or so News Bureau photographers, making only slight attempts to influence their photographic approach. According to Vanderbilt, the photographs in the Office

for Emergency Management–Office of War Information (OEM-OWI) News Bureau collection range in date from about 1940 to 1946, with most dating between 1941 and 1943. The photographs were produced to support conservation and scrap-salvage campaigns, publicize and encourage the effort to mobilize industry for the war, and document the production of war matériel. The last category includes a number of series devoted to the factories and workers who produced military aircraft.

4. *America at War Collection* and the

5. *Portrait of America Collection*
 These two collections, which are relatively small, represent prepackaged stories prepared for dissemination during the war by the Office of War Information. The America at War Collection, contained in lot 4102, consists of eighty prints that depict "combat actions, U.S. natural resources, training activities, and similar features."[13] The Portrait of America Collection, which makes up about forty lots, consists of a series of edited picture stories for foreign release that portray various aspects of life in the United States. Although most of the photographs were obtained from non–Office of War Information sources, at least one story presents pictures made by a photographer from Stryker's OWI section.[14]

6. *Office of War Information Collection (Overseas Operations Branch, news photograph files)*
 These photographs, numbering in the thousands, depict "current war news involving all armies, combat action, personalities, and war production" and were gathered during World War II from the military and elsewhere for release to publications overseas.

The first two collections contain all but a handful of the Stryker photographs and form the major part of the classified file. Some of the photographs in the third collection were interfiled with the prints from the first two and became part of both the sequence of lots and the classified file. None of the prints from the last three collections was added to the classified file.

When Vanderbilt assigned lot numbers to the photographic prints, he did not observe the boundaries of the six collections listed above. Instead he assigned lot numbers in blocks as he sorted through the accumulation, and a few lots contain photographs from more than one collection. Most of the lots of Resettlement Administration and Farm Security Administration photographs, however, fall into two large blocks.[15]

Several factors contributed to this piecemeal method of establishing lots and assigning numbers. First, when he was processing the materials, Vanderbilt may not have thought of them as falling into the well-defined collections he later described. Second, the Office of War Information Overseas Operations Branch, which

continued to use the photographs during the war, wanted the file organized as quickly as possible. Third, because the backlog of unfiled and uncategorized photographs was so large, it made sense to assign each batch a lot number as soon as it had been put into order. And fourth, Vanderbilt was captivated by the problem of assembling the photographs into a unified visual encyclopedia—the classified file.

THE FSA-OWI COLLECTION

Because the prints have been interfiled, it would be difficult and time-consuming to isolate the photographs that make up the first three collections listed above. For the purposes of this book the content of the three combined is referred to as the FSA-OWI Collection. In addition to black-and-white photographic prints the collection also contains black-and-white negatives (and associated interpositives) and color transparencies. The library has extensive holdings of written records associated with the photographs as well.[16]

Identifying all of the lots making up the FSA-OWI Collection is difficult. After some study the editors have tentatively identified 2,176 FSA-OWI lots within the groups of lots numbered from 1 to 2273.[17] This calculation includes many of the lots of photographs that Stryker and Vanderbilt gathered from other sources but, to the degree possible, omits such items as lots from the Portrait of America Collection.[18] The photographic prints from most of the first 1,819 lots were microfilmed and then added to the classified file.[19]

There is no accurate count of the number of photographic prints in the collection, although rough calculation shows that the average size of the approximately 1,800 lots that make up the 88,000-print classified file is 49 prints. This figure, extrapolated to 2,176 lots, suggests the total of 107,000 prints for the entire collection.

No complete index to the collection exists.[20] As Vanderbilt intended, the classified file itself provides subject access. The backs of the mounted prints are stamped with the number of the lot from which the prints were taken, enabling a researcher to move from the classified file to the original assignment.[21]

THE STRYKER OPUS

How many of the photographs represent the work of Roy Stryker's section? A reasonable estimate can be made by counting the lots produced for various agencies during certain time periods. The editors have tentatively identified 1,565 lots as the Stryker opus, representing a little over 70 percent of the collection, or approximately 77,000 prints. Most of these prints are now in the classified file. For comparison, there are 342 lots containing photographs from the OEM-OWI News Bureau, 209 lots containing photographs gathered from other sources, and 60 lots made at the Office of War Information during 1944 and 1945, after Stryker's departure from government.

The following profiles describe Stryker's 1,565 lots by date, place, and photographer. Because the sizes of the lots vary, the figures given only approximate the distribution of prints.

Many think of the photographs Stryker's section created as documents of the Great Depression, but it is worth remembering that the section began its work six years after the stock market crash and, as these figures show, produced the bulk of its images in the Depression's waning years.

The total number of lots represented in this profile—since there are nine lots for which the catalog cards provide no year—is 1,556. There are 188 lots that contain prints made during a range of years, for example, 1938–1941. Although the multiyear lots may not contain prints from each of the years listed, a portion of each has been added to the totals for each year, to better represent the distribution of lots.

Date	No. of lots	Percentage of total
1935	26	2
1936	114	7
1937	109	7
1938	139	9
1939	250	16
1940	236	15
1941	242	16
1942	266	17
1943	174	11
Total	1,556	100

Region and State

Many believe that the section's photographers spent most of their time in the South and in California, but the distribution of lots by region shows that they worked extensively in other parts of the United States as well.

The total number of lots of photographs by state is 1,580. Because the catalog cards for thirteen lots provide no indication of place, those lots have not been counted. Twenty-eight of the 1,565 lots contain photographs taken in from two to five states, and these have been counted as a full lot for each state represented. The regional totals are calculated as percentages of 1,580.

The Northeast: 166 lots (10 percent)
 (Connecticut, 28; Maine, 16; Massachusetts, 15; New Hampshire, 10; New York, 68; Rhode Island, 5; Vermont, 24)
The Mid-Atlantic Region: 287 lots (18 percent)
 (Delaware, 3; District of Columbia, 94; Maryland, 68; New Jersey, 22; Pennsylvania, 54; Virginia, 46)
The Great Lakes Region: 220 lots (14 percent)
 (Indiana, 19; Illinois, 50; Michigan, 38; Minnesota, 37; Ohio, 48; Wisconsin, 28)
The South: 371 lots (23 percent)
 (Alabama, 41; Arkansas, 17; Florida, 33; Georgia, 43; Kentucky, 23; Louisiana, 49; Mississippi, 27; Missouri, 28; North Carolina, 46; South Carolina, 16; Tennessee, 20; West Virginia, 28)

The Midwest: 107 lots (7 percent)
 (Iowa, 45; Kansas, 19; Nebraska, 19; North Dakota, 17; South
 Dakota, 7)
The Southwest: 192 lots (12 percent)
 (Arizona, 25; New Mexico, 42; Oklahoma, 26; Texas, 99)
The Rocky Mountain and Great Basin regions: 113 lots (7
 percent)
 (Colorado, 31; Idaho, 24; Montana, 44; Nevada, 1; Utah, 9;
 Wyoming, 4)
The Northwest: 51 lots (4 percent)
 (Oregon, 39; Washington, 12)
California: 70 lots (4 percent)
Puerto Rico and the Virgin Islands: 2 lots (less than 1 percent;
 but this percentage is misleading as the lots from Puerto Rico
 and the Virgin Islands contain hundreds of photographs)
Mexico: 1 lot (less than 1 percent)

Photographers

The editors have identified forty-four photographers within the Stryker opus. The following list names the sixteen photographers who made the most extensive contributions to the file.

There are 145 lots that contain the work of more than one photographer; for each photographer the list gives the total number of lots in which his or her work may be found. Because these lots vary in size, a photographer represented in many lots may in fact have fewer photographs in the collection than a photographer whose work is found in a smaller number of lots.

No. of lots	Photographer (Agency or agencies)
374	Russell Lee (RA-FSA)
261	Arthur Rothstein (RA-FSA)
197	Marion Post Wolcott (FSA)
189	John Vachon (FSA-OWI)
175	Jack Delano (FSA-OWI)
94	Dorothea Lange (RA-FSA)
94	John Collier, Jr. (FSA-OWI)
63	Marjory Collins (FSA-OWI)
46	Ben Shahn (RA-FSA)
38	Arthur Siegel (FSA-OWI)
37	Carl Mydans (RA)
32	Gordon Parks (FSA-OWI)
24	Esther Bubley (OWI)
16	Edwin Rosskam (FSA)
15	Walker Evans (RA-FSA)
15	Paul Carter (RA)

THE BLACK-AND-WHITE NEGATIVES

The FSA-OWI Collection contains original negatives—the negatives produced from the film in the photographers' cameras—and a mixture of duplicate negatives, copy negatives, and transparencies (interpositives).[22] The following chart presents estimates based

on a variety of surveys made within the Library of Congress during the last few years:

	Original negatives	Duplicates and others
Resettlement Administration–Farm Security Administration	121,850	15,000
Office of War Information	46,785	14,000
Office for Emergency Management	11,530	850
Totals	180,165	29,850
Grand total	210,015	

NUMBERING NEGATIVES AND KILLING IMAGES

The editors estimate that the negatives associated with Stryker's section include all those produced for the Resettlement Administration–Farm Security Administration and about half of those made at the Office of War Information, for a total of about 145,000 original negatives. Since the estimated number of Stryker-related prints is 77,000, as many as 68,000 related original negatives may remain unprinted in the collection.[23] Most of these are the negatives for images that were rejected, or "killed," although a few may have been left unprinted through inadvertence or are negatives for which the prints have been lost from the file. Through the years the content and status of these unprinted negatives have excited much interest. How many of the killed negatives remain? Did Stryker punch holes in them? Do they contain heretofore unseen gems from Stryker's photographers?

A description of how Stryker's section at the Resettlement Administration and Farm Security Administration prepared and edited images offers an insight into this matter. Most of the film the photographers exposed was developed at the section's photographic laboratory in Washington, D.C., although occasionally in the early years the photographers developed some of their own negatives in the field or in their own darkrooms. The negatives were developed in batches, but a batch did not always consist of a coherent group from a single assignment. Sometimes the editorial process began as soon as the negatives had been developed. Stryker expected the photographers who developed their own negatives to weed out poor pictures and redundant images before prints were made.

Once developed, the negatives were assigned numbers, typically by the section's laboratory staff, although in some cases the photographers may have assigned them.[24] The negative number is written on the edge of the negative and on its paper storage envelope. Generally, the numbers were assigned to batches of negatives as they were developed, without regard to image content. Because of the way negatives were developed and numbered, images created at the same place and time tend to carry sequential numbers, but there are *many* exceptions to this rule.

Test, or proof, prints were made from the newly developed negatives, and then the process of selection began in earnest. In the early years Stryker seems to have selected pictures autocratically, provoking an adverse reaction from some of the photographers

A-1. Killed negative from the Ben Shahn series, "Cotton Pickers," Pulaski County, Arkansas, October 1935. Ben Shahn.

that intensified when they discovered that he sometimes punched holes in killed 35-mm negatives (figure A-1).[25] No holes were punched in the larger negatives, but at least for the first few years most of the killed negatives larger than 35-mm were either discarded or given to the photographer.[26] In later years most of the killed negatives were left in the negative files. By the 1940s, perhaps reacting to the controversy of the early years, Stryker established a procedure that gave the photographers a well-defined role in image selection. The process is outlined in a manual for the section:

> After the negatives are numbered, two 8×10″ prints are made from each negative. These are called "first prints." In the case of the 35mm film two 5×7″ prints are run off on the Emby Automatic Printer. A few 8×10″ test enlargements are also made from the 35mm film.
>
> Mr. Stryker edits these first prints by tearing the corners, or by sometimes making notes in the margins, of those he thinks ought not to be in the file. We call this "killing."
>
> One set of the "first prints" are [sic] mailed to you in the field. Two franked post cards will be enclosed. One is for you to fill in the date and sign and return to the office, acknowledging receipt of the pictures. The other is for you to fill out and send in after you have captioned the prints and are returning them to the office.
>
> If you disagree with Mr. Stryker's notes, or you do not agree that certain prints should be "killed," it is your privilege to leave the print in for the files, and so indicate. It is also your privilege to kill any prints you do not wish in the files, by tearing the corners.[27]

The photographers also used the "first prints" as a reference when drafting captions for the photographs selected for the file. Many of their original drafts may be found in the caption files in the FSA-OWI Written Records.[28] A print for each selected image was mounted on an eleven-by-fourteen-inch board upon which a clerk wrote an edited version of the photographer's caption. Then the print was filed.

Some of the killed negatives are marked on the caption lists, where the word *killed* is entered opposite the negative number, or on the negative storage envelope, which is sometimes marked "killed." As the photographs were being selected for this book, the editors searched for killed negatives from five series: "Cotton Pickers," "Migrant Workers," "New York City Block," "Tenant Farmers," and "Salvation Army." A dozen or more were located for "Tenant Farmers" and "Salvation Army," a handful for "Cotton Pickers," and one for "Migrant Workers." The editors judged most of these redundant and inferior to the negatives selected for the file. Only in "Cotton Pickers" and "New York City Block" were images uncovered that were considered worthy of inclusion in this book.

COLOR TRANSPARENCIES

The production of a reference-image laser videodisk in the Prints and Photographs Division led to a thorough inventory of the collection's 1,610 color transparencies. The disk contains virtually all of the color transparencies from the collection: 645 from the Farm Security Administration and 965 from the OEM-OWI News Bureau and Stryker's OWI section combined. An automated index associated with the videodisk allows access by photographer, title, subject, date, and geographic location. The FSA-OWI Collection itself includes black-and-white copy negatives and black-and-white prints of the color transparencies.

NOTES

1. When Chadwyck-Healey prepared their microfiche edition in 1978–1979, they counted 87,677 photographs in the classified file.
2. [Paul Vanderbilt], *Index to Microfilm Reproductions in the Photograph Section: Series A, Lots 1–1737* (Washington, D.C.: Library of Congress, 1946), 1–2; Paul Vanderbilt, *Guide to the Special Collections of Prints and Photographs in the Library of Congress* (Washington, D.C.: Library of Congress, 1955), 3, 54–55, 118–20, 129; *Farm Security Administration Collection: P&P no. 52* [four-page collection description and bibliography] (Washington, D.C.: Library of Congress Prints and Photographs Division, n.d.); Annette Melville, *Special Collections in the Library of Congress: A Selective Guide* (Washington, D.C.: Library of Congress, 1980), 107–8, 260–61; and *America 1935–1946* [microfiche edition of the FSA-OWI classified file] (Cambridge: Chadwyck-Healey, n.d. [1983]), advertising brochure.
3. An account of Stryker's early vision of this encyclopedic picture file is discussed in Hurley, *Portrait of a Decade: Roy Stryker and the Development of Documentary Photography in the Thirties* (Baton Rouge: Louisiana State University Press, 1972), 95–120. For Vanderbilt's ideas on the subject see his letter to Werner Severin, 27 October 1958, Paul Vanderbilt Papers, Archives of American Art, Smithsonian Institution (hereafter cited as Vanderbilt Papers), 3–4.

4. Vanderbilt's plan for reorganizing the file is outlined in his thirty-two-page memorandum titled "Preliminary Report on the Organization of a Master File for the Publications Section of the Office of War Information," 31 October 1942, Roy E. Stryker Papers, Archives of American Art, Smithsonian Institution, Washington, D.C. (hereafter cited as Stryker Papers).

5. Information about Vanderbilt and his reorganization of the file has been derived from materials in the Vanderbilt Papers; Written Records of the Farm Security Administration, Historical Section–Office of War Information, Overseas Picture Division, Washington Section Collection (hereafter cited as FSA-OWI Written Records); and interviews by Claudine Weatherford, 11 October 1985, and Nicholas Natanson, 28 August 1986, *Documenting America,* project records, Supplementary Archives, Prints and Photographs Division, Library of Congress.

6. The two photographs of the old file cabinets are in the Vanderbilt Papers. Although partially covered by Vanderbilt's new labels, the old category markings are visible on some of the mounted prints in the FSA-OWI classified file in the Prints and Photographs Reading Room.

7. Rosskam to Stryker, 5 July 1941, Vanderbilt Papers.

8. Vanderbilt, "Preliminary Report," Stryker Papers, 13.

9. There are slight variations in the way the list of classes is presented in the signs that guide researchers to the file in the Prints and Photographs Reading Room at the Library of Congress and in *America 1935–1946: An Index to the Microfiche* (Cambridge: Chadwyck-Healey, 1981), 5–8. The editors have used both sources as a basis for the list presented here.

10. The microfiche edition of the classified file is *America 1935–1946.* Filmed in the 1940s, the lots are available on 109 reels of microfilm from the Photoduplication Service, Library of Congress, under the title *Farm Security Administration–Office of War Information* (P&P no. 3).

11. Vanderbilt, *Guide to the Special Collections,* 3, 54–55, 117–20, 129.

12. Untitled, undated manuscript in box 3, Vanderbilt Papers.

13. Vanderbilt, *Guide to the Special Collections,* 2.

14. The subject of "Portrait of America," no. 38, is Father Walter Cassidy, photographed by John Collier, Jr., in New Mexico in 1943. Supplementary Reference files, box 22, lots 863–76, FSA-OWI Written Records.

15. The blocks are lots 300–658 and 1000–1737.

16. The FSA-OWI Written Records are in lot 12024 and are available on microfilm. They are described in Annette Melville, *Farm Security Administration, Historical Section: A Guide to Textual Records in the Library of Congress* (Washington, D.C.: Library of Congress, 1985).

17. Lot 1 is the lowest numbered member of the group, but the highest numbered lot is harder to determine. The highest numbered lots with photographs made by the Office of War Information seem to be 2247 and 2269, but they are surrounded by lots of photographs that the agency had gathered. Vanderbilt's microfilm control cards end at lot 2273. Most of the lots below 2273 tend to be dated 1945 or earlier, whereas most of the lots above 2273 include photographs taken after 1947 or photographs that were acquired by the Library of Congress after 1947. Thus we have used lot 2273 as the cutoff point in our survey.

18. There is some unrelated material falling between lots 1 and 2273 that is hard to distinguish from the nonagency photographs Stryker and Vanderbilt had gathered. The total of 2,176 lots takes into account 32 lot numbers that were never assigned or were canceled; 26 lots (falling between lots 1 and 2273) containing "Portrait of America" photographs; 41 lots containing material that has no apparent connection with the Resettlement Administration, Farm Security Administration, Office of War Information, or Office for Emergency Management; and the creation of lots 557A and 1072A.

19. The prints in lots 1820 through 1839 were microfilmed and stamped with their subject class numbers, but they were never added to the classified file.

20. Indexes to portions of the collection include [Vanderbilt], *Index to Microfilm Reproductions,* and *America 1935–1946: Index to the Microfiche.*

21. The microfiche edition, however, does not provide the lot numbers from which the individual prints came.

22. Duplicate negatives are copies of original negatives, copy negatives are negatives made by copying a print (in the FSA-OWI Collection, copy negatives typically reproduce gathered images), and transparencies (interpositives) are transparent positive images used as an intermediate material in the production of duplicate negatives.

23. The Photoduplication Service of the Library of Congress will attempt to fill orders for prints from these negatives if the negative numbers can be determined by an examination of the caption sheets and other documents. The Prints and Photographs Division, however, does not permit patrons to preview the images by viewing the negatives directly.

24. The Vanderbilt Papers contain a half-dozen pages from a procedure manual without a title page; internal evidence suggests that the manual was prepared by the Historical Section in 1940 or later. One section states, "After your film is developed and you are notified as to its condition, the negatives are numbered."

25. For an example of reports of the hole punching see Hank O'Neal, *A Vision Shared: A Classic Portrait of America and Its People, 1935–1943* (New York: St. Martin's Press, 1976), 46. These reports seem to refer to 1935 and 1936. Although the editors have not surveyed the collection for negatives with holes, they have seen several 35-mm negatives from 1938 with holes punched in them.

26. Melville, *A Guide to Textual Records,* 13. For example, a large number of Dorothea Lange's Resettlement Administration and Farm Security Administration negatives are now in the Dorothea Lange Collection at the Oakland Museum.

27. Procedure manual (cited in note 24), Vanderbilt Papers.

28. A description of the process and the caption files may be found in Melville, *A Guide to Textual Records,* 12–13.

Adams, Mark, and Russell Lee. "Our Town in East Texas." *Travel*, March 1940, 5–12.

Agee, James, and Walker Evans. *Let Us Now Praise Famous Men.* Boston: Houghton Mifflin, 1941. Revised edition, 1960.

Allen, Fred H. *New York City, Westchester, and Nassau Counties in Relation to Real Estate Investments, 1942.* New York: Bowery Savings Bank et al., 1942.

America 1935–1946. Cambridge: Chadwyck-Healey, 1980. Microfiche edition of the FSA-OWI classified file.

America 1935–1946. Advertising brochure. Cambridge: Chadwyck-Healey, [1983].

America 1935–1946: Index to the Microfiche. Cambridge: Chadwyck-Healey, 1981.

Anderson, James C. *Roy Stryker: The Humane Propagandist.* Louisville: University of Louisville Photographic Archives, 1977.

Anderson, Sherwood. *Home Town.* New York: Alliance Book Corp., 1940.

Baldwin, Sidney. *Poverty and Politics.* Chapel Hill: University of North Carolina Press, 1968.

Beals, Carleton. *The Crime of Cuba.* Philadelphia: J. B. Lippincott, 1933.

Beloff, Halla. *Camera Culture.* Oxford and New York: B. Blackwell, 1985.

Berger, Maurice. *FSA: The Illiterate Eye: Photographs from the Farm Security Administration.* New York: Hunter College Art Gallery, 1985.

Bernstein, Irving. *A Caring Society: The New Deal, the Worker, and the Great Depression: A History of the American Worker, 1933–1941.* Boston: Houghton Mifflin, 1985.

Bettelheim, Bruno. "Individual and Mass Behavior in Extreme Situations." *Journal of Abnormal Psychology* 38, no. 4 (October 1943):417–52.

Bird, Caroline. *The Invisible Scar.* New York: D. McKay, 1966.

Bush, Martin H. *The Photographs of Gordon Parks.* Wichita: Wichita State University, 1983.

Campbell, Russell. *Cinema Strikes Back: Radical Filmmaking in the U.S., 1930–1942.* Ann Arbor: UMI Research Press, 1982.

Caplan, Lincoln, ed. "Walker Evans on Himself." *New Republic,* 13 November 1976, 23–27.

Collier, John, Jr. *Visual Anthropology: Photography as a Research Method.* New York: Holt, Rinehart and Winston, 1967. Rev. ed. John Collier, Jr., and Malcolm Collier. Albuquerque: University of New Mexico Press, 1986.

Collins, Marjory. Papers. Schlesinger Library, Radcliffe College, Cambridge, Mass.

Conkin, Paul K. *Tomorrow a New World: The New Deal Community Program.* Ithaca, N.Y.: Cornell University Press, 1959.

Conrat, Maisie, and Richard Conrat. *Executive Order 9066: The Internment of 110,000 Japanese Americans.* Cambridge: MIT Press, 1972.

Curtis, James C. "Dorothea Lange, Migrant Mother, and the Culture of the Great Depression." *Winterthur Portfolio* 21, no. 1 (Spring 1986):1–20.

Curtis, James C., and Sheila Grannen. "Let Us Now Appraise Famous Photographs: Walker Evans and Documentary Photography." *Winterthur Portfolio* 15, no. 1 (Spring 1980):1–23.

Daniel, Pete. *Breaking the Land.* Urbana: University of Illinois Press, 1985.

Daniel, Pete, Merry Foresta, Maren Stange, and Sally Stein. *Official Images: New Deal Photography.* Washington, D.C.: Smithsonian Institution Press, 1987.

Delano, Jack. Papers. Archives of American Art, Smithsonian Institution, Washington, D.C.

Dixon, Daniel. "Dorothea Lange." *Modern Photography,* December 1952, 68–77, 138–41.

Dixon, Penelope. *Photographers of the Farm Security Administration: An Annotated Bibliography, 1930–1980.* New York: Garland Publishing, 1983.

Documenting America, 1935–1943. Project records. Supplementary Archives, Prints and Photographs Division, Library of Congress, Washington, D.C.

Dykeman, Wilma, and James Stokely. *Seeds of Southern Change: The Life of Will Alexander.* Chicago: University of Chicago Press, 1962.

Elkins, Stanley. *Slavery: A Problem in American Institutional and Intellectual Life.* Chicago: University of Chicago Press, 1959.

Ellison, Ralph. *Shadow and Act.* New York: Random House, 1964.

Evans, Walker. *American Photographs.* New York: Museum of Modern Art, 1938.

———. *Many Are Called.* Boston: Houghton Mifflin, 1966.

———. "The Reappearance of Photography." *Hound & Horn* 5 (October–December, 1931): 124–28.

———. *Walker Evans.* New York: Museum of Modern Art, 1971.

———. *Walker Evans: Photographs for the Farm Security Administration, 1935–1938.* New York: Da Capo Press, 1973.

———. *Walker Evans at Work.* New York: Harper and Row, 1982.

Farm Security Administration Collection: P&P no. 52. Brochure. Washington, D.C.: Library of Congress Prints and Photographs Division, n.d.

Farm Security Administration–Office of War Information. Written Records of the Farm Security Administration, Historical Section–Office of War Information, Overseas Picture Division, Washington Section Collection, Prints and Photographs Division, Library of Congress, Washington, D.C.

Farm Security Administration–Office of War Information Collection. Photographs. Prints and Photographs Division, Library of Congress, Washington, D.C.

Farm Security Administration–Office of War Information Collection (P&P no. 3). Microfilm edition of about 1,800 lots from the FSA-OWI Collection. Photoduplication Service, Library of Congress, Washington, D.C.

Federal Writers' Project. *California: A Guide to the Golden State.* New York: Hastings House, 1939.

Five Cent Cotton: Images of the Depression in Alabama. Birmingham: Birmingham Public Library, 1982.

Ganzel, Bill. *Dust Bowl Descent.* Lincoln: University of Nebraska Press, 1984.

Garver, Thomas H. *Just before the War.* Balboa, Cal.: Newport Harbor Art Museum, 1968.

Graves, John Temple, II. "The Big World at Last Reaches Gee's Bend." *New York Times Magazine,* 22 August 1937, 12–15.

Green, Jonathan. *American Photography: A Critical History, 1945 to the Present.* New York: Harry N. Abrams, 1984.

Hamilton, Virginia Van der Veer. *Seeing Historic Alabama: Fifteen Guided Tours.* University: University of Alabama Press, 1982.

Heyman, Therese Thau. *Celebrating a Collection: The Work of Dorothea Lange.* Oakland: Oakland Museum, 1978.

Heyman, Therese Thau, and Joyce Minick. "Dorothea Lange." *American Photographer* 2, no. 2 (February 1979): 50–54.

Hogue, Alexander. "The U.S. Dust Bowl." *Life,* 21 June 1937, 60–65.

Hull, Anne. "John Vachon, Noted Cameraman, Departs." *Greenbelt [Maryland] Cooperator* 8, no. 8 (8 October 1943): 1–2.

Hurley, F. Jack. "Pie Town, N.M., 1940." *American Photographer* 10, no. 3 (March 1983): 76–85.

———. *Portrait of a Decade: Roy Stryker and the Development of Documentary Photography in the Thirties.* Baton Rouge: Louisiana State University Press, 1972.

———. *Russell Lee, Photographer.* Dobbs Ferry, N.Y.: Morgan and Morgan, 1978.

James, William. *Selected Papers on Philosophy.* New York: E. P. Dutton, 1917.

Katz, Leslie. "Interview with Walker Evans." *Art in America,* March–April 1971, 82–89.

Keller, Ulrich. *The Highway as Habitat: A Roy Stryker Documentation.* Santa Barbara, Cal.: University Art Museum, 1986.

Kennedy, Renwick C. "Life at Gee's Bend." *Christian Century,* 1 September 1937, 1072–75.

Lange, Dorothea. "The Assignment I'll Never Forget: Migrant Mother." *Popular Photography* 46, no. 2 (February 1960): 42–43, 126.

———. Interview by Richard Doud, 22 May 1964. Archives of American Art, Smithsonian Institution, Washington, D.C.

Lee, Russell. "Pie Town." *Creative Camera* 193/194 (July–August 1980): 246–53.

Leighton, George R. *Five Cities: The Story of Their Youth and Old Age.* New York: Harper and Brothers, 1939.

———. "Omaha, Nebraska." *Harper's,* July 1938, 113–14, 320–28.

Lemann, Nicholas. *Out of the Forties.* Austin: Texas Monthly Press, 1983.

Leuchtenberg, William E. *Franklin D. Roosevelt and the New Deal, 1932–1940.* New York: Harper and Row, 1963.

Levine, Lawrence W. "American Culture and the Great Depression." *Yale Review* 74 (Winter 1985): 196–223.

———. "Hollywood's Washington: Film Images of National Politics in the Great Depression." *Prospects* 10 (1986): 169–95.

———. "Progress and Nostalgia: The Self Image of the 1920s." In *The American Novel and the 1920s,* edited by Malcolm Bradbury. London: Edward Arnold, 1971.

McCamy, James L. *Government Publicity.* Chicago: University of Chicago Press, 1939.

McDonald, Janet Strain. "Quilting Women." In *Black Belt to Hill Country: Alabama Quilts from the Robert and Helen Cargo Collection.* Birmingham: Birmingham Museum of Art, 1982.

McElvaine, Robert S. *The Great Depression: America, 1929–1941.* New York: Times Books, 1984.

MacLeish, Archibald. *Land of the Free.* New York: Harcourt, Brace, 1938.

Maloney, T. J., ed. *U.S. Camera 1939.* New York: William Morrow, 1938.

———. *U.S. Camera 1940.* New York: Random House, 1939.

———. *U.S. Camera 1942*. New York: Duell, Sloane, and Pearce, 1941.

Manhattan Land Book. New York: G. W. Bromley, 1934.

Mayer, Grace M. Introductory note to *The Bitter Years, 1935–1941*, edited by Edward Steichen. New York: Museum of Modern Art, 1962.

Meltzer, Milton. *Dorothea Lange: A Photographer's Life*. New York: Farrar, Straus and Giroux, 1978.

Melville, Annette. *Farm Security Administration, Historical Section: A Guide to Textual Records in the Library of Congress*. Washington, D.C.: Library of Congress, 1985.

———. *Special Collections in the Library of Congress: A Selective Guide*. Washington, D.C.: Library of Congress, 1980.

Mitchell, Margaret. *Gone with the Wind*. New York: Macmillan, 1936; Pocket Books, 1968.

Morse, John D., ed. *Ben Shahn*. New York: Praeger Publishers, 1972.

Newhall, Beaumont. "Documentary Approach to Photography." *Parnassus*, March 1938, 3–6.

New York. Map. From vol. 6 of the series *New York, 1903–1919*. Pelham, N.Y.: Sanborn Map Co., 1907.

Nixon, Herman Clarence. *Forty Acres and Steel Mules*. Chapel Hill: University of North Carolina Press, 1938.

Ohrn, Karin Becker. *Dorothea Lange and the Documentary Tradition*. Baton Rouge: Louisiana State University Press, 1980.

O'Neal, Hank. *A Vision Shared: A Classic Portrait of America and Its People, 1935–1943*. New York: St. Martin's Press, 1976.

Parks, Gordon. *A Choice of Weapons*. New York: Harper and Row, 1966.

———. *Moments without Proper Names*. New York: Viking Press, 1975.

———. Interview by Richard Doud, 28 April 1964. Archives of American Art, Smithsonian Institution, Washington, D.C.

Plattner, Steven. *Roy Stryker: U.S.A., 1943–1950*. Austin: University of Texas Press, 1983.

Post Wolcott, Marion. Keynote Address. Presented at the Women in Photography Conference, Syracuse, N.Y., 10–12 October 1986.

———. *Marion Post Wolcott: FSA Photographs*. Carmel, Cal.: Friends of Photography, 1983.

Pratt, Davis, ed. *The Photographic Eye of Ben Shahn*. Cambridge: Harvard University Press, 1975.

Puckett, John Rogers. *Five Photo-Textual Documentaries from the Great Depression*. Ann Arbor: UMI Research Press, 1984.

Radin, Paul, and James Johnson Sweeney. *African Folktales and Sculpture*. New York: Pantheon Books, 1952.

Raedeke, Paul. "Introduction + Interview." *Photo-Metro*, February 1986, 3–17.

Raper, Arthur F. *Tenants of the Almighty*. New York: Macmillan, 1943.

Rasmussen, Wayne D. *A History of the Emergency Farm Labor Supply Program, 1943–47.* Agriculture Monograph no. 13. Washington, D.C.: U.S. Department of Agriculture, Bureau of Agricultural Economics, 1951.

Real Estate Directory of the Borough of Manhattan. New York: Real Estate Directory Company, 1938.

Real Property Inventory City of New York: Borough of Manhattan. New York: New York Housing Authority, 1934.

Rodman, Selden. *Portrait of the Artist as an American.* New York: Harper and Brothers, 1951.

Rose, Joseph R. *American Wartime Transportation.* New York: Thomas Y. Crowell, 1953.

Rosenman, Samuel I. *The Public Papers and Addresses of Franklin D. Roosevelt.* New York: Harper and Brothers, 1950.

Rosskam, Edwin, and Ruby A. Black, eds. *Washington: Nerve Center.* New York: Alliance Book Corp., 1939.

Rostow, Eugene V. "The Japanese American Cases—A Disaster." In *The Shaping of Twentieth Century America: Interpretive Essays,* edited by Richard M. Abrams and Lawrence W. Levine. Boston: Little, Brown, 1971.

Rothstein, Arthur. "Direction in the Picture Story." *The Complete Photographer* 21 (10 April 1942):1356–63. Revised version in vol. 7 of *The Encyclopedia of Photography,* edited by Willard D. Morgan. New York: Greystone Press, 1971, 2890–901.

———. *Documentary Photography.* Boston: Focal Press, 1986.

Schlesinger, Arthur, Jr. *The Crisis of the Old Order, 1919–1933.* Boston: Houghton Mifflin, 1957.

Sekula, Allan. *Photography against the Grain: Essays and Photo Works, 1973–1983.* Halifax: Press of the Nova Scotia College of Art and Design, 1984.

Shahn, Ben. *The Shape of Content.* 1957. Reprint. New York: Vintage Books, 1969.

Shahn, Bernarda Bryson. *Ben Shahn.* New York: Harry N. Abrams, 1972.

"A Small Town Goes to War . . ." *American Press* 61, no. 8 (June 1943):6–16.

Smith, Beverly. "Molasses and Sowbelly." *American Magazine* 124, no. 1 (July 1937):156–57, 164–67.

Smith, J. Russell. *North America: Its People and the Resources, Development, and Prospects of the Continent as an Agricultural, Industrial, and Commercial Area.* New York: Harcourt, Brace, 1925.

Sonkin, Robert / Gee's Bend, Alabama, Collection. Papers and sound recordings. Archive of Folk Culture, Library of Congress, Washington, D.C.

Spicer, Edward H., Asael T. Hansen, Katherine Luomala, and Marvin K. Opler. *Impounded People: Japanese-Americans in the Relocation Centers.* Tucson: University of Arizona Press, 1969.

Stange, Maren. "The FSA Project and Its Predecessors." *Views: The Journal of Photography in New England* 5, no. 2 (Winter 1983–1984):9–16.

————. "'Symbols of Ideal Life': Technology, Mass Media, and the FSA Photography Project." *Prospects* 11 (1986): 81–104.

————. *"Symbols of Ideal Life": Social Documentary Photography in America, 1890–1950*. New York: Cambridge University Press, 1988.

Steichen, Edward. "The F.S.A. Photographers." In *U.S. Camera 1939*, edited by T. J. Maloney (New York: William Morrow, 1938).

————, ed. *The Bitter Years, 1935–1941*. New York: Museum of Modern Art, 1962. With an introductory note by Grace M. Mayer.

Stein, Sally. "Marion Post Wolcott: Thoughts on Some Lesser Known FSA Photographs." In *Marion Post Wolcott: FSA Photographs*, 3–10. Carmel, Cal.: Friends of Photography, 1983.

Steinbeck, John. *The Grapes of Wrath*. New York: Viking Press, 1939. Reprint. Bantam, 1946.

Stevenson, Robert Louis. *Across the Plains*. London: C. Scribner's Sons, 1892.

Stoeckle, John D., and George Abbott White. *Plain Pictures of Plain Doctoring*. Cambridge: MIT Press, 1985.

Stott, William. *Documentary Expression and Thirties America*. New York: Oxford University Press, 1973. Reprint. London: Oxford University Press, 1976.

Stouffer, Samuel A., Arthur A. Lumsdaine, Marion Harper Lumsdaine, Robin M. Williams, Jr., M. Brewster Smith, Irving L. Janis, Shirley A. Star, and Leonard S. Cottrell, Jr. *The American Soldier: Combat and Its Aftermath*. Studies in Social Psychology in World War II, vol. 2. Princeton: Princeton University Press, 1949.

Strausberg, Stephen F. "The Effectiveness of the New Deal in Arkansas." In *The Depression in the Southwest*, edited by Donald W. Whisenhunt. Port Washington, N.Y.: Kennikat Press, 1980.

Stryker, Roy E. "Documentary Photography." *The Complete Photographer* 21 (10 April 1942): 1364–74. Revised version in vol. 7 of *The Encyclopedia of Photography*, edited by Willard D. Morgan, 1179–83. New York: Greystone Press, 1971.

————. Papers. Photographic Archives, University of Louisville, Louisville, Ky.

————. Papers. Archives of American Art, Smithsonian Institution, Washington, D.C.

Stryker, Roy E., and Paul H. Johnstone. "Documentary Photographs." In *The Cultural Approach to History*, edited by Caroline F. Ware, 324–30. New York: Columbia University Press, 1940.

Stryker, Roy E., and Nancy Wood. *In This Proud Land: America 1935–1943 as Seen in the FSA Photographs*. Greenwich, Conn.: New York Graphic Society, 1973. Reprint. New York: Galahad Books, 1975.

Susman, Warren I. *Culture as History: The Transformation of American Society in the Twentieth Century*. New York: Pantheon Books, 1984.

———. "History and Film: Artifact and Experience." *Film & History* 15 (May 1985):26–36.

Szarkowski, John. Introduction to *Walker Evans.* New York: Museum of Modern Art, 1971.

———. *Looking at Photographs.* New York: Museum of Modern Art, 1973.

Tagg, John. "The Currency of the Photograph." In *Thinking Photography,* edited by Victor Burgin. London: Macmillan, 1982.

Taylor, Paul S. "Migrant Mother: 1936." *American West* 7, no. 3 (May 1970):41–47.

Taylor, Paul S., and Dorothea Lange. *An American Exodus: A Record of Human Erosion.* New York: Reynal and Hitchcock, 1939. Rev. ed. New Haven: Yale University Press, 1969. Reprint. New York: Arno Press, 1975.

Thomas, Dorothy Swaine. *The Salvage.* Berkeley: University of California Press, 1952.

Thomas, Dorothy Swaine, and Richard S. Nishimoto. *The Spoilage.* Berkeley: University of California Press, 1946.

Thompson, Jerry L. "Walker Evans: Some Notes on His Way of Working." In *Walker Evans at Work,* 9–17. New York: Harper and Row, 1982.

Todd, Charles L. "The 'Okies' Search for a Lost Frontier." *New York Times Magazine,* 27 August 1939, 10.

———. "Trampling Out the Vintage." *Common Cause* 8, no. 7 (July 1939):7–8, 30.

Todd, Charles L. / Migratory Labor Collection. Papers and sound recordings. Archive of Folk Culture, Library of Congress, Washington, D.C.

Trachtenberg, Alan. "Walker Evans' America: A Documentary Invention." In *Observations: Essays on Documentary Photography,* edited by David Featherstone. Carmel, Cal.: Friends of Photography, 1984.

Trend, M. G., and W. L. Lett. "Government Capital and Minority Enterprise: An Evaluation of a Depression-Era Social Program." *American Anthropologist* 88, no. 3 (September 1986): 595–609.

Trillin, Calvin. "The Black Womens of Wilcox County Is About to Do Something." *New Yorker,* 22 March 1969, 102–8.

Trilling, Lionel. "Greatness with One Fault in It." *Kenyon Review* 4 (Winter 1942):99–102.

Tugwell, Rexford G., Thomas Munro, and Roy E. Stryker. *American Economic Life.* New York: Harcourt, Brace, 1925.

U.S. Office of War Information. *Handbook of Emergency War Agencies.* Washington, D.C.: Government Printing Office, March 1943.

Vachon, Brian. "John Vachon: A Remembrance." *American Photographer* 3, no. 4 (October 1979):34–45.

Vachon, John. "Tribute to a Man, an Era, an Art." *Harper's,* September 1973, 96–99.

Valle, James E. *The Iron Horse at War.* Berkeley: Howell-North Books, 1977.

Vanderbilt, Paul. "Computations for a Viewfinder." *Afterimage* (September 1976).

————. *Guide to the Special Collections of Prints and Photographs in the Library of Congress.* Washington, D.C.: Library of Congress, 1955.

————. Papers. Archives of American Art, Smithsonian Institution, Washington, D.C.

[Vanderbilt, Paul.] *Index to Microfilm Reproductions in the Photograph Section: Series A, Lots 1–1737.* Washington, D.C.: Library of Congress, 1946.

White, George Abbott. "Vernacular Photography: FSA Images of Depression Leisure." *Visual Communication* 9, no. 1 (Winter 1983):53–75.

Winkler, Allan M. *The Politics of Propaganda: The Office of War Information, 1942–1945.* New Haven: Yale University Press, 1978.

Works Progress Administration. Federal Writers' Project Life Histories. Manuscript Division, Library of Congress, Washington, D.C.

Wright, Richard, and Edwin Rosskam. *Twelve Million Black Voices: A Folk History of the Negro in the United States.* New York: Viking Press, 1941.

Wroth, William, ed. *Russell Lee's FSA Photographs of Chamisal and Peñasco, New Mexico.* Santa Fe: Ancient City Press, 1985.

The following list provides the negative, numbers for the photographs reproduced from the FSA-OWI Collection in Prints and Photographs, Library of Congress. Prints of these photographs may be ordered from the Library's Photoduplication Service. For those interested in determining the size of the original negatives, the following letter codes forming the suffix of each negative number indicate size as follows:

A. 8 × 10 inches
B.. 5 × 7 inches (none included here)
C. 4 × 5 inches
D. 3¼ × 4¼ inches
E. 2¼ × 2¼ inches
M. 35mm

Page	Image	Negative Number	Page	Image	Negative Number	Page	Image	Negative Number
16	Fig. 2		51	Fig. 25	LC-USF3301-30811-M2	89	c	LC-USF3301-6023-M5
	(top right)	LC-USF34T01-9098-C	59	Fig. 26	LC-USF342T01-1295-A		d	LC-USF3301-6025-M5
	Fig. 3		69	Fig. 30	LC-USF34T01-9058-C	94	a	LC-USF3301-1295-M3
	(bottom)	LC-USF34T01-9095-C	80	a	LC-USF3301-6029-M3		b	LC-USF3301-1306-M1
17	Fig. 4			b	LC-USF3301-6029-M5	95	c	LC-USF34T01-8964-D
	(top left)	LC-USF34T01-9093-C	81	c	LC-USF3301-6028-M2	96	a	LC-USF34T01-8939-D
	Fig. 5		82	a	LC-USF3301-6050-M5		b	LC-USF3301-1286-M5
	(top right)	LC-USF34T01-9097-C		b	LC-USF3301-6217-M2	97	c	LC-USF34T01-8938-D
	Fig. 6	LC-USF34T01-9058-C	83	c	LC-USF3301-6218-M5	98	a	LC-USF34T01-8968-D
18	Fig. 7	LC-USF34T01-4900-D	84	a	LC-USF3301-6020-M2	99	b	LC-USF3301-1311-M3
	Fig. 8	LC-USF34T01-19729-E	85	b	LC-USF3301-6022-M5	100	a	LC-USF34T01-8859-D
19	Fig. 9	LC-USF3301-6437-M1	86	a	LC-USF3301-6020-M1		b	LC-USF3301-1307-M3
	Fig. 10	LC-USF34T01-62164-D		b	LC-USF3301-6221-M2	101	c	LC-USF34T01-8951-D
21	Fig. 11	LC-USF342T01-8138-A	87	c	LC-USF3301-6026-M1	102	a	LC-USF3301-1287-M2
24	Fig. 13	LC-USF34T01-9599-C	88	a	LC-USF3301-6026-M3	103	b	LC-USF34T01-8904-D
44	Fig. 18	LC-USF342T01-1167-A		b	LC-USF3301-6025-M3		c	LC-USF3301-1277-M4

Page	Image	Negative Number	Page	Image	Negative Number	Page	Image	Negative Number
104	a	LC-USF34T01-8906-D	168	a	LC-USF34T01-19253-C	224	a	LC-USF34T01-39623-D
	b	LC-USF34T01-8902-D	169	b	LC-USF34T01-19266-E	225	b	LC-USF3301-13092-M3
105	c	LC-USF34T01-8878-D		c	LC-USF34T01-19262-C	230	a	LC-USF34T01-13430-C
	d	LC-USF34T01-8905-D	170	a	LC-USF34T01-19268-E		b	LC-USF34T01-13422-C
106	a	LC-USF3301-1294-M2	171	b	LC-USF34T01-19271-E	231	c	LC-USF34T01-13423-C
	b	LC-USF3301-1305-M2		c	LC-USF34T01-19273-E	232		LC-USF34T01-13432-C
107	c	LC-USF3301-1296-M5	172	a	LC-USF34T01-19277-E		b	LC-USF34T01-13438-C
	d	LC-USF34T01-8944-D	173	b	LC-USF34T01-21993-C	233	c	LC-USF34T01-13411-C
108	a	LC-USF34T01-8934-D	178	a	LC-USF34T01-51215-D	234	a	LC-USF34T01-13408-C
109	b	LC-USF34T01-8945-D	179	b	LC-USF34T01-51222-D	235	b	LC-USF34T01-13407-C
	c	LC-USF3301-1278-M1	180	a	LC-USF34T01-51218-D	236	a	LC-USF34T01-13384-C
110	a	LC-USF34T01-8916-D		b	LC-USF34T01-51221-D		b	LC-USF34T01-13500-C
111	b	LC-USF3301-1295-M2	181	c	LC-USF34T01-51227-D	237	c	LC-USF34T01-13502-C
112	a	LC-USF34T01-8837-D	182	a	LC-USF34T01-50772-E	238	a	LC-USF34T01-13491-C
113	b	LC-USF34T01-8826-D	183	b	LC-USF3301-30470-M2	239	b	LC-USF34T01-13445-C
118	a	LC-USF34T01-16269-C		c	LC-USF3301-30472-M1		c	LC-USF34T01-13492-C
119	b	LC-USF34T01-16247-C	184	a	LC-USF3301-30461-M3	243	a	LC-USF34T01-72255-D
120	a	LC-USF34T01-16451-C		b	LC-USF3301-30440-M3		b	LC-USF3301-13292-M1
	b	LC-USF34T01-16288-E		c	LC-USF3301-30438-M1	244	a	LC-USF34T01-72355-D
121	c	LC-USF34T01-16333-C	185	d	LC-USF3301-30493-M2		b	LC-USF34T01-72383-D
	d	LC-USF34T01-16206-E	186	a	LC-USF3301-30464-M3	245	c	LC-USF34T01-72344-D
122	a	LC-USF34T01-16113-E	187	b	LC-USF3301-30466-M1	246	a	LC-USF34T01-72670-E
123	b	LC-USF34T01-16292-E	191	a	LC-USF34T01-24117-D		b	LC-USF34T01-72394-D
124	a	LC-USF34T01-16425-C		b	LC-USF34T01-24116-D	247	c	LC-USF34T01-72575-D
125	b	LC-USF34T01-16336-C		c	LC-USF34T01-24118-D	248	a	LC-USF34T01-72516-D
126	a	LC-USF34T01-16330-E		d	LC-USF34T01-24119-D		b	LC-USF3301-13289-M2
127	b	LC-USF34T01-16276-C	192	a	LC-USF34T01-24213-D	249	c	LC-USF34T01-72499-D
132	a	LC-USF3301-6715-M5		b	LC-USF34T01-24226-D	250	a	LC-USF34T01-72337-D
	b	LC-USF3301-6715-M3		c	LC-USF34T01-24211-D		b	LC-USF34T01-72325-D
133	c	LC-USF3301-6715-M2		d	LC-USF34T01-24210-D	251	c	LC-USF34T01-72379-D
134	a	LC-USF3301-6712-M5	193	e	LC-USF34T01-24207-D	255	a	LC-USW3T01-11723-E
135	b	LC-USF3301-6712-M3		f	LC-USF34T01-24205-D		b	LC-USW3T01-11699-E
136	a	LC-USF3301-6712-M1		g	LC-USF34T01-24203-D	256	a	LC-USW3T01-11850-D
137	b	LC-USF3301-6714-M1		h	LC-USF34T01-24204-D	257	b	LC-USW3T01-11883-D
	c	LC-USF3301-6718-M4	194	a	LC-USF34T01-24288-D	258	a	LC-USW3T01-11703-E
	d	LC-USF3301-6718-M3		b	LC-USF34T01-24164-D	259	b	LC-USW3T01-11178-D
138	a	LC-USF3301-6719-M5	195	c	LC-USF34T01-24616-D		c	LC-USW3T01-11135-D
	b	LC-USF3301-6719-M3	196	a	LC-USF34T01-24208-D	260	a	LC-USW3T01-11100-D
139	c	LC-USF3301-6719-M1	197	b	LC-USF34T01-24194-D	261	b	LC-USW3T01-11851-D
140	a	LC-USF3301-6717-M4		c	LC-USF34T01-24195-D	262	a	LC-USW3T01-11236-E
	b	LC-USF3301-6717-M1	198	a	LC-USF34T01-24185-D		b	LC-USW3T01-11250-E
141	c	LC-USF3301-6716-M3		b	LC-USF34T01-24216-D	263	c	LC-USW3T01-11139-D
142	a	LC-USF3301-6716-M2	199	c	LC-USF34T01-24189-D	264	a	LC-USW3T01-11328-D
	b	LC-USF3301-6713-M2	200	a	LC-USF34T01-24293-D	265	b	LC-USW3T01-11886-D
143	c	LC-USF3301-6722-M1	201	b	LC-USF34T01-24256-D		c	LC-USW3T01-11868-D
144	a	LC-USF3301-6721-M2	202	a	LC-USF34T01-24190-D	266	a	LC-USW3T01-11840-D
145	b	LC-USF3301-6720-M3		b	LC-USF34T01-24236-D	267	b	LC-USW3T01-11132-D
150	a	LC-USF34T01-25226-D	203	c	LC-USF34T01-24123-D		c	LC-USW3T01-11329-D
151	b	LC-USF34T01-25359-D	204	a	LC-USF34T01-24258-D	268	a	LC-USW3T01-11837-D
	c	LC-USF34T01-25386-D	205	b	LC-USF34T01-24159-D	269	a	LC-USW3T01-11781-D
152	a	LC-USF34T01-2407-M2	209		LC-USF34T01-39633-D	270	a	LC-USW3T01-11318-D
	b	LC-USF34T01-25363-D	210	a	LC-USF3301-13097-M2	271	b	LC-USW3T01-11752-E
153	c	LC-USF34T01-25380-D	211	b	LC-USF3301-13098-M2		c	LC-USW3T01-10949-D
154	a	LC-USF34T01-25365-D	212	a	LC-USF3301-13095-M4	272	a	LC-USW3T01-11119-D
155	b	LC-USF34T01-25374-D		b	LC-USF3301-13085-M2	273	b	LC-USW3T01-11815-D
156	a	LC-USF34T01-25393-D	213	c	LC-USF3301-13082-M4	274	a	LC-USW3T01-11765-D
157	b	LC-USF34T01-25354-D	214	a	LC-USF3301-13103-M5	275	b	LC-USW3T01-11817-D
	c	LC-USF34T01-25379-D	215	b	LC-USF3301-13094-M1		c	LC-USW3T01-11334-D
158	a	LC-USF34T01-25348-D		c	LC-USF3301-13064-M2	279		LC-USW3T01-15461-E
159	b	LC-USF34T01-25378-D	216	a	LC-USF3301-13096-M5	280	a	LC-USW3T01-15871-D
	c	LC-USF34T01-25229-D		b	LC-USF3301-13067-M3	281	b	LC-USW3T01-15818-D
163	a	LC-USF34T01-19236-D	217	c	LC-USF3301-13095-M2		c	LC-USW3T01-15815-D
	b	LC-USF34T01-19242-D	218	a	LC-USF3301-13089-M3	282	a	LC-USW3T01-15557-E
164	a	LC-USF34T01-19243-D	219	b	LC-USF34T01-39637-D	283	b	LC-USW3T01-15550-E
165	b	LC-USF34T01-19238-D	220	a	LC-USF34T01-39626-D	284	a	LC-USW3T01-15539-E
166	a	LC-USF34T01-19245-D	221	b	LC-USF3301-13070-M2		b	LC-USW3T01-15579-E
	b	LC-USF34T01-19241-D	222	a	LC-USF34T01-39617-D	285	c	LC-USW3T01-15830-D
167	c	LC-USF34T01-19251-C	223	b	LC-USF34T01-39622-D		d	LC-USW3T01-15915-D

Page	Image	Negative Number	Page	Image	Negative Number	Page	Image	Negative Number
286	a	LC-USW3T01-15432-E	300	a	LC-USW3T01-17776-E	318	a	LC-USW3T01-37194-E
287	b	LC-USW3T01-15813-D		b	LC-USW3T01-17774-E		b	LC-USW3T01-37124-E
288	a	LC-USW3T01-15573-E	301	c	LC-USW3T01-17887-C	319	c	LC-USW3T01-37181-E
289	b	LC-USW3T01-15410-E	302	a	LC-USW3T01-15237-C	320	a	LC-USW3T01-37431-E
290	a	LC-USW3T01-15509-E		b	LC-USW3T01-15287-C	321	b	LC-USW3T01-37150-E
291	b	LC-USW3T01-15950-D	303	c	LC-USW3T01-18508-C	322	a	LC-USW3T01-37735-E
292	a	LC-USW3T01-15431-E	304	a	LC-USW3T01-17782-E		b	LC-USW3T01-37526-E
	b	LC-USW3T01-15796-D	305	b	LC-USW3T01-17807-E	323	c	LC-USW3T01-37545-E
288	a	LC-USW3T01-15573-E	306	a	LC-USW3T01-15203-C	324	c	LC-USW3T01-37374-E
289	b	LC-USW3T01-15410-E		b	LC-USW3T01-17838-E	325	b	LC-USW3T01-37677-E
290	a	LC-USW3T01-15509-E	307	c	LC-USW3T01-17809-E	326	a	LC-USW3T01-37761-E
291	b	LC-USW3T01-15950-D	308	a	LC-USW3T01-15258-C		b	LC-USW3T01-37696-E
292	a	LC-USW3T01-15431-E	309	b	LC-USW3T01-17814-E	327	c	LC-USW3T01-37968-E
	b	LC-USW3T01-15796-D	310	a	LC-USW3T01-14613-E	328	a	LC-USW3T01-38141-E
293	c	LC-USW3T01-15445-E	311	b	LC-USW3T01-17941-C		b	LC-USW3T01-37902-E
298	a	LC-USW3T01-15225-C	315		LC-USW3T01-36913-E	329	c	LC-USW3T01-37975-E
	b	LC-USW3T01-15196-E	316	a	LC-USW3T01-36883-E	339	Fig. A-1	LC-USF3301-6218-M4
299	c	LC-USW3T01-17884-C	317	b	LC-USW3T01-36921-E			

The index covers both text and photographs. Italic page numbers refer to illustrations. People, places, or subjects discussed in the notes are identified by a page number followed by a note number. The index was prepared by Victoria Agee.

Designer: Steve Renick
Compositor: G&S Typesetters, Inc.
Mechanicals: Nancy Webb
Text: 10/12 Baskerville
Display: Syntax
Printer: Malloy Lithographing, Inc.
Binder: John H. Dekker & Sons
Editorial Coordinator: Marilyn Schwartz
Production Coordinator: Ellen Herman